Canada: The State of the Federation 2006/07

Transitions
Fiscal and Political Federalism in an Era of Change

Edited by

John R. Allan
Thomas J. Courchene
Christian Leuprecht

Conference organizers:

Sean Conway
Peter M. Leslie
Christian Leuprecht

Institute of Intergovernmental Relations
School of Policy Studies, Queen's University
McGill-Queen's University Press
Montreal & Kingston • London • Ithaca

The Institute of Intergovernmental Relations

The Institute is the only academic organization in Canada whose mandate is solely to promote research and communication on the challenges facing the federal system.

Current research interests include fiscal federalism, health policy, the reform of federal political institutions and the machinery of federal-provincial relations, Canadian federalism and the global economy, and comparative federalism.

The Institute pursues these objectives through research conducted by its own staff and other scholars, through its publication program, and through seminars and conferences.

The Institute links academics and practitioners of federalism in federal and provincial governments and the private sector.

The Institute of Intergovernmental Relations receives ongoing financial support from the J.A. Corry Memorial Endowment Fund, the Royal Bank of Canada Endowment Fund, the Government of Canada, and the governments of Manitoba and Ontario. We are grateful for this support, which enables the Institute to sustain its extensive program of research, publication, and related activities.

L'Institut des relations intergouvernementales

L'Institut est le seul organisme universitaire canadien à se consacrer exclusivement à la recherche et aux échanges sur les questions du fédéralisme.

Les priorités de recherche de l'Institut portent présentement sur le fédéralisme fiscal, la santé, la modification éventuelle des institutions politiques fédérales, les mécanismes de relations fédérales-provinciales, le fédéralisme canadien au regard de l'économie mondiale et le fédéralisme comparatif.

L'Institut réalise ses objectifs par le biais de recherches effectuées par son personnel et par des chercheurs de l'Université Queen's et d'ailleurs, de même que par des congrès et des colloques.

L'Institut sert comme lien entre les universitaires, les fonctionnaires fédéraux et provinciaux et le secteur privé.

L'Institut des relations intergouvernementales reçoit l'appui financier du J.A. Corry Memorial Endowment Fund, de la Fondation de la Banque Royale du Canada, du gouvernement du Canada et des gouvernements du Manitoba et de l'Ontario. Nous les remercions de cet appui qui permet à l'Institut de poursuivre son vaste programme de recherche et de publication ainsi que ses activités connexes.

ISSN 0827-0708
ISBN 978-1-55339-191-3 (bound).
ISBN 978-1-55339-189-0 (pbk.)

In recognition of his service to the Institute of Intergovernmental Relations and to Queen's University, this book is dedicated to Sean Conway.

The Institute of Intergovernmental Relations would like to acknowledge the support from the following conference sponsors:

COUNCIL OF
ONTARIO UNIVERSITIES

CONSEIL DES
UNIVERSITÉS DE L'ONTARIO

Forum of Federations
An International Network on Federalism

Forum des fédérations
un réseau international sur le fédéralisme

CONTENTS

PREFACE

This 2006–07 edition of *Canada: The State of the Federation*, entitled *Transitions: Fiscal and Political Federalism in an Era of Change*, focuses on a series of consequential events and developments that have ushered in new frameworks and new challenges relating to federal-provincial and interprovincial fiscal relations. One of the most important of these was the 2007 budget's acceptance of the equalization recommendations contained in the report of the federally commissioned Expert Panel on Equalization and Territorial Formula Financing. With the mushrooming of energy prices wreaking havoc with the new equalization program, the jury is still out as to whether this new framework will achieve the longevity of its five-province-standard predecessor or whether further transitions will be in order. A second area of change relates to a series of recent proposals for reworking aspects of federal-provincial political relations: open federalism and the respect for the constitutional distribution of powers; the declaration that the Québécois form a nation within a united Canada; and the Speech from the Throne commitment to circumscribe the role of the spending power. The third transition has to do with the rise of cities as the dynamic, economic and institutional motors of the Information Age. This is part of a more general phenomenon, namely the increasing importance of issues that are in the national interest but are under provincial jurisdiction. As this volume is going to press, *Compete to Win* (the report of the Competition Policy Review Panel) recommends that Canada's largest urban centres acquire more powers as well as a more stable, secure, and growing revenue source. In the chapters that follow, our distinguished roster of authors wrestle analytically and from a policy perspective with all three of these transitions.

A majority of the contributions in this volume originated as papers delivered at the IIGR's conference "Fiscal Federalism and the Future of Canada" held on 29–30 September 2006. The conference was organized under the guidance of IIGR's then Director, Sean Conway, with much of the heavy lifting left in the able hands of Peter Leslie and Christian Leuprecht. The Institute is pleased to thank the authors, discussants, and session chairs, including Finance Minister James Flaherty, Marc-Antoine Adam, Robin Boadway, Ken Boessenkool, Paul Boothe, Don Drummond, Robert Gagné, Anne Golden, John Honderich, Guy Laforest, Harvey Lazar, Janice MacKinnon, Al O'Brien,

Wolfgang Renzsch, Anwar Shaw, Michael Smart, Jennifer Smith, Janice Gross Stein, and Jean-François Tremblay.

Special thanks for orchestrating and overseeing the staging of the conference go to the Institute's staff: Patti Candido and Mary Kennedy ably assisted by April Chang, Eric Leclerc, Reama Khayat, and Ryan Zade.

As can often be the case, the march of events since the conference has had important implications for both the Institute and the conference proceedings. In terms of the former, Institute Director Sean Conway, already undertaking the oral history of the Paul Martin government, was seconded to the Office of the Principal at Queen's. He relinquished his directorship, although he remained the IIGR Associate Director (External Relations). I accepted the role of Acting Director of the IIGR and then in May of 2007 I assumed the IIGR directorship for a two-year period. At this point in time John Allan joined the Institute as the operational Associate Director. On the conference front, the adoption of the new equalization formula in the 2007 budget and the reworking of the Offshore Accords required a reconsideration of aspects of the fiscal relations component of the proposed volume. Likewise the already-noted open-federalism/Québécois nation/spending power provisions led to reconstituting much of the remainder of the volume. In this regard we thank Anne Golden and Janice Stein for agreeing to submit new papers and we thank our new authors – Garth Stevenson, Joe Ruggeri, Wade Locke and Paul Hobson, James Feehan and Gordon DiGiacomo.

Converting a set of papers into a publishable volume is never an easy task. Our Institute staff was, as always, clearly up to the challenge. Mary Kennedy kept track of the multitude of files as well as ensured that the papers were appropriately finalized. Patti Candido not only looked after the financial accounts but also coordinated aspects of the conference fundraising. The assistance of Sean Gray, Paul Michna, Ryan Zade, and Eric Leclerc at various stages of the production process is much appreciated. The superb editing of Carla Douglas maintained the IIGR's high standard of presentation. Valerie Jarus deserves special praise for a careful and comprehensive approach to ensuring that the published papers reflect the work that has gone into their production. Mark Howes was responsible for the design of the conference brochures as well as the cover design for the volume.

The Institute is grateful for the conference funding received from Bell Canada, the Ontario Government, the Forum of Federations/ Forum des federations and the Council of Ontario Universities. In this regard, our thanks go to Sean Conway.

Previous editions of *Canada: The State of the Federation* included a "chronology" of events for the relevant year. Beginning with this volume, these chronologies (including those from earlier years) will appear on our website and will be accessible directly from the IIGR homepage (www.iigr.ca). We

thank April Chang, Nadia Verrelli and Sean Gray for compiling the 2006 and 2007 chronologies.

Former IIGR Director Sean Conway is leaving the Institute and Queen's. In appreciation for his leadership and overall contribution to IIGR and Queen's, we are pleased to dedicate this volume to him.

At both a personal and an institutional level, I wish to express thanks to my co-editors John Allan and Christian Leuprecht.

Finally, on behalf of the IIGR it is a pleasure and a privilege to extend our gratitude to the contributors of this volume. The Institute can only be as good and as effective as the people who devote their time and talent to producing theoretical and policy analyses that are readable and relevant. I believe that readers of *Transitions* will quickly realize that the authors have performed up to the highest standard.

Thomas J. Courchene
Director, IIGR
Summer 2008

CONTRIBUTORS

Marc-Antoine Adam is a member of the Quebec Bar and heads the Direction de la réflexion stratégique at the Secrétariat aux affaires intergouvernementales canadiennes in the Quebec government. When his chapter in this volume was written, he was on leave at Queen's University as visiting fellow to the Institute of Intergovernmental Relations.

John R. Allan is Associate Director, Institute of Intergovernmental Relations. He is also Vice-President Emeritus and Professor of Economics Emeritus of the University of Regina.

Robin Boadway is the David Chadwick Smith Chair in Economics at Queen's University and a Fellow of the Institute of Intergovernmental Relations.

Paul Boothe is the Senior Associate Deputy Minister at Industry Canada. At the time of writing, he was Professor and Fellow at the Institute of Public Economics, University of Alberta.

Thomas J. Courchene is the Jarislowsky-Deutsch Professor of Economic and Financial Policy and the Director of the Institute of Intergovernmental Relations in the Queen's School of Policy Studies. He is also a Senior Scholar of the Institute for Research on Public Policy (Montreal).

Gordon DiGiacomo is a doctoral candidate in Political Science at Carleton University and a part-time professor at the University of Ottawa. He specializes in federalism, the constitution and public policy.

James P. Feehan is a professor of Economics at Memorial University of Newfoundland. His recent research has focused on public finance, fiscal federalism, the economics of public infrastructure, and natural resource issues. At Memorial University, he also serves as the Joint Director of the Institute of Social and Economic Research and the J. R. Smallwood Foundation for Newfoundland and Labrador Studies.

Anne Golden is the President and Chief Executive Officer of The Conference Board of Canada and primary author of *Mission Possible: Successful Canadian Cities,* Volume 3.

Paul A.R. Hobson is a professor in Acadia University's Department of Economics. He has served on the executive of the Canadian Economics Association, is a

past-president of the Atlantic Canada Economics Association, and is a Senior Policy Advisor to the Atlantic Provinces Economic Council.

Christian Leuprecht is Assistant Professor of Political Science at the Royal Military College of Canada. He holds cross-appointments to the Department of Political Studies and the School of Policy Studies at Queen's University where he is also a research associate at the Institute of Intergovernmental Relations.

L. Wade Locke is a professor of Economics at Memorial University. He specializes in the Newfoundland and Labrador economy, resource economics, public finance, public policy, innovation indicators, productivity, economic impact assessment and cost-benefit analysis. He is also a past president of the Atlantic Canada Economics Association.

Janice MacKinnon is a professor of Public Policy at the University of Saskatchewan, Chair of the Institute for Research on Public Policy and a member of the Board of the Canada West Foundation. She was also Finance Minister in Saskatchewan in the 1990s when the province became the first in Canada to balance its budget.

Al O'Brien was appointed by the Federal Government as Chair of the Expert Panel on Equalization and Territorial Formula Financing, which reported to the federal Minister of Finance in June 2006. He retired as Deputy Provincial Treasurer of the Province of Alberta in May 1999. In his 35-year career in the Alberta Public Service, Al served as Director of the Budget Bureau, Assistant Deputy Treasurer, Controller, and as Deputy Provincial Treasurer, Management and Control from 1984 to 1996. He is a Fellow of the Institute for Public Economics at the University of Alberta.

Joe Ruggeri is Vaughan Chair in Regional Economics and Director of the Policy Studies Centre at the University of New Brunswick.

Anwar Shah is lead economist and program leader, Public Sector Governance, World Bank Institute, a member of the executive board, International Institute of Public Finance in Germany, and fellow at the Institute for Public Economics at the University of Alberta.

Janice Gross Stein is the Belzberg Professor of Conflict Management and the Director of the Munk Centre for International Studies at the University of Toronto.

Garth Stevenson is a professor of Political Science and former chairman of the department at Brock University, specializing in Canadian government and politics.

Jean-François Tremblay is an assistant professor in the Department of Economics at the University of Ottawa.

I

Introduction

1

Introduction and Overview

Thomas J. Courchene and John R. Allan

Le chapitre préliminaire fournit un bref aperçu des principaux thèmes du tome 2006-2007 de Canada : état de la fédération. Ce tome, intitulé « Transitions : fédéralisme fiscal et politique dans une ère de changements », cherche à analyser plusieurs nouveaux développements dans les politiques intergouvernementales du Canada et à faire des liens entre eux : l'introduction d'un principe de « fédéralisme ouvert » par le gouvernement Harper; la reconnaissance du Québec à titre de « nation» distincte; la restructuration du programme de péréquation dans le budget 2007 et ses répercussions sur le fédéralisme fiscal, pour ne nommer que ceux-là. L'introduction divise le livre en six parties, puis offre un bref résumé de la contribution de chaque auteur au sujet qui l'occupe. Enfin, elle fait valoir que compte tenu des changements drastiques apportés à la fédération sur plusieurs fronts, l'idée de « transition » jouera vraisemblablement, dans les années à venir, un rôle déterminant dans les relations intergouvernementales.

INTRODUCTION

Not surprisingly, the election of Stephen Harper's minority Conservative government in January 2006 represented a dramatic break with many of the policies and commitments of the Chrétien-Martin Liberals. Kelowna is out. So is Kyoto. And Paul Martin's series of bilateral deals with the provinces (day care, cities, infrastructures) have been replaced by Harper's "open federalism," replete with a commitment to limit the exercise of the federal spending power in areas of exclusive provincial jurisdiction. At another level, the Harper government adopted some of the achievements and inherited some of the problems that characterized the Liberal regime. With respect to the former, for example, Finance Minister James Flaherty now champions Ottawa's fiscal and budgetary

prowess in ways very similar to those of his Liberal predecessors. And any listing of inherited problems would certainly have to include the fiscal tug-of-war with Nova Scotia and, more particularly, Newfoundland and Labrador over the restructuring of equalization – most notably the treatment of resource revenues – in the wake of Paul Martin's 2004 "fixed framework."

Hence, it is fair to say that Canada is in a transition period on policy grounds (since in several areas we are in the process of moving toward new equilibria) as well as on political grounds (since the Conservatives are in a minority position). Accordingly, *Transitions: Fiscal and Political Federalism in an Era of Change ("Transitions")*, seems an apt title for a volume devoted to an analysis of the continuing evolution of Canada's intergovernmental policies and challenges.

This volume has its origins in the Institute's annual conference (September 2006). However, the march of events quickly overcame selected components of the conference and revealed that other key aspects were missing. For example, while the reports of the Expert Panel on Equalization and Territorial Formula Financing (the "Expert Panel") and the Advisory Panel on Fiscal Imbalance (the "Advisory Panel") were available at the time of the conference, the new equalization program (actually programs) introduced in the 2007 federal budgets necessitated additional papers and fresh perspectives. In consequence, roughly half of the papers in this volume represent contributions that were either commissioned or accepted post-conference. It is a pleasure to express our gratitude to all our authors and to acknowledge that their continued interest in the Institute's activities is our most precious asset.

Transitions is organized as follows. Part II (*The Politics and Economics of Fiscal Federalism: Setting the Stage*) consists of three background papers. The first is a historical and policy overview of fiscal federalism by Brock University's Garth Stevenson. The other two background papers deal with the reports of the two equalization panels. In his paper, Al O'Brien, Chair of the Expert Panel, summarizes the principal findings of the federal report (*Achieving a National Purpose: Putting Equalization Back on Track*), while those of the Advisory Panel's report (*Reconciling the Irreconcilable: Addressing Canada's Fiscal Imbalance*) are provided by the inclusion of its concluding chapter.

Part III (*Equalization: Policy Perspectives*) presents two policy evaluations of the new equalization system (in the larger context provided by the reports of the two panels and the 2007 federal budget). The first of these is by University of Saskatchewan's Janice MacKinnon and the second by University of Alberta's Paul Boothe. In Part IV (*Equalization: Analytical Perspectives*), papers by Robin Boadway (Queen's University), Jean-François Tremblay (University of Ottawa) and Joe Ruggeri (University of New Brunswick) provide in-depth analyses of the related issues of fiscal balance and equalization.

Part V (*Equalization: The Offshore Accords*) rounds out the assessment of the new equalization system with two papers on the implications for offshore

energy, the first by Memorial's James Feehan on Newfoundland and Labrador, and the second, on the impact on the Maritime provinces, by Acadia's Paul Hobson and Memorial's Wade Locke.

The focus of Part VI (*Cities, Local Government, and Federalism*) is on municipal governments, most particularly on cities, with papers by Anwar Shah of the World Bank, Anne Golden of the Conference Board of Canada, and Thomas Courchene of Queens. Part VII (*Federalism and the Spending Power*), the final section of the volume, addresses aspects of the federal spending power. The initial paper is by Marc-Antoine Adam, Government of Quebec, who analyzes the potential of s.94 of the Constitution to be revitalized in the spending-power context. This is followed by Gordon DiGiacomo's analysis of the interaction between benefits provided pursuant to Employment Insurance and the exercise of the federal spending power. The volume then concludes with a very different perspective – Networked Federalism – provided by University of Toronto's Janice Gross Stein.

The remainder of the introduction is devoted to a more detailed overview and summary of the included papers.

THE POLITICS AND ECONOMICS OF FISCAL FEDERALISM: SETTING THE STAGE

FISCAL FEDERALISM AND THE BURDEN OF HISTORY (GARTH STEVENSON)

Garth Stevenson's historical overview is a most appropriate backdrop to this year's *State of the Federation*. In part, this is because the paper traces the many threads of Canada's policy and political transitions in federal-provincial fiscal relations from our origins as "an economy based on natural resources, and a society in which social services were mainly provided by the Catholic Church in Quebec and by private charities elsewhere" through to the present time. If there is a constant in Stevenson's story, it is "the continuity of provincial discontent with our intergovernmental fiscal arrangements."

Stevenson provides a broad, historical overview of intergovernmental developments from Confederation through to the creation of the CHST. His analysis then becomes more detailed as he focuses on the more recent debates of fiscal federalism: issues of fiscal balance, the spending power, Paul Martin's offshore accords, the three fiscal federalism reports (Expert Panel, Advisory Panel, the report of Canadian Centre for Policy Alternatives), the Harper election and open federalism, Flaherty's 2007 budget, including the new equalization formula, and, of course, the continuing provincial discontent that currently embraces most of the provinces.

As with several of the other authors in this volume, Stevenson concludes with his own proposals for reforming Canada's fiscal relations. Specifically,

he would i) transfer the corporate income tax to Ottawa; ii) transfer the GST to the provinces; and iii) phase out the CST (for CAP, and PSE), which, with respect to areas of provincial responsibility, would leave Ottawa involved only in the health areas (via the CHT). Among the virtues of these reforms would be increasing own-source provincial revenues, limiting the role of the federal spending power in areas of provincial jurisdiction, and reworking the tax assignment in ways that are consistent with the principle of subsidiarity (moving taxes on mobile and volatile taxes up the jurisdictional ladder and vice versa).

THE EXPERT PANEL REPORT (AL O'BRIEN)

In the aftermath of Ottawa's 2004 "fixed framework" approach to equalization (i.e., $10.9 billion for 2005–06, to be escalated thereafter by 3.5 percent annually for a decade) and the later 14 February 2005 agreement (*The 2005 Nova Scotia and Newfoundland and Labrador Additional Fiscal Equalization Offset Payments Act*), the federal government created the Expert Panel on Equalization and Territorial Formula Financing, chaired by former Alberta deputy provincial treasurer, Al O'Brien.[1] In the same time frame, the Council of the Federation established an independent Advisory Panel on Fiscal Imbalance with a mandate to examine the vertical and horizontal fiscal imbalances among Canada's federal, provincial and territorial governments. This Advisory Panel was co-chaired by Robert Gagné and Janice Stein.[2] We focus on each in turn, beginning with the federally-commissioned report.[3]

Al O'Brien outlines the Expert Panel's mandate and recommendations for both the equalization program and for territorial formula financing (TFF). The major recommendations of the Expert Panel include abandoning Paul Martin's 2004 fixed framework in favour of the Expert Panel's "principles-based" approach; opting for a ten-province standard with 50 percent inclusion of resource revenues and 100 percent inclusion of all other revenues; reducing the number of tax bases from 33 by consolidating the smaller bases into five larger, well-established RTS bases; and imposing a confiscatory fiscal-capacity cap to ensure that no equalization-receiving province ends up with an all-in fiscal capacity (defined to include 100 percent of *all* revenues plus equalization) that is higher than that of the lowest non-receiving province.

[1] The other Expert Panel members were Fred Gorbet, Robert Lacroix, Elizabeth Parr-Johnston and Mike Percy.

[2] The other Advisory Panel members were Peter Meekison, Senator Lowell Murray and John Todd.

[3] We were remiss in not including any paper dealing from a territorial perspective with the issue of territorial financing. The omission of a paper dealing specifically with the unique situation of Saskatchewan is also regretted.

The three annexes to the O'Brien paper relate, in turn, to the recommendations for equalization, to the recommendations for TFF, and to the manner in which the Expert Panel's reductions of tax bases from 33 to 5 was accomplished.

Interestingly, and unlike the experience associated with many similar panels, essentially all of the Expert Panel's recommendations were adopted by the Minister of Finance in his 2007 budget.

THE ADVISORY PANEL REPORT *(RECONCILING THE IRRECONCILABLE: CONCLUSION)*

The Advisory Panel's mandate was broader than that of the Expert Panel: not only was it mandated to examine the vertical and horizontal imbalances "among Canada's federal, provincial, and territorial governments and to make recommendations as to how any fiscal imbalances should be addressed," it was also directed to examine "the current health and social transfer system, the Equalization program, Territorial Formula Financing, and other major federal transfers to provinces and territories and to review a full range of mechanisms aimed at redressing fiscal imbalances between governments" (*Reconciling the Irreconcilable*, 7).

With respect to equalization, the Advisory Panel recommends a ten-province standard, with 100 percent of all revenues entering the formula. This would generate a level of equalization that is well in excess of the status quo, as well as in excess of the equalization arising from the Expert Panel's formula. The Advisory Panel notes that if affordability then becomes an issue, negotiations between the two orders of government should take place and the equalization standard should be lowered in per-capita terms (as negotiated), so that the payments do become affordable. Regarding vertical fiscal balance, the Advisory Panel believes that there is an imbalance in favour of Ottawa. Accordingly, it recommends that the combined per capita CHT/CST be increased from $807 to $960 (which increase would notionally be assigned to the CST). The Advisory Panel supports the federal government's commitments to escalate the CHT at 6 percent per year, and recommends that the CST should be escalated at 4.5 percent per year. On the issue of governance, the Advisory Panel proposes that the two levels of government establish a First Ministers' Fiscal Council (FMFC) to deal on an ongoing and quinquennial basis with intergovernmental fiscal arrangements. In addition, this FMFC would establish a new body, the Canadian Institute for Fiscal Information (CIFI), to serve as an "impartial third party with the role and stature to gather information, undertake analyses, prepare reports, and offer recommendations to all governments on the operation of the system as a whole" (*Reconciling the Irreconcilable*, 96).

With these reports as background, we now turn to the assessments of the new equalization program as detailed in the 2007 federal budget (as noted,

largely the O'Brien model). By way of concluding this section, we note that the policy perspectives on the equalization program (by Paul Boothe and by Janice MacKinnon) are broadly supportive of the Expert Panel approach, whereas the analytical perspectives (by Robin Boadway and Jean-François Tremblay), at least with respect to the treatment of resource revenues, are more comfortable with the approach taken by the Advisory Panel.

EQUALIZATION: POLICY PERSPECTIVES

EQUALIZATION: TAX PROBLEMS AND THE 2007 FEDERAL BUDGET
(JANICE MACKINNON)

Janice MacKinnon commends the 2007 federal budget for restoring predictability and stability to federal-provincial relations by "establishing a long-term framework for equalization and other transfers based on rules and principles." In terms of equalization, uppermost in MacKinnon's mind is the budget's return to a principles-based approach in the wake of the damage done by Paul Martin's offshore side deals and by his untying the amount of equalization from a formula-determined level. At a more general level, she welcomes the end to the practice of having an equalizing component in other transfers (i.e., "backdoor equalization"). The reference here is in support of the move to put federal cash transfers on an equal per-capita basis by province, although those for health care will only be made equal-per-capita after 2013–14, i.e., after the current health agreement expires. Her hope is that in the future all federal programs "will be funded on a per capita basis unless there is some compelling policy reason to do so otherwise."

MacKinnon's contribution is also refreshing in that she offers some candid comments with respect to most provinces. For Quebec: "it is easier for Quebec to remain a 'have-not' province receiving sizeable equalization payments, than to make the difficult decisions to tackle its own problems with its economic structures and social programming." For her home province: "If Saskatchewan had been willing to compromise and recognize the need for some form of cap, it could probably have negotiated a less restrictive cap." And while equalization is supported throughout the country, we need to be realistic in terms of what it can achieve: "The goal is not to ensure that Canadians in Alberta and Prince Edward Island enjoy the same level of services, and there need to be strict limits on the extent to which resources are redistributed across provinces."

Her conclusion follows directly from this analysis: "Although equalization was broken, mainly by the 2005 side deals with Newfoundland and Nova Scotia, the 2007 budget 'fixed' the main problem by establishing a more realistic approach to what equalization can achieve and what it can NOT achieve, and should not even try to tackle" [capitalization in original].

NATURAL RESOURCE REVENUES AND FISCAL FEDERALISM: AN ALBERTA PERSPECTIVE (PAUL BOOTHE)

By way of an introductory comment, the editors note that Paul Boothe's paper was presented at the IIGR conference and then finalized during his University of Alberta interregnum from senior positions in the federal civil service. In his paper, he first emphasizes the very special place that resources (especially energy) occupy in the psyche, politics and economics of Alberta and Albertans, and then reflects on the treatment of resource revenues in the O'Brien report and in the new equalization formula. With respect to the first of these, the single defining event was the introduction of the National Energy Program (NEP). As he observes, "Albertans, led by Premier Peter Lougheed, regarded the NEP as tantamount to a declaration of war by Ottawa on Alberta." By way of another editorial aside, this perspective is especially important at a time when the energy/environment nexus has the potential for igniting a 21st century version of the NEP, as Peter Lougheed has recently speculated.

Boothe then turns his attention to dispelling a few energy-related myths. For example, it simply is not true that, because Alberta's energy is provincially owned, Ottawa and the other provinces derive no benefit from their development. And, seemingly for balance, "it is simply incorrect to argue that the federal government is unfairly capturing Alberta's natural resource-revenues to finance its activities in other parts of the country." Evidence is presented on both counts.

The remainder of his paper deals with the energy-equalization relationship. Boothe is, by and large, in favour of the compromise for the treatment of resources found in the O'Brien report. And he accepts the manner in which the 2007 budget has embraced the O'Brien report, including the additional option of an alternative formula with zero resource-revenue inclusion but continuing with the requirement of the fiscal-capacity cap. However, he does note that although Alberta and Ontario have been largely supportive of these reforms, Saskatchewan, Newfoundland and, to a lesser extent, Nova Scotia, have vigorously condemned them. Hence the durability of the 2007 arrangements may ultimately rest on the judgement of voters.

EQUALIZATION: ANALYTICAL PERSPECTIVES

NATURAL RESOURCE SHOCKS AND THE FEDERAL SYSTEM: BOON AND CURSE? (ROBIN BOADWAY)

Issues related to energy rents/revenues have created challenges for Canada's equalization program since its inception some fifty years ago (1957). In his contribution to this volume, Robin Boadway distinguishes between the implications arising from an energy boom, per se, and those arising because of the

nature of Canada's federation. Hence, he focuses in turn on energy booms in a unitary state, then in a centralized federation and, finally, in a decentralized federation where resource ownership is provincial. In terms of a unitary state, he notes:

> It is not at all clear that the location of valuable deposits of natural resource wealth should itself dictate the location of nodes for the development and growth of diversified activity. On the contrary, natural resources are often located in remote areas that have no other natural advantages for economic development.

Boadway goes on to note that this may be exacerbated in a decentralized federation because "of the potential that resource revenues give the provinces to engage single-mindedly in proactive province-building policies, possibly to the detriment of the development of the nation as a whole." This theme, that the "boon of a positive shock in resource wealth can be a curse at the same time," is reflected in the subtitle of the paper.

Boadway then examines the implications of his analysis for Canada's approach to fiscal federalism and equalization. In terms of equalization, his preference is for the Advisory Panel's approach over the Expert Panel's approach, largely because he believes that horizontal equity requires that 100 percent of *all* revenues should enter the formula. Should this, as it almost certainly would, generate an issue of affordability, Boadway suggests that the appropriate remedy would be to adjust the standard rather than the proportion of resource revenues to be equalized. This alternative would entail equal per capita changes in entitlements for all provinces, thereby maintaining horizontal balance among have-not provinces; in contrast, reducing the proportion of resource-revenues equalized damages relatively the resource-poor provinces. The alternative of "equalizing down," as Australia does, is simply not available politically to Canada at this time.

In terms of vertical fiscal balance, he favours revenue sharing (again as exemplified by Australia and its GST) rather than having the provinces acquire additional tax points. Indeed, he is very concerned that the vertical fiscal gap be sufficiently large for Ottawa to be able to adequately exercise the federal spending power. In Boadway's view, this combination of a large fiscal gap (in Ottawa's favour) and the exercise of the federal spending power is a most-important instrumentality: "It is the only one that is available to the federal government to fulfill its constitutional responsibilities under both parts of section 36 as well as to fulfill its legitimate policy interest in achieving national efficiency and equity."

Clearly, Boadway's recommendations would constitute a markedly centralist departure from the status quo, both for equalization and, more generally, of the conceptual underpinnings of fiscal federalism.

FISCAL BALANCE AND REVENUE-SHARING (JEAN-FRANÇOIS TREMBLAY)

Jean-François Tremblay's contribution continues the centralization thrust of the Boadway paper, in part because both papers draw from the authors' joint article, *A Theory of Fiscal Imbalance* (2006). Specifically:

> The main purpose of this paper is to argue that the best way to reallocate a greater share of public funds to provincial governments and maintain vertical fiscal balance in the federation in the long-run is neither to increase federal transfers in their current form, nor to reallocate additional tax room to the provinces, whether that occurs through a coordinated tax-point transfer or through uncoordinated tax decentralization. Instead, the federal and provincial governments should adopt revenue-sharing arrangements under which both levels of government would share the revenues from particular tax bases according to specific rules.

Toward this end, Tremblay presents a series of equity, efficiency and economic-union rationales for a greater centralization of taxes and, therefore, for a larger fiscal imbalance. His choice of taxes for revenue sharing are sales taxes (via a federally run and uniform national GST) and corporation taxes (again via a federally run and uniform national corporate tax). The provincial shares of both these taxes would be allocated on an equal per capita basis. Among the benefits claimed would be a lesser need for equalization, a more harmonized taxation system, and an elimination of "destructive competition in provincial tax policies."

Tremblay concludes by noting that if the optimal fiscal gap is not the same throughout the federation – e.g., if it is smaller for Quebec – then he would (reluctantly) embrace some version of asymmetrical fiscal arrangements for Quebec.

EQUALIZATION REFORM IN CANADA: PRINCIPLES AND COMPROMISES (JOE RUGGERI)

Joe Ruggeri presents and evaluates a fresh approach to Canada's system of equalization and transfer payments. However, en route to this new proposal, he also provides a brief overview of the origins and history of the equalization program and of the variety of ways in which that program has attempted to come to grips with the challenges arising from resource revenues. This accomplished, Ruggeri undertakes a comparison of the Advisory Panel and Expert Panel reports, with emphasis on how resource revenues are treated in each. The basic issue here is that Ottawa cannot directly access revenues from provincial natural resources. Hence, the equalization program needs to provide answers to two questions: first, should resource revenues contribute to a

province's measured fiscal capacity? And second, should the constitutional constraint on the federal government's capacity to raise revenues from natural resources be considered in determining the federal financial commitment to the program? Ruggeri notes that the Advisory Panel's answer is "yes" to the first question, since it recommends 100 percent inclusion of resource revenues in the formula. The answer from the Expert Panel (and that actually adopted) is "yes, but, ..." with the "but" being that only 50 percent of resource revenues will be counted in fiscal capacity. In terms of the second question, both reports recommend "affordability caps" if necessary (i.e., scaling overall equalization down to "acceptable levels"), with the Expert Panel also recommending a fiscal cap to prevent a "have-not province" from being transformed by equalization into an effective "have province."

Ruggeri's proposal is that the answer to the first question should be 100 percent inclusion of all resource revenue, while the answer to the second should be that Ottawa ought not be responsible for financing equalization payments that would be attributable to provincial resource revenues. Given these answers, his preferred approach is as follows. First, calculate the fiscal capacity and the equalization arising from the application of a national-average standard (NAS) with 100 percent inclusion of all revenues. Second, calculate the equalization arising from applying the NAS to provincial revenues with 0 percent inclusion of resource revenues. Third, subtract these two, with the difference being the amount of equalization arising from resource revenues. Fourth, calculate the average per capita value of this difference for the receiving provinces and, fifth, subtract this amount ($170 per capita in his example) from the equalization entitlements obtained in step number one. The end result is that the provincial fiscal capacities are determined by NAS and 100 percent inclusion, whereas the level of payments would exclude the equalization otherwise attributable to provincial resource revenues. In simpler terms, *the allocation of provincial shares* of equalization would include resource revenues, but the *amount to be allocated* would not. Ruggeri compares the results obtained from this intriguing compromise with those yielded by the two reports, as well as by the federal formula contained in the 2007 federal budget.

EQUALIZATION: THE OFFSHORE ACCORDS

In 1984 the Supreme Court of Canada ruled that offshore oil belonged to Canada, not to Newfoundland and Labrador (and, by extension, not to Nova Scotia). However, in 1985 for Newfoundland and Labrador (via the "Atlantic Accord") and 1986 for Nova Scotia (via the "Offshore Accord"), Ottawa permitted these provincial governments to tax offshore oil and gas as if they were located on their land.

Among other provisions, these accords provide "offset" payments to miti-gate the clawback of resource revenues in the form of reduced equalization entitlements, thereby ensuring that the effect of equalization on such revenues is not confiscatory. One might note in passing that the definition of offshore energy revenues adopted in these Accords includes ancillary revenues, such as corporate income taxes. The net result, therefore, is a federal treatment of the "Accord" provinces decidedly more generous than that accorded Saskatch-ewan which *does* own the oil and gas in the province, but where the effects of equalization have, on occasion, been confiscatory.

During the 2004 federal election, Prime Minister Paul Martin promised Newfoundland and Labrador Premier Danny Williams that, in Williams's words, provision would be made for a full federal offset of all offshore energy clawbacks under the equalization program. After much grandstanding, the result was the 2005 Offshore Revenues Agreement (ORA), which applied to both Newfoundland and Labrador and Nova Scotia.

It is the implications for the Atlantic region of this 2005 agreement that is the focus of Part V of *Transitions*, most particularly the manner in which the O'Brien Report and the 2007 federal budget interacted with the ORA. Of the two papers included, that by James Feehan assesses the implications for New-foundland and Labrador, while that by Paul Hobson and Wade Locke addresses the significance for the Maritimes.

EQUALIZATION 2007: NATURAL RESOURCES, THE CAP AND THE OFFSET PAYMENTS
AGREEMENTS (JAMES FEEHAN)

The Feehan paper begins with a most useful summary of events leading up to and including the new equalization formula contained in the 2007 federal budget. This new formula included i) a 50 percent inclusion rate of resource revenues in the formula; ii) offset payments that would transfer equalization clawbacks back to Newfoundland and Labrador; and iii) a confiscatory cap on overall revenues (defined for this purpose to include 100 percent of energy revenues) such that an equalization-receiving province could not have an all-in per capita fiscal capacity greater than that of the lowest non-equalization-receiving province. It is this "cap" that is now at the centre of Canada-Newfoundland and Labrador relations.

As Feehan notes, however, there are two additional options open to New-foundland and Labrador. Option two allows for the full exclusion of all natural resource revenues from the equalization formula, but with the confiscatory cap still in place. The third option (available only to Nova Scotia and New-foundland and Labrador) is the Martin 2004 formula (the so-called "fixed envelope" system), which allows overall equalization to grow at the annual rate of 3.5 percent and under which there would be 100 percent inclusion of resource revenues but no fiscal cap. Under this latter option, Newfoundland and Labrador's equalization would be the difference between its per capita

fiscal capacity (as defined above) and the ten-province value. One advantage of this model is that the offset payment under the 2005 Accord would not reduce Newfoundland and Labrador's equalization; in consequence, the province could at the same time be an equalization-receiving province *and* have an all-in fiscal capacity in excess of that of the lowest non-recipient province. While options one and two are available on a continuing basis for all provinces, should Newfoundland and Labrador opt for option three, it then locks itself into this option for the duration (although Ottawa seems to be relenting a bit here).

Feehan presents an excellent (albeit unavoidably complex) assessment of these options and then focuses on the confiscatory cap and, in particular, why it is 100 percent. His view is that the cap is too severe and needs rethinking. Over the history of equalization, Feehan notes that there have been several occasions when the operative cap related to resource revenues was 50 percent; there is precedent for a less-than-confiscatory cap. His concluding comment focuses on achieving a balance:

> Critics should understand that arguing against a clawback mechanism is unten-able when all natural resource revenue, or any other major revenue source, is excluded from equalization. On the other side, the federal government should, firstly, recognize the limitations imposed by the offset agreements, and, sec-ondly, re-assess the clawback rate on provinces' natural resource revenues.

The bottom line here is that there is both room and rationale for compromise, especially since Feehan's view is that a bit of compromise may lead to a situation where all provinces could agree on a single equalization formula rather than the multiple formulas that currently exist.

CHANGES TO CANADA'S MAJOR FEDERAL-PROVINCIAL TRANSFER PROGRAMS: IMPLICATIONS FOR THE MARITIME PROVINCES (PAUL HOBSON AND WADE LOCKE)

The Hobson and Locke approach to assessing the impact of Budget 2007 on the fiscal capacities of the Maritime provinces is to undertake an empirical simulation of the various fiscal-federalism models on offer. Among the many conclusions and implications that derive from these simulations, three (at least) are of more than passing interest.

The first is that although all three Maritime provinces are better off initially under the Budget 2007 formula, over time and cumulatively the 2004 fixed framework dominates. Then the natural question is the following: Why are Nova Scotia and Newfoundland and Labrador allowed to access the 2004 fixed framework, but not New Brunswick and PEI (and, by extension, all other provinces)? This question did not arise in the context of the budget debate largely, one must surmise, because the Hobson and Locke calculations were not available at that time.

A second noteworthy result relates to the conversion of the CST and, eventually, the CHT, to an equal per capita basis. To this point, the per capita cash transfer to each province was a residual, namely the difference between the equal-per-capita entitlement and the value of the tax-point transfer to the province. This was "full" equalization in that the cash-plus-tax-transfer per capita revenues for all provinces are brought up to that of the top province (Alberta). Under the conversion to equal-per-capita cash transfers, the resulting relative redistribution will be from lower-than-average income provinces toward higher-than-average income provinces. In terms of the Hobson-Locke paper, this means that all three Maritime provinces lose again, this time relatively and absolutely to the above-average-income provinces.

A final (for present purposes) noteworthy conclusion relates to the range of issues addressed by Feehan. Specifically, Hobson and Locke emphasize that the presence of the confiscatory cap generates a *two-step process for equalization*. In order to determine whether a province qualifies for equalization, the total fiscal capacity of a province (100 percent inclusion of all revenues) must be below that of the lowest non-equalization receiving province. If a province thus qualifies, then its equalization payment will be determined via the new equalization program (50 percent resource inclusion). This is a departure from traditional one-step procedures when the formula determines both eligibility and payments.

The editors note that an intriguing complication to the new equalization program may be about to enter centre stage, namely, the possibility that Ontario slips into have-not territory in terms of the new formula, i.e., the 50 percent resource-revenue-inclusion formula. Ontario is already a have-not province in terms of 100 percent inclusion of all revenues. This would mean that the lowest non-receiving province would become British Columbia, with potential windfalls to Saskatchewan, Nova Scotia and Newfoundland and Labrador and a considerable increase in the cost of the program to the federal government.

CITIES, LOCAL GOVERNMENT AND FEDERALISM

One of the important initiatives of the short-lived Paul Martin government was to elevate the role of cities in the federation. This included the commissioning in 2004 of the External Advisory Committee on Cities and Communities (EACCC) chaired by former British Columbia premier and Vancouver mayor Mike Harcourt. As events transpired, the EACCC reported on Prime Minister Harper's watch and the report disappeared without much of a trace. Nonetheless, the analytical and policy literature seems to point in the direction of the continuing ascendancy of cities. The fact that Canadian cities, especially our global city-regions, are poorly positioned politically and fiscally

in the international rankings of cities seems to establish a presumptive case that we have not heard the end of this issue. In consequence, Part VI offers, in anticipatory fashion, three perspectives by Anwar Shah, Anne Golden, and Thomas Courchene on the role of cities and local government in century 21.

RETHINKING FISCAL FEDERALISM IN CANADA: A LOCAL GOVERNMENT
PERSPECTIVE (ANWAR SHAH)

The World Bank's Anwar Shah was invited to the IIGR's fiscal-federalism conference to offer an international perspective on recent Canadian developments in fiscal and political federalism. In addressing this mandate, Shah divides his comments into two distinct parts. The first is a commentary on recent developments in the Canadian federation, and the second relates to his concern that Canada's approach to local governance lags behind creative approaches adopted elsewhere.

Concerning recent developments, Shah offers a series of wide-ranging comments and recommendations, including complimenting Canada on returning to a principled approach to equalization; proposing that Canada move in the New Zealand direction of performance-based budgeting; suggesting that the federal government adhere more closely to the provisions of the Social Union Framework Agreement; and offering kudos to Ottawa for refocusing its activities to areas of exclusive federal jurisdiction. All of these are couched in the context of hoping that Canada will remain an example of best practice for decentralized federations.

Shah's principal message, however, is that Canada's approaches to local government and governance require "urgent attention." In an era where city and municipal governments generally are increasingly important, Canada's cities not only lack constitutional status but, by international standards, they play a relatively smaller role, both politically and fiscally. For example, local governments in Canada account for 12 percent of overall government expenditures and 6 percent of GDP, compared to 28 percent and 11 percent respectively for US local governments and 28 percent and 13 percent for their OECD counterparts. The clear implication is that we need to place greater reliance on this level of government.

The remainder of his paper then focuses on alternative analytical perspectives to local governance, such as traditional fiscal federalism (where local government is subordinate in a multi-tiered system); new public management (where public managers create value by mobilizing and facilitating a network of providers beyond local government); and new institutional economics (where citizens as principals create various orders of government as agents to serve their interests), etc. In the last section of his paper, Shah makes a case for a citizen-centred local governance, where government is responsive to citizens' preferences, is prudent and efficient with citizens' monies, and is accountable

to citizens. Conveniently, he provides a rather all-encompassing tabular comparison between the traditional approach to local government and a citizen-centred approach.

CITIES: A NATIONAL PRIORITY (ANNE GOLDEN)

Anne Golden's thesis is that "in today's globally competitive and connected world, our major cities' distinctive needs require national attention – and action – so they can realize their potential as drivers of sustainable prosperity." Indeed, "big cities need more resources, more autonomy and more influence on senior government decision-making." This is true both in absolute terms and in relation to other (smaller) cities since the challenges facing major cities are "an order of magnitude" greater than those facing other municipalities. Golden also asserts that this is true also of the costs the major cities face: immigration settlement issues; magnets for low-income residents; social housing; public health; police and fire services; infrastructure costs for mass transit and suburbia; and recreational and cultural facilities that only big cities can sustain.

Golden also refers to the conclusions of the earlier Conference Board of Canada's "hub city" study (Brender and Lefebvre 2006). The findings indicate that economic growth in each of these hub cities (Vancouver, Edmonton, Calgary, Saskatoon and Regina, Winnipeg, Toronto, Montreal, and Halifax) has generated an "even faster" rate of economic growth in the other communities within their respective provinces or regions. In other words, and intriguingly, investing in hub cities leads to intra-provincial economic convergence.

On the question of whether Ottawa should defer from focusing on cities because the Constitution effectively make cities the creatures of provinces, Golden answers as follows:

> It would be paradoxical to expect Ottawa to restrict itself to indirect ways of helping cities out of deference to constitutional roles prescribed in 1867, an era when conditions were entirely different. All intelligent human arrangements must evolve in response to changing conditions. No observer of Canadian and global trends would today design a constitution that forbade federal government involvement in the engines of national prosperity. It is, after all, a two way street: flourishing cities help Ottawa achieve its overall economic and social objectives.

Golden's concern is that, rather than this being recognized, many of the current transfer programs (EI, the federal gas tax transfer) have built-in biases (either inadvertent or deliberate) against major cities and their residents. Her conclusion is that "the federal government should re-examine all of the programs that transfer funds to cities – directly and indirectly – to ensure that these programs meet the priority strategic requirements of major cities."

GLOBAL FUTURES FOR CANADA'S GLOBAL CITY REGIONS
(THOMAS J. COURCHENE)

In an argument similar to that presented by Golden, Thomas Courchene notes that it is in global city-regions (GCRs) that one finds the dense concentrations of human capital and human-capital-intensive activities so vital in the information age. Because of this, GCRs are becoming the coordinating and integrating networks in their regional economies as well as the national nodes in the international networks that drive growth, trade and innovation. Unfortunately, Canada's GCRs are, in an international comparative context, fiscally weak and jurisdictionally constitutionless. For example, our cities rely primarily on property taxes and provincial transfers rather than being able to access broad-based taxation like the personal income tax which the Nordic and several continental European cities are able to tap. In consequence, Canadian GCRs tend to spend much less than continental European GCRs. Even American cities have far greater revenue autonomy, a point he demonstrates by comparing the access to taxation by Edmonton and Calgary on the one hand and by Seattle and Denver on the other.

Even when Ottawa decides to transfer funding to cities, the GCR's fiscal dilemma is sometimes compounded because Ottawa still tends to view the big cities as places to distribute from. For example, the allocation of the federal gas tax to municipalities is viewed by Courchene as a form of equalization program, one that redistributes from big cities to smaller ones. What the GCRs want and need is access to broad-based taxation on a derivation basis, i.e., allocated on the basis of the revenues derived from the various cities in the first place. One example of this, and a convenient bridge to the jurisdictional section that follows, is the "double devolution" proposed by the External Advisory Committee on Cities and Communities, namely, shifting responsibilities and resources from the federal government to the provincial governments, and then from the provincial governments to the local level.

On the jurisdictional front, the reality that our collective future will almost surely depend on how our GCRs will fare vis-à-vis US GCRs means, according to Courchene, that Canada's major cities need to be integrated more formally and more fully into the processes of fiscal and political federalism. While Prime Minister Martin took some steps in this direction, the very definition of open federalism as encompassing respect for the existing division of powers means that the way forward under Prime Minister Harper is less clear. What is possible is that the provinces could accord their major cities a more formal role in the Council of the Federation and in the formulation of provincial positions in the context of federal-provincial relations.

Although most of Courchene's essay is cast in terms of the GCRs, he concludes by noting that there are ways, drawn from the work of the Canada West Foundation, by which smaller cities might be able to opt into structures/processes initially designed for the GCRs.

FEDERALISM AND THE SPENDING POWER

The combination of Prime Minister Stephen Harper's commitment to open federalism and the House of Commons declaration that the Québécois constitute a nation within a United Canada has served to direct attention to the constitutional division of powers on the one hand and the exercise of the federal spending power on the other. This is so because inherent in the manner in which the Prime Minister defined open federalism is a respect for the constitutional division of powers. And, in turn, respect for the division of powers necessarily requires that some constraints be placed on the exercise of the federal power in areas of exclusive provincial jurisdiction. Since this combination of principles characterizes both the 2007 *Speech from the Throne* and Finance Minister Flaherty's budgets, it is clearly an appropriate introduction to the three papers that constitute the final section of *Transitions*.

The first of the three, by Marc-Antoine Adam, falls four-square within these parameters, since it addresses ways to circumscribe the exercise of the federal spending power within a constitutional framework. Then Gordon DiGiacomo focuses on the evolution of the UI/EI program in terms of the manner in which the federal government chose to respond to situations where the courts gave it the right to manoeuvre in areas that Quebec believed to be in provincial jurisdiction. Finally, and in sharp contrast to the Adam position, Janice Gross Stein argues that the world is evolving in ways that require more, not less, overlap and shared policy space: hence her preference for what she refers to as networked federalism, which is arguably at the opposite end of the spectrum from the vision of watertight compartments implied by a strict adherence to the principles of open federalism.

SECTION 94 AND THE DIVISION OF POWERS (MARC-ANTOINE ADAM)[4]

The overarching issue for Marc-Antoine Adam is that key aspects of the practice of Canadian federalism should be, but are not, grounded in the Constitution. Of particular concern is that the federal government and others have on occasion declared that the exercise of the federal spending power is in no way limited by the distribution of powers. From the vantage point of many, this is hardly compatible with the federal principle, and it is certainly anathema to the province of Quebec.

By way of addressing these concerns, he proposes that we ought to consider s.94 of the Constitution as an instrument or regulator for the exercise of

[4] Marc-Antoine Adam spent the 2006–07 academic year at the IIGR as a visiting scholar in residence, on leave from the Government of Quebec. This paper was written during this academic sabbatical.

the federal spending power. Essentially, s.94 is a provision that allows the non-Quebec provinces (or the common-law provinces) to transfer upward to Ottawa selected powers relating to property and civil rights in concurring provinces (s.92(13)). As one of the editors has noted elsewhere (Courchene 2006, 49), the provinces' proposal in 2004 for the non-Quebec provinces to transfer responsibility for pharmacare to Ottawa (with Quebec opting out with compensation) is effectively a non-constitutional example of the upward transfer potentially available constitutionally through s.94. As Adam goes on to note, there is also a flip side to s.94, namely, that it allows Ottawa to initiate legislation in areas of property and civil rights as long as the provinces agree to this (with the right of those provinces that do not pass the equivalent or template federal legislation in their own legislatures to opt out).

Several important issues remain, and they occupy the second half of the Adam paper. Principal among these is that most observers view s.94 as a dead letter. Can it be resurrected in this way? And if so, can s.94 be construed as allowing provinces that opt out to receive federal compensation? Is s.94 reversible? All of these issues require further research.

Nonetheless, the role for s.94 as a potential regulator for the exercise of the federal spending power is promising in at least four respects: i) it is already enshrined in the Constitution; ii) it requires provincial consent for any federal intervention in areas of property and civil rights; iii) it can be triggered by either the provinces or by Ottawa; and iv) should the common-law provinces wish to transfer aspects of property and civil rights to Ottawa (e.g., pharmacare), this would not, by the very definition of s.94, be subject to a Quebec veto.

THE GOVERNMENT OF CANADA'S CONTRADICTORY APPROACH TO FEDERAL-PROVINCIAL RELATIONS (GORDON DIGIACOMO)

The thrust of the DiGiacomo paper is that, in its dealing with the provinces, the federal government does not always take advantage of the legislative authority that it has (or that the courts have given it) and that, on occasion, it has devolved power to provinces when there was no legally compelling reason to do so. He notes that in the labour-force training and environmental areas, Ottawa's approach has sometimes been first to assert its authority over an area, then to surrender jurisdiction, and finally, in its negotiations with the provinces, to give up far more than it needs to. The focus of his analysis is to assess whether this pattern of behaviour was true for the UI/EI program as it relates to maternity and parental benefits.

By way of background, DiGiacomo surveys some of the relevant literature relating to how Ottawa approaches the division of powers, drawing from some of the more general assessments of how it approaches policy generally. Textual references are to Stephen Clarkson (Ottawa has alternated between trying to enforce its authority and devolving its own powers), to Carolyn Tuohy

(institutionalized ambivalence across a wide range of policy choices) and, relatedly, to the F. Rocher and M. Smith papers that offer four visions that can be viewed as elaborating on Tuohy's institutionalized ambivalence (equality of the provinces with Ottawa, the nationalizing vision, asymmetrical federalism, and a rights-based constitutional vision). These approaches are appropriate in their own right in a volume devoted to transitions in federal-provincial political, institutional/constitutional and fiscal relations.

In terms of how all of this might apply in terms of illness, maternity (and later, parental) benefits under UI/EI, DiGiacomo notes that the 1971 UI Act states that if a provincial government established its own program for maternity or sickness benefits, the federal program would cease for these provinces and UI premiums would be pared down appropriately. This was included in the legislation in spite of the fact that the legal opinions were consistent with the proposal that loss of earnings due to sickness and maternity should be covered by insurance rather than welfare. DiGiacomo cites this as an example of the federal government asserting its jurisdiction over an area and then ceding it to the provinces even though it was not necessary to do so. But Ottawa and Quebec could not agree on the details of any such devolution, so that the status quo prevailed.

In March of 2002, Quebec asked the Court of Appeal of Quebec to determine the constitutionality of those sections of the *Employment Insurance Act* authorizing payment of maternity and parental benefits. The Quebec Appeal Court ruled in early 2004 that pregnancy and parental benefits are not at all part of unemployment insurance as conceived in 1940, (where 1940 was the date of the UI amendment transferring jurisdiction to Ottawa). Ottawa appealed virtually immediately, but a few months later it reached an agreement in principle with Quebec for devolving maternity and parental benefits, and for reducing the EI premium rates for Quebecers by an amount equivalent to the portion associated with these areas. The agreement was to hold no matter what the outcome of the Supreme Court decision. In 2005, the Supreme Court rejected the Quebec government's contention that the federal government had exceeded its jurisdiction by providing a social program through the *Employment Insurance Act*. DiGiacomo asserts, therefore, that in spite of the reality that it likely had jurisdiction over these areas, Ottawa chose to give the province the option of taking over maternity and parental benefits if it wanted to. In terms of the earlier-mentioned competing visions, DiGiacomo views this as a victory for the equality-of-the-provinces-with-Ottawa vision over the nationalizing vision. And it represents an example of one way in which Ottawa has limited the exercise of its spending power as this relates to the division of powers.

NETWORKED FEDERALISM (JANICE GROSS STEIN)

Janice Stein approaches the analysis of decision making in a decentralized federation very differently. As she sees it:

[The] federal project in Canada is not to disentangle overlapping jurisdictions. It is to acknowledge complexity and [to] pull on the best from the private, voluntary, and public sectors to create shared policy space across levels of government for new ideas, feedback, and correction. Our challenge of the next twenty-five years is not to simplify and order ... but to build a grid that allows all these governments to manage complexity and avoid the gridlock that can be so crippling. The model of networks, embedded in a grid, is ... a more useful metaphor than that of parallel lines of government neatly separated from one another.

I call this networked federalism, located in a grid where movement is along many of the axes, not through a central hub. Others call it the "whole of government" or multi-level governance.

Stein then adds:

Although networks have existed for centuries, the revolution in information and communications technology enabled them to proliferate and grow. They are only now becoming socially important because of their comparative advantage in handling the large volumes of information that flow around the world at unprecedented speed.

Among the many implications arising from a networking approach to federalism would be that Canada's cities would be brought more fully into federal decision making. As noted earlier, cities, especially global city regions, are key nodes in the international networks that drive growth, trade and innovation in the global economy; allowing them to be players in fiscal and political federalism would be an obvious next step.

Stein goes on to point out that policy making is already becoming less hierarchical. Phrased differently, public policy is already network-like, so in this sense networked federalism can be viewed as evolutionary, not revolutionary. Moreover, networked federalism does not require constitutional change. However, it does preclude unilateralism. But the most serious obstacle to networked federalism is the deeply embedded political culture of rights and entitlements of both orders of government and their emphasis on control. She then asserts that our challenge is not another round of constitutional design, but a shift in culture to accommodate networked politics.

Stein concludes with several bold assertions, the final one of which reads as follows:

Federal institutions, like all other government institutions, must better reflect the societies they govern. Jurisdictional arguments and silo arrangements reflect the past. They slow access by government to new information and new ideas, and lag in policy responsiveness. Problem solving "networked federalism" is just one approach to bring laggard governments up to speed with their societies.

CONCLUSION

In conclusion, transitions seemed an appropriate theme for this issue of *Canada: The State of the Federation 2006–07*. The profound changes introduced by the 2007 budget to the system of equalization, the Harper government's commitment to "open federalism," respect for the division of powers, and the proclamation that the "Québécois form a nation within a united Canada," have all contributed to significant change and a sense of transitoriness in intergovernmental relations in Canada. The ongoing information revolution – which has privileged cities in general, and "global city-regions" in particular, as the new, dynamic drivers of growth, innovation and trade – is a further source of destabilization.' Our authors have addressed these change factors, putting them in historical perspective and analyzing their implications for Canadians. We are indebted to them. The way forward, however, remains uncertain.

The repercussions attributable to the recent, unprecedented increases in resource prices are perhaps the major source of this uncertainty. The interaction between these price changes and the new equalization formula, with its inclusion of one-half of resource revenues, is giving an entirely new meaning to the "have and have-not" province distinction: namely, those that have substantial resource revenues (particularly oil and gas revenues) and those that do not. Compensating for the growing gap between the fiscal capacities of those two classes of provinces will impose severe stresses upon the equalization program and the federation, most particularly in the event that Ontario falls – for a second time – into the "have-not" category. As one of the authors of this introduction has speculated (Courchene 2008), the resulting increase in the cost of equalization to the federal treasury could well cause the new "O'Brien formula" to fail to achieve the longevity of its five-province-standard predecessor.

Still further uncertainty, should any be required, is likely to be provided by the emergence of environmental federalism and the intergovernmental stresses likely to be associated with divergent strategies for combating global warming, together with the role that these may play in the next federal election. "Transitions" are thus likely to play a prominent role in future editions of *Canada: The State of the Federation*.

REFERENCES

Boadway, R. and J.F. Tremblay. 2006. "A Theory of Fiscal Imbalance." *Finanz Archiv-Public Finance Analysis* 62: 1-27.

Brender, N. and M. Lefebvre. 2006. *Canada's Hub Cities: A Driving Force of the Canadian Economy*. Ottawa: The Conference Board of Canada.

Courchene, T.J. 2006. "Variations on the Federalism Theme." *Policy Options* (September): 46-54.

Courchene, T.J. 2008. "Fiscalamity! Ontario: From Heartland to Have-Not." *Policy Options* (June): 46-54.

II

The Politics and Economics of Fiscal Federalism: Setting the Stage

2

Fiscal Federalism and the Burden of History

Garth Stevenson

Les relations fiscales fédérales-provinciales au Canada ont été une source récurrente de mécontentement depuis la Confédération, et les efforts répétés pour qu'elles soient plus grandement acceptées ont eu tendance à engendrer de nouveaux problèmes aussi souvent qu'ils en ont résout de vieux. Ceci peut être expliqué partiellement par la difficulté d'atteindre un équilibre vertical et horizontal dans une fédération avec des écarts économiques prononcés entre ses régions. En plus, le fédéralisme fiscal est chargé de son legs historique. La théorie du changement institutionnel de Paul Pierson, qui met en valeur l'importance du parcours, du moment et de l'ordre, peut éclaircir la situation. Une série de décisions importantes, qui remontent à de meilleures ententes et que la Nouvelle-Écosse avait reçues en 1869, ont gelé le fédéralisme fiscal dans un modèle complexe qui semble résister aux efforts d'amélioration. Les controverses récentes du déséquilibre fiscal, du financement des programmes sociaux et de la fraction des revenus des ressources naturelles utilisés dans l'équation de la formule de péréquation ont été difficiles à résoudre principalement pour ces raisons, bien que le budget fédéral de mars 2007 ait fait des progrès vers une solution. Même si les changements futurs seront probablement marginaux, il est peut-être salutaire d'étudier des réformes plus essentielles, comme l'élimination des impôts provinciaux sur les bénéfices des sociétés, le transfert de toutes les recettes de la TPS aux provinces, et l'élimination du transfert canadien en matière de programmes sociaux.

Paper prepared for the conference "Different Perspectives on Canadian Federalism," University of Waterloo, 27–29 April 2007.

INTRODUCTION

Can anything be done to end the intergovernmental disputes over fiscal federalism? Thousands of Canadians have probably asked themselves this question since Sir John A. Macdonald's government offered "better terms" to a discontented Nova Scotia in January 1869, an initiative that provoked perhaps predictable complaints (and demands for compensation) in the legislative assembly of Ontario.[1] Although the fiscal structure of the Canadian state has actually changed beyond recognition over nearly a century and a half, the continuity of provincial discontent with our intergovernmental fiscal arrangements, and of the rhetoric with which it is expressed, is certainly impressive. Only the weather has been as durable a source of Canadian unhappiness, and even that may decline in importance with global warming.

The controversy over "fiscal imbalance," which has persisted for much of the first decade of the twenty-first century, and the seemingly associated, although actually distinct, problem of how to redesign the system of equalization payments, would probably not surprise Sir John, if he could look down upon our present discontents. The sheer size of the numbers involved, even when adjusted for inflation, might disturb his thrifty Scottish soul, and the growing irrelevance of the constitutional distinction between "direct" and "indirect" forms of taxation might be somewhat unexpected. Fundamentally, though, the politics of fiscal federalism and intergovernmental relations are pretty much the same as they were when the herds of buffalo roamed across the unfenced prairies between the Red River and the Rockies and when rafts of pine timber still floated past the parliament buildings on their way to the busy seaport of Quebec.

The problem of fiscal federalism is twofold, although the distinction between its parts is not always obvious. In the first place, both the federal and provincial (to which some might add the municipal) levels of government should have access to enough revenue to carry out their responsibilities effectively and without financial strain. This happy situation, if and when achieved, is referred to as one of vertical balance. In the second place, the disparity in the resources available to different governments at the same level should not be so great that it exposes some Canadians to hardship depending on where they live, and ideally not so great that it influences their decision about where to live. This happy, and even more elusive, situation is referred to as one of horizontal balance.

[1] This episode is discussed in Garth Stevenson (1993, 110-115).

Ideally, both kinds of balance should be achieved with a minimum of inter-governmental transfers, since accountability and responsibility are greater when decisions about spending money are made by the same government that has to raise it. Accountability would also benefit, one suspects, from making the system simpler and easier to understand than it is at present. Additionally, each level of government should have access to suitable kinds of revenue, meaning mainly taxation, which are neither inefficient nor inequitable, and which have little or no impact outside the borders of the territory for which that government is responsible.

While it is easy to state these various requirements, it is far more difficult to achieve them, particularly since they are not always compatible with one another. If all the provinces or states in a federation were equally prosperous, and thus had equal capacities to raise revenue from their own resources in proportion to the size of their populations, the problem of horizontal imbalance would, by definition, not exist. If in addition the economies of the provinces or states were similar enough to one another that the various possible sources of revenue and their relative importance did not vary significantly from one province to another, the achievement of vertical balance with minimal recourse to intergovernmental transfers would be a fairly simple exercise. It would merely be necessary to match sources of revenue and their potential to yield revenue with an estimate of the resources needed to carry out the constitutional responsibilities of each level. On the basis of this calculation (admittedly rough since yields depend on rates of taxation and responsibilities can be interpreted in ways that involve varying degrees of expense) one could then decide which tax sources should be provincial, which federal, and which divided between the two levels of government.

The economic disparities that lead to horizontal imbalance between provinces, which are more pronounced in Canada than in some other federations, obviously complicate the search for an ideal system. A specific kind of taxation, or taxation in general, will yield far more revenue per capita in a rich province than in a poor one, while the financial resources needed to carry out provincial responsibilities in an adequate manner will be pretty much the same for both. Therefore to achieve a semblance of horizontal, as well as vertical, balance it will be necessary to relax the rule that intergovernmental grants should be kept to a minimum. If we make this concession, however, it should be fairly easy to estimate a level of grants to the poor province that would bring its per capita revenue up to the level of its more fortunate neigh-bour. In fact Canada's system of equalization, which has existed for half a century and been constitutionally entrenched for the latter half of that period, is supposedly intended to do so, more or less.

Given these general principles, why is it so difficult to achieve a distribution of revenues, whether from taxes, grants, or a combination of both, that is

satisfactory to all the provincial governments? A cynic might say that provincial politicians have nothing to gain, and much to lose, by appearing to be satisfied. Even aside from the old aphorism that the squeaky wheel gets the grease, it is far easier and more convenient to attribute the deficiencies of one's highways, hospitals, universities or schools to the distant federal government, which is generally inhibited by constitutional propriety and self-respect from responding to the verbal abuse that is thrown in its direction, than it is to repair the deficiencies. Blaming other provincial governments is more hazardous, since they are more likely to take offence, and since their co-operation may be required subsequently in the endless battle to win concessions from "Ottawa." However, even that may be more convenient than admitting that the source of the province's problems might lie within its own borders, or even within the walls of its legislature. Thus it is unlikely that provincial grumbling over fiscal federalism would ever cease, even if the system were to approach perfection.

This having been said, it does not follow that efforts to improve the system are pointless. Accountability, simplicity, efficiency, equity, and fairness as between the various governments of our federation are goals worth pursuing, whether or not those who would benefit from progress towards these goals appear to be grateful. But to understand the current state of fiscal federalism and the direction in which it should go, one must understand where it came from. This paper will begin with a sketch of the origins and development of the institution which we call fiscal federalism, will consider recent proposals for reform, and will conclude by suggesting how the system might be improved. The paper will deliberately avoid the question of whether municipal government should be recognized as a third order of government with guaranteed access to certain kinds of revenue, not because the question is unimportant, but because it should be the subject of another paper.

HOW WE GOT HERE

In his book *Politics in Time,* Paul Pierson reminds us that ongoing policies are types of institutions, that institutions are the product of long processes of change, and that their current situation is the result of many incremental changes over time. At any given time institutions or policies rarely correspond closely, in their characteristics or their effects, with the intentions of their founders, even if the founders had any long-term objectives to begin with, which is not always the case. Pierson also suggests that the timing and sequence, or ordering, of various developments, changes, and decisions affects the outcome, or the shape and consequences of the institution or policy at any point in time. In addition, he suggests that the choices made over time may

lead in the direction of additional choices at a later date, and may close off (or at least make unlikely) choices and options that might otherwise have been pursued. He refers to this tendency as path dependence (Pierson 2004).[2]

The incremental development of Canadian federalism provides a good example to support all of these observations. The constitution of 1867 was designed for an economy based on agriculture and natural resources, and a society in which social services were mainly provided by the Catholic Church in Quebec and by private charities elsewhere. It included complex provisions related to public finance, of which the following were the most important: In sections 91 and 92 the provinces were restricted to "direct" taxation, which was not expected to be of major importance, giving Parliament the exclusive right to impose "indirect" taxes, of which the customs tariff was then the most important. Section 109 gave the provinces ownership of natural resources, above and below ground, and access to any revenues from that source. (Unlike the United States, Canada would follow the English common law principle that mineral resources, even under privately-owned land, belong to the Crown, i.e. the province.) Section 111 transferred existing provincial debts to the central government. Section 118 provided for modest federal subsidies to the provinces. There were also a number of financial provisions referring uniquely to a specific province, setting a pattern that would be followed as new provinces were added to the original four.

The most significant developments between 1867 and the end of the twentieth century, in the sense that they make a lasting contribution to path dependence, may be listed as follows:

1869: "Better terms" for Nova Scotia establish the precedent that additional grants to any province may be made at the discretion of Parliament.

1887: The Judicial Committee of the Privy Council authorizes a provincial corporation tax in *Bank of Toronto* v. *Lambe* (1887).

1907: After consultation with the provinces, the Constitution is amended to replace section 118 with a new allocation of statutory subsidies. British Columbia is dissatisfied with the outcome, but the precedent that the provinces will be consulted before any significant amendment to the constitution is established.

1917: Federal income tax is imposed for the first time. It is widely assumed to be a temporary expedient to pay for the war, which the British Empire and its allies appear to be losing.

[2] For a thoughtful analysis of the theory and its implications, see Shu-Yun Ma (2007).

1927: The Maritime provinces begin to receive special subsidies on a regu-
lar basis, allegedly to compensate for the damage done to them by
federal economic policies.

1930: The three western provinces carved out of the Hudson Bay Compa-
ny's territories (which had been annexed by Canada in 1869) are given
control over their lands and resources, placing them in the same posi-
tion as the other provinces.

1937–9: The Rowell-Sirois Royal Commission recommends that the provinces
cease imposing income, corporation and estate taxes. In return the fed-
eral government will (again) take over all their debts, will pay "Adjustment
Grants" to the less affluent provinces, and will assume various addi-
tional responsibilities. The recommendations are not implemented.

1942: For the duration of the war (and in practice somewhat longer) the
provinces "rent" their power to impose income, corporation and es-
tate taxes, in return for additional subsidies. At the same time the
federal government introduces the practice of deducting personal in-
come tax at the source of income.

1943: The Judicial Committee of the Privy Council authorizes a provincial
sales tax, which is rather dubiously alleged to be "direct," in *Atlantic
Smoke Shops* v. *Conlon* (1943). Eventually every province except
Alberta will have a retail sales tax.

1954: Quebec imposes a personal income tax and the federal government
agrees that the amounts paid can be credited against the liability to
pay federal tax. This effectively ends the tax rental system.

1957: Equalization payments, similar to the adjustment grants recommended
by Rowell-Sirois, begin, but they will be allocated by the federal gov-
ernment according to a formula fixed by Parliament and not by an
Australian-style independent commission as Rowell-Sirois had rec-
ommended. Initially they are paid to all provinces except Ontario.

The federal government begins to subsidize provincial programs of
universal hospital insurance, the beginning of what will eventually
be the largest single item of public expenditure in Canada.

1959: Quebec, which has prevented its universities from accepting the fed-
eral grants paid to universities in the other provinces, agrees to pay
comparable grants itself, in return for which the federal tax on corpo-
ration income in Quebec is reduced, with a corresponding increase in
the provincial tax.

1962: The tax rental system is formally interred, with the provinces now free to impose any level of income and corporation tax, but the federal government will continue to collect those taxes on behalf of any province that wishes it to do so. More significantly, the federal government promises to reduce its income tax incrementally over the next five years, allowing the provinces to occupy an increasing share of the field. This reinforces the principle, which arguably dates from 1954, that the level of federal taxation is negotiable at the behest of the provinces.

1965: Federal legislation allows any province to "opt out" of health insurance and an assortment of other shared cost programs, meaning that federal grants to the province will be terminated and replaced by reductions in federal direct taxation within that province, provided the province agrees to continue a comparable program. As anticipated, Quebec "opts out" of all the programs but no other province takes advantage of the legislation.

1967: The federal government begins to pay grants to the provinces for post-secondary education, rather than making grants directly to the colleges and universities.

1977: The federal grants in aid of health insurance and post-secondary education are replaced by a singularly complex arrangement known as Established Programs Financing (EPF), which consists of tax abatements and cash grants in roughly equal proportions. Federal income and corporation taxes are reduced so that the provinces can increase their own taxes by a like amount, but since this opportunity will provide greater benefits for some provinces than for others, the abatements are sweetened with "associated equalization" for those that require it. At the same time, Quebec retains its existing abatements as a result of the arrangements made in 1959 and 1965. In addition, the provinces receive annual cash grants such that the combined per capita yield of the tax abatement and the grant will be approximately the same for each province. To achieve this, the poorer provinces that benefit less from the abatement receive larger per capita cash payments than the richer provinces.

1982: Federal responsibility to make equalization payments "to ensure that provincial governments have sufficient revenues to provide reasonably comparable levels of public services at reasonably comparable levels of taxation" is entrenched in the constitution. At the same time, another provision allows provincial indirect taxes on natural resources.

1991: In *Reference re. Canada Assistance Plan*, the Supreme Court of Canada
 rules that the federal government can unilaterally reduce or other-
 wise alter its payments to a provincial government (in this case for
 the Canada Assistance Plan) without seeking or receiving the con-
 sent of the provincial government (*Reference re. Canada Assistance
 Plan* 1991).

1991: The federal government introduces a Goods and Services Tax (GST)
 to replace the archaic indirect tax on manufactured goods and urges
 the provinces to harmonize their retail sales taxes with the GST. Only
 Quebec agrees to do so, and also to collect the GST within Quebec
 on behalf of the federal government.

1996: Five years later a new government reaches agreement with Newfound-
 land, Nova Scotia and New Brunswick whereby those provinces will
 abolish their retail sales taxes in return for sharing the proceeds of
 the GST, which is fixed at a level of 15 percent in those three prov-
 inces, compared to 7 percent in the other provinces. In return they are
 promised a subsidy of $961 million over four years.

 EPF, or more precisely the cash portion of it, is replaced with a single
 block grant known as the Canada Health and Social Transfer (CHST).
 The federal government continues to claim that the tax abatements
 made almost two decades earlier should be counted as part of its con-
 tribution to health care and post-secondary education, a claim disputed
 by the provinces and by almost everyone else. Eight years later, CHST
 will be replaced with two block grants, the Canada Health Transfer
 (CHT) and the Canada Social Transfer (CST).

This is an admittedly selective list, and some might say that it should be
considerably longer. In particular, there have been several major changes in
the formula for calculating equalization payments since 1957, with the for-
mula used to calculate the revenue base becoming increasingly complex and
comprehensive. The standard against which provincial revenues are assessed
has been variously based on the two richest provinces (1957–62 and 1964–7),
the average of all provinces (1962–4 and 1967–82), or the average of the five
provinces closest to the overall average (1982 to 2007, although not strictly
adhered to after 2004).

Likewise, there have been numerous changes in the system whereby the
major direct taxes (on incomes and corporations) are shared between the two
levels of government. Up to and including 1977, the changes mainly took the
form of reducing federal taxes so that the provinces could occupy a larger
share of the revenue source in question. After 1977, this practice was aban-
doned, largely because of a series of fiscal deficits at the federal level which

lasted until almost the turn of the century. Instead, the provinces have been allowed increasing flexibility in imposing their taxes, in an effort to prevent them from collecting the taxes on their own behalf, so that the relationship between provincial and federal taxes has become increasingly tenuous, and the paperwork imposed on the taxpayer increasingly onerous. Why the federal government wishes to continue collecting taxes for the provinces is not entirely clear, but it has largely succeeded in its objective. Only Quebec collects its own personal income tax (as it has done without interruption since 1954) and only Quebec, Ontario and (since 1981) Alberta collect their own corporation taxes. However, at the end of the twentieth century the provinces stopped calculating their provincial income tax as a percentage of the federal tax, forcing their long-suffering taxpayers to do all the mathematical calculations twice. The federal government continued to collect the taxes for them nonetheless.

These incremental changes in policy have taken place, of course, against a massive backdrop of social and economic change, including a nearly ten-fold increase in the population, the shift from an economy largely of self-employed farmers and fishers to an industrial, and now increasingly post-industrial, economy of wage and salary earners, the development of the welfare state, and in recent years a rapidly aging population. In the process of all these changes, the major items of state expenditure have shifted dramatically since the Second World War from infrastructure and defence to health care, education, welfare and pensions. Interest on the substantial public debt, of course, also accounts for a large share of state expenditures at both levels.

A few conclusions can be drawn from the history summarized above. First, the system has evolved through a series of incremental changes, most of them at the behest of the federal government, although some of them in response to complaints by one or more provinces. Second, there has hardly ever, in 1867 or later, been any serious effort to treat all the provinces alike or according to a fixed set of principles and standards. Third, the changes have made the system increasingly complex and difficult to understand, which has reduced accountability and had a detrimental effect on the quality of public debate about fiscal federalism. Fourth, since the changes have been made in response to short-term problems or concerns, it is impossible to identify any consistent purpose or direction behind the evolution of fiscal federalism or indeed any consistent set of outcomes, apart from making the system more complex and increasing the elements of asymmetry among the provinces. Fifth, most of the changes have resolved one problem but at the expense of creating one or more new problems.

The untidy and seemingly directionless evolution of Canadian fiscal federalism tends to confirm Pierson's generalizations about the slow and incremental way in which institutions evolve, as well as their failure to conform to any

long-term goals and expected outcomes that might have existed at the beginning. The conclusions of the preceding paragraph also give credence to the concept of path dependence. Path dependence occurs because the costs of changing an existing pattern of behaviour appear to be greater than the costs of staying the same, even when staying the same has obvious disadvantages. It is particularly characteristic of fields, such as federal-provincial relations, in which change requires coordinating the behaviour of several distinct actors.

All of the characteristics of Canadian fiscal federalism outlined above – incrementalism, asymmetry, excessive complexity, short-term orientation, and the tendency of one "solution" to create a new problem – became evident at a very early stage in its development. To some extent they were inherent in the fiscal provisions of the British North America Act, and they were decisively and perhaps irreversibly reinforced by the "better terms" given to Nova Scotia when the ink was scarcely dry on the original document. One of the early students of Canadian fiscal federalism, James Maxwell, asserted long ago that the "better terms" of 1869 "made a breach in the constitution not yet repaired" (Maxwell 1989, 396). While Maxwell had a valid point, the constitution itself encouraged such a breach with its very complex fiscal arrangements and its plethora of provisions applying to particular provinces.

Two other major instances of path dependence arose from decisions made in the middle decades of the twentieth century. First, the wartime tax rental agreements, taking effect in 1942, created a lasting bias in favour of integrating or "harmonizing" the federal and provincial systems of direct taxation, a bias that was reinforced by the then-fashionable Keynesian approach to macroeconomic policy. Of course, the simplest way to set the stage for Keynesian policies would have been for the provinces to vacate the major fields of direct taxation, as recommended by the Rowell-Sirois Commission. This was politically and perhaps constitutionally impossible, and Keynesianism was eventually discarded anyway, but the ghost of the idea has lingered on in the notion that the federal government should collect taxes for the provinces (or vice-versa as in the case of Quebec and the GST), even if no discernible purpose is served thereby. The fact that American federalism gets along perfectly well without such a practice is rarely if ever acknowledged.

Second, the post-war development of shared cost programs (in defiance of the Rowell-Sirois Commission, which had disapproved of them on grounds that they lacked efficiency and accountability) entangled a whole host of new issues with the already complex politics of fiscal federalism. These programs were particularly resented in Quebec, where they seemed to threaten that province's original understanding of Confederation. In 1957, no less an authority than Pierre Elliott Trudeau, then a freelance intellectual, pointed out that federal spending in areas of provincial jurisdiction raised the question of whether the federal government should more appropriately give up some tax-

ing room to the provinces (Trudeau 1968).[3] However, subsequent governments (including to some extent his own) found the temptation to spend in these areas hard to resist, particularly since these types of expenditures seemed to interest and attract Canadian voters more than the equally important subjects enumerated in section 91 of the Constitution.

If vows of abstinence were rarely observed for long, federal remorse more typically took the form of special arrangements for Quebec, or else efforts to withdraw (more or less) from existing programs and hand them over to the provinces. Rapidly escalating and unpredictable costs provided another motive to proceed in the latter direction. Efforts to do so were constrained, however, by the continuing belief in the department of finance that the federal government must collect a sufficiently large amount of taxation to pursue Keynesian fiscal policy, even though such policy was no longer being (if it ever had been) seriously pursued. The result of these conflicting pressures and motives reached the *reductio ad absurdum* of EPF, which, complex as it was, had perforce to be superimposed over the "opting out" arrangements made a dozen years earlier for Quebec. How many persons, if any, actually understood EPF is a question that would perhaps not be tactful to ask. A few years after it came into force, Donald V. Smiley, the most influential Canadian federalism scholar of his generation, introduced his last book with the following confession: "In particular, I have nothing to say about fiscal federalism – a subject which I once tried to comprehend but which, I am now convinced, is so complicated that one should either cultivate it as a full-time specialty or leave it alone entirely" (Smiley 1987, xi). Despite its dysfunctional absurdity, the ghost of EPF has lingered on through several subsequent shifts in fiscal arrangements. The fact that the federal government almost three decades later was still counting the all but forgotten "tax points" given up in 1977 as part of its "contribution" to the costs of health care is a classic instance of path dependence.

THE "FISCAL IMBALANCE" DEBATE

Between 1984 and 1996, two federal governments and two ministers of finance systematically pursued the goal of reducing the federal deficit, which had risen to a dangerous level by the end of the Trudeau years (see Hale 2002, 187-190, 201-202, and 225-227). Immediate success was not possible, but a

[3]Although Trudeau wrote this article in 1957, it is significant that he chose to publish it again when he was a candidate for the leadership of the Liberal Party.

combination of tax reform (mainly the introduction of the GST in 1991), re-
ductions in program spending (most dramatically in the Martin budget of 1995),
and a revival of the North American economy that coincided with the election
of President Bill Clinton in 1992, eventually brought the series of deficits to
an end. By 1997, the federal deficit had disappeared, and over the next few
years federal budgetary surpluses were unexpectedly large. This achievement,
inevitably, was viewed as being partly at the expense of the provinces, since
funds that had been channelled through them accounted for a large share of
the reductions in program spending. Nonetheless, the provinces also benefited
from the improvement in the North American economy, so that by 1996–97
only three provinces still had significant deficits, one of which was Prince
Edward Island with its 0.4 percent of Canada's population (Treff and Perry
1997, 2:1-2:20). Unfortunately the two other exceptions were Quebec and
Ontario, which together account for about five-eighths of the population.

Quebec's sovereignist government, disappointed in its objective of win-
ning independence for Quebec and approaching the end of the eight years that
seems to be the normal life span of Quebec governments, sensed a politically
potent issue in these facts, and the issue of "fiscal imbalance" was born. More
precisely, the Quebec government appointed a Commission on Fiscal Imbal-
ance on 9 May 2001, including four distinguished academics among its seven
members. To give it a bipartisan flavour, a former Quebec Liberal minister,
Yves Séguin, was appointed as chairman. The choice of the commission's
name seemed to suggest that its conclusions had been determined in advance,
an impression reinforced by the contents of a discussion paper entitled "Fis-
cal Imbalance: Problems and Issues," which it released when its investigations
had scarcely begun. However, in an effort to demonstrate that the issue was
neither inspired by partisan politics nor unique to Quebec, the commission
consulted a respected conservative research organization, the Conference Board
of Canada, which endorsed the view that a "fiscal imbalance" existed. The
Séguin commission also sponsored a survey of public opinion across Canada
on the question. Finally, the commission held public hearings, although only
in Quebec.

In the Canada-wide survey of public opinion, 66 percent of those polled
(and 71 percent of respondents in Quebec) agreed with the proposition that
"the federal government has too much revenue for the responsibilities that it
has while the provincial governments lack revenues to fulfill their responsi-
bilities" (Commission 2002, 11-12). This was not particularly surprising for
two reasons. First, there is a tendency in polls to respond positively to any
proposition that sounds fairly plausible, especially if the respondent is not
well-informed about it. Second, health care, the most expensive provincial
responsibility, was at this time the main preoccupation of Canadian voters,
while some of the most important and expensive federal responsibilities, such
as national defence, external aid, immigration, employment insurance, and

programs for indigenous peoples, touch the average voter less directly and have, to put it politely, less popular appeal. In fact, it is probably surprising that the percentage expressing agreement with the statement was not higher.

The commission completed its investigations more promptly than is usual for such bodies, and the Séguin report appeared in the spring of 2002. The report claimed that "Fiscal imbalance has been one of the major issues of the Canadian federation since the mid-1990s," or, in other words, since the major cuts to fiscal transfers in the federal budget of 1995. It cited a study by the Conference Board which predicted that in the absence of major fiscal reform, Quebec would continue to have deficits every year for the next two decades, while federal surpluses would escalate each year to reach the astonishing level of nearly $90 billion by 2019–20. This bizarre prediction was based on the assumption that federal spending would increase by only 2.1 percent per year, while provincial spending was projected to increase at a more credible rate of 3.6 percent. (The annual increase in revenues was projected to be almost the same at both levels: 3.2 percent for the federal government and 3.1 percent for the provinces.) The very low anticipated rate of increase in federal spending was entirely attributed to a rapid decline in the cost of servicing the federal public debt, a trend based on the dubious assumption that the federal government would use all of its surpluses to reduce the size of the debt. In fact the report predicted, very questionably, that the federal debt would virtually disappear within two decades, even though the federal level of government has never been free of debt since it assumed the then-existing debts of the provinces in 1867.

The Séguin report blamed the present and future fiscal imbalance on three factors: imbalance between spending responsibilities and sources of revenue, inadequate intergovernmental transfers, and the federal tendency to use its "spending power" in areas of provincial jurisdiction. The last of these factors would seem to be more a consequence than a cause of the federal government's greater affluence, but the commission argued that it was a cause because it distorted provincial priorities, had a destabilizing effect by making provincial budgets vulnerable to federal decisions, and tended to take the form of highly visible short-term projects rather than ongoing contributions to routine expenditures. None of this was entirely new since very similar complaints had been frequently made by the provincial governments, with Ontario taking the lead as often as Quebec, since at least as far back as the 1950s. (The Séguin commission itself noted examples of such complaints over the preceding few years, but did not pursue the history of the issue further back than 1997.)

In its extended analysis of the three factors, the report predictably devoted considerable attention to health care, an almost obsessive preoccupation of Canadians at that time, as a large and rapidly growing burden on provincial finances. (It predicted that education spending, on the other hand, would grow much more slowly, as would spending on most of the major federal responsibilities.) The

report claimed that the Canada Health and Social Transfer (CHST), by which the federal government shares the costs of both health and post-secondary education, was inadequate in size, subject to arbitrary and unpredictable changes, and (more questionably) that it "penalizes the less affluent provinces." (Soon afterwards, Ontario would not only deny the last of these assertions but would claim exactly the opposite.) Equalization, the other major federal transfer to the provinces, was also criticized in practice, although strongly supported in principle. The main complaints in this regard were that it was based on a five-province standard (excluding resource-rich Alberta from the calculation), that it was subject to a ceiling, and that the tax bases used to calculate equalization were poorly defined and incomplete. Thus it was alleged that Quebec received a much smaller equalization payment than it should.

The Séguin commission made a number of recommendations that would, if implemented, significantly alter the Canadian system of fiscal federalism. It proposed that the CHST be abolished and replaced by a new division of tax room between the two levels of government. This might take the traditional form of giving the provinces a larger share of the income tax, but the commission expressed a preference for a federal relinquishment of the GST in favour of the provinces. It also recommended reforming equalization by basing it on a ten-province standard, eliminating the ceiling and floor on equalization payments, and improving the calculation of tax bases, particularly by measuring capacity to raise property taxes on the basis of assessed value. Finally, it recommended that Quebec continue its interminable campaign against the legitimacy of the federal spending power and that it continue to demand an unconditional right to opt out of shared cost programs, receiving financial compensation in return.[4]

In response to the Séguin report, Stéphane Dion, who was then the federal minister of intergovernmental affairs, denied that there was a vertical fiscal imbalance at all. Dion questioned the methodology of the Conference Board's calculations on which Séguin had relied. Quite rightly, he doubted the usefulness of any effort to calculate financial data two decades in advance of the facts. He pointed out that recent federal surpluses had been small in relation to the deficits of the not-so-distant past and also in relation to the size of the federal debt, that all governments faced financial pressures, and that the provinces had the constitutional authority to increase their tax revenues if necessary. Also, the fact that some of them had reduced taxes indicated that they were not really suffering (Dion 2002).

In the following year the Quebec Liberals returned to office, continuing the Quebec tradition whereby no governing party since the Quiet Revolution has

[4] The recommendations are in Commission on Fiscal Imbalance (2002).

won more than two general elections in succession. Yves Séguin became minister of finance, a position he held until 2005. In March 2004 the National Assembly unanimously adopted a motion calling on the federal government to recognize the existence of the fiscal imbalance and to take measures to counteract its effects (cited in Parti Québécois 2004).

In September 2004, however, Prime Minister Paul Martin largely defused the "fiscal imbalance" issue, at least in its original form, by unveiling what was billed as "A 10-year plan to strengthen health care," reversing the cuts to federal health care spending that he had imposed as minister of finance almost a decade earlier, and promising increased funding for health care in the future (Prime Minister 2004). As part of this package, the CHST was divided into a Canada Health Transfer and a Canada Social Transfer, with the former scheduled to increase significantly in size over the next decade. This initiative deprived vertical fiscal imbalance of much of its importance as a political issue, at least outside of Quebec and to some extent even there. Yves Séguin was dropped from the Quebec cabinet in a shuffle a few months later. However, the Council of the Federation, a permanent interprovincial body recently established at the initiative of Quebec's Liberal Premier Jean Charest, appointed an Advisory Panel on Fiscal Imbalance to investigate the issue in 2005.

A NEW GOVERNMENT AND A SERIES OF REPORTS

The issue of fiscal imbalance was given a new lease on life by the federal Conservative leader, Stephen Harper, who promised during the election campaign of 2005–06 to do something about it if his party was elected to office. This promise received some of the credit for the Conservative victory, and particularly for the unexpected election of ten Conservative members of parliament from Quebec.

Yet, after he became Prime Minister, Harper and his minister of finance, Jim Flaherty, began to soft-pedal the issue, despite the fact that Flaherty had held the same office in the provincial government of Ontario a few years earlier. A lengthy document released with Flaherty's first budget in 2006, which promised to maintain the increases in health care funding promised earlier by the Liberals, convincingly refuted most of the arguments in the Séguin report (Canada 2006a). It asserted that Quebec's deficit was expected to disappear in the current fiscal year, that the fiscal balances of the federal and provincial levels of government had followed very similar trends since 1995–96, that federal transfers for health care were growing faster than provincial spending on health care, and that federal revenues had declined more rapidly than provincial revenues in relation to GDP since the 1990s, largely because of federal tax reductions. It also pointed out, as Stéphane Dion had done earlier, that the provinces had access to virtually every significant source of revenue and that

their share of total state revenues exceeded that of the sub-national govern-
ments in any other federation. Simultaneously with the release of this
document, a long-overdue increase in military spending, partly in response to
the war in Afghanistan, made allegations that the federal government had more
revenue than it needed increasingly difficult to sustain.

At the same time, the budget implemented a Conservative election promise
by reducing the GST from seven to six percent, with a further reduction prom-
ised later. If the government was daring the provinces to raise their sales taxes
by a comparable amount, and thus help to redress the alleged vertical fiscal
imbalance, there were (predictably) no takers. Was this merely a lack of cour-
age, or a tacit admission that the vertical fiscal imbalance was a myth?

The issue of horizontal fiscal imbalance, meaning fiscal disparities among
the provinces themselves, proved to have both a broader appeal and a longer
shelf life, although, almost by definition, it is an issue on which consensus
among the provincial governments is virtually impossible. This issue had not
been entirely ignored by the Séguin report, but that report was primarily con-
cerned with vertical fiscal imbalance, possibly in the hope that concentrating
on the latter issue would facilitate a broad coalition among the provincial
governments to put pressure on "Ottawa." However, the financial circumstances
of the various provinces are so different from one another that a concerted
campaign on any fiscal issue, however defined, makes little sense. Alberta
can hardly make a serious claim to be in need, and does not do so. For the
eight provinces that depend, to varying degrees, on equalization payments, a
campaign around the issue of equalization is probably more likely to bear
fruit than one on the more nebulous issue of vertical fiscal imbalance.

Thomas J. Courchene, one of Canada's leading economists, has suggested
that Quebec shifted its attention from vertical to horizontal balance because it
calculated that, as the principal recipient of equalization, it would get about
half of any additional equalization forthcoming from the federal government,
but only about a quarter of any additional funds made available by surrender-
ing tax room to the provinces (Courchene 2006). But there were other reasons
as well why the issue of horizontal imbalance began to occupy the centre of
the stage, almost before the ink was dry on the Séguin report. First, Ontario in
2003 elected a Liberal provincial government headed by Dalton McGuinty.
The new premier charged that Ontario as a rich province was being unfairly
discriminated against in the allocation of federal funds, particularly the block
grants for health and post-secondary education. His government began a
campaign for "fairness," complete with its own website. McGuinty also com-
plained on more than one occasion that Ontario and Alberta taxpayers
contributed most of the revenue that supported the equalization program, and
that Ontario taxpayers could not afford to make the program any more gener-
ous (McGuinty 2006). While more subtle than Premier Mitch Hepburn's

complaint in the 1930s that Ontario was "the milch cow of the Dominion," the message was essentially the same.

Second, in 2004 the federal Liberal government announced controversial changes in the equalization program, described as "A New Framework for Equalization," almost simultaneously with the more popular increases in health care funding (Canada n.d.). Although the Liberals implied that the new approach would make equalization more generous, the reality was that a cap was placed on the amount of equalization to be paid each year, with a fixed rate of increase in subsequent years. This was similar to the arrangement for health and social transfers, but totally unprecedented for equalization. The press release promised that the allocation of this fixed amount among the provinces would eventually be determined by the recommendations of a "panel of experts," rather than by the formula that had been in use for more than twenty years. Pending the receipt of those recommendations, it would be on a per capita basis, which seemed to make little sense if the purpose of the program was to counteract horizontal fiscal imbalance.

Finally, Prime Minister Martin, about a year before leaving office, made an ill-advised agreement known as the Atlantic Accord with the premiers of Newfoundland and Labrador and Nova Scotia. This provided that any revenues received by those provinces from offshore oil and gas would have no effect on the size of their substantial equalization payments. (Saskatchewan and British Columbia, which would have benefited from a similar arrangement for their non-renewable resources, received nothing in return.) Newfoundland and Labrador would also receive a payment of $2 billion to retire a portion of its debt (Newfoundland and Labrador 2005). This politically motivated agreement, which seemed like a return to the era of "better terms" before formal equalization was established, bequeathed a political hot potato to Stephen Harper, who had further muddied the waters himself by an ill-advised promise that non-renewable natural resource revenue bases would be excluded from the calculation of the equalization formula (Williams 2007).

The year 2006 saw the publication of three major reports on fiscal federalism, one of which was devoted entirely to equalization while the two others devoted considerable attention to it. A fourth report, on the economic prospects and financial needs of Canadian cities, appeared early in 2007. The first off the mark, in March 2006, was the report of the Advisory Panel on Fiscal Imbalance, which bore the rather unfortunate title *Reconciling the Irreconcilable* (Council 2006). Co-chaired by Robert Gagné, an economist nominated by the premier of Quebec, and Janice Gross Stein, a political scientist nominated by the premier of Ontario, the five-member panel also included a Conservative senator from Nova Scotia, a former deputy minister of intergovernmental affairs from Alberta, and a former minister of finance from the Northwest Territories. Like the Séguin commission, it argued that vertical fiscal

imbalance was a genuine problem, although its forecasts regarding federal surpluses were considerably more conservative than Séguin's. However, it did not recommend any transfer of tax room to the provinces. Instead it proposed changes to the CHT and CST which would abandon the fiction that the tax abatements of 1977 were part of the federal contribution, increase the size of the cash grants, give the same per capita cash grant to each province, and thus remove the unequal treatment of rich provinces of which Premier McGuinty had complained.

As regards equalization, the panel suggested a more generous formula that would be based on a ten-province rather than the five-province standard established in 1982 and would include all revenue from natural resources in the calculation. This would end the special arrangements Martin had made with Newfoundland and Labrador and Nova Scotia, as well as the fixed yearly amount imposed by the "New Framework." Overall, the total amount of equalization paid would increase by more than 50 percent, with Quebec benefiting the most from the change. The Advisory Panel also proposed more generous financial treatment for the northern territories and the establishment of a permanent First Ministers' Fiscal Council for consultation and liaison among the governments.

The second report, only two months later, was that of the Expert Panel on Equalization and Territorial Financing, appointed by the Liberal government a year earlier and headed by Al O'Brien, a former Deputy Treasurer in the government of Alberta (Canada 2006b).The panellists also included Fred Gorbet, a former Deputy Minister of Finance in the federal government. As its name suggested, this panel had narrower terms of reference than the Advisory Panel on Fiscal Imbalance. It too recommended returning to the ten-province standard for equalization. However, it suggested that only 50 percent of non-renewable natural resource revenue should be included in the formula, rather than 100 percent, an option that would make the equalization program significantly less expensive for the federal government. Responding to a suggestion in the Séguin report, the panel also recommended basing the calculation of the residential property tax base on market value assessment, a procedure that would reduce equalization payments to British Columbia but increase them to every other recipient province.

Two more months elapsed before the appearance of the third report, commissioned by a moderately left-of-centre think tank, the Canadian Centre for Policy Alternatives, and written by an economic consultant named Hugh Mackenzie (Mackenzie 2006). Rather gloomily entitled *The Art of the Impossible*, this report attracted less attention than the other two but added some fairly new ideas to the debate on fiscal federalism. It suggested that, as in Australia, equalization payments should be based on a calculation of provincial needs as well as provincial capacity to raise revenue. It was lukewarm at best towards the inclusion of non-renewable natural resource revenues in the equalization

formula, although not totally rejecting the idea. It also drew attention to the financial needs of municipal and local government, a topic that raises constitutional sensitivities on the part of provincial governments and was thus largely ignored by the other reports. Finally, it suggested that provinces should be discouraged from competing with one another to reduce taxes.

Finally, to complete the series of reports, the Conference Board weighed in early in the new year with a document entitled *Mission Possible: Successful Canadian Cities* (Waldie 2007). This report argued that the large cities were the sources of most of Canada's wealth and economic growth (a claim that might be disputed in some parts of Alberta) and that they needed more taxing powers and more access to the revenues collected by higher levels of government in order to carry out their responsibilities. It was favourably received in Toronto, where Mayor David Miller had been repeating the same argument for some time. (Toronto has since launched a campaign, complete with a website and signs on TTC vehicles, to have one percentage point of the GST transferred to the city.) Whether by coincidence or not, the federal government announced exactly a month later that it would make a massive financial contribution to improving transportation infrastructure in the GTA, including a long-discussed extension of the TTC subway.

Meanwhile the provincial governments continued to express very divergent views about fiscal federalism. The premiers of all ten provinces met to discuss equalization in Montreal in April 2006 and in Toronto in February 2007. In June 2006 Flaherty met with his provincial counterparts at Niagara-on-the-Lake to discuss the same subject in the light of the O'Brien report, which had just been released. The meetings accomplished nothing other than to indicate that there was no prospect of consensus among the provinces. Ontario, traditionally the richest province but now a distant second behind affluent Alberta, continued its campaign for "fairness" in the allocation of funding for social programs, and shocked most of the other provinces by opposing any increase in equalization payments (Samyn 2006). Premier McGuinty expressed dissatisfaction with the report of the Advisory Panel on Fiscal Imbalance, which he had helped to establish, and continued to claim that Ontario's contributions to federal revenues exceeded by $23 billion, or almost $2000 per capita, the benefits it received from federal spending.

Newfoundland and Labrador, which has surrendered the unenviable distinction of being the poorest province to Prince Edward Island without losing any of its customary truculence, was mainly concerned to ensure that its off-shore oil and gas revenues would continue to have no impact on its equalization payments, as promised by former Prime Minister Paul Martin. Premier Danny Williams, who at one point in 2004 had ordered the Canadian flag removed from provincial government buildings as a symbolic protest against the federal Liberals, denounced the O'Brien report, whose recommendations would have resulted in a net loss to his province. Although bearing a conservative

label himself, he warned that the federal Conservatives would lose all three of their Newfoundland and Labrador ridings if they cancelled the Atlantic Accord (Leblanc 2006).

Saskatchewan, a significant producer of oil, argued that non-renewable resource revenues should not be taken into account in calculating equalization. Alberta, which has no direct interest in the equalization formula since no conceivable formula could make it a recipient of equalization, took the same position. (This has been a time-honoured, albeit irrelevant, theme in the discourse of Alberta governments, and has apparently convinced most Albertans that their provincial government, rather than the federal one, bears the costs of equalization.) In March 2007, Alberta's new minister of finance, Lyle Oberg, unexpectedly announced that the province no longer had any objection to the equalization formula suggested in the O'Brien report, which he predicted would be adopted in any event. However, Premier Ed Stelmach overruled his minister a few days later and declared that Alberta's position had not changed (Chase 2007).

Premier Jean Charest of Quebec, who for various reasons was well-disposed towards the new federal government, was generally restrained in his comments. In fact the "fiscal imbalance" issue was largely and surprisingly ignored by all three parties in the Quebec election campaign of March 2007. However, the Bloc Québécois members of parliament had threatened in September 2006 to bring down the minority federal government after the presentation of the budget if federal payments to the provinces were not increased by $12 billion per annum, including $3.9 billion for Quebec (Leblanc and Chase 2006). André Boisclair, the leader of the Parti Québécois, briefly mentioned the same figure of $3.9 billion in his televised debate with the other party leaders on 13 March 2007. Federalists could presumably take comfort from the fact that it was a more modest request than Dalton McGuinty's $23 billion.

The Harper government's second budget, presented on 19 March 2007, was awaited with eager anticipation, particularly since the provincial election in Quebec was to occur a week later. As anticipated, "Restoring Fiscal Balance for a Stronger Federation" was a major theme of the budget.[5] More specifically, it adopted selected recommendations from the Séguin and Gagné/Stein reports, while the O'Brien report had the greatest influence on the proposals for equalization. From Séguin was taken the idea that the property tax base for the calculation of equalization entitlements would be based on market value. As proposed by the Gagné/Stein report, there was a promise of equal per capita cash payments for the CST and the CHT, although the latter would

[5] Details that follow are from Canada, Department of Finance, *Budget 2007: Restoring Fiscal Balance for a Stronger Federation,* accessed from the department's website on 19 March 2007.

not take effect for seven years (after the expiration of the Martin government's ten-year plan for health care financing) and was thus a promise of dubious value, especially coming from a minority government. The CST would also be formally divided into three component parts, ostensibly earmarked for welfare, post-secondary education, and child care. As suggested by O'Brien, equalization would be based on a ten-province standard, for the first time since 1982, but with only half of non-renewable resource revenues entering into the calculation. There were also improvements in the financing formula for the northern territories, as recommended by both Gagné/Stein and O'Brien. The changes in equalization would remove British Columbia from the list of recipient provinces starting in 2007–08. Equalization payments to Newfoundland and Labrador and Nova Scotia would decline, while payments would increase substantially: from $5.539 billion to $7.160 billion in the case of Quebec and from a negligible $13 million to $226 million for Saskatchewan. Manitoba, New Brunswick and Prince Edward Island would receive small increases. For the first time in history, Quebec would receive more than half of all the money distributed in equalization payments.

Two other features of the budget that might make Canadian federalism more rational and more intelligible should be mentioned. First, the government promised not to launch any new shared cost programs in areas of provincial jurisdiction without the consent of a majority of the provinces, a promise that had been made, sincerely or otherwise, by the Liberal government in the Social Union Framework Agreement of 1999. Second, the provinces and territories that had not already assumed full responsibility for labour training programs (British Columbia, Newfoundland and Labrador, Nova Scotia, Prince Edward Island and Yukon) would be required to do so, receiving appropriate fiscal compensation in return.

However, nothing is ever simple in Canadian fiscal federalism and this budget was no exception. Although the budget promised "comparable treatment for all Canadians," there were a host of special provisions for particular provinces. The provinces were promised that the shift to per capital grants for the CHT and CST would not reduce grants to any of them. Newfoundland and Labrador and Nova Scotia were promised that they could continue to operate under the previous equalization system for the duration of their offshore accords, which would continue in force, but that they could opt into the new equalization regime permanently at any time they chose to do so. Furthermore, all provinces were promised "the greater of the Equalization entitlements under the formula based on a 50-percent exclusion rate and the amounts they would receive under the same formula based on full exclusion of all natural resource revenues," a provision of particular interest to Saskatchewan. This enabled the prime minister to state, in a letter to the premier of Saskatchewan, that "Our Equalization plan fully meets our commitments on the exclusion of natural resource revenues." (In fact every premier and territorial government

leader received a similar letter highlighting the provisions of the budget that would particularly benefit his province or territory, although in the case of Alberta about all that could be said in that regard was a reminder that Al O'Brien had once been the Deputy Treasurer of that province.)[6] The ghost of "better terms" still haunts the corridors of Ottawa.

Both Premier McGuinty and Premier Charest proclaimed themselves reasonably satisfied with the budget, and Gilles Duceppe of the Bloc Québécois indicated that he would not force an election after all, since Quebec had received, according to his calculation, about 80 percent of what it asked for (Lévesque 2007). Although an editorial in *Le Devoir* grumbled that the budget was "too little too late" to resolve the fiscal imbalance, its staff cartoonist, Michel Garneau, produced a drawing of a perspiring Jean Charest being carried across the finish line on the back of Stephen Harper and exclaiming, "I've found my second wind!" (*Le Devoir* 2007) Saskatchewan and Newfoundland and Labrador expressed disappointment that non-renewable resource revenues would continue to be included in the equalization formula.

A MODEST PROPOSAL

In fairness, the provisions for fiscal federalism in the 2007 budget somewhat improved the chaotic situation bequeathed to "Canada's New Government," as it calls itself, by its Liberal predecessors. (They could hardly have made it much worse.) The ten-province standard for equalization, the change in the method of calculating the property tax base, and the equal per capita grants for the CST and CHT are all major steps in the direction of fairness, although the absurdly long delay in the date proposed for implementing the change to the CHT, as well as the feeble excuse for the delay, make that promise of no more than symbolic importance. If it is ever actually implemented, the change to per capita grants will presumably mark the final interment of the pretence that the tax abatement of 1977 should still be counted as part of the federal contribution to health care. O'Brien's 50 percent solution to the problem of whether or not to count resource revenues in the equalization formula, while hard to defend on any logical grounds, is a pragmatically reasonable compromise on an issue where consensus was clearly impossible. The division of the CST into three parts, although not really binding the provinces actually to spend the money as designated, will give taxpayers some idea of what they are paying for.

[6]All the letters were available on the prime minister's web site, 19 March 2007.

Incremental changes in fiscal federalism, often accompanied by long delays and special side deals, will likely remain the normal Canadian practice for the foreseeable future. Nonetheless, it may be worthwhile to conclude by sketching a more radical set of reforms which might increase transparency and accountability and would have other benefits as well.

First, the corporation income tax should be levied exclusively by the federal government. Given the reality of corporate power in the market economy, it is questionable whether this tax is really "direct" in any sense that John Stuart Mill would have recognized. Transferring it entirely to the federal level would eliminate the need for the abstruse calculations which are used to allocate the income of corporations that do business in more than one province among the provincial governments. It would also eliminate the arrangement whereby the federal government presently collects the tax on behalf of seven provinces. In addition, it would simplify equalization by removing the corporation tax base from the formula. Most important, it would end the competition among the provinces to attract investment by lowering their corporation tax rates, a problem identified in the Mackenzie report. This change would cost the provinces about $19 billion a year.

In return, the GST should be completely transferred to the provinces, which could then integrate it with their provincial sales taxes, as Newfoundland and Labrador, New Brunswick and Nova Scotia have already done. The provinces could share the proceeds with their municipalities if they so wished. Alberta, which has never had a provincial sales tax, might choose to transfer the GST entirely to its municipalities. Canada's cities could thus benefit from this tax without raising constitutional concerns about federal intrusion in a field of provincial jurisdiction. This change would cost the federal government about $32 billion a year, so that the combination of the two changes in taxation would mean a net loss to the federal government of about $13 billion.

To make up at least part of this loss, the CST should be phased out. This would remove the federal government and its spending power from three fields of provincial jurisdiction, while preserving the federal role in financing health care which most Canadians, for better or for worse, seem to consider essential. The CST will cost the federal government about $9.5 billion in 2007–08, and is projected to rise to more than $12 billion in 2013–14 as a result of an annual increase of three percent per capita that is promised in the budget. The reduction of federal spending by this amount would not quite cover the net loss to the federal government of the two suggested changes in taxation, but there would probably be some reduction in the cost of equalization by removing corporation tax from the formula, even though the GST would be added to the formula.

REFERENCES

Atlantic Smoke Shops v. *Conlon* (1943), A.C. 550.

Bank of Toronto v. *Lambe*. (1887), 12 A.C. 575.

Canada. n.d. Department of Finance. A New Framework for Equalization. Accessed 9 June 2006 from the Department of Finance Web site at http://www.fin.gc.ca/fin-eng.html

Canada. 2006a. Department of Finance. *Restoring Fiscal Balance in Canada. Focusing on Priorities*. Budget 2006. Ottawa: Department of Finance.

— 2006b. Department of Finance. *Achieving a National Purpose: Putting Equalization Back on Track*. Report of the Expert Panel on Equalization and Territorial Formula Financing. Ottawa: Department of Finance.

Canada. 2007. *Aspire to a Stronger, Safer, Better Canada (Budget 2007)*. Accessed 19 March 2007 at http://www.budget.gc.ca/2007/pdf/bp2007e.pdf

Chase, S. 2007. "Confrontation Looms Over Equalization Plan." *The Globe and Mail*, 15 March.

Commission on Fiscal Imbalance. 2002. *A New Division of Canada's Financial Resources*. Quebec: Commission on Fiscal Imbalance, 131–156.

Council of the Federation. 2006. *Reconciling the Irreconcilable: Addressing Canada's Fiscal Imbalance*. Report of the Advisory Panel on the Fiscal Imbalance. Available at http://www.councilofthefederation.ca/pdfs/Report_Fiscalim_Mar3106.pdf

Courchene, T.J. 2006. "Variations on the Federalism Theme." *Policy Options* 27:7.

Dion, S. "An Artificial Consensus." Open letter sent by Stéphane Dion to newspapers on 11 October 2002.

Hale, G. 2002. *The Politics of Taxation in Canada*. Peterborough: Broadview.

Leblanc, 2006. "The Rock proves a hard place for Harper." *The Globe and Mail*, 16 October.

Leblanc, D. and S. Chase. 2006. "Bloc demands $12 billion in transfers to back Tories." *The Globe and Mail*, 22 September.

Le Devoir. 2007. "J'ai trouvé mon deuxième souffle!" 20 mars.

Lévesque, K., R. Dutrisac and A. Robitaille. 2007. "Un progrès pour le Québec, selon les chefs." *Le Devoir*, 20 mars.

Ma, Shu-Yun. 2007. "Political Science at the Edge of Chaos? The Paradigmatic Implications of Historical Institutionalism." *International Political Science Review* 28(1): 57–78.

Mackenzie, H. 2006. *The Art of the Impossible: Fiscal Federalism and Fiscal Balance in Canada*. Ottawa: Canadian Centre for Policy Alternatives.

Maxwell, J.A. 1989. "Better Terms." In *Federalism in Canada: Selected Readings*, ed. G. Stevenson. Toronto: McClelland and Stewart, 392–401.

McGuinty, D. 2006. "Fairness for all – including Ontario." *The National Post*, 13 April.

Newfoundland and Labrador. 2005. *Atlantic Accord Atlantique. The Agreement*. Accessed 15 February 2007 from the Web site of the government of Newfoundland and Labrador at http://www.gov.nl.ca/atlanticaccord/agreement.htm

Parti Québécois. 2004. "Déséquilibre fiscal." *La lettre du Parti Québécois.* 17:9 19 mars.

Pierson, P. 2004. *Politics in Time: History, Institutions, and Social Analysis.* Princeton: Princeton University Press.

Prime Minister of Canada. 2004. "A 10-year Plan to Strengthen Health Care" [September 16]. Accessed 5 November 2004 from the prime minister's Web site at http://pm.gc.ca/eng/default.asp

Reference re. Canada Assistance Plan (1991), 2 S.C.R. 525.

Samyn, P. 2006. "McGuinty Breaks Ranks with Premiers." *The National Post,* 13 April.

Smiley, D.V. 1987. *The Federal Condition in Canada.* Toronto: McGraw-Hill Ryerson.

Stevenson, G. 1993. *Ex Uno Plures: Federal-Provincial Relations in Canada 1867–1896.* Montreal and Kingston: McGill-Queens University Press.

Treff, K. and D.B. Perry. 1997. *Finances of the Nation 1996.* Toronto: Canadian Tax Foundation.

Trudeau, P.E. 1968. "Federal Grants to Universities." In his *Federalism and the French Canadians.* Toronto: Macmillan, 79–102.

Waldie, P. 2007. "Cities Must Have More Economic Clout, Report Says." *The Globe and Mail,* 6 February.

Williams, D. 2007. "PM Promised Six Times, Williams Says." *The National Post,* 24 January.

3

Strengthening Canada's Territories and Putting Equalization Back on Track: The Report of the Expert Panel on Equalization and Territorial Formula Financing

Al O'Brien

Al O'Brien, Président du Groupe d'experts sur la péréquation et la formule de financement des territoires, expose le mandat et les recommandations du Groupe d'experts. Ces recommandations comprennent embrasser une approche basée sur des principes, opter pour une norme à la moyenne nationale avec une inclusion de 50% des recettes des ressources, réduire le nombre des bases d'impôts de 33 à 5, et imposer un plafond de capacité fiscale spoliateur sur les provinces bénéficiaires. Les trois annexes de ce rapport relatent, chacune à leur tour, aux recommandations de péréquation, aux recommandations pour la formule de financement des territoires, et à la manière à laquelle Le Groupe d'experts a réduit le nombre de bases d'impôts de 33 à 5.

I am very pleased to participate in the Institute of Intergovernmental Relations conference on Fiscal Federalism and the Future of Canada. I have long had much admiration for the Institute both as a Deputy Minister in Alberta and especially as the chair of the Expert Panel on Equalization and Territorial Formula Financing. My assigned task today is to summarize 14 months of consultations and two one-hundred-page reports in just a few pages. I will do my best, but I do hope that you will refer to our reports for a more comprehensive outline of our review of the recommendations.

WHAT WE WERE ASKED TO DO

In March 2005, the federal minister of finance established the Expert Panel to undertake a comprehensive review of Canada's equalization program and

Territorial Formula Financing (TFF). We were asked to advise on the following:

- The allocation of provincial equalization and TFF entitlements, including consideration of
 - the current Representative Tax System (RTS) approach;
 - how to treat various provincial and local revenue sources, including natural resources, property taxes and user fees;
 - macroeconomic approaches to measuring fiscal capacity; and
 - whether to introduce expenditure need to the equalization formula.
- Mechanisms to improve the stability and predictability of payments
- Measures to assist in evaluation of the overall level of support for equalization and Territorial Formula Financing
- Whether to create a permanent independent advisory body

Our mandate was to address interprovincial fiscal disparities in the context of section 36(2) of the Canadian Constitution, which commits the Government of Canada to ensuring that provincial governments have sufficient revenues to provide reasonably comparable levels of public services at reasonably comparable levels of taxation.

In the case of TFF, our terms of reference also indicated "that the Government of Canada is committed to ensuring that citizens living in the Yukon, Northwest Territories and Nunavut have access to basic services, reasonably comparable to those available to other Canadians," paralleling the constitutional objective of equalization.

Our mandate did not include broader issues of national fiscal arrangements, in particular the question of "vertical fiscal imbalance" between the federal and provincial levels of government which the Council of the Federation Panel addressed.

Early on, our Panel concluded that separate reports were required for equalization and TFF. While both programs start with a common purpose, they are very different in terms of how they are designed, what they measure, how they operate, and how significant they are in comparison to the revenues provinces and territories can raise from their own sources.

WHAT WE RECOMMENDED – EQUALIZATION[1]

I will turn first to our recommendations on equalization. Our report contained 18 specific recommendations [which are appended], but for present purposes I will highlight only our basic approach.

[1] Recommendations appear in Annex A.

The Panel was initiated in the context of the October 2004 "new frame-work," which established a "fixed envelope" for equalization for fiscal year 2004–05, with growth of overall equalization funding fixed at 3.5 percent annually for ten years. The allocation of the envelope among provinces would be based on relative measures of fiscal capacity, but the overall size of the program was to be reviewed only every five years. The Panel was asked to provide advice on "evidence-based aggregate measures of the evolution in fiscal disparities ... to assist in future re-evaluations of the overall level of federal support for Equalization and TFF."

This approach raised the critical question of whether the standard of fiscal capacity to which receiving provinces are raised should fall out of a "fixed pool," or rather, if the "pool" should derive from a standard that is based on the program's objectives. We found virtually no support for the "fixed enve-lope" among provinces or the academic community. Our most fundamental recommendation is that both the size of the program and provincial alloca-tions should be returned to a principles-based formula.

We concluded that a ten-province average is a "natural" basis for establish-ing the standard that reflects the reality of the financial circumstances of all provinces. While acknowledging that the determination of a standard is clearly a political decision, in our view the standard should start with a principles-based formula and be adjusted on a per capita basis if required to address concerns regarding affordability.

We also concluded that a "representative tax system" remains the best con-ceptual basis for measuring fiscal capacity, but recommend that the existing 33 revenue bases be collapsed to five (see appendix for details). We recom-mend a single calculation of entitlements based on a three-year moving average and data lagged two years. We believe these simplifications would provide much improved transparency and certainty in the program, with virtually no loss in accuracy and a reasonable trade-off in the responsiveness of the pro-gram to changing economic and fiscal circumstances.

Undoubtedly, the most contentious issue regarding the measurement of fis-cal capacity is the treatment of revenues from provincially owned natural resources. Our panel concluded that inclusion of 50 percent of actual resource revenues is the most appropriate way of addressing the conflicting goals of ensuring that provinces receive a net fiscal benefit from exploitation of the resources which they own, while achieving the constitutional objective of en-suring that provincial governments have sufficient revenue capacity to provide reasonably comparable levels of public services.

However, consistent with the principle of equity, we recommend that no province receive equalization payments which would result in that province having greater overall fiscal capacity than that of the lowest non-receiving province. Currently, that means Ontario's fiscal capacity becomes the "cap" for all receiving provinces.

WHAT WE RECOMMENDED – TERRITORIAL FORMULA FINANCING[2]

As with equalization, the federal government provides grants to the three territories to help close the gap between the revenue a territory can raise from its own sources and the resources required to provide public services that are reasonably comparable to those available to other Canadians. Clearly, however, the dispersion and isolation of northern populations result in costs of delivering public services that are substantially higher than those in southern Canada. While we concluded that measures of expenditure need were neither necessary nor appropriate in the case of equalization, the very high cost of delivering public services in the three territories requires that the standard to which territorial fiscal capacity is raised must reflect expenditure need, rather than simply raising revenue capacity to a national standard.

This need was historically reflected in the TFF program by a "gap-filling" grant equal to the difference between a "gross expenditure base" less "eligible revenues." The adoption of a fixed envelope under the Fall 2004 new framework, growing at a fixed 3.5 percent regardless of rates of population growth and the evolution of fiscal capacity and expenditure need in the individual territories, and creating a zero-sum game in which gains in one territory come at the expense of the other territories, is particularly problematic.

As with equalization, the Panel's most fundamental recommendation is to return to a principles-based formula to determine both the size of the TFF program and individual territorial allocations that reflect the very different circumstances in each territory. We recommend that the formula adopt "new operating bases" for each territory reflecting the additional funding provided under the new framework. This re-basing will address territorial concerns regarding the adequacy of funding under the previous gross expenditure base.

We recommend simplifying the TFF formula and improving economic development incentives by establishing a revenue block that includes 70 percent of the measured revenue capacity from seven of the largest territorial revenue sources. We also recommend replacing the complex "keep-up," "catch-up" and "northern discount" factors used to measure "eligible revenues" under the previous formula with a representative tax system approach.

In the case of resource revenues, the situation of the territories is again distinct from that of the provinces. The federal government has constitutional authority for natural resource development and management in the three territories. While all territories see natural resources as a key source of economic development opportunity, agreements on devolution and resource revenue sharing with the federal government are in place only in the Yukon. Accordingly,

[2] Annex B contains detailed recommendations.

we concluded that resource revenue should be excluded from the calculation of revenues included in Territorial Formula Financing. We do believe the territories should see net fiscal benefits from resource development. Our recommendation provides the flexibility necessary to accommodate both existing and future devolution agreements and to support resource development in the north.

KEY DECISIONS

In my view, the most basic decision the Government of Canada must make regarding equalization and Territorial Formula Financing is whether to return to formula-driven programs based on clear principles that apply uniformly across Canada, or to continue with what in recent years has become an increasingly ad hoc approach based on bilateral negotiations and focused on predetermined financial outcomes.

Finding the appropriate balance between ownership of resources and the objective of ensuring that all provinces have the fiscal capacity to provide the basic public services for which they are constitutionally responsible is clearly critical to returning to a principles-based equalization program. Similarly, addressing the issue of devolution and resource revenue sharing is essential in the discussion about TFF.

I also believe a very important decision will be to determine the role of the equalization program in the broader "fiscal balance" debate. Our Panel recommends that equalization should be the primary vehicle for equalizing fiscal capacity among provinces. In my view, the test of success should be that provinces have the fiscal capacity to fund the public services for which they are constitutionally responsible from their own sources, supplemented by federal transfers under a single, robust equalization program with one standard.

THOUGHTS ON PROCESS

The first imperative is to restore clarity to the program. We believe Canadians have become confused about the basic purpose and nature of the equalization program. For example, many observers have argued that the intent of the program is, or should be, to eliminate fiscal and economic disparities, rather than to permit a decentralized federal system of government to deliver public services efficiently in the inevitable presence of such disparities. The resulting confusion, exacerbated in my view by the appearance that payments are a matter of negotiating power and political expediency, have led many Canadians to accept the view that such payments are simply a subsidy for "inefficient" or "excessive" government.

We believe Canadians' confidence in equalization and TFF will be improved by ensuring clear, principles-based approaches to the programs, and by adopting our recommendations to simplify and stabilize the basis for determining entitlements and payments.

Our Panel concluded that a permanent independent advisory commission would not be the most effective means of strengthening the programs. We did recommend that transparency, communications, and governance be improved through these measures:

- Annual reports to Parliament on key measures related to equalization and TFF in combination with the Canada Health Transfer, the Canada Social Transfer, and any other general-purpose transfers provided to some or all of the provinces and territories.
- The federal government issuing a public discussion paper outlining key issues and options for changes to equalization and TFF prior to continued five-year renewals, which would serve as the basis for a parliamentary review process in which provinces, territories, academics and interested parties would be able to express their views.
- Finance Canada making an up-to-date and user-friendly simulation model of the equalization program available on its Web site, together with the associated databases.
- Support from federal and provincial governments for ongoing academic research and review of research reports through the intergovernmental process.

I also believe the intergovernmental consultation process would be much improved if first ministers focused on the principles and goals of the programs and instructed finance ministers to address specific mechanisms and formulas for achieving these goals.

CONCLUSION

Can the confidence of Canadians in the fairness and relevance of the equalization program be restored? I believe it can.

I believe that Canadians support the objective set out in section 36(2) of the Canadian Constitution, and that the equalization and TFF programs play a critical role in the effective functioning of Canada's decentralized federation and the competitiveness of the Canadian economy.

I also believe that the Expert Panel's reports provide a balanced and workable basis for putting equalization back on track and strengthening Canada's territories.

ANNEX A
PUTTING EQUALIZATION BACK ON TRACK:
RECOMMENDATIONS FROM THE PANEL

1. A clear set of principles should be adopted to guide future development of the equalization program in Canada.

RETURNING TO A RULES-BASED, FORMULA-DRIVEN APPROACH:

2. A renewed equalization formula should be developed and used to determine both the size of the equalization pool and the allocation to individual provinces.
3. A ten-province standard should be adopted.
4. Equalization should continue to focus on fiscal capacity rather than on assessing expenditure needs in individual. provinces.
5. Equalization should be the primary vehicle for equalizing fiscal capacity among provinces.

IMPROVING THE EQUALIZATION FORMULA:

6. The Representative Tax System (RTS) approach for assessing fiscal capacity of provinces should be retained.
7. Steps should be taken to simplify the Representative Tax Systems (RTS).
8. A new measure for residential property taxes should be implemented based on market value assessment for residential property.
9. User fees should not be included in equalization.

STRIKING A BALANCE ON THE TREATMENT OF RESOURCE REVENUES:

10. In principle, natural resource revenues should provide a net fiscal benefit to provinces that own them.
11. Fifty percent of provincial resource revenues should be included in determining the overall size of the equalization pool.
12. Actual resource revenues should be used as the measure of fiscal capacity in the equalization formula.
13. All resource revenues should be treated in the same way.
14. A cap should be implemented to ensure that, as a result of equalization, no receiving province ends up with a fiscal capacity higher than that of the lowest non-receiving province.

IMPROVING PREDICTABILITY AND STABILITY:

15. The current approach for determining equalization entitlement and pay-
 ments should be replace with a one-estimate, one-entitlement, one-payment
 approach.
16. Three-year moving averages combined with the use of two-year lagged
 data should be used to smooth out the impact of year-over-year changes.

ASSESSING EQUALIZATION:

17. The federal government should track and report publicly on measures of
 fiscal disparities across provinces.

IMPROVING GOVERNANCE AND TRANSPARENCY:

18. A more rigorous process should be put in place to improve transparency,
 communications, and governance. This is preferable to setting up a per-
 manent independent commission to oversee equalization.

ANNEX B
TERRITORIAL FORMULA FINANCING: RECOMMENDATIONS

The Panel considered all the ideas and options presented during its consultation process and developed a comprehensive new approach to TFF. These are the Panel's recommendations.

1. **Replace the fixed pool under the new framework with a formula-driven approach, providing three separate gap-filling grants to the territories.**
 While a legislated, fixed pool provides greater financial certainty for the federal government and a predictable and growing source of funds for the territories, the downside impact on the territories outweighs the benefits. It is important to have a program that reflects the differences among the territories and fills the gaps between their expenditure needs and their own fiscal capacity.

2. **Address concerns with the adequacy of Territorial Formula Financing through an adjustment to the Gross Expenditure Bases for each of the territories to create New Operating Bases.**
 The Panel recommends that the current Gross Expenditure Bases (GEBs) for the territories be adjusted to reflect the 2005–06 new framework funding levels for TFF. The Panel also recommends that these adjusted bases be renamed the New Operating Bases.

3. **Simplify the TFF formula by measuring revenue capacity using a Representative Tax System (RTS).**
 Using a Representative Tax System (RTS) approach simplifies the process, eliminates many of the previous adjustment factors, and is preferable to broader macro measures. The contentious tax effort adjustment factor would also be eliminated. It provides reasonable comparability among the territories and also adds administrative simplicity, greater transparency, and sound incentives.

4. **Further simplify the measurement of revenue capacity by establishing a revenue block that includes seven of the largest own-source revenues for the territories.**
 Seven tax bases should be used to determine the territories' fiscal capacity: personal income tax, corporate income tax, payroll tax, gas and diesel, tobacco, and alcohol tax revenues. This not only simplifies the formula, but also covers up to two-thirds of the territories' own sources of revenues.

5. **Improve the incentives for the territories to raise their own revenues by including only 70 percent of territories' measured revenue capacity in the formula.**
 Economic development is crucial to the future of the territories. Under the recommendation, the territories would be able to keep more of the financial benefits of economic development without seeing a corresponding drop in TFF funding.

6. **Exclude resource revenues from the calculation of revenues included in Territorial Formula Financing.**
 Unlike the provinces, the authority for developing and managing natural resource developments in the territories lies with the federal government. Since the 1980s, the Government of Canada has been engaged in discussions to devolve this authority to the territories. In principle, the Panel believes that, just like the provinces, the territories should see direct benefits from the development of resources in the territories. Each of the territories is in a different stage of discussions regarding devolution and resource revenue sharing. The Yukon is the only territory with an agreement in place. Excluding resource revenues provides the flexibility necessary to accommodate future agreements and support resource development in the territories.

7. **Use the New Operating Bases as approximate measures of expenditure needs.**
 The Panel saw no evidence to suggest that the New Operating Bases, adjusted annually, are not an adequate approximation of expenditure needs in the territories. While several suggestions were made on how to develop comprehensive measures of expenditure needs and costs in the territories, the Panel believes this would be a complex and extensive process and may not result in a better approximation than the recommended New Operating Bases.

8. **Undertake a review of significant expenditure needs and higher costs of providing public services in Nunavut.**
 While the panel does not recommend an extensive study of expenditure needs in the territories, the case for assessing expenditure needs and higher costs of delivering public services in Nunavut is substantially different. Compared with the rest of Canada, initial evidence points to serious disparities in outcomes for health, education, and social well-being in addition to an urgent need for adequate housing. The Panel's recommendations for adjusting the funding bases for TFF and providing annual escalators are designed to address the adequacy of TFF for the territories. However, these adjustments are not sufficient to address the challenges and gaps in

Nunavut. The Panel recommends that more work be done to assess expenditure needs in Nunavut as a starting point for addressing those needs on an urgent basis. The review should be done jointly by the Government of Nunavut and the Government of Canada. Any additional funding necessary to address Nunavut's needs should be provided through targeted programs rather than through adjustments to the TFF formula.

9. **Adjust the New Operating Bases annually by the relative growth in population in the territories and growth in provincial and local spending (PAGE).**
 Instead of escalating the total amount of TFF by a set percentage of 3.5 percent (as is now the case with the new framework), the Panel recommends returning to the Population-Adjusted Gross Expenditure (PAGE) escalator that takes into account comparable growth in spending in the provinces as well as relative changes in territorial population compared with the rest of Canada.

10. **Improve stability and predictability by using three-year moving averages.**
 Without a fixed pool, there can be substantial year-over-year changes in TFF entitlements. Using three-year averages smoothes out those changes and provides more stability to both the federal and territorial governments.

11. **Address issues of governance, accountability, dispute resolution, and renewal through an expanded and more transparent process.**
 The Panel does not support the idea of establishing a separate, independent permanent commission to address TFF issues. Continuing the current approach with a legislated TFF program, expanded accountability, annual reporting requirements, and mechanisms for parliamentary review, is a better match for Canada's federation. It also should provide a more open process where issues involving both the territories and the federal government can be identified and addressed.

ANNEX C
STREAMLINING REVENUE BASES

Old Revenue Sources and Tax Bases	New Tax Bases
Personal income tax Payroll taxes	Personal income
Business income Capital taxes	Business income
Property tax Miscellaneous tax	Property taxes
14 resource revenue categories*	Actual resource revenues
Sales taxes Tobacco taxes Gasoline taxes Diesel fuel taxes Vehicle licenses Commercial vehicle license Alcoholic beverages Hospital and medical insurance premiums Race track revenues Insurance premiums Lottery tickets Other games of chance Preferred share dividends	Sales taxes

*There are Forestry Revenue, New Oil Revenue, Old Oil Revenue, Heavy Oil Revenue, Mined Oil Revenue, Third-tier Oil Revenue, Mined Third-tier Oil Revenue, Natural Gas Revenue, Sales of Crown Leases, Other Oil and Gas Revenue, Total Mineral Revenue, Water Power Rentals, Shared Revenue, Offshore activities /NFLD, Shared Revenue Offshore Activities/NS. Each had its own tax base.

Under the former classification of revenues, each of the 33 revenues sources had its own, separate, tax base. The Expert Panel's proposal is to reduce the number of tax bases from 33 to 5. The table indicates where these 33 resource revenues sources will be now be allocated.

4

Reconciling the Irreconcilable:
Addressing Canada's Fiscal Imbalance*

Ceci est le chapitre final de Réconcilier l'irréconciliable: s'attaquer au déséquilibre fiscal au Canada. Cette étude fut menée par Le comité consultatif sur le déséquilibre fiscal, un comité du Conseil de la fédération. L'annexe à ce chapitre final présente l'ensemble complet des recommandations du rapport.

The Council of the Federation established the Advisory Panel on Fiscal Imbalance in May 2005 with a mandate to:

• look at the underlying causes of fiscal imbalance;
• review a full range of mechanisms to address fiscal imbalance; and
• make recommendations on ways to restore fiscal balance.

We talked with citizens, political leaders, government officials and experts in the field. We commissioned studies and a public dialogue. We undertook extensive analyses of our own, modelling different policy alternatives and assessing their impact.

The Report addresses the three elements of the mandate we received from the Council of the Federation. Throughout, we have been guided by the premiers' considered position that fiscal relations in this country need to be guided by clear principles of transparency, accountability, adequacy, predictability, equity, and fairness. We have examined the evolving position of the territories in Confederation. We have discussed the nature, origins, and impact of fiscal imbalance, both horizontal and vertical, and have evaluated the policies that Canada has developed over the years to address them. We have reflected on how these issues are managed and negotiated, and we have concluded that

*This is the concluding chapter to the report of the Advisory Panel on Fiscal Imbalance to the Council of the Federation. The full set of recommendations are attached as an Annex to this chapter.

improving the institutions and processes of fiscal governance is as important as fixing the substance of the fiscal arrangements themselves.

The Panel has made four sets of recommendations, each of which bears on an element of our mandate. There are recommendations on the territories (Chapter 4), vertical fiscal imbalance (Chapter 5), horizontal fiscal imbalance (Chapter 6), and governance (Chapter 7). These appear in the attached Annex.

Chapter 4's recommendations relating to the territories are intended to place Canada's three northern territories on a secure financial footing, recognizing that treating Canadians living in the North fairly requires that their special needs and circumstances be addressed. Fairness calls for a twofold approach. First, the fiscal transfer arrangements must be conceived an implemented with the particular needs of northerners clearly in mind. Second, the capacity of the three territories to develop their own economies must be strengthened and confirmed – in particular, by ensuring that key development decisions are made by northerners themselves and that main benefits of the development of natural resources remain with northern communities.

Our recommendations in Chapter 5 – to separate out the equalization associated with the 1977 transfer of tax points and to include it along with supplemental equalization in a separate envelope which the Panel labelled "Tax Point Adjustment" would make it possible to separate out equalization from the cash transfer program. The associated equalization and the supplemental equalization implementation by the federal government would now be transparent and would stand alone.

The Panel also recommends strongly that the cash transfer program should be disentangled from the transfer of tax points in 1977 and should be governed by the principle of equal per capita transfers to all provinces. With respect to federal transfer programs relating to health, postsecondary education, and social assistance, where the costs of offering the service are related to the number of people being served, the grants received by the provinces will be linked directly to population size. These equal per capita transfers should be untied from a tax point transfer that was made nearly thirty years ago. This separation of the tax point transfer from equal per capita transfers would end much of the unproductive discussion between the two orders of government regarding how much of the program each government supports. The numbers will now speak for themselves. It will also make any future transfer of tax points clearer and more transparent. This recommendation speaks to the principles of fairness and transparency – principles that Canadians reiterated again and again.

The recommendations in Chapter 6 on horizontal fiscal imbalance are designed to improve the way the equalization program works so that it clearly addresses the central principle which gives it life – namely, that provincial governments must be endowed with sufficient revenues to provide reasonably comparable levels of public services at reasonably comparable levels of taxation. Recent amendments to the equalization program have moved it away

from its original purpose. Our recommendations are designed to bring it back to that central objective. We understand that adherence to principle needs to be set in the context of what is reasonable and affordable. Having ourselves wrestled with the challenge of striking the right balance, we realized that this program will always require periodic review and adjustment. We believe that the changes we recommend in this report will address the principle while meeting the needs of today as effectively as possible. We also feel strongly that the horizontal transfer arrangements can and must be restructured to render them more transparent, fair, and intelligible to all Canadians, and more flexible as circumstances change.

Finally, on governance, we propose two institutional innovations. The first is the establishment of a First Ministers' Fiscal Council that would meet regularly, commission work as needed, and generally develop a stable, ongoing intergovernmental relationship. This in turn would reduce the likelihood of abrupt changes of course, arbitrary actions on either side, and unpleasant surprises. The Panel sees this as a long-overdue part of the maturing process of the Canadian federation. Second, the Panel, taking a leaf from the book of the Canadian Institute of Health Information (CIHI), proposes the creation of a similar body, the Canadian Institute of Fiscal Information (CIFI). The Panel believes that an organization with the credibility to produce authoritative public data and information about Canadian fiscal arrangements would bring real benefits, both to concerned citizens and to their federal, provincial, and territorial governments. For too long, Canadians have lived in an intergovernmental world in which the two orders of government systematically disagree on the facts and on the flows of resources among governments. It is natural in federal-provincial disputes that each side will make the best case it can to Canadians, but this does not excuse the wilful obscurantism of the present system, where, for example, tax points transferred thirty years ago are claimed – or denied – to be a continuing part of federal accounting was largely unknown to the provinces. The Panel believes that an institute to analyze intergovernmental data could over time establish a shared, authoritative information base to inform public discussions.

While the four sets of recommendations are presented in four chapters, the Panel insists that they are all interrelated. We have tried to make that clear at several points in the Report, but it is worth repeating again. Any significant adjustments in equalization payments will have, in aggregate, an impact on vertical fiscal imbalance. Granting the territories control over their natural resources will affect, in ways no one today can precisely forecast, their position in the Canadian system of inter-regional redistribution. It will also foster the continued evolution of the territories towards a status more closely equivalent to that of their provincial counterparts. And governance affects everything; the process through which agreements are reached matter. The institutions that the Report proposes will shape the approaches that Canadian governments

take to the fiscal challenges they face, and will shape the manner in which those challenges are addressed.

There is one final issue we want to speak to here. Some people, reading this report, will say: "Ah, there they go again. The one thing the provinces can agree on is demanding more money from the federal government. And their Panel is running true to form, proposing to raid the federal treasury for billions of dollars." We submit that this argument is mistaken and misguided. Is there a fiscal imbalance? The provinces and territories say there is. Righting the balance by definition involves shifting some financial resources from the Government of Canada to the provincial and territorial governments. Whether we have identified the right amount and described the best means to correct the imbalance will be for the premiers, the prime minister, and Canadians to judge, but the Panel's recommendations should not come as a surprise.

The Advisory Panel has tried to be sensitive to the needs and concerns of the Government of Canada. We believe that we have proposed a set of policy instruments that would allow Canada's political leaders to put the country's fiscal arrangements on a more solid, more intelligible, and more transparent footing. We believe that the principles that shape the analysis in this Report are fair and will be seen as fair by both orders of government and by Canadians. The implementation of the proposed new arrangements would do credit to the national government. The Panel's governance proposals open the door to a much more collaborative and mutually respectful system of intergovernmental relations.

Canada is entering the twenty-first century rich in resources, rich in people, and rich in talent, yet our governments are struggling with a fiscal architecture designed for the last century. Making our fiscal system more transparent and more accountable is an essential first step. So is making our system as fair as possible. We need effective institutions to govern our fiscal system and to enable it to work better. The recommendations in this report are respectfully designed to accomplish these objectives.

ANNEX A
RECONCILING THE IRRECONCILABLE

RECOMMENDATIONS

4.1 The Panel recommends that the new framework for financing territorial governments be replaced by a formula-based financing mechanism based on expenditure need and eligible revenue of each territory, as was the case under previous Territorial Formula Financing (TFF).

This new formula should include the following features:

- Eligible revenues should be simplified from the previous TFF, eliminating the Tax Effort Adjustment Factor and including only the most significant tax and revenue sources.
- The initial GEBs (Gross Expenditure Bases) should be based on the funding levels established for 2006–07. Future GEB adjustments should include those indicated by adequacy review, program transfers, and new obligations stemming from Aboriginal Rights agreements.
- Escalators should be linked for each territory to per capita territorial expenditure changes and relative population growth.
- Volume growth in eligible revenues should be subject to an appropriate incentive. However, a decline in eligible revenues should not result in a corresponding penalty.

4.2 The Panel recommends that the Government of Canada and the territorial governments expedite negotiations to conclude agreements where territories assume province-like authority and responsibility for management of lands and natural resources and become the principal beneficiaries of revenues and royalties derived from these resources. Arrangements must take into account Aboriginal rights, needs, and participation.

4.3 The Panel recommends that the special needs and circumstances of the territories be provided for in such specific federal program transfers. Specifically, the Panel believes that

- funding for territories should be based on actual demand and cost rather than on per capita allocations;
- the terms of cost-shared programs should recognize the limited revenue capacities of territorial governments; and
- all such program funding should be excluded from TFF calculations.

4.4 The Panel recommends that Nunavut receive extraordinary investment in the areas of housing, infrastructure, and economic and social development.

CHAPTER 5: ADDRESSING VERTICAL FISCAL IMBALANCE

5.1 The Panel recommends the creation of a fully transparent Tax Point Adjustment (TPA) program.

5.2 The Panel recommends that the per capita amount under the CHT and CST be increased from $807 to $960. This new money should be allocated to the Canada Social Transfer to correct the vertical fiscal imbalance as it relates to postsecondary education and social assistance.

5.3 Looking forward, the Panel supports the federal government's commitment to an assured growth rate of 6 percent per year of the CHT until fiscal year 2013–14. It recommends that an assured growth rate of 4.5 percent per year be established for the CST over the same period.

CHAPTER 6: HORIZONTAL FISCAL BALANCE: REFORMING THE EQUALIZATION PROGRAM

6.1 The Panel recommends that the equalization program be based on a ten-province standard and comprehensive revenue coverage with the inclusion of 100 percent of natural resource revenues.

6.2 The Panel also recommends a smoothing mechanism: a three-year moving average on all revenue bases, lagged two years, in order to provide provinces with single-point estimates for their equalization payments.

6.3 The Panel recommends that concerns about affordability on the part of the federal government be addressed by scaling back the standard established by recommendations 6.1 and 6.2. The degree of scaling should be negotiated between the two orders of government.

CHAPTER 7: THE GOVERNANCE OF FISCAL FEDERALISM

7.1 The Panel recommends that the federal, provincial, and territorial governments together establish a First Ministers' Fiscal Council (FMFC) as the principal institution in Canada for dealing with intergovernmental fiscal issues.

7.2 The Panel recommends that the federal, provincial, and territorial governments together establish a new body, the Canadian Institute for Fiscal Information (CIFI).

III

Equalization: Policy Perspectives

5

Equalization: Its Problems and the 2007 Federal Budget

Janice MacKinnon

La péréquation, qui a déjà été décrite comme « la colle qui tient notre fédération en un tout », fut mise en péril par des ententes avec Terre-Neuve et la Nouvelle-Écosse signées par le gouvernement du Premier Ministre Paul Martin. Les ententes menèrent à des inégalités. Les ressources naturelles de la Saskatchewan n'étaient pas exclues de la péréquation comme celles de Terre-Neuve et de la Nouvelle-Écosse; le résultat des ententes est que la capacité fiscale de l'Ontario fut surpassée par celle de Terre-Neuve.

Les ententes de circonstance ont aussi encouragé d'autres provinces à adopter des approches ou tactiques de relations fiscales fédérales-provinciales plus agressives et étroitement intéressées. Le budget fédéral de 2007 adresse la plupart de ces problèmes en ré-établissant la péréquation comme programme basé sur des règles, et dicté mathématiquement, en créant un plafond qui empêche les provinces recevant la péréquation d'avoir une capacité fiscale plus élevée que les provinces ne la recevant pas, et en créant le principe selon lequel les transferts futurs seront basés sur une équation par habitant. Le Premier Ministre Stephen Harper a aussi refusé de faire des compromis avec les provinces comme la Saskatchewan et Terre-Neuve, où les Premiers Ministres étaient agressifs et intransigeants dans la négociation de leur cas.

INTRODUCTION

Equalization has been described as "the glue that holds our federation to-gether" and a program that "reflects a distinctly Canadian commitment to fairness" (Canada 2006a, Executive Summary, 1). The principle of fairness is reflected in the redistributive nature of the program in that equalization has the effect of redistributing revenue from the richer to the poorer provinces. Its role in fostering national unity is related to the fact that the goal of the

interprovincial redistribution of resources is to ensure that Canadians from all regions "have access to comparable public services at reasonably comparable levels of taxation" (Canada 2006a Equalization 101, 1). The importance of equalization to Canada is reflected in the fact that it is part of the Canadian Constitution.

Despite the importance of equalization to Canada's sense of identity, recently there has been evidence that equalization is "broken." The program has been the source of federal-provincial tension and of controversy among the provinces. Moreover, both levels of government have commissioned reviews of equalization. The federal report, *Achieving a National Purpose: Putting Equalization Back on Track*, was the product of a panel of experts commissioned by the government of Prime Minister Paul Martin, although the report was released in May 2006 after the new government of Prime Minister Stephen Harper had taken power. The provincial-territorial report, *Reconciling the Irreconcilable: Addressing Canada's Fiscal Imbalance* (Council 2006), was orchestrated by the Advisory Panel to the Council of the Federation – which represents the provinces and territories – and it considered equalization as well as the issue of the fiscal imbalance. Both the federal and provincial-territorial reports agree that equalization needs to be changed, although they diverge in their views of what changes are required.

The federal report on equalization formed the basis for the comprehensive, long-term approach to federal-provincial fiscal relations adopted in the 2007 federal budget, *Aspire: To a Stronger, Safer, Better Canada* (Canada 2007, 110-138). To understand and assess the effectiveness of these changes, it is necessary to review the recent history of equalization and to address the key questions: what were the main factors in "breaking" equalization, how badly is it "broken," and how can it be "fixed"?

THE ISSUES

The most compelling evidence that equalization is not irreparably broken is the fact that no province disputes the principle of equalization. Instead, the debate among Canadian governments and academics is about the scope and decision-making structure of the equalization program. In terms of the decision-making structure, the Council of the Federation report recommends the creation of a First Ministers' Fiscal Council by the federal, provincial and territorial governments "as the principal institution in Canada for dealing with intergovernmental fiscal issues" (Council 2006, 95). Because the Council would negotiate all federal-provincial transfers every five years, it is argued that there would be "greater stability and predictability to the process" (Council 2006, 96). Also, the power of the federal government to make unilateral decisions about equalization and other federal transfers would be curtailed.

An even more contentious debate centres on the scope of the equalization program. Many provinces that receive equalization argue in favour of expanding the program, while provinces like Ontario that do not receive equalization contend that such enhancements are unaffordable. Thus, a key issue that has to be addressed is the extent to which equalization should address what has been called the horizontal fiscal imbalance – the "great disparity in the ability of individual provinces and territories to deliver comparable levels of services at reasonably comparable rates of taxation" (Council 2006, 9).

THE APPROACH

My approach in addressing these issues has been influenced by my experience as a provincial finance minister in the 1990s and by my career as a Canadian historian. From a historical perspective, it is important to understand the role that equalization played when it was created and the extent to which circumstances have changed since the program was established in 1957. From a political perspective, during my tenure as Saskatchewan's finance minister, I was involved in the negotiations about changes to the equalization formula in 1993.

Ministers, as any deputy minister knows, always say that they intend to focus on the general principles and practical political realities involved in programs like equalization because the truth is they do not understand the complex technical issues involved. (That, of course, is why we have deputy ministers.) True to form, I will focus on the broader issues and practical political realities involved in assessing and fixing the shortcomings of equalization. In short, I will focus on the big picture issues and leave others to address the specific changes to equalization that are being recommended by the federal and provincial-territorial reports.

Fixing equalization requires a big-picture perspective in two senses. Equalization has to be seen in the much broader context of federal-provincial fiscal relations. Also, it has to be remembered that equalization is only one policy tool available to the federal government to address inequalities in Canada. Assuming that there are significant limits to the federal government's capacity to use equalization to address the horizontal fiscal imbalance, this does not necessarily mean that the federal government cannot act to lessen inequalities in Canada. There are other programs that can be enhanced to promote greater fairness in Canada.

WHAT IS BROKEN: THE "SIDE DEALS"

Deciding what needs to be "fixed" and what does not need to be "fixed" about equalization requires understanding what is broken. Most recently, the decision

by the government of Prime Minister Paul Martin to abandon the rules-based, formula-driven approach to equalization and to sign "side deals" with Newfoundland and Nova Scotia did a lot of damage to equalization. Almost as important as the terms of the side deals was the process used by the Premier of Newfoundland to pressure the federal government. Newfoundland Premier Danny Williams' tactic of relying heavily on the media to make his province's case and his use of antics like taking down the Canadian flag were not lost on other provinces. Nor was the success that he achieved using these kinds of tactics. In the 1990s, when I was a provincial finance minister and was involved in the renegotiation of equalization, success by a provincial government required working with other provinces on specific issues to find common ground. The lesson of the side deals was that success requires aggressive, persistent and high profile advocacy of a province's own interests, and the rallying of its electorate to its cause, rather than seeking common ground with other provinces. Hence, other provinces became more aggressive in their positions and more narrowly focused on their own provincial interests.

The terms of the side deals also led to an understandable sense of unfairness in other provinces and this was reflected in the positions taken by the provinces of Saskatchewan and Ontario. Consider the case of Saskatchewan. For years Saskatchewan has used the federal-provincial negotiating process to make its case about an equalization formula that allows clawbacks of resource revenues that have at times exceeded 100 percent (Courchene 2004). When the side deals with Newfoundland and Nova Scotia excluded natural resources from equalization in the two Atlantic provinces, Saskatchewan had good reason to feel aggrieved and to question the merits of using "quiet diplomacy" to achieve success in federal-provincial fiscal controversies. But to take the position that "one bad deal deserves another" – that Saskatchewan should have the same deal as Newfoundland and Nova Scotia – only worsened an equally justified sense of grievance in Ontario.

If natural resources are excluded from equalization calculations, then the fiscal capacity of provinces receiving equalization, like Newfoundland, may be greater than that of Ontario – a situation that defies common sense. But to take the next step, as Ontario has done, and talk about the $18 billion dollar gap between what Ontario taxpayers contribute to federal coffers and what they receive in return from transfers and other federal programs is equally troubling. The 2006 federal budget detailed the reasons why there is a gap between what Ontario residents contribute to federal coffers and what they receive in return. It showed that the $18 billion gap that existed in 2003 consisted of the following:

- 42 percent of the gap was accounted for by above average revenues that reflected above average incomes and business activity;
- 18 percent was related to below average payments to Ontario residents for income-tested transfers to persons, such as elderly benefits, which also reflect

the province's above average personal incomes and below average unemployment rate;
- 14 percent is accounted for by Ontario's per capita share of federal debt reduction; and
- 23 percent is accounted for by below-average transfers, most notably the fact that the province does not receive equalization due to its above-average fiscal capacity (Canada 2006, 120-21).

In short, the vast majority of the gap is explained by the fact that Ontario has more rich taxpayers and prosperous businesses than most other provinces. While the Ontario government can legitimately question the extent to which revenues are redistributed from richer to poorer provinces and the number of federal programs that have an equalizing component, it is excessive to imply that somehow Ontario taxpayers are being short-changed to the tune of $18 billion per year. Equally troubling to provinces receiving equalization was the Ontario position that the program should not be enhanced.

FIXING EQUALIZATION: THE PROCESS

What is critical is that the arguably unreasonable positions taken by Ontario and Saskatchewan and their more aggressive approach in advancing them is a direct result of the side deals with Newfoundland and Nova Scotia and the high profile tactics used to achieve them. What is "broken," then, is the power of the federal government to use an ad hoc process to reach an agreement with two provinces despite the impact these deals have on other provinces. The solution, then, is to return to a rules-based, formula-driven equalization program, one that prevents the federal government from using an ad hoc decision-making process.

There is no reason to believe that adopting the recommendation of the Council of the Federation report to replace the federal power to decide transfers with a federal-provincial council empowered to make these choices will achieve better results. What is especially interesting about the report about the fiscal imbalance and equalization that was commissioned by the Council of the Federation was that the provinces and territories could not agree on their response to the report, even though they had commissioned it. Because equalization is effectively a " zero-sum game" in that the advantages gained by one province or group of provinces often come at the expense of other provinces, achieving consensus among the provinces is a difficult if not impossible task. The role of balancing the interests of the various provinces of Canada is one that properly rests with the federal government, with the critical caveat that in the case of equalization, federal decision-making has to be rooted in established rules and formulas and cannot be subject to the whims of political expediency.

Equalization also has to be seen within the broader context of federal-provincial fiscal relations. Equalization is only one piece of the federal-provincial fiscal pie and in practical terms the redesign of equalization occurs within this broader context. When provincial finance ministers assess federal-provincial fiscal relations, they do not just calculate what their province is getting from equalization. On the contrary, they consider a whole range of federal-provincial fiscal issues, from transfers to provincial projects that require federal funding. Consider the case of British Columbia. That province's assessment of how it is faring in federal-provincial fiscal relations will include calculations about what it is receiving from equalization and other transfers from the federal government. Equally important, however, will be the level of federal support for what can be considered national initiatives within the province, notably the Olympics and the Pacific Gateway Project to upgrade ports in British Columbia.

Considering the size and diversity of Canada, the task of balancing the interests of the various provinces is one that rightly rests with the federal government, which needs to have the final say about equalization and other federal transfers and programs. But final decision-making power does not mean an unfettered capacity to act unilaterally. What the federal government has to do is build a consensus – an acceptance by enough of the provinces – that the redesign of equalization along with the changes in other transfers and federal programs is reasonably fair. Thus, the task of seeking consensus and compromise among the various provincial interests and rejigging equalization in the broader context of federal-provincial relations requires the political skills of federal politicians, not the technical skills of experts.

Although a fundamental change in the decision-making structure of equalization is not warranted, there is at least one other change in the governance of equalization that has merit. In its consultations, the Advisory Panel on Fiscal Balance found that some participants were concerned that "no objective criteria exist for evaluating the effectiveness of the Equalization program" (Council 2006, 37). This is not a small problem for a major federal program that expends billions of taxpayers' dollars. It could be argued that it would be difficult to find quantitative measures to assess the effectiveness of equalization since so many other factors can affect the fiscal capacity of provinces. Nonetheless, this should not be an excuse for allowing the provinces, territories and federal government to side-step their responsibility to work together to find ways to measure the effectiveness of equalization.

THE LIMITS OF EQUALIZATION: THE HISTORICAL DIMENSION

If the short-term problems with equalization result from the side deals, the long-term problems relate to the extent to which Canada has changed since

equalization was created in the 1950s. Understanding some of these changes helps to explain a key theme of this paper: if equalization is to be "fixed," then, Canadians have to become more realistic in their expectations of what the program can and cannot achieve.

Equalization was established in an era dominated by Keynesian economics and by a vision of Canada that dates back to the 1939 Royal Commission on Dominion-Provincial Relations (the Rowell-Sirois Commission) (Canada 1954). Keynesian economics was based on the idea that states could engineer their own economies and establish the taxation levels required to fund social programs. The Rowell-Sirois Commission report articulated the vision of the Canadian welfare state that dominated federal policy making for more than a generation and became equated with Canadian unity. It argued in favour of a centralized taxation system that would allow the federal government to manage the economy effectively, establish programs with national standards and use what it called "national adjustment grants" to redistribute money among provinces so that similar programs existed across the country (Canada 1954, 125-30).

For better or worse, the world of Keynesian economics has passed, and the vision of Canada that flowed from the Rowell-Sirois report is no longer as relevant as it was a generation ago. The emergence of the global economy has meant that governments can no longer engineer their economies, and their power to set taxation levels at whatever level is deemed necessary to fund social programs has been severely constrained by the need for tax rates to be competitive. The Canadian tax system has become much more decentralized, and interprovincial competition has led to further pressure on governments to reduce taxes. Moreover, as the cost of social programs has increased and the provinces have begun paying a greater share of the costs, it has become increasingly difficult if not impossible for the federal government to impose national standards for such programs.

THE LIMITS OF EQUALIZATION: ONTARIO AND ALBERTA

Equally important are the changes that have occurred in the two provinces that have consistently been "have" provinces in the sense that they do not receive equalization. In Ontario, governments of all political stripes have argued since the early 1990s that Canada's largest province is no longer its richest and it cannot afford to support the same level of redistribution of resources from richer to poorer provinces. Recently, Premier Dalton McGinty has focused on the gap between what Ontario taxpayers contribute to federal tax revenues and what they receive in return in the form of federal transfers or programs. As mentioned earlier, the implication that Ontario is being shortchanged in the amount of $18 billion is excessive. However, there is

undeniable truth to the argument that Ontario is facing competitive pressures that mean it can no longer sustain the levels of taxation that were possible a generation ago (Ontario 2005). There is also evidence that the redistribution of resources among the provinces has left Ontario with the "lowest level of per-capita effective revenues," which has curtailed its capacity to fund programs and sustain its infrastructure (Courchene 2005). In short, there is a very well documented argument that Canada's largest province can no longer support the same level of interprovincial redistribution of resources as it could a generation ago. Hence, Canadians' expectations of what equalization can achieve have to be more limited than they were a generation ago.

While Ontario is facing fiscal pressures, Alberta is reaping a fiscal bonanza from resource revenues and is benefiting from its new status as a debt-free jurisdiction. In terms of fiscal capacity, Alberta is clearly in a league of its own. Alberta's fiscal capacity for 2007–2008 was more than $11,000 per capita, while the fiscal capacity of the other nine provinces after equalization ranged from $6,200 to $6,900 (Canada 2006, Executive Summary, 2). When one also considers that Alberta is debt free while other provinces pay billions in interest costs, the gap between what Alberta and the rest of Canada's provinces can afford to spend on programs is dramatic.

Thus, for a variety of reasons, the capacity of the federal government to redistribute resources from the richer to the poorer provinces to create a situation where there are similar national programs with similar standards from coast to coast to coast is severely constrained. The gap between what Alberta can afford to spend on social programs and what a province like Prince Edward Island can afford is virtually unbridgeable. It is also true that Ontario cannot or will not continue to sustain increasing levels of redistribution of resources from richer to poorer provinces.

PUBLIC EXPECTATIONS OF WHAT EQUALIZATION CAN ACHIEVE

While much has changed since equalization was created in the 1950s, there is evidence that public opinion has not followed suit. Public expectations of what equalization can or should do are not consistent with the limits on what that program can in fact achieve. The panel commissioned by The Council of the Federation in its consultations discovered that Canadians were not satisfied with the vague language used in section 36(2) of the *Constitution Act* to describe equalization. The section states that provinces should provide "reasonably comparable levels of public service at reasonably comparable levels of taxation" (Canada 1982, s. 36(2)). Instead, there was public support for a higher standard. Canadians who were consulted wanted to have the "same acceptable standards" of programs across the country (Council 2006, 39). The title of the panel report, *Reconciling the Irreconcilable*, might aptly describe

such a view. Equalization can lessen the inequalities in the fiscal capacities of the provinces, but it simply cannot create a situation where the provinces of Alberta and Prince Edward Island have the fiscal capacity to have the "same acceptable standards" of programs.

DEFINING THE LIMITS OF EQUALIZATION

Equalization can be "fixed" as long as Canadians have realistic ideas about what the program can and cannot achieve. In fact, defining those limits will be important to the long term success of equalization. Equalization should remain as an unconditional transfer designed to lessen the inequalities in provincial fiscal capacities. The important ideal that there should be some redistribution of resources among Canadian provinces so that there is a basic standard of essential services available to Canadians in all regions should be maintained. But it should also be clear that the goal is not to ensure that Canadians in Alberta and Prince Edward Island enjoy the same level of services, and there need to be strict limits on the extent to which resources are redistributed among the provinces.

The most effective way to restrict the extent of redistribution of resources among provinces is to establish the principle that equalization is the only program that has an equalizing component. What should be phased out are other transfers and federal programs that have an equalizing dimension. What has been called "back door equalization" has fostered regional discontent, at times distorted programs and is not transparent, in that it is difficult to measure the total costs of redistributing fiscal resources from wealthier to poorer provinces.

The problems with such programs are exemplified by the Employment Insurance program and its forerunner which provides more generous benefits to those living in regions that experience high unemployment levels. The program leads to inequities in that the unemployed in major urban centers like Toronto, where the cost of living is very high, have lower benefits than the unemployed in Atlantic Canada, where it is much more affordable to live. Also, for some time, western Canadians have believed that the program discriminates against the region which has historically had low unemployment rates even in tough economic times since westerners have traditionally moved to other parts of Canada to seek work. Today, there is the additional problem of severe labour shortages in western Canada and an Employment Insurance program that does not actively encourage the unemployed in other parts of Canada to move westward in search of work. As the problems with Employment Insurance show, other federal transfers and programs should be based on sound public policy decisions, not on a "back door" way to add on another layer of equalization.

Another consideration is that having only one equalization program would be more transparent. Currently, it is difficult to assess how much revenue is

being dedicated to redistributing resources from richer to poorer provinces. If there were only one program whose explicit goal was redistribution among provinces, it would be easier to measure the financial resources being devoted to this goal and to find mechanisms to evaluate its success.

Not only should equalization be the single program that seeks to redistribute fiscal resources among provinces, the current program should not be changed or expanded in an effort to address the horizontal fiscal imbalance between Alberta and the other provinces. In this regard, it has been argued that the equalization program should be expanded to address the yawning gap between resource-rich provinces like Alberta and the other provinces (Courchene 2006). But equalization was not designed to bridge that kind of gap and it should not be redesigned to do so.

In fact, any attempt to find a new formula or policy that has the effect of tapping into the resource wealth of Alberta and other western provinces would lead to a crisis in Confederation. The battle would not be with Alberta alone but would involve Saskatchewan and British Columbia and it would make the controversy over the National Energy Policy seem pale by comparison. The provinces of Saskatchewan and Alberta fought long and hard from 1905 until 1930 to achieve control of their natural resources, and both provinces would deeply resent any attempt by the federal government to find innovative ways to access revenues from those resources. Also, any fundamental change in federal-provincial transfers that had the effect of reducing the transfers to Saskatchewan, Alberta and British Columbia to offset their increasing resource revenue would be seen as very unfair to the region. So in terms of political non-starters, topping the list should be ideas about addressing the horizontal fiscal imbalance by tapping into western Canada's resource wealth for the benefit of the rest of Canada.

It should be remembered that the rest of Canada already shares in the prosperity of Alberta. The biggest share of revenue from the Alberta tar sands development does not accrue to the government of Alberta but goes to the federal government in the form of various taxes and is therefore distributed to the rest of Canada. Much of the machinery, equipment, services and labour that are used in the development of Alberta resources come from other parts of Canada.

OTHER WAYS IN WHICH THE FEDERAL GOVERNMENT CAN ADDRESS INEQUALITY

Although there are significant limitations on the ability of the federal government to use equalization and other federal transfers to lessen inequalities among provinces, this does not mean that the federal government lacks the power to address inequalities among Canadians. In a global economy, one of the greatest

challenges for governments is to understand what they can and what they cannot control. Smart governments accept that there are areas in which their power to act is limited. Instead, they focus on the areas exclusively within their domain and act strategically and effectively within this sphere. Equalization is clearly a federal program, but there are significant constraints on the extent to which the federal government can use the program to address the horizontal fiscal imbalance or disparities among provinces in Canada.

The limitations on the capacity of the federal government to redistribute revenue among provinces have to be seen in the broader context of the various federal programs that can be used to address inequalities in Canadian society. There are several programs under the exclusive control of the federal government that can be enhanced to mitigate inequalities among Canadians. The federal government has exclusive jurisdiction over the Child Benefit, a program designed to enhance the incomes and services available to low-income families with children. If the federal government wants to address inequalities among seniors, it can unilaterally increase the Guaranteed Income Supplement, a federal program that provides subsidies to low-income seniors. And federal student assistance programs can be enhanced to alleviate the fiscal problems of students. Thus, there are various policy tools that are exclusively within federal jurisdiction that can be used to lessen inequalities among Canadians.

THE 2007 FEDERAL BUDGET AND FEDERAL-PROVINCIAL FISCAL RELATIONS

When the government of Prime Minister Stephen Harper took office in early 2006, federal-provincial fiscal relations were severely strained by the previous government's ad hoc approach to equalization, especially the side deals signed with Newfoundland and Nova Scotia and by the lingering effects of the 1995 federal budget. Although necessary to cut the deficit, the 1995 budget cut transfers to the provinces by 40 percent over three years, a higher level of spending cuts than the federal government made to its own programs. The size of the cuts, the unilateral way in which they were implemented, and the need for the provinces to replace federal funding for health, education and social programs led to federal-provincial tensions and demands by the provinces for long-term commitments for federal transfers. The 2007 federal budget went a long way to meeting this demand. Funding for post-secondary education, social programs and daycare facilities was increased in 2007–08 and 2008–09 and there was a commitment to increase funding in these areas by three percent a year until 2013–14 (MacKinnon 2007).

More generally, the 2007 federal budget restored predictability and stability to federal-provincial fiscal relations by establishing a long-term framework

for equalization and other transfers based on rules and principles. The budget restored equalization as a rules-based, formula-driven program and in the process provided greater stability, predictability and fairness. It implemented the main recommendations of the federal panel on equalization, including the adoption of a ten-province standard and the creation of a cap, whereby a province receiving equalization has its entitlement capped when its fiscal capacity reaches the same level as a province contributing to equalization. The budget also signalled the federal government's intention to end the past practice of having an equalizing component in other transfers, a practice that has been considered to be a prime example of "back door equalization." Instead, future federal transfers will be distributed on a per capita basis, although federal transfers for health care will only be made on a per capita basis after 2013–14, when the current health agreement expires.

The federal budget was successful in "fixing" some of the main problems with the equalization program. With a program that is based on established rules and formulas, the federal government is in effect prevented from making ad hoc side deals like those made with Newfoundland and Nova Scotia, which were the main source of controversy over the equalization program. The creation of the cap goes a long way to addressing Ontario's legitimate complaint that provinces receiving equalization should not have a greater fiscal capacity than provinces that are contributors, although the continuation of the side deals means that for the foreseeable future Newfoundland's fiscal capacity will exceed that of Ontario, Saskatchewan and perhaps British Columbia. By distributing most transfers on a per capita basis and signalling its intention to end "backdoor equalization," the federal budget is moving in the direction of having one transparent equalization program with goals and results that can be measured, although there has been no indication that the Employment Insurance program will be changed. In future, however, it appears that other federal programs will be funded on a per capita basis unless there is some compelling public policy reason to do otherwise.

One of the continuing shortcomings of equalization was highlighted by the case of Quebec. The province was the biggest "winner" in terms of the amount of funding it received from equalization and other transfers and the Quebec premier made the controversial decision to use the extra federal funding to cut provincial taxes. This situation reflects the fact that equalization is not an "active" program. That is, there are no incentives or other mechanisms in place to encourage provinces to address the structural weaknesses in their economies and improve their economic standing so that they no longer have to rely on equalization payments to fund provincial programs. It is widely acknowledged that Quebec has many structural problems with its economy and a rich array of social programs. The question is fairly being asked: is it easier for Quebec to remain a "have-not" province receiving sizeable equalization payments from other provinces like Ontario and Alberta than to make the difficult

decisions to tackle its own problems with its economic structures and social programming?

Another important consideration is the way in which the federal government dealt with aggressive and uncompromising provinces. Compromise is essential to harmonious federal-provincial relations, and as the 2005 side deals showed, rewarding uncompromising behaviour can encourage other provinces to become more aggressive and self-centred in their approaches. In the negotiations that preceded the 2007 budget, provinces like Ontario displayed a willingness to compromise. Canada's largest province "won" important issues, notably the cap on the entitlements of provinces receiving equalization and the decision to distribute future transfers on a per capita basis. However, Ontario also compromised. It abandoned its past objections to increases in equalization funding and accepted significant increases in funding of more than $1.5 billion in 2007–08 alone.

Saskatchewan, on the other hand, was aggressive and uncompromising in its demand that the prime minister honour his election commitment to exclude natural resources from equalization calculations and not apply any cap to the province's equalization entitlements. The prime minister claimed that he lived up to his election promise by allowing provinces like Saskatchewan to exclude natural resources from their equalization calculations; however, the 2007 budget made the entitlements of resource-rich provinces like Saskatchewan subject to the cap. Without the cap, resource-rich western provinces could be receiving billions of dollars in oil revenues while Ontario taxpayers continued to pay them equalization. However, as Tom Courchene has shown, the cap will claw back virtually 100 percent of Saskatchewan's natural resource revenue increases, and by 2008–09 the province will no longer be entitled to equalization (Courchene 2007).

If Saskatchewan had been willing to compromise and recognize the need for some form of cap, it could probably have negotiated a less restrictive cap. Instead, the province's position was uncompromising and at times aggressive; for example, the Saskatchewan premier was widely reported to have walked out of a meeting with the prime minister. There is no doubt that the prime minister played hard-ball with Saskatchewan. Perhaps he was sending a message to other provincial premiers that uncompromising positions and aggressive behaviour no longer lead to success in federal-provincial fiscal relations.

Thus, the 2007 federal budget was an important turning point in the history of equalization. In the budget, equalization once again became a program based on rules and formulas rather than ad hoc decisions. The implementation of a cap which, in the future, prevents provinces receiving equalization from being better off than contributors to it, was important in making the program fairer. The approach to equalization also recognized the limits of the program by phasing out the equalizing components of other transfers and by moving to

a future where there is only one equalization program that redistributes resources from richer to poorer to provinces. In the 2007 budget the equalization program was made more consistent with some of the fundamental realities of Canada in the twenty-first century.

CONCLUSION

Equalization has been an important part of Canada's political and social fabric, but its continued success requires realistic ideas about its future. As much as policy experts might want the program to be based on technical consistency and clarity, equalization and the other federal transfers and programs will become muddied by the compromises and balancing of provincial interests that are necessary in a large and diverse country like Canada. As much as some Canadians would like to see the same national programs from sea to sea to sea, the diversity of Canada and the disparities in the fiscal capacities of the provinces will mean that a more modest standard will be achieved.

The noble ideal of redistributing resources from richer to poorer provinces with the goal of ensuring some comparability in the services available to all Canadians is worth preserving. However, such a goal should not be achieved at the expense of Canada's two wealthiest provinces. Ontario and Alberta remain committed to the principle of equalization. But that commitment will be sorely tested if Ontario citizens come to believe that the quality of their own services is being compromised or Albertans think that the federal government is trying to tap into resource revenues that rightfully belong to the province. Although equalization was broken, mainly by the 2005 side deals with Newfoundland and Nova Scotia, the 2007 budget "fixed" its main problems by establishing a more realistic approach to what equalization can achieve and what it can NOT achieve and should not even try to tackle.

REFERENCES

Canada. 1954. *Report of the Royal Commission on Dominion-Provincial Relations Book I: Canada, 1867–1939*. Ottawa: Queen's Printer.

— 1982. *Constitution Act*. s. 36(2).

— Department of Finance. 2006a. *Achieving a National Purpose: Putting Equalization Back on Track, Expert Panel on Equalization and Territorial Formula Financing*. Ottawa. Also available at http://www.eqtff-pfft.ca/english/EQTreasury/index.asp

— Department of Finance. 2006b. *Focusing on Priorities: Canada's New Government: Turning a New Leaf*.

— Department of Finance. 2007. *Budget 2007: Aspire: To a Stronger, Safer, Better Canada*. Ottawa.

Council of the Federation. 2006. Advisory Panel on Fiscal Imbalance. *Reconciling the Irreconcilable: Addressing Canada's Fiscal Imbalance*. Ottawa: Council of the Federation Secretariat. Also available at http://www.eqtff-pfft.ca/english/ EQTreasury/index.asphttp://www.councilofthefederation.ca/pdfs/ Report_Fiscalim_Mar3106.pdf

Courchene, T.J. 2004. "Confiscatory Equalization: The Intriguing Case of Saskatchewan's Vanishing Energy Revenues." *Choices*. Montreal: Institute for Research on Public.Policy.

— 2005. "Vertical and Horizontal Fiscal Imbalance: An Ontario Perspective." Special Report. Montreal: Institute for Research on Public Policy.

— 2006. "Variations on the Federalism Theme." *Policy Options* (September). Montreal: Institute for Research on Public Policy.

— April 2007. "A Blueprint for Fiscal Federalism." *Policy Options*. Montreal: Institute for Research on Public Policy.

MacKinnon, J. April 2007. "Rules-Based Fiscal Federalism: Clarifying Federal-Provincial Doles." *Policy Options*. Montreal: Institute for Research on Public Policy.

Ontario Chamber of Commerce. 2005. *Fairness in Confederation: Fiscal Balance: Driving Ontario to "Have-Not" Status*. Phase 1 Report from the Ontario Chamber of Commerce. Available at http://occ.on.ca/Policy/Reports/38

6

Natural Resource Revenues and Fiscal Federalism: An Alberta Perspective

Paul Boothe

Les ressources naturelles, leur droit de propriété, et les revenus générés par la gestion de ces ressources ont été depuis longtemps une source de discorde dans la fédération canadienne. Il y a plusieurs raisons pour cette situation. Une de ces raisons est que les ressources naturelles ne sont pas distribuées de façon égale dans toutes les provinces et la valeur relative des ressources naturelles varie considérablement. Le Canada est une de quelques fédérations où le droit de propriété des ressources naturelles est attribué aux provinces au lieu du gouvernement fédéral. Ce rapport examine la nature spéciale des revenus des ressources naturelles en Alberta et leur place dans l'histoire, la politique et l'économie de cette province. Le rapport conclut que les ressources naturelles, comme la langue et la culture au Québec, sont devenues une question sensible en Alberta. En plus, l'article évalue les propositions pour le traitement des revenus des ressources naturelles du rapport du Groupe d'experts sur la péréquation et la formule de financement territoriale (le rapport O'Brien) et conclut que les recommandations du rapport reflètent une compréhension claire des rôles historiques et politiques que les ressources naturelles jouent dans les provinces. Enfin, cet article spécule sur la voie à suivre pour réformer les grandes relations fiscales du Canada.

The views expressed in this paper are my own and should not be attributed to any other individual or organization. I am grateful to Tom Courchene, Peter Meekison and John Allan for comments on earlier drafts.

INTRODUCTION

Natural resources, their ownership, and the revenues derived from them have long been a source of contention in the Canadian federation. There are a number of reasons that this is the case. For example, natural resources are unevenly distributed across provinces and the relative values of different resources vary. Further, Canada is one of few federations that assigns ownership of natural resources to provinces rather than the federal government.

The politics of natural resources have played an important part in Western Canada's, and especially Alberta's, history. Provincial ownership of natural resources was granted to the original four provinces in the *Constitution Act* of 1867, but was withheld from Alberta and Saskatchewan for 25 years after they entered Confederation in 1905.[1] Canada's equalization program, which was formally established in 1957, has seen a number of changes in its treatment of natural resource revenues. The OPEC price shocks of the 1970s caused the federal government to undermine provincial ownership of resources, culminating in its National Energy Program (NEP) of 1980, and this led to deep and long lasting divisions in the country.

In Atlantic Canada, the provinces of Newfoundland and Nova Scotia challenged federal ownership of offshore resources as British Columbia had previously. Although the courts upheld federal ownership, the federal government under Prime Minister Mulroney negotiated accords that ensured that Newfoundland and Nova Scotia would be the "principal beneficiaries" of the resources. In 2004, Premier Williams of Newfoundland lowered Canadian flags in the province in a successful bid to force Paul Martin, prime minister of a minority federal government, to honour his (privately communicated) election promise to compensate the province for any reductions in equalization related to natural resource revenues.

It would seem, historically and politically at least, that there are reasons to think that natural resource revenues are not the same as other government revenues. Indeed, in the case of non-renewable natural resources, some make the case that they are also economically different, representing the proceeds of the sale of a capital asset rather than a permanent stream of revenue.

In this paper, I explore the special nature of natural resource revenue in Alberta and its place in the history, politics and economics of the province. In addition, I evaluate the proposals for the treatment of natural resource revenue in the report of the Expert Panel on Equalization and Territorial Formula Financing (the O'Brien Report). Finally, I speculate on the way forward for the reform of fiscal relations more generally in Canada.

[1] Manitoba was also denied control of its natural resources when it entered Confederation in 1870.

The remainder of the paper is organized as follows. I begin by examining the role of natural resources as an icon in Alberta history and politics. I next attempt to dispel some persistent myths about Alberta's natural resources and Canadian fiscal federalism. The treatment of natural resource revenue in the O'Brien Report is addressed next, followed by a section on the way ahead. A brief summary concludes the paper.

NATURAL RESOURCES AS AN ALBERTA ICON

For other Canadians, including those in government in Ottawa, it is difficult to understand why Albertans attach such special significance to natural resources. Natural resources are currently a massive source of revenue, but their contribution to the provincial economy and government revenues has varied substantially over time. Indeed, energy price swings have added a great deal of volatility to the Alberta economy. Yet, for Albertans, natural resources are much more than just a source of financial strength. They are an icon.

To explain the significance of natural resources by way of analogy, natural resources in Alberta are like language and culture in Quebec. They are a defining symbol of the province. Since the NEP, Albertans are ever vigilant against an attack by Ottawa on their ownership of natural resources. It is a staple of Alberta politicians to pledge to defend Alberta's natural resources from the predations of a federal government serving the interest of Central Canada.

The struggle to gain control of its natural resources has a long history in Alberta. Starting with Frederick Haultain, territorial Premier at the time Alberta entered Confederation, the Alberta view was that natural resources must be provincially owned, as was the case for the original provinces of Confederation (Rennie 2004, viii). However, when Alberta became a province in 1905, Ottawa retained ownership, thus relegating the province to second-class status. Every Alberta Premier thereafter championed provincial control of resources. Finally, in 1929, Premier Brownlee came to an agreement with Prime Minister Mackenzie King that resulted in the Natural Resources Transfer Agreement (NRTA) of 1930. The preamble to the Agreement summarizes the Alberta view neatly:

> And whereas it is desirable that the Province should be placed in a position of equality with the other Provinces of Confederation with respect to the administration and control of its natural resources as from its entrance into Confederation in 1905... (Canada 1930, 1).

The reaction to the Agreement in Alberta was overwhelming. Palmer and Palmer (1990) capture the euphoria in their description of Brownlee's return to Edmonton from Ottawa by train shortly before Christmas, 1929:

When Brownlee returned from Ottawa, over 2,000 people met him at the railway station in freezing weather, organizers lit a large bonfire, a band played and fireworks exploded into the night (217).

Even at the time, Albertans recognized the NRTA as a turning point in the history of the province. Equality with the original provinces of Confederation had been achieved.

Natural resources have been a major economic and political influence on the history of the province, but no other single event had the impact of the NEP. To use another Quebec analogy, the NEP was to Alberta what the 1982 patriation of the Constitution was to Quebec. Over a quarter century later, the NEP is still constantly referred to by Alberta politicians and journalists.

Introduced in 1980 by the federal government, the NEP responded to the massive increase in energy prices following the second OPEC price shock. The NEP had three main elements: maintain the price of Western Canadian oil sold to Eastern Canada at substantially less than world levels; increase Canadian government ownership of the oil industry and increase exploration on federally controlled lands; and levy special taxes on Western Canadian natural gas exported to the United States.[2]

Albertans, led by Premier Peter Lougheed, regarded the NEP as tantamount to a declaration of war by Ottawa on Alberta. In a televised address to the people of the province, he promised to vigorously oppose the NEP. As part of Alberta's response, oil production destined for Eastern Canada was reduced, forcing increased importation of additional foreign supplies at world prices.

Ottawa and Alberta negotiated a compromise agreement in the autumn of 1981, and the NEP was dismantled by the subsequent federal government headed by Prime Minister Mulroney. However, the NEP is largely blamed by Albertans for the economic collapse that followed almost immediately.[3] Mansell and Percy (1990) summarize the changes in the economy from 1981 to 1982:

• Drilling rigs operating in Western Canada declined from 550 to 120.
• Alberta GDP growth declined by ten percentage points.
• Alberta's unemployment rate rose by five percentage points.

[2] The federal government began regulating the price of oil produced in Canada in 1973 and levied export taxes on oil to the US to ensure adequate supplies for Eastern Canada. For a detailed account of the period, see Helliwell et al. (1988). For a discussion of the impacts on federal transfers, see Courchene (2007).

[3] It is likely that the drastic fall of world oil prices that followed on the heels of the NEP was also a significant driver of the collapse of the Alberta economy. It is an article of faith among Albertans, however, that the NEP was largely responsible for the devastation of the Alberta economy in the early 1980s.

- Net migration declined from +10,000 to -30,000.
- Over the period 1982–1985, more than 20,000 Alberta families lost their homes through mortgage foreclosures.

The economic collapse following the introduction of the NEP was the worst to hit the province since the depression of the 1930s. The consequences were long lasting. Bitterness over the NEP remains strong even today, a quarter century later. Both federal and provincial wings of the Liberal Party were discredited, perhaps permanently, in the eyes of voters. Most importantly, distrust of Ottawa and the need to defend Alberta's natural resources became articles of faith in the political culture of the province.

FISCAL FEDERALISM MYTHS ABOUT ALBERTA'S NATURAL RESOURCES

A persistent myth regarding Alberta's natural resources is that, because they are provincially owned, the federal government and other provinces derive no benefit from their development. Of course, this ignores the federal taxes paid by the resource industry and individuals working in it. Also ignored is the fact that many suppliers to the resource industry are located outside the province. Finally, it ignores benefits that accrue to other regions when unemployed workers move to work in Alberta's resource industry, reducing unemployment in their home provinces and, often, remitting a portion of their wages to family back home.

Fortunately, a recent study by Timilsina et al. (2005) for the Canadian Energy Research Institute (CERI) attempts to quantify and locate projected benefits to governments from the development of Alberta's oil sands over the period 2000 to 2020. Two important results from the study are summarized in figures 1 and 2. In figure 1, we see the projected distribution of all government revenues (in billions of 2004 dollars). Revenues accrue as royalties (paid only to Alberta) and indirect (sales) taxes, corporate and personal income taxes (paid to the federal and all provincial governments) and property taxes (paid to municipalities). The largest projected recipient of revenues from all taxes is the federal government at $51 billion, followed by the Province of Alberta at $44 billion. Other provincial governments are projected to receive $12 billion, while municipalities (including those in Alberta) are projected to receive $17 billion.

Figure 2 gives the breakdown of projected government revenues from oil sands development by type of tax. Interestingly, royalties are the third largest of five sources at 20 percent of total revenues, behind personal income taxes (25 percent) and corporate income taxes (21 percent).[4]

[4] Of course, a portion of the corporate and personal income taxes accrue to Alberta.

Figure 1: Estimated Distribution of Oil Sands Revenue by Government 2000–2020 (Billions of 2004 dollars)

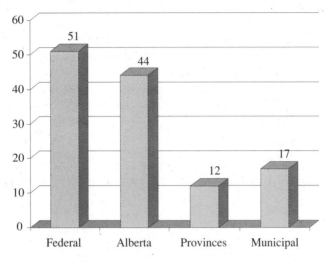

Source: Adapted from Timilsina et al. 2005

Figure 2: Estimated Distribution of Oil Sands Revenue by Tax 2000–2020

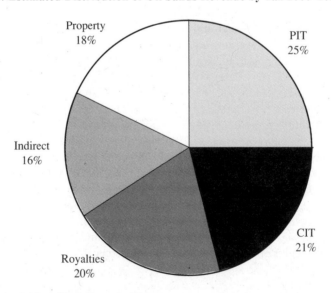

Source: Adapted from Timilsina et al. 2005

Is this projected distribution of the location and type of government revenue representative of past revenues from Alberta's natural resources? The answer is probably no. The oil sands are a high-cost source of energy, and, as such, attract a relatively low royalty rate compared to conventional oil and gas. However, oil sands extraction is a very capital-intensive industry that has benefited from generous capital cost allowances from both the Alberta and federal governments. Thus, it is likely that past conventional oil and gas development paid both higher royalties (to Alberta) and higher corporate income taxes (to Ottawa and Alberta) per dollar of revenue. Thus, while the federal government may not have been the largest beneficiary of past development, the benefits accruing to Ottawa and other provinces were still very substantial. As conventional production declines and non-conventional resources are increasingly developed, the projected distribution of revenues found in the CERI study is more likely to become the norm.

A second persistent myth about Alberta's natural resources is that the federal government unfairly captures resource revenue to finance its activities in other parts of Canada. This myth is fuelled by an uncritical examination of data from the Provincial Economic Accounts (PEA) which are used to calculate "fiscal gaps," i.e. the difference between federal receipts and federal expenditures in a province. Most recently, Ontario's fiscal gap has been highlighted by Premier McGuinty in his efforts to secure larger federal transfers.

Figure 3 shows per capita fiscal gaps by province based on 2004 PEA data. Three provinces – Ontario, Alberta and BC – show positive fiscal gaps in that year, i.e. the federal government collected more revenue than its expenditures in those provinces. Because of its large population, in absolute levels the Ontario fiscal gap is greatest. However, in per capita terms, Alberta's fiscal gap is more than $1,000 greater than Ontario's.

How should we understand these fiscal gaps? Figure 4 provides a decomposition of Alberta's 2004 fiscal gap of $8.9 billion. The chart compares federal receipts and expenditures in Alberta to what they would have been if the province had been at the Canadian average. For example, federal government expenditures on goods and services were $1.3 billion (14 percent of the total fiscal gap) below average. Likewise, Alberta's share of federal debt repayment was $1.2 billion above average.

It is clear from inspection of the expenditure and revenue categories that most of the deviations from average stem from the normal workings of the federal tax and transfer systems. Given that the tax and transfer systems are redistributive by design, provinces that are home to an above-average number of high-income families and firms will pay above-average taxes and receive below-average federal transfers. Indeed, these systems of income redistribution are at work between individuals within provinces as well as between individuals in different provinces.

The federal tax system and most federal programs operate without regard to location. However, a few exceptions are worth noting. Starting with

equalization, Alberta taxpayers contribute about $900 million to finance this program and receive nothing, given the province's large fiscal capacity. In the case of CHST cash, this transfer includes a component that equalizes the tax point portion of the total CHST transfer.[5] Finally, an argument is sometimes made that a portion of the EI transfer to individuals is based on location, given that eligibility for benefits is determined, in part, by the regional unemployment rate. Taken altogether, federal spending that Alberta is ineligible to receive contributes less than about $1.2 billion to the $8.9 billion fiscal gap of the province. The rest is largely a result of Albertans' above-average incomes. Absolutely no provincial natural resource revenues are involved. Thus, it is simply incorrect to argue that the federal government is unfairly capturing Alberta natural resource revenue to finance its activities in other parts of the country.

Figure 3: 2004 Per Capita Fiscal Gaps by Province

Source: Provincial Economic Accounts

[5] After 2004, the CHST was divided into the Canadian Health Transfer and the Canadian Social Transfer. See the Report of the Advisory Panel on Fiscal Imbalance (Council of the Federation 2006) for a discussion of the issue of equalization associated with these transfers.

Figure 4: Decomposing Alberta's 2004 Fiscal Gap

($ billions and % of total)

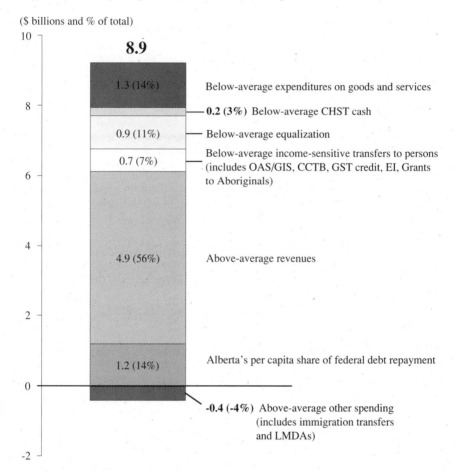

Source: Finance Canada calculation based on Provincial Economic Accounts

NATURAL RESOURCE REVENUE IN THE O'BRIEN REPORT

In 2004, the federal minister of finance established an expert panel of five distinguished Canadian economists to advise the Government of Canada on the allocation of equalization entitlements.[6] Tabled in June 2006, their report, entitled *Achieving a National Purpose: Putting Equalization Back on Track,* provided eighteen recommendations regarding reform of the federal equalization program. Five of the recommendations had to do with natural resource revenues. In the view of the Panel, "No issue in the entire Equalization program is more contentious than how to deal with resource revenues" (Canada 2006, 105).

The equalization program has been with us now for 50 years. Natural resource revenues have been included in the formula used to calculate entitlements since 1962. In the original formulation, 50 percent of natural resources were included and fiscal capacity was measured by a three-year moving average of actual revenues. The treatment of natural resources in the formula has changed eight times since they were first included.

The Expert Panel reviewed four arguments for the special treatment of resource revenues in the equalization formula. The first is a constitutional argument that natural resources are special because they are owned directly by provinces. The second is that natural resource revenues should be treated in such a way so as to preserve incentives for their development by provincial governments. The third is that provinces incur substantial costs in the development of natural resources. The final argument is that the equalization program should take account of the fact that some natural resources are non-renewable.

The constitutional argument is that, having been awarded ownership of natural resources in the Constitution, provinces should receive some net benefit from natural resources even if they are recipients of equalization payments. If equalization entitlements are reduced dollar-for-dollar as natural resource revenues rise, recipient provinces do not, in practical terms, enjoy net benefits from the ownership of their resources. A variant of this argument, made by the Economic Council (1982), attempts to align equalization impacts with those that would occur if natural resources were privately owned. They argue that if natural resource revenue was treated as income in the hands of provincial residents, a portion would be taxable by the provincial government. Therefore, they argue, only the portion that would be taxed by the provincial

[6] The Council of the Federation also established an advisory panel of experts to examine the broader issue of fiscal imbalance. Premiers were divided on the report of the advisory panel (Council of the Federation 2006).

government if resources were privately held should be included in the calculation of equalization entitlements.

The incentives argument follows closely on the constitutional argument. As owners, provinces exercise substantial control over the development of natural resources and corresponding revenues. If equalization entitlements are reduced dollar-for-dollar as natural resource revenues rise, recipient provinces' incentive to develop natural resources will be diminished. The result, it is argued, will be a loss of economic activity for the country as a whole.

The development costs argument is somewhat different than the previous two. Natural resources are often located in remote areas and thus require substantial infrastructure investments to develop. However, Canada's equalization scheme is based on revenue capacity, not expenditure need, so there is no opportunity for provinces, as owners, to deduct development costs from their gross natural resource revenues. This is in contrast to private businesses that pay taxes on net revenues. Following this line of reasoning, only a portion of natural resource revenues should be included in the calculation of equalization entitlements to compensate for the fact that development costs are not deducted.

A final argument is that non-renewable natural resources should not be included in the calculation of equalization entitlements. Here a distinction is drawn between revenues from renewable natural resources such as hydroelectric power or forestry and revenues from non-renewable natural resources such as oil and natural gas. The argument is that revenues from the former should be treated as regular, ongoing income, while revenues from the latter should be treated as the one-time proceeds from the sale of a capital asset and therefore not equalized.

After considering these arguments, the Expert Panel made five recommendations regarding natural resource revenues in their report:

1. In principle, natural resource revenues should provide a net fiscal benefit to provinces that own them.
2. Fifty percent of provincial resource revenues should be included in determining the overall size of the Equalization pool.
3. Actual resource revenues should be used as the measure of fiscal capacity in the Equalization formula.
4. All resource revenues should be treated in the same way.
5. A cap should be implemented to ensure that, as a result of Equalization, no receiving provinces ends up with a fiscal capacity higher than that of the lowest non-receiving province (Canada 2006, 7).

In rationalizing their recommendations, the Expert Panel found the first three arguments for special treatment of natural resource revenues compelling. They did not agree that a distinction should be drawn between revenues

from renewable and non-renewable natural resources. In the Panel's view, inclusion of 50 percent of natural resource revenues in the calculation of entitlements struck the right balance between the interests of recipient provinces that own significant natural resources and those that do not. The Panel rejected full exclusion of natural resource revenues because "Receiving provinces without resource revenues would see a substantial drop in the overall Equalization pool and the amount they receive. Economics and efficiency aside, this does not meet the fairness test for all Canadians" (Canada 2006, 108).

While the Panel believed that, in theory, the correct measure of fiscal capacity for natural resources is economic rent, practical problems in its measurement make actual resource revenues a preferred indicator. Further, the Panel argued that all natural resource revenues should be treated similarly, whether they accrue directly to provinces through royalties or indirectly as remittances from crown corporations such as provincial energy utilities.

A fifth, more controversial recommendation relates to a cap on equalization entitlements. This recommendation is included under the natural resource heading because it interacts with the recommendation regarding the 50 percent inclusion rate. This recommendation places an upper limit on the amount of equalization a province can receive. In the Panel's view, basic fairness dictates that equalization payments should not grow beyond the point where the fiscal capacity of a recipient province (including all its natural resource revenue) exceeds that of a non-recipient province. In short, federal taxpayers in non-recipient provinces should not be asked to finance equalization payments to provinces whose fiscal capacity exceeds their own.

THE WAY AHEAD

Can the Expert Panel's recommendations regarding the treatment of natural resource revenues form the basis for a durable reform of Canada's equalization program? From the public pronouncements of provincial premiers since the release of the report, it is clear that the traditional solidarity of recipient provinces has unravelled and a divide has opened up between equalization recipients that are resource rich and those that are not. No reform proposal can fully satisfy the demands of the various actors. Thus, a successful reform will need to strike a balance.

In my view, the Expert Panel has been successful in finding that balance in its recommendations. It has proposed a practical plan to return equalization to a principles-based, formula-driven footing – a move that all parties agree is needed. The Panel's recommendations greatly simplify the program where it relates to natural resource revenues. All natural resources are treated equivalently regardless of whether they are renewable or non-renewable, or whether they are exploited by crown corporations or by the private sector. All are

measured by actual revenues, and all are included in the equalization formula at a 50 percent rate.

The 50 percent inclusion rate recognizes the constitutionally mandated ownership of natural resources and the principle that provinces should receive some benefit from that ownership even if they are equalization recipients. At the same time, it recognizes the need to be fair to recipient provinces that are not rich in natural resources. Finally, the cap recognizes the need to be fair to citizens of non-recipient provinces, by ensuring that they are not called upon to finance equalization payments to provinces with higher fiscal capacity than their own. Thus, some but not all of the key interests of every province have been addressed.

In Budget 2007 (Canada 2007), the federal government adopted the O'Brien Report's recommendations, while adding a couple of clever twists. To fulfill its campaign promise to fully exclude natural resource revenues from equalization, the government offered individual provinces the choice of the best of the O'Brien formula (with 50 percent resource revenue inclusion and a higher equalization standard) or a modified formula (with full resource revenue exclusion and a lower equalization standard). The cap will apply in both cases. To fulfill its promise to honour the previous government's offshore accords with Newfoundland and Nova Scotia, the government offered the two provinces the option of continuing with the accords and the previous, fixed-pool equalization system or to permanently adopt the O'Brien formula.

Outside of equalization, the federal government proposed to remove associated equalization (i.e., the equalization associated with the tax-points transferred to provinces in 1977 when Established Program Financing was launched) from the Canadian Social Transfer immediately by increasing cash transfers to provinces that do not receive equalization to match transfers to provinces that do. A similar change will be made to the Canadian Health Transfer when the current agreement expires in 2014. In the future, the CST will grow at three percent per year.

The reaction of the provinces to these reforms has been mixed. The governments of Alberta and Ontario have been largely supportive, based on the move to per capita cash transfers for CST and CHT, although the Ontario government has argued that the move to per capita cash transfers for CHT should not wait until 2014. The Alberta government has dropped its longstanding opposition to inclusion of natural resources in the equalization formula. At the other end of the spectrum, the governments of Saskatchewan, Newfoundland, and to a lesser extent, Nova Scotia, have vigorously condemned the reforms. The Saskatchewan government believes that natural resource revenues should be fully excluded from the equalization formula and that it should receive equalization even if its overall fiscal capacity (including natural resource revenue) exceeds that of non-recipient provinces. It will gain little from the option to choose full exclusion of natural resources because of the equalization cap. The governments of Newfoundland

and Nova Scotia claim they are entitled to the new, enriched equalization formula as well as the special treatment of the offshore accords. The Prime Minister and the federal Minister of Finance insist that they have fulfilled their promises to address the fiscal imbalance and their election commitments to the people of Saskatchewan, Newfoundland and Nova Scotia. Time will tell whether this package provides a durable reform of equalization.

SUMMARY

In this paper I have explored the special importance that natural resources play in the history, economics and politics of Alberta. Historically, that fact that Alberta entered Confederation as a second-class province without the benefit of ownership and control of its natural resources has had a profound impact on the political culture of the province and attitudes towards the federal government. Natural resources in Alberta became like language and culture in Quebec – a political touchstone.

Likewise, the NEP was a profound political and economic shock to the province. To Albertans it represented an attempt by the federal government to break the political bargain on natural resource ownership embodied in the constitution and undo the equality with other provinces that had taken the province's first twenty-five years to attain. In addition, together with the collapse in world oil prices, it set in train an economic collapse unprecedented since the Great Depression. The NEP in Alberta became like the repatriation of the constitution in Quebec – an unprecedented assault on the province's rights and responsibilities by Ottawa.

I next reviewed the recommendations of the Expert Panel on Equalization and TFF relating to natural resource revenues. In my view, the Panel's recommendations show a clear understanding of the historical and political role natural resources play in all provinces. Will the O'Brien formula recently adopted by the federal government provide a durable reform of equalization? While some provincial governments (including Alberta) seem satisfied, others have voiced strong opposition. Ultimately, the judgment of voters may be required to answer this question.

REFERENCES

Canada. 1930. *Alberta Natural Resources Act, 1930*. Accessed 27 February 2007 at
http://laws.justice.gc.ca/en/A-10.6/text.html
Canada. 2006. *Achieving a National Purpose: Putting Equalization Back on Track*.
Report of the Expert Panel on Equalization and Territorial Formula Financing.
Accessed 27 February 2007 at http://www.eqtff-pfft.ca/epreports/EQ_Report_e.pdf

Canada. 2007. *Aspire to a Stronger, Safer, Better Canada* (Budget 2007). Accessed 19 March 2007 at http://www.budget.gc.ca/2007/pdf/bp2007e.pdf

Council of the Federation. 2006. *Reconciling the Irreconcilable: Addressing Canada's Fiscal Imbalance. Report of the Advisory Panel on the Fiscal Imbalance.* Accessed 27 February 2007 at http://www.councilofthefederation.ca/pdfs/ Report_Fiscalim_Mar3106.pdf

Courchene, T.J. 2007. "A Short History of Equalization." *Policy Options* 28:3.

Economic Council of Canada. 1982. *Financing Confederation: Today and Tomorrow.* Ottawa: Supply and Services Canada.

Helliwell, J., M. MacGregor, R. McRae and A. Plourde. 1988. *Oil and Gas in Canada: The Effects of Domestic Policies and World Events.* Toronto: Canadian Tax Foundation.

Mansell, R. and M. Percy. 1990. *Strength in Adversity: A Study of the Albert Economy.* Edmonton: Western Centre for Economic Research and C.D. Howe Institute.

Palmer, H. and T. Palmer. 1990. *Alberta: A New History.* Edmonton: Hurtig.

Rennie, B., ed. 2004. *Alberta Premiers of the Twentieth Century.* Regina: Canadian Plains Research Centre, University of Regina.

Timilsina, G., N. LeBlanc and T. Walden. 2005. *Economic Impacts of Alberta's Oil Sands.* Calgary: Canadian Energy Research Institute.

IV

Equalization: Analytical Perspectives

Natural Resource Shocks and the Federal System: Boon and Curse?

Robin Boadway

Les ressources naturelles peuvent être une bénédiction mixte. D'un côté, elles sont une source de redevances qui peuvent facilement être dévoyée au fond public avec peu de perte d'efficacité, augmentant ou déplaçant d'autres sources de recettes avec plus de distorsion. En même temps, les ressources naturelles peuvent être une 'malédiction' si les revenus ne sont pas exploités et gérés efficacement. Les exploiter puise de la main-d'œuvre et des capitaux venant d'autres secteurs de l'économie, dont ceux qui sont des sources plus dynamiques de croissance de productivité. De plus, tant que les revenus ne sont pas mis de côté pour le futur, ils peuvent engendrer des changements importants dans le taux réel de change, aggravant ainsi les conséquences pour les autres secteurs de l'économie. Manquer de les sauvegarder prive aussi les futures générations d'une partie de l'abondance de la dotation de l'économie. L'exploitation des ressources naturelles peut aussi conduire à des effets secondaires dans l'environnement qui peuvent aussi, si on ne s'en rend pas compte, accabler les générations futures. Où les ressources naturelles sont concentrées dans une région, la redistribution de main-d'œuvre et des capitaux doit plus que compenser les coûts additionnels du déménagement. Une nouvelle infrastructure coûteuse doit être construite pour tenir compte du développement de cette région riche en ressource. Dans un cadre fédéral, il y a des problèmes supplémentaires. Si les provinces possèdent des ressources naturelles, comme au Canada, d'autres sérieux problèmes se posent. La pression est sur le système fédéral de péréquation. Plus important encore, la province propriétaire des ressources voudra utiliser les recettes de ses ressources pour bâtir l'économie de la province en utilisant l'argent dans la diversification et l'attirance de d'autres industries, et, par le fait même, possiblement déformer le développement régional. Ces problèmes sont exposés, et quelques suggestions pour les résoudre sont présentées.

This paper is based on a presentation prepared for the Institute of Intergovernmental Relations conference on Fiscal Federalism and the Future of Canada, 28–29 September 2006, Kingston, Canada. I have benefited considerably from discussions with Gregor Smith and Jean-François Tremblay.

INTRODUCTION

The most stunning development affecting Canadian fiscal federalism in re-
cent years has been the unprecedented oil and gas boom in Alberta and to a
lesser extent its neighboring provinces. This has led to an ongoing shift of
economic activity and of people to Alberta, and a level of horizontal imbal-
ance between Alberta and the rest of Canada that is beyond the capability of
the equalization system to address. Moreover, there is the prospect for a great
deal of possibly painful restructuring of industry elsewhere, including the
manufacturing sector in central Canada. The purpose of this paper is to specu-
late on the implications of a major regional oil and gas boom – or any resource
boom for that matter – for fiscal federalism and the operation of the decen-
tralized Canadian federation.

It is useful to distinguish policy challenges posed by the resource boom per
se from those related to federalism. Even in a unitary nation, policy chal-
lenges exist that are not well understood. Earlier discussions of natural
resources and fiscal federalism have focused on the consequences of natural
resources for the revenue-raising abilities of the various provinces, and espe-
cially on the implied differences in ability to provide comparable levels of
public services at comparable levels of taxation in violation of section 36(2)
of the Canadian Constitution. These are the passive consequences of resource
revenues. I want to shift the focus to emphasize the potential that resource
revenues give for provinces to engage single-mindedly in proactive province-
building policies, possibly to the detriment of the development of the nation
as a whole. This potential implies that the boon of a positive shock in resource
wealth can be a curse at the same time.

Why would one suppose that a major oil and gas boom could be a curse? I
will argue that our federal system is not well suited to deal with such a boom
when it is concentrated largely in one province. More fundamentally, eco-
nomic policy analysis gives us relatively little guidance on policies to deal
with the consequences of such a boom, whether in a federal context or not. As
we know from the Norwegian example, the resource curse can partly be avoided
by good management of resource revenues. This may be more difficult in a
decentralized federation because of the irresistibility of province-building.

Canada has always been a resource-rich economy, and this has greatly in-
fluenced its pattern of development. All provinces have relied to an extent on
resources as the driver of their development. However, the recent oil and gas
boom, and particularly its concentration largely in Alberta, is of unprecedented
magnitude. This has implications for fiscal federalism, but more generally it
has fiscal and economic implications independent of those related to federal-
ism. Even in a unitary nation, there would be policy challenges, many of which
are not well understood by economists and policy experts. For that reason,
much of the discussion to follow will be speculative and based on reasoning

that has not been empirically verified. We shall work from first principles to explore some of the consequences of a regionally based resource boom and what it implies for public policy.

CONTEXT

It is useful to begin with some context. There are some key features of natural resources that should inform our thinking. Natural resources are diverse by type, and endowments of them are unevenly found across Canada. The resources can be renewable or non-renewable, and in either case, their value can be volatile and unpredictable over time. The development of natural resources is therefore risky, and it is also highly capital-intensive.

Natural resources are owned by the provinces.[1] That entails that the rents generated by exploiting natural resource endowments, after accounting for all costs of exploration and development, can be appropriated by the provincial public sectors through various mechanisms like the sale of rights and the collection of royalties and taxes. However, resource development requires infrastructure that is dedicated to the purpose, especially since resource endowments are often found in under-populated and sometimes remote areas. The infrastructure investments will typically be provided by the provinces, albeit using funds that ultimately come from the resource rents subsequently generated.

Resource products are traded, and there may be a high degree of foreign ownership of resource firms. There will be downstream economic activity related to resource development, such as refinement and other processing, as well as transportation or transmission. There will be longer term environmental and social consequences of developing natural resources, especially given that resource development competes with other sectors, in other regions, for labour and maybe capital.

The unique nature of natural resources gives rise to particular policy issues, which after all these years are still not well understood. Economic historians have studied them, and the new economic geography does as well.[2]

[1] Provincial ownership is given by section 117 of the *Constitution Act*, which states that the provinces should retain their "public property not otherwise disposed of by this Act" (e.g., turned over to the federal government) and reinforced in section 109 which says that "all land, mines, minerals, and royalties belonging to the several provinces" should continue to belong to them. Provincial property rights over natural resources are further protected in section 125, which states: "No Lands or Property belonging to Canada or any Province shall be liable to Taxation."

[2] See, for example, Krugman (1995, 1998).

But, unlike other areas of economic analysis, there is no accepted toolkit of economic policy principles to address the consequences of resource development.

Our interest is in the implications of a major resource boom for the operation of our federal fiscal system. However, it is useful to begin by setting aside federalism issues and considering the consequences of natural resource booms for economic policy in a unitary, but geographically diverse, nation. This is useful for highlighting the special problems that can be attributable to federalism as opposed to the resource boom per se.

NATURAL RESOURCE POLICY IN A UNITARY NATION

Consider the consequences for a unitary nation and its policies of a particular region – Region A – becoming recently endowed with a relatively large and valuable stock of oil and gas. The issues we discuss are particular to large discoveries in a given region: limited natural resource differences across regions do not give rise to similar problems. We begin by outlining the consequences for the private economy of such a resource boom. This is followed by a discussion of the public policy responses in the unitary nation, and an outline of some of the key policy issues that arise in responding to a large resource boom.

PRIVATE SECTOR OUTCOMES

First principles of economics inform us of the likely response of the private sector to a major increase in the value of oil and gas in Region A. The immediate consequence is that large amounts of labour and especially capital are attracted to the resource sector. The labour will be attracted from other industries and other regions, and to some extent other countries as well. This labour required in the resource industry will span various skill levels from engineering to equipment operators. Some training will typically be required, though many of the skills are of a general type and readily transferable from other uses. The increase in the demand for labour will put upward pressure on wage rates, particularly for those skill types that are relatively important for resources. In the case of capital, it is useful to distinguish between physical capital and financial capital. Assuming that the manufacturing base is limited in Region A, physical capital may be attracted from other regions or it may be imported. In this sense, some of the economic activity induced by the resource boom is spread to other regions. But the need to import capital goods has an important effect in reducing the adjustments that must be made in the rest of the country. In the case of financial capital, the fact that Canada's capital markets are integrated with the rest of the world means that much of the required financial capital is attracted from international capital markets primarily.

Nonetheless, there is likely some national segmentation of capital markets, so some of the additional financial capital needed will be diverted from uses in other regions.

The resource boom will naturally have different consequences for different regions. In Region A, the population rises as a result of both interregional migration and immigration from abroad. The age structure of the population declines and its skill structure rises as a result of the inflow of working-age persons. Wage rates rise, possibly dramatically, due to labour shortages. Indeed, the increase in wage rates is the means by which persons are attracted to Region A. This is accompanied by an increase in property values as the adjustment of the housing stock to accommodate the increased population takes time. The boom in the oil and gas industry spills over to other industries in Region A that are complementary to the resource industry or are required to service the growing population. Indeed, the larger population may itself induce further growth because of agglomeration economies that exist when population is more concentrated and labour markets deeper. To the extent that this occurs naturally, even more productive resources need to be shifted to Region A.

The rise in economic activity in Region A is accompanied by a reduction elsewhere, although the reduction will not be one-to-one. As mentioned, some of the physical capital needed in the oil and gas industry might be imported from abroad and much of it may be externally financed. As well, some of the additional labour requirements in Region A will be met by immigration. The fact that the oil and gas industry itself is capital-intensive reduces the need to attract labour from other regions. However, the growth in the non-resource industries in Region A, especially the labour-intensive non-traded service and construction sectors, will increase the demand for labour in Region A. This will increase the pressure on wage rates, which will hurt important sectors elsewhere in the country, including the important manufacturing and high-technology sectors where much of the productivity growth occurs.

In the nation as a whole, the fact that much of the output of oil and gas is sold abroad and that foreign investment flows in to finance the industry's expansion means that the real exchange rate rises. This is dampened, however, by the induced imports of intermediate goods and capital equipment and, potentially more important, to the extent that domestic savings increases. The latter is very much affected by how the revenues generated by oil and gas sales are used. If they are saved, particularly in foreign assets, exchange rate effects will be considerably mitigated. However, if they are spent, additional pressure may be put on industries elsewhere in the country depending where the revenues are spent. What is done with the oil and gas revenues is a matter for policy to decide, as discussed below. In any case, there is likely to be some shift in industrial structure from non-resource to resource industries, including from industries with innovation potential. This is the so-called Dutch

disease, also referred to as the resource curse.[3] The extent to which it occurs depends on how much the real exchange rate (and the wage rate) rises, and that again is partly a matter of policy. The fact that the oil and gas industry is itself capital-intensive implies that the Dutch disease can be minimized.

Finally, regional disparities are affected by the oil and gas boom. Per capita incomes will increase in Region A relative to elsewhere, although some of the benefits of the boom will be spread elsewhere by changes in activity levels and by the fact that capital ownership is spread across the country. Unemployment will be induced in other regions as the industrial structure changes, although this will be mitigated by outward migration. Other regions will lose working-age population to Region A and will be left with a higher age structure. All these things will have policy consequences, to which we now turn.

PUBLIC SECTOR CONSEQUENCES AND POLICIES IN THE UNITARY NATION

The private sector adjustments mentioned above are necessarily accompanied by public policies. It is these public policy responses that differ according to whether the nation is federal or unitary. Here, we focus on the hypothetical question of what the policy responses might be if the country were government as a unitary nation. This pedagogical device serves to focus the mind on the particular problems that an oil and gas boom has for the federation.

The unitary national government will run a national system of revenue-raising that imposes a common tax structure on all households and firms regardless of where they reside. This implies that the national government obtains the public share of rents from natural resources using some combination of sales of rights, resource taxes and royalties. These resource revenues could be put directly into the national consolidated general revenues, or they could be set aside and saved in a heritage-type fund. As mentioned, their disposal has consequences for manufacturing and other industries. To the extent that they are saved, the consequences of the resource boom for these other industries will be dampened. Moreover, the domestic economy will be sheltered even more if the savings are held in foreign assets so that they are not used to fuel domestic investment, at least presuming the domestic capital market is to some extent independent of world capital markets despite the fact that they are integrated.

Other aspects of the national fiscal system will kick in as well. The corporation income tax system applies to resources as well as to other industries affected, and will receive additional revenues as the profits of these industries

[3] The effect of natural resources on growth and development is analyzed in Sachs and Warner (1999, 2001).

rise. Some of these additional tax revenues will be reimbursed to domestic shareholders through the dividend tax credit system, but that will not be the case for profits accruing on behalf of foreigner shareholder or tax-sheltered shareholders like pension funds. Additional revenues will also be indirectly obtained from income and sales tax revenues resulting from increased wage earnings and induced consumer spending.

The redistributive consequences of the oil and gas boom will also be addressed by the national fiscal system. The national progressive personal income tax system will address changes in distribution of personal income, including those reflecting regional differences. The various elements of the social safety net, such as employment insurance and welfare, will provide temporary social protection for those displaced from employment in other regions of the national economy. The national government also responds to changes in regional populations and their demographic characteristics by gradually adjusting public service levels in all regions. To the extent that comparable levels of public services are provided to the relevant target groups in all regions, there is implicit social insurance and implicit equalization provided nationwide via the public sector.

Finally, the national government assumes responsibility for providing infrastructure investments in Region A to facilitate resource development and ancillary activities. This involves transportation and communications investments as well as local infrastructure like utilities and water. Investment will also be required in health and education facilities, and even in investment in human capital in skills and professions in high demand. Of course, not all the latter need be undertaken in Region A. It may be more effective to train, say, engineers, in existing universities elsewhere in the county.

PROBLEMS FOR POLICY-MAKING IN THE UNITARY NATION

The public sector cannot help but respond to an oil and gas boom. Property rights to natural resources rest with the public sector, so the government cannot avoid being involved in development decisions. And, the development of natural resources leads to some difficult policy choices by the national government even in this unitary nation. Some of these involve judgments of economic efficiency and growth, while others involved equity considerations in light of the fact that the resource boom creates both gainers and losers. The discussion here outlines some of the policy issues that need to be addressed. Many of them involve factors that have received relatively little attention in the academic literature.

The overarching policy decision in responding to a boom in oil and gas resource values is, how fast to develop natural resources. This is a difficult decision since it is affected by a number of factors, some of which are not known with certainty. One concerns expectations about future oil and gas

prices, which, despite standard predictions about an upward trend, are notoriously volatile and respond to events such as weather and political upheaval. Even knowing future prices is not sufficient, since the rate of success of exploration investment is itself uncertain. The decision about how rapidly to develop natural resources must also deal with legitimate concerns about the costs of industrial and regional adjustment, especially given the fact that other industries include those with potential for technological progress and innovation. There is also the need to cost the environmental consequences of resource development, such as the degradation of the landscape, the depletion of water supplies and the effect on woodlands and wildlife. Unlike industrial adjustment, these can be to some extent cumulative rather than transitory. Related to this are the social consequences of resource development, including the impact on aboriginal and other vulnerable communities. Finally, given that for non-renewable resources development entails the running down of national wealth, one of the most difficult evaluative issues is that of dealing with the trade-off between present and future generations. The implication of this catalogue of effects of resource development is that the decision about how rapidly to proceed involves more than economic cost-benefit analysis.

Given the rate at which resource development is to proceed, the next issue is the mundane one of how much of a share of natural resource revenues should accrue to the public sector, and what instruments should be designed to capture them. The design of instruments to collect the rent from natural resources has been widely studied and there is some consensus among economists.[4] Rents can be collected *ex ante* through the sale of exploration rights and crown leases, or they can be collected *ex post* through appropriately designed rent taxes. The proper mix of these two things is not clear, and governments typically use a mixture. In principle, the sale of leases should collect all expected rents, which might be reasonable given that the property rights to the resources belong to the public. But, the sale of leases typically does not extract all expected rents, presumably in good part because of the anticipation that there will be *ex post* rent taxes to pay. In principle, the design of policies to collect rents for the public sector should be straightforward; however, it is typically not executed well in practice. For example, *ex ante* lease sales may not be competitive enough to extract all future expected rents. And, *ex post* rent-collection devices like royalties are highly imperfect because they are not levied on a base consisting of resource rents.

Once resource revenues are collected, what should be done with them? How much of them should be saved in a heritage fund, and how much spent,

[4] For a summary of measures used around the world to collect rents from natural resources, see Boadway and Flatters (1993).

including on infrastructure and other region-building-type expenditures? There are many advantages to adopting the Norwegian model, if only the government could commit to so doing.[5] The Norwegian model involves saving all rents in a heritage fund, investing the funds in foreign assets, and living off the capital income of the fund so as to keep it intact. Such a highly disciplined use of resource rents is unique to Norway, and even there it is under some pressure. The system has a number of advantages. It facilitates intergenerational wealth sharing; it avoids the creation of excessive current demand on the domestic economy; it shields the domestic economy against major changes in the industrial structure – the resource curse or Dutch disease; it reduces exchange-rate appreciation that might be detrimental to the domestic economy; and it shelters the government from the volatility that characterizes resource revenues. But, implementing the Norwegian system entails a level of commitment that few governments show evidence of satisfying.

In addition to designing a system for collecting resource rents, it is important to have in place a corporate/business tax system that is as non-distortionary as possible so that investment is allocated efficiently among different uses. In the jargon of economics, the tax system should ensure that marginal effective tax rates are reasonably uniform across industries and regions, and that the corporate income tax serves as a withholding tax in respect of undistributed corporate earnings and non-resident shareholders. It is clear that the current business tax system in Canada does not satisfy these ideals. As the Mintz Report (1998) documented, it favours the resource sector by its system of generous write-offs, and, until recently, by the availability of the income-trust vehicle that was heavily used to reduce corporate tax liabilities in the resource sector. Moreover, it is hard to justify allowing provincial royalties to be deductible from the federal income tax base.

The design of a national tax/transfer/social insurance system is also relevant as a means of addressing in all regions the consequences of resource development for individual workers and their households. This includes the progressivity of income tax and the social-protection system of employment insurance and welfare. Designing these systems must take due account of the trade-off between social insurance and the incentive that potential workers might have to seek employment, including that available in other regions. This is the classical equity-efficiency trade-off that involves important value judgments concerning, for example, the relative roles of the state and other institutions – such as family, friends, community, and charitable organizations – in the provision of social insurance.

[5] For an overview of Norwegian oil policy, see OECD (2007).

The social protection system involves more than transfers and social insurance. Given the rapid changes in the level of population – and its dispersion in rural and remote areas – that accompany the resource boom, it also involves choosing the relative levels of public services for health, education, and social and other services to provide in Region A and in other regions. How rapidly should hospitals, schools, colleges and universities be built in Region A to facilitate population adjustment? At the heart of this decision is a judgment about social citizenship. Presumably social citizenship is defined to be nationwide in a unitary nation, so that, as an ideal, comparable levels of public services should be available to citizens in all regions. However, even in a unitary nation, service levels will differ across regions since the costs of providing comparable levels of services differ considerably. Urban dwellers receive higher levels of many public services than do rural dwellers, reflecting differences in the cost of provision. At the same time, persons in comparable settings in different regions might be entitled to comparable treatment. Translating that into a specific program of responses to rapid changes in population resulting from an oil and gas boom in Region A is a matter of judgment, and is not independent of the desired rate of development of the natural resources themselves. In any case, the redistributive nature of the tax transfer system and the system of social insurance, combined with the fact that public services would be funded from national general revenues, implies that there would be a large amount of implicit inter-regional redistribution resulting from policy responses to an oil and gas boom in Region A.

A further difficult decision that cannot be avoided by the unitary government is the extent of infrastructure investment to provide to service resource activities and remote populations. This affects the extent to which labour can be attracted to Region A, and reflects a conscious decision about the speed and extent of resource development. How much of this infrastructure development should be financed by resource revenues themselves is also an important policy question.

The most difficult decision involves not how many productive resources of various kinds to devote to natural resource development, but how much infrastructure and other investments ought to be undertaken to attract other activities that might diversify Region A's industrial structure. This includes deciding whether pro-active policies should be undertaken to encourage upstream activities, such as refining and processing of the resources. More ambitiously, should public investments be made to diversify horizontally into related industries, or more ambitiously to create such things as industrial parks and universities, whose presence might give a jump start to all sorts of industrial activity, including those of lasting value like manufacturing and high-tech industries. Economics offers little guidance as to the ideal allocation of industrial activity across regions, and especially the extent to which resource-rich regions should be diversified industrially. Are there agglomeration effects

that should be exploited? Should Region A be diversified just because it already has a lot of resource activity and presumably a critical mass of workers for a potentially thick labour market? Is Region A a good place to foster diversification, a good growth node? Those who advocate a cities agenda recognize that agglomeration of labour can generate endogenous growth. Where should these agglomerates be located? It is not at all clear that the location of valuable deposits of natural resource wealth should itself dictate the location of nodes for the development and growth of diversified economic activity. On the contrary, natural resources are often located in remote areas that have no other natural advantages for economic development.

These are all difficult policy issues that even a unitary national government must confront. Neither economics nor other relevant disciplines give unambiguous guidelines for policy, especially with respect to efficient agglomeration. The point is that there are policy imperatives that arise from resource booms quite apart from those that are special to federations. Moreover, there is no presumption that a national government will have any monopoly on good policy judgment, even if it is benevolent.

ADDITIONAL PROBLEMS ARISING IN A FEDERATION

The above discussion stresses that, even in a unitary nation, there are many difficult policy issues that must be addressed when one region receives a large shock to its resource wealth. Both efficiency and equity issues are involved in deciding the pace of development of the resource; how much infrastructure spending should accompany the resource boom; how speedy the response should be; how much interregional and international migration to the regions should be encouraged; and how the fiscal system of taxes, transfers, social insurance and public services should be adjusted in response to the various dislocations that will occur in all regions. Resolving these policy issues involves making judgments about the expected future path of resource prices; how much diversification of activity should be encouraged in the resource-rich region; what weight should be given to the social and environmental costs of resource development; and, most difficult, deciding how the fruits of the resource boom should be shared among residents of all regions and between present and future generations.

All these problems also apply in a federation when one province benefits from a major resource boom. As well, there are a number of others that are unique to federations. This section will recount the issues that arise when the nation is a decentralized federation where provinces have significant amounts of policy and fiscal discretion. It is useful for pedagogical purposes to distinguish between the case where natural resources are owned by the federal government and that where they are owned by the provinces.

THE CASE WHERE RESOURCES ARE OWNED FEDERALLY

It is, of course, a well recognized fact that, unlike in many federations, provinces own the natural resources within their borders. While provincial ownership leads to various pressures within the federation because of the financial disparities to which it gives rise, it is not the sole source of problems that arise when a province-specific resource boom occurs, although it certainly exacerbates it. There are a number of issues that arise in a federal context even apart from the issues arising from provincial resource revenues. Suppose, as in Canada, that the federation is otherwise highly decentralized in public service provision and revenue raising, and suppose also that the main elements of the existing federal-provincial fiscal arrangements are in place. Let us imagine what the consequences would be of a major oil and gas boom in one province, say, Alberta.

The economic impact of the oil and gas boom in Alberta will generate significant fiscal-capacity differences between it and the rest of Canada (ROC), even in the absence of resource revenues. Wage rates will be bid up, and per capita incomes will be above the national average. The equalization system exists to address differences in revenue-raising capacity, but even under a ten-province standard, Alberta would be left with a substantially higher fiscal capacity than other provinces. That is because, although the have-not provinces would be raised to the national average, above-average provinces like Alberta would not be equalized down. At the same time, there would also be changes in the need for provincial public services in Alberta and the ROC. Migration would cause increases in population in Alberta and reductions elsewhere, and public services would have to adjust accordingly. However, since the migration would involve mainly younger, healthier working-age persons, the relative need for public services per capita would rise in regions in the ROC (especially Atlantic Canada) losing such persons, and fall in Alberta. This would be offset to the extent that in-migrants to Alberta located in remote areas where costs of providing public services are higher. In principle, a system of equalization could deal with these changes in expenditure requirements, but the current system does not. It disregards demographic and cost-of-provision differences, effectively implying that per capita expenditure requirements are equal.

On balance, the shift in economic activity from the ROC to Alberta would likely exacerbate differences in the ability of provinces to provide comparable levels of public services at comparable levels of taxation. As the fiscal federalism literature stresses, such differences can lead to both inefficiencies and inequities. Inefficiencies arise to the extent that persons and businesses are encouraged to migrate to take advantage of higher levels of public services at lower tax costs (higher so-called net fiscal benefits). Of course, there are likely to be many other factors drawing persons to Alberta, such as the prospect

of higher-paying jobs. Nonetheless, empirical evidence suggests that fiscal factors have some influence on migration decisions.[6] This is not to say that there should not be significant migration into Alberta from elsewhere, only that it should reflect productivity factors rather than purely fiscal ones.

The changes in fiscal capacity among provinces may be thought of as a passive consequence of the oil and gas boom in the sense that they arise even if provincial governments do not change their fiscal stances. However, provinces are not likely to stand pat in the wake of an oil and gas boom in Alberta. More generally, provincial fiscal policies are not taken in isolation, but reflect an awareness of the competition that exists for valuable mobile resources and businesses. Fiscal competition is generally taken to be one of the healthy features of a federation. It enhances the efficiency and account-ability with which provinces provide services for their citizens, and encourages innovation. However, these benefits presume that provinces are reasonably equal in their abilities to engage in fiscal competition. But, where one province has a significant fiscal capacity advantage over the others (after equalization), the value of competition can break down.

In the context of a major oil and gas boom in Alberta, fiscal competition likely favours Alberta with its much higher fiscal capacity, and it can take various forms. Fiscal measures might be taken to attract good workers to Al-berta, and other provinces might find it difficult to respond. By the same token, fiscal policies, using both tax policy and infrastructure, might be used to at-tract businesses to the province. Even in the absence of provincially owned resource rents, Alberta can be expected to engage in province-building activi-ties that will attract industrial activity away from the ROC. Given that the differential fiscal-capacity benefit that Alberta enjoys is a result of its endow-ment of oil and gas rather than some natural industrial advantage, the ability to use its superior fiscal capacity to engage in beggar-thy-neighbour indus-trial policies could lead to an inefficient pattern of industrial location. More generally, given that part of the costs of adjustment to resource development are borne by other regions, there may be an incentive for a single region to develop resources too rapidly.

There are other sorts of inefficiencies that can arise from decentralized de-cision making, such as non-harmonized tax/transfer systems, distortions in the internal economic union, and spillovers of benefits or costs of provincial programs. Most of these are not unique to natural resource booms. In the case of an oil and gas boom, some such problems can be identified. One is that

[6] Empirical estimates of the effect of fiscal benefits on interprovincial migration can be found in Winer and Gauthier (1982), Day (1992) and Day and Winer (2006). The efficiency consequences of these responses are estimated in Wilson (2003).

coordination among provinces is required to transport oil and gas across provincial boundaries. Another is that the heavy use of water in the process of extracting oil from the tar sands, for example, could affect the supply of water in neighbouring provinces and territories. There could also be environmental spillovers across provincial boundaries.

From an economics perspective, a case can be made that the federal government has a role in addressing the inefficiencies and inequities resulting from an oil and gas boom in a province. This could involve redistributive interprovincial transfers, the use of the spending power to influence provincial behaviour, federal taxation and spending policies that might mute the consequences of inefficient province-building, and serving as a coordinator to induce cooperative behaviour among provinces. It is not clear that the federal-provincial fiscal arrangements, as currently structured, can deal adequately with the effects of a major oil and gas boom in Alberta. These include the need to adjust public service levels across provinces and respond to fiscal capacity differences, as well as mitigate the effects of the inevitable province-building in Alberta. As we have argued, the expectation that Alberta would use its fiscal capacity advantage in a pro-active way to foster industrial development and diversification of the Alberta economy would cause a reallocation of industry to Alberta from the ROC over and above that resulting from fiscal capacity differences and fiscally induced migration alone.

One reading of the Constitution would justify federal concern about the consequences of a significant shift in industrial activity from the ROC to Alberta induced by differential fiscal capacities. Section 36(1) does, among other things, give the federal government joint responsibility with the provinces for economic development.[7] What is not clear is how the federal government can fulfill this responsibility. It cannot, for example, restrain province-building development policies in one province that are at the expense of other provinces. The current system of equalization is not sufficient. Although it undoes some of the most egregious fiscal capacity differences among provinces, it does so only for those below the national standard tax base. It does not deal with adjustment problems or with the effect of province-building in Alberta on the ROC, especially in Atlantic Canada. Some federal instruments are useful, such as its nationwide system of progressive taxation and its employment insurance system. Moreover, in this setting where it obtains the public's share of resource rents, it has enough resources to pursue a national infrastructure strategy (although the details of how it should do so are not at all well developed).

[7] Section 36(1) says, among other things that ... "Parliament and the legislatures, together with the government of Canada and the provincial governments, are committed to ... furthering economic development to reduce disparity in opportunities ..."

Finally, the federal government can continue to play an important role in facilitating the harmonization of provincial fiscal policies through its tax collection agreements and its role in financing social programs. These continue to be important national objectives independent of an oil and gas boom. But, coordinated decision-making in other areas – such as environmental policy, cross-border spillover issues with respect to water, and aboriginal policy – is also important.

CASE WHERE RESOURCES ARE OWNED BY THE PROVINCES

The fact that natural resources are owned by the provinces in Canada exacerbates the problem of dealing with a major resource boom concentrated in one province. In addition to all the policy challenges posed above, provincial ownership of resource revenues lead to the following concerns.

First, the usual problems created by differential provincial fiscal capacities are greatly intensified. Revenues from oil and gas significantly increase Alberta's fiscal capacity relative to those of all other provinces, including Ontario. Indeed, if such revenues are treated as current additions to revenue-raising capacity, Alberta's ability to raise revenues per capita is of the order of twice that of Ontario.[8] Even if the equalization system were to include natural resources fully, Alberta would be left with a considerably higher revenue-raising capacity than the national average under any conceivable standard used, including the ten-province standard. This is an unprecedented source of horizontal imbalance in the Canadian federation. If these are used for current purposes, the purely fiscal incentives created for persons and businesses to migrate to Alberta are substantial. Although there is some dispute over the relative magnitude of fiscally induced migration, the numbers for gross interprovincial migration are now sizeable and the demographics of migrants are relatively favourable to Alberta, which makes the horizontal imbalance more pronounced. Recent work on the long-run welfare consequences of fiscally induced migration suggests that it is quantitatively significant (Wilson 2003).

Related to these effects of the oil and gas boom on fiscal-capacity disparities is the fact that, even under the existing system of fiscal arrangements, the equalization system is strained. This is especially the case the more decentralized are revenue-raising responsibilities in the Canadian federation. The affordability of the equalization system is already becoming an issue with the gradual reallocation of tax room from the federal government to the provinces, which itself increases fiscal disparities. It will become even more acute

[8] See the estimates provided in Expert Panel on Equalization and Territorial Formula Financing (2006, 8-9).

with the increase in disparities resulting from the oil and gas boom in Alberta as well as lesser resource booms in other provinces. And, the affordability problem has been magnified by the fact that, for various reasons, the federal government has chosen not to exploit fully its ability to obtain resource revenues through the income tax system. As has been well documented (Mintz Report 1998), the existing system of business taxes provides preferential treatment to the resource industries through its generous treatment of exploration and development expenses. In addition, federal revenue losses occur through the deductibility of provincial resource levies from the federal corporate tax base, and, until recently, through the toleration of income trusts. We return briefly to these issues in the final section.

With affordability being threatened, the sustainability of even the existing equalization system becomes tenuous. Despite the well-known commitment of section 36(2) of our Constitution, the sustainability of equalization requires a non-trivial national consensus about the extent of the Canadian sharing community. How much are Canadians in all provinces willing to commit to ensuring that residents of all provinces can enjoy comparable levels of public services at comparable levels of taxation? To put it another way, how far does national social citizenship, as opposed to provincial social citizenship, extend? Do we define our sharing community primarily at the national level or at the provincial level?[9] These become open questions when disparities of fiscal capacity become wide.

Perhaps the most critical consequence of provincial resource ownership is the intensification of asymmetric fiscal competition. Alberta clearly has the resources to engage in infrastructure development and other forms of spending designed to build and diversify the provincial economy, and this at the expense of other provinces. Since it derives simply from the availability of resource revenues, and not from any economic or geographical rationale, it is certainly questionable that this province-building constitutes efficient development. A priori, one might expect that province-building is not efficient, because it is based on the interest of one province only, whereas other provinces are affected. Unfortunately, considerations of this sort seem to be missing from the national debate. The issue is quite similar to that which has animated the debate about cities. Those who worry about neglecting the existing cities as potential sources of growth should doubly worry about too many resources being devoted to building up infrastructure in Alberta simply because it has oil and gas revenues. No economic imperative suggests that the best place for economic development is where large amounts of oil and gas are located.

[9] The concept of social citizenship and the sharing community and their relevance for the fiscal arrangements are discussed in Banting and Boadway (2004).

Of course, these effects arising from fiscally induced migration of economic activity and asymmetric fiscal competition are very much dependent on resource revenues being treated as general revenues rather than being saved in a heritage fund. To the extent that Alberta goes the Norwegian route, many of the problems resulting from provincial ownership of resource revenues will evaporate.

The best federal response to these problems is not clear. It is not feasible to meet the asymmetric capacities for province building simply by enhancing equalization. That is not to say that the treatment of resource disparities under equalization is not an important issue. But that alone is not sufficient to meet the challenge of responding to the possible inefficient consequences of province-building that follow a significant resource boom. This all implies that the way in which the federal government deals with fiscal balance in light of the new reality is critical. The final section discusses the more modest issue of what feasible measures might be taken to address the fiscal balance issue given the present realities. The more ambitious agenda of responding to province-building is left for further study.

REMARKS ON REBALANCING THE FEDERATION

The debate over rebalancing the federation takes on heightened importance in light of the asymmetries resulting from the oil and gas boom in Alberta. Both the horizontal and the vertical dimensions are relevant. Moreover, they are intertwined in the sense that measures taken to rebalance the federation vertically have consequences for horizontal balance, and achieving horizontal balance necessarily implies some constraints on the direction and magnitude of vertical rebalancing. More generally, rebalancing has important implications for the efficiency and equity than can be achieved in the Canadian economic union, and will have longer-term effects on the evolution of the federation. And, the treatment of natural resources is at the heart of the fiscal-balance debate. Despite the interdependency of the horizontal and vertical dimensions, it is useful to review the issues surrounding them sequentially.

HORIZONTAL BALANCE: THE EXPERT PANEL VS. THE ADVISORY PANEL

The recent reports of the Expert Panel on Equalization and Territorial Formula Financing and the Advisory Panel on Fiscal Imbalance provided a careful analysis of horizontal balance and its policy implications. There are more similarities than differences between the Expert Panel recommendations and those of the Advisory Panel, but the most significant difference concerns natural resource revenues. Both recommend equalizing only revenue-raising capacity, using a ten-province standard. In the case of resource revenues, the

Advisory Panel calls for full equalization of resource revenues using a Representative Tax System (RTS) approach, much like the current system. However, the Expert Panel suggests including only 50 percent of resource revenues, and equalizing on the basis of actual revenues, which is a major departure from past practices.

The Expert Panel offers five reasons for this approach, none of which I find persuasive.[10] The first is the constitutionality argument and revolves around the conflict that arises between the provincial ownership of resource revenues and the federal equalization commitment under section 36(2). The argument is that the provincial ownership of resource revenues precludes full equalization because the latter amounts to undoing that ownership. This is not persuasive on a couple of grounds. First, the provincial ownership of tax revenues applies equally well to all its revenue sources and not just resources, and few would argue that this compromises the case for revenue equalization. Moreover, equalization does not constitute taxation, although equalization transfers are conditioned on a province's ability to raise resource revenues. The federal government does, in fact, impose taxes directly on resources through its income and sales tax systems, and this has not been ruled out by provincial ownership arguments.

The second argument is affordability. It suggests that since the federal government has no direct access to resource revenues (royalties, sale of leases, etc.), this makes equalizing them infeasible. There are two responses to this. The first is that the federal government does, as we have mentioned, have access to revenues generated by resources using conventional income and sales taxes. Indeed, they could if they so chose obtain much more revenue from resource industries than they do now by reforming the business tax system. Second, to the extent that affordability is an issue, it should be addressed by changing the standard rather than changing the proportion of resource revenues equalized. It is straightforward to show that changes in the standard entail equal per capita changes in entitlements for all provinces, and so maintain horizontal balance among have-not provinces. Proportional reductions in resource equalization will work to the detriment of resource-poor provinces.

The third argument is that full equalization of resource revenues discourages have-not provinces from developing natural resources. This incentive problem is overstated. There is no evidence that the full equalization of resource revenues that has applied for the past two decades has had any effect on the rate at which resources are exploited. Moreover, there are theoretical arguments against this incentive story. Once resources have been discovered, whatever equalization clawback there is will occur whenever they are

[10] For more detailed discussion of these points, see Boadway (2005, 2006a).

developed. There is no thus advantage in postponing development. Any disincentive that exists will apply at the stage of discovery and not development.

A potentially serious problem with equalizing resources is the difficulty of measuring the revenue-raising capacity of given resources. Different resource deposits will have different capacities for raising revenues given their different costs of extraction. This was a main reason for the Expert Panel advocating the use of actual revenues rather than the RTS system. The problem with using actual revenues is that it exacerbates incentive problems since actual revenues depend on tax rates actually chosen by the provinces. In these circumstances, the inclusion of only a portion of resources revenues in the formula is almost mandatory. A way of getting around the measurement issue that does not have drastic implications for incentives is to use a so-called stratification approach by which revenues are disaggregated into groups with more comparable revenue-raising capacities. This is done to some extent in the current system.

Finally, an argument that has been stressed by some observers (e.g., Courchene 2004) is that since it is costly for provincial governments to earn resource revenues – because of the need to provide dedicated infrastructure and other business services – resource revenues should not be fully equalized. The problem with this argument is that it is a piecemeal approach that deviates from the principle that only revenues should be equalized and not expenditure needs, and it ignores the fact that many other revenue bases incur costs. For example, the health and education systems certainly contribute to the size of the earnings capacity on which personal and corporate tax bases depend. It would therefore be discriminatory to treat natural resources differently on these grounds.

The upshot of the Expert Panel proposal is that it puts too much emphasis on these arguments, and results in a system that arbitrarily and systematically harms provinces that are resource-poor. Not only does this fail to ameliorate the major source of fiscal-capacity differences among provinces, it also facilitates the role of natural resource endowments as a major determinant of economic development.

VERTICAL BALANCE: BEWARE OF TAX POINT TRANSFERS

The issue of vertical balance boils down to the extent to which provinces should obtain their revenues from their own tax sources as opposed to federal transfers. In essence, there are three options for approaching the vertical balance issue. One is to maintain the status quo, which entails keeping federal transfers to the provinces roughly as they are in proportion to provincial spending. The second is to turn over tax room to the provinces and at the same time reduce federal transfers. The third is to do the opposite: increase the tax share of the federal government and with it the level of transfers. The second alternative has achieved some prominence and been the subject of various proposals.

In particular, it has been suggested by the Séguin Commission (2002), Poschmann and Tapp (2005), and Smart (2005) that the Goods and Services Tax (GST) should be turned over to the provinces, with the transfer being accompanied by a reduction in social transfers. Although the relationship with the natural resource issue is somewhat tenuous, it is worth outlining why this might not be a good idea. On the contrary, I shall suggest that the third alternative is preferred.

There are three main arguments for turning over sales tax room to the provinces. The first one is accountability. The argument is that provinces will be more accountable for their spending to the extent that they are required to raise their own revenues to finance it. This was forcefully put in Poschmann and Tapp (2005). The second is that turning over revenue-raising power to the provinces and reducing social transfers will reduce the ability of the federal government to use transfers to influence provincial decision making. The Séguin Commission (2002) relied heavily on this argument. Not only would avoiding use of the spending power enable provinces to pursue their priorities in an unfettered way, it would also avoid the kind of abrupt and unexpected changes in transfers to the provinces such as occurred in the 1995 budget when the federal government reduced transfers dramatically. The final argument is that turning over sales tax room to the provinces could be a way of encouraging the provinces to harmonize their sales taxes. Arguably, the harmonization of provincial sales taxes is the most important step that could be taken to improve the efficiency of the Canadian economic union and the competitiveness of Canadian industries.

There are, however, compelling counter-arguments to further decentralization of revenue-raising to the provinces. The accountability argument is not very convincing and really amounts to an argument of faith. There has been a good argument made as to why provinces would be less vigilant spending general revenues that come from their own sources rather than from federal transfers. Both are fungible once they are received. Moreover, accountability already exists for marginal increases in revenue since they must be financed by additional taxes raised in the province. Perhaps more important, in the case of the sales tax, provinces simply do not use sales tax rates to fine-tune their budgets. Instead, they essentially take as given whatever revenues come in at their given tax rates. Why they should treat those revenues as any different from unconditional revenues received as transfers is not clear. If one took the accountability argument seriously, one would have to suppose that serious accountability problems also accompanied windfall revenues obtained from natural resources.

Similarly, the argument that turning over sales-tax points to the provinces (as the federal government has started to do with the 2006 budget) facilitates sales-tax harmonization is highly wishful thinking. On the contrary, it almost certainly makes tax harmonization more difficult. Tax harmonization in the

past has only occurred when the federal government was a dominant revenue-raiser. Revenue sources that are concentrated at the provincial level are the most disharmonized in the federation, resource taxes being the most obvious example. Moreover, when the federal government has vacated particular sorts of tax room to the provinces, the taxes have become less harmonized. A case in point is the personal income tax. In the extreme, when the federal government turned over the inheritance tax to the provinces, it gradually disappeared. There is no particular reason to suppose that the provinces would unilaterally choose to harmonize their sales taxes in response to a reduction in federal GST rates. The advantages of harmonization have been well known to them for some time now, and they have chosen not to act.

More important, it is not clear that a harmonized GST is administratively feasible in a federal system in which the provinces have real discretion over their own tax rates. The absence of border controls makes it very difficult to administer the credit and invoice procedure when taxes are different in all provinces.[11] It is true that models exist by which decentralized value-added taxes could be implemented.[12] However, they have yet to be applied in any context, including the European Union. In Canada, it is the case that the Quebec Sales Tax (QST) operates as a decentralized value-added tax harmonized with the federal GST. But it is not clear that extending the QST system to other provinces would be reasonable on administrative grounds. To put it differently, it may be feasible to run a decentralized and harmonized value-added tax system, but, given its administrative costs, there is a preferred alternative discussed below that would avoid these costs.

Another counter-argument to the decentralization of tax room to the provinces is that greater fiscal disparities would be created among provinces and the pressure on the equalization system would increase. If the existing structure of equalization were to be maintained, the size of the transfers would have to increase. Affordability concerns would become more intense, and the sustainability of equalization at its current level would be jeopardized.

Finally, a rebalancing of the federation that entailed smaller federal-provincial transfers would render the spending power less effective. One can have different views about the role of the federal spending power, and one could certainly argue that it has been abused or used in non-cooperative ways in the past. Nonetheless, the federal spending power remains an important policy instrument. It is the only one that is available to the federal government to fulfill its constitutional responsibilities under both parts of section 36

[11] This is discussed in more detail in Boadway (2006b).

[12] For some options, see Keen and Smith (2000), and McLure (2000), and Bird and Gendron (2001).

as well as to fulfill its legitimate policy interest in national efficiency and equity. Even if federal transfers are largely unconditional (as is the case now), the mere existence of significant federal-provincial transfers gives the federal government a meaningful seat at the intergovernmental interaction table and affords it some legitimacy in persuading provinces of the merits of coordination and harmonization of policies. But it also allows the federal government to engage in spending projects that foster national development, such as investment in infrastructure, human capital and the cities.

A PREFERRED OPTION

The above discussion argues against further decentralization of revenue-raising to the provinces. Indeed, a strong case can be made that the most important current objectives of the Canadian federation can be achieved by rebalancing the federation in favour of federal revenue-raising.

The preferred option would take the following form. The provinces would vacate the sales tax completely and the federal government would take up the tax room with an enhanced national GST. By definition, this would harmonize the sales tax system, thus achieving a sought-after source of efficiency improvement. The loss in provincial sales tax revenue would be made up with an explicit revenue-sharing agreement with respect to the GST tax revenue. (The exact sharing proportions need not be proposed here: it is the principle that is important.) The revenue-sharing component could be allocated among the provinces in a variety of ways, though the cleanest might be an equal per capita allocation. That way, no further equalization would be required.

The consolidation of the GST at the national level, with its revenues shared at specified rates with the provinces, is precisely the method that is used in Australia and in Germany. It is also similar to the system that is currently used for the three Atlantic provinces that participate in the Harmonized Sales Tax. The latter is a revenue-sharing scheme with the revenues being allocated to the three provinces using the derivation principle. In this case, the revenues then become provincial sources of revenue that are fully equalized, which makes them analogous to an equal per capita transfer. As argued, accountability is not sacrificed. The provinces obtain general revenues according to their share of the GST revenues allocated to them, just as under the current system they obtain general revenues according to the provincial sales tax revenues that they receive. They have neither more nor less control over the revenues in either case.

An issue that is likely to arise with such a system concerns the treatment of Quebec, which already has a harmonized sales tax system. There is no reason why Quebec's preferences could not be accommodated by an asymmetric arrangement whereby they continue to levy the QST and retain the province's share of revenues for themselves. Since Quebec's revenues will likely differ

from the equal per capita revenues obtained by the other provinces, there would be a need to equalize Quebec's sales tax revenues so that the same per capita share is obtained. That could readily be worked out administratively without any serious issues of principle being compromised.

Such a rebalancing would leave the CHT/CST system of social transfers intact. There will still be some desire to reform the process by which such transfers are determined and changed, and that remains an item on the future agenda.

Of more immediate relevance, the rebalancing reforms suggested would not resolve the major issues arising from the oil and gas boom in Alberta, or those that might arise in other provinces in the future. The best that can be said is that the rebalancing would not exacerbate the problem. Greater mitigation of the consequences of the oil and gas boom involves actions that only Alberta can take. In particular, if oil and gas revenues' net of associated infrastructure costs are sequestered in a heritage fund and the capital not drawn down, the major problems would not arise. This would be the case, for example, if a Norwegian-style heritage fund were set up whereby *all* net provincial oil and gas revenues are deposited in it and the fund treated as a perpetuity whose capital income is available for current use. It seems unlikely that such a scenario will occur given the incentives for province-building. Perhaps that is all the more reason for the federal government to pursue its own infrastructure and human capital development strategy.

REFERENCES

Advisory Panel on Fiscal Imbalance. 2006. *Reconciling the Irreconcilable: Addressing Canada's Fiscal Imbalance.* Ottawa: The Council of the Federation.

Banting, K. and R. Boadway. 2004. "Defining the Sharing Community: The Federal Role in Health Care." In *Money, Politics and Health Care,* ed. H. Lazar and F. St-Hilaire. Montreal: Institute for Research on Public Policy.

Bird, R.M. and P.-P. Gendron. 2001. "VATs in Federal Countries: International Experience and Emerging Possibilities." *Bulletin for International Fiscal Documentation* 55: 293–309.

Boadway, R. 2005. "Evaluating the Equalization Program." Study prepared for the Expert Panel on Equalization and Territorial Formula Financing, Ottawa (40 pp.). Available at http://www.eqtff-pfft.ca/submissions/EvaluatingtheEqualizationProgram.pdf

Boadway, R. 2006a. "Two Panels on Two Balances." *Policy Options* 27: 40–45.

— 2006b. "The Principles and Practice of Federalism: Lessons for the EU?" *Swedish Economic Policy Review* 13(1): 9–62.

Boadway, R. and F. Flatters. 1993. *The Taxation of Natural Resources: Principles and Policy Issues.* World Bank Policy Research Working Paper WPS 1210, No. 1993. Washington: The World Bank.

Commission on Fiscal Imbalance (the Séguin Commission). 2002. *A New Division of Canada's Financial Resources: Final Report*. Quebec: Government of Quebec. Available at http://www.desequilibrefiscal.gouv.qc.ca/

Courchene, T.J. 2004. "Confiscatory Equalization: The Intriguing Case of Saskatchewan's Vanishing Energy Revenues." *IRPP Choices*: 1–39.

Day, K.M. 1992. "Interprovincial Migration and Local Public Goods." *Canadian Journal of Economics* 25: 123–44.

Day, K.M. and S.L. Winer 2006. "Policy-Induced Migration in Canada: An Empirical Investigation of the Canadian Case." *International Tax and Public Finance* 13(5): 535–64.

Expert Panel on Equalization and Territorial Formula Financing 2006. *Achieving a National Purpose: Putting Equalization Back on Track*. Ottawa: Department of Finance.

Keen, M. and S. Smith 2000. "Viva VIVAT!" *International Tax and Public Finance* 7: 741–51.

Krugman, P.R. 1995. *Development, Geography, and Economic Theory*. Cambridge, MA: MIT Press.

— 1998. "What's New About the New Economic Geography?" *Oxford Review of Economic Policy* 14(2): 7–17.

McLure, C.E., Jr. 2000. "Implementing Subnational Value Added Taxes on Internal Trade: The Compensating VAT." *International Tax and Public Finance* 7: 723–40.

OECD 2007. Economic Survey of Norway. Paris: OECD.

Poschmann, F. and S. Tapp 2005. *Squeezing Gaps Shut: Responsible Reforms to Federal-Provincial Fiscal Relations*. Toronto: C.D. Howe Institute.

Sachs J.D. and A.M. Warner. 1999. "The Big Push, Natural Resource Booms and Growth." *Journal of Development Economics* 59: 43–76.

— 2001. "The Curse of Natural Resources." *European Economic Review* 45 (4): 827–38.

Smart, M. 2005. *Federal Transfers: Principles, Practice, and Prospects*. Toronto: C.D. Howe Institute.

Technical Committee on Business Taxation (The Mintz Committee), 1998. *Report*. Ottawa: Department of Finance.

Wilson, L.S. 2003. "Equalization, Efficiency and Migration – Watson Revisited." *Canadian Public Policy* 29: 385–95.

Winer, S.L. and D. and D. Gauthier. 1982. *Internal Migration and Fiscal Structure: An Econometric Study of the Determinants of Interprovincial Migration in Canada*. Ottawa: Economic Council of Canada.

8

Fiscal Balance and Revenue-Sharing

Jean-François Tremblay

Ce chapitre fait valoir que la meilleure approche pour maintenir l'équilibre fiscal vertical au sein de la fédération, à long terme, serait d'adopter une entente entre les gouvernements fédéral et provinciaux, basée sur une formule de partage des revenus. Après la révision de certaines considérations importantes qui devraient être prises en compte pour établir un degré optimal d'asymétrie entre les paliers de gouvernement dans la répartition des dépenses et de ses propres sources de revenus, l'argumentaire en faveur d'une recette de partage des revenus est présenté. Cet article fait valoir que, contrairement au maintien des transferts fédéraux dans leur forme actuelle ou dans la décentralisation des impôts, adopter un système de partage des recettes permettrait d'atteindre un meilleur équilibre entre les objectifs d'efficacité économique et l'exercice du pouvoir fédéral de dépense.

INTRODUCTION

The issue of fiscal balance in the Canadian federation has been much debated in recent years. Along its vertical dimension, fiscal balance requires that expenditures and own-source revenues be appropriately allocated across levels of government, and that the federal government has the proper ability to influence, through the provision of transfers to provinces or otherwise, the conduct of economic and social policy in the federation, including in areas of provincial jurisdiction – in other words, it requires the right balance between the exercise of the federal spending power and provincial autonomy.

Although there has been fairly wide support in the last few years for increasing the share of total public funds in the hands of provincial governments, views about how best to proceed to do so have ranged from increasing federal transfers in their current form to reallocating tax room to the provinces. Apart from having opposite effects on the degree of asymmetry between the own-

source revenues and expenditures of each order of government, these two approaches for reallocating public funds from the federal government to provinces also have very different implications for the federal spending power and the level of provincial autonomy.

The "open federalism" pledge of the current government includes commitments to insure fiscal balance in a permanent fashion, to constrain the federal spending power and to move towards a more rules-based transfer system. Since taking office, the current government has announced reductions of the GST, thereby vacating some tax room that could in principle be occupied by the provinces. The 2007 budget also announced increased cash transfers to provinces, including an enlarged equalization program and additional transfers intended for post-secondary education, labour market training and infrastructure investment.

The main purpose of this chapter is to argue that the best way to reallocate a greater share of public funds to provincial governments and maintain vertical fiscal balance in the federation in the long run is neither to increase federal transfers in their current form, nor to reallocate additional tax room to the provinces, whether that occurs through a coordinated tax-point transfer or through uncoordinated tax decentralization. Instead, the federal and provincial governments should adopt revenue-sharing arrangements under which both levels of government would share the revenues from particular tax bases according to a specific formula. Formula-based revenue-sharing would more likely achieve the delicate balance between objectives of economic efficiency and the appropriate exercise of the federal spending power, and would be consistent with the "open federalism" commitment of the current government.

OPTIMAL FISCAL GAP AND VERTICAL FISCAL BALANCE

Before discussing how revenue-sharing may contribute to maintaining fiscal balance in the Canadian federation, it is useful to say a few words about the notion of an optimal fiscal gap, that is, the optimal level of asymmetry between the tax revenues and the expenditures of each level of government (Boadway 2004).

While there is no single view about what constitutes the optimal fiscal gap, very few would challenge the notion that it is positive, i.e. that expenditure responsibilities should be more decentralized than taxation. The efficiency rationales for a relatively high degree of expenditure decentralization are well known, and relate largely to the greater ability of local governments to accommodate local preferences and needs.[1] The actual size of the optimal fiscal gap, however, depends on a wide range of considerations about the optimal allocation of both expenditure and taxation (Boadway 2004; Lazar, St-Hilaire and Tremblay 2004a). For a given allocation of expenditure responsibilities

though, determining the optimal size of the fiscal gap is equivalent to determining the optimal degree of decentralization of taxation.

From a limited economic efficiency perspective, the optimal allocation of taxation across levels of government may be defined as the allocation that minimizes the economic cost of raising revenues (Dahlby and Wilson 1994; Dahlby 2005; Boadway and Tremblay 2006). Taxation distorts the behavior of economic agents and these distortions impose efficiency costs on the economy. For example, various types of taxes may affect the investment decisions of firms, the labor-supply decisions of workers, the consumption, saving and location decisions of individuals, etc. Economists usually define the *marginal cost of public funds* as the total cost of raising an additional dollar of public revenues, including the efficiency cost associated with behavioral responses to taxes. In order to minimize the total efficiency cost of taxation in a federation, the levels of taxation of central and sub-national governments must be such that the marginal cost of public funds is equalized across all governments, both vertically and horizontally. Therefore, in a very narrow sense, we can say that there exists a fiscal imbalance if the economic cost of raising revenues differs, either across the federal and provincial governments or across provincial governments themselves (Dahlby 2005).

The marginal cost of public funds will tend to vary vertically if different levels of government do not have access to the same tax bases. Some tax bases are more responsive to taxation, and therefore taxing such bases imposes larger efficiency costs. In Canada, however, the federal and provincial governments have unrestricted access to virtually the same tax bases making this consideration largely irrelevant. More importantly in the Canadian context, there will be horizontal differences in the marginal cost of public funds to the extent that fiscal capacities differ across provinces. Dahlby and Wilson (1994) and Boadway and Tremblay (2006) argue that the level of federal transfers to provinces required to achieve fiscal balance is the level that leads to an equalization of the marginal cost of public funds across the federal and provincial governments and across provinces with different fiscal capacities.

Minimizing the efficiency cost of taxation therefore requires some minimal degree of tax centralization. Of course, for a given allocation of expenditures, a more centralized tax structure implies greater intergovernmental transfers. In turn, a larger asymmetry between the expenditures and the own-source revenues of each level of government can be argued to weaken accountability.[2] As the argument goes, governments may be more accountable to their electorate, and manage

[1] See Tiebout (1956) and Oates (1972) for important contributions on the economic benefits of expenditure decentralization.

[2] The issue of accountability in the context of Canadian intergovernmental fiscal relations has been recently discussed in Poschman and Tapp (2005).

public funds more judiciously, if they raise all their revenues through their own taxes.

In a fairly narrow sense, the optimal fiscal gap may be viewed as trading off the benefits of fiscal centralization, in terms of minimizing the efficiency cost of taxation, against the benefits of fiscal decentralization in terms of greater accountability of provincial governments (Tremblay 2006). However, this conception of the optimal fiscal gap is defined with respect to fairly restricted notions of taxation efficiency and political accountability. In a broader sense, the optimal fiscal gap should take into account two other types of considerations. First, it should depend on the effects of fiscal centralization or decentralization on the ability of governments to achieve cooperative policy outcomes in the federation (Boadway 2004).[3] This consideration gives rise to several efficiency issues. Secondly, the optimal fiscal gap should guarantee the appropriate level of autonomy to provincial governments in the design of economic and social policy.

FISCAL DECENTRALIZATION AND NON-COOPERATIVE POLICIES

A high degree of fiscal decentralization limits the ability of governments to achieve cooperative policy outcomes in the federation. Provincial governments behave largely non-cooperatively in the sense that they choose their policies independently and mainly in their own interests. This tends to result in inefficient policies and implies that there may be important gains associated with a relatively high level of fiscal centralization. Although the efficiency issues associated with fiscal centralization/decentralization are well known, it is useful here to say a few words about some of the most important ones in the Canadian context.

First, the interprovincial mobility of labor, firms and capital may result in fiscal competition among provinces leading to inefficient policies, generally in the form of races to the bottom in tax setting.[4] The mobility of tax bases implies that the marginal cost of public funds perceived by provincial governments tends to be higher than that faced by the federal government (Dahlby 2005), and therefore tends to distort provincial tax policies relative to what would be optimal from the perspective of the entire federation. This distortion

[3] In this context, a cooperative policy outcome is one that, for a given allocation of expenditure responsibilities, would achieve a second-best optimum, given that taxes are distortionary. See Boadway and Tremblay (2006).

[4] See Zodrow and Mieszkowski (1986) and Wilson (1986) for standard analyses of tax competition models leading to inefficient policies, and Wilson (1999) for a survey of tax competition theories.

in the marginal cost of public funds perceived by provincial governments tends to favor a greater centralization of taxation.

Second, a higher level of centralization leads to a more harmonized tax system. The lack of harmonization, in consumption taxes in particular, has important efficiency costs that are amplified by decentralization. Although provinces can, in principle, harmonize their tax policies through cooperation, harmonization tends to be difficult to achieve when the federal government does not occupy a substantial share of the tax base (Boadway 2006).

Third, a more centralized tax system provides interregional insurance to provinces that are hit by asymmetric economic shocks (Persson and Tabellini 1996; Lockwood 1999; Bordignon, Manasse and Tabellini 2001). Although the equalization program offers some insurance to provinces for asymmetric variations to their tax bases, federal transfers to provinces financed through the federal tax system also have important insurance effects.

Fourth, given that there are important differences in fiscal capacities across provinces, a relatively high degree of fiscal decentralization will give rise to relatively larger interprovincial differences in net fiscal benefits, i.e. in the difference between the taxes paid by individuals and the value of the public goods and services received from provincial governments. Such differences may lead to fiscally induced migration (Boadway and Flatters 1982; Boadway 2001). If migration decisions respond to gaps in net fiscal benefits across provinces, in addition to labour market opportunities, it will result in a sub-optimal interprovincial allocation of labour. Hence, a more centralized tax structure tends to reduce gaps in net fiscal benefits, making the allocation of labour more sensitive to labour-market conditions. In turn, it tends to improve average productivity in the federation as a whole.

The issues outlined above all provide rationales for having a relatively large vertical fiscal gap (Boadway 2004). There are also efficiency issues that favour a more decentralized tax structure. The recent instability in federal-provincial fiscal relations and the "soft budget constraint" problem that it potentially generates is certainly one of them. Smart (2005) argues that federal transfers to provinces have been systematically increased in recent years relative to budgets announcements. He suggests that this reflects the inability of the federal government to commit to stable fiscal arrangements with the provinces and that this commitment failure distorts the incentives of provincial governments for sound fiscal management. In order to attract higher transfers in the future, provincial governments may have incentives to over-expand – the so-called soft-budget constraint problem.[5]

[5] Vigneault (2007) provides a recent review of the soft-budget constraint problem in federations while Boadway and Tremblay (2006) show how the inability of a central government to commit to a given structure of transfers can give rise to a fiscal imbalance in favour of sub-national governments.

Overall though, it is probably safe to say that the objective of attaining more cooperative policies in the federation, in particular with respect to tax policy, tends to favour a degree of fiscal centralization that is somewhat greater than that implied by the narrow notion of optimal fiscal gap discussed above.

PROVINCIAL AUTONOMY AND THE FEDERAL ROLE IN DESIGNING ECONOMIC AND SOCIAL POLICY

In addition to taking account of these efficiency considerations, the optimal fiscal gap must also insure that provincial governments have the appropriate level of autonomy. The appropriate level of autonomy, in turn, depends on what one believes to be the proper roles of the federal and provincial governments in the conduct of economic and social policy. There are at least a few potential rationales for having the federal government exercise influence on the design of economic and social policy, including in areas of provincial jurisdiction.

In particular, there may be provincial expenditure programs that generate spillover benefits to other provinces. For example, because of interprovincial migration, part of the return from provincial governments' investment in education and labour force training will accrue in other provinces. This benefit spillover will tend to induce provincial governments to under-invest in these areas. In principle, this distortion generates a role for the federal government. Productivity and welfare can potentially increase in all provinces if the federal government provides provinces with incentives to increase investment in education and training. There are numerous other areas in which provincial expenditures can provide benefits in other provinces, and in which we would therefore expect provincial governments to set sub-optimal policies. Examples include environmental protection and infrastructure investment, among others. There are also areas where provincial programs can be designed so as to shift some costs to other provinces and where some federal influence on the design of programs can therefore be beneficial. The provision of federal transfers conditional on the absence of minimum residency requirements for eligibility to provincial social assistance programs is one example of federal influence in an area of provincial jurisdiction that is undoubtedly welfare-improving in all provinces.

The federal government may also have a role to play in redistribution policies, many of which are in areas of provincial jurisdiction. In fact, the optimal fiscal gap will partly depend on the perceived role of each level of government in pursuing objectives of equity and redistribution (Boadway 2004, Banting and Boadway 2004). If the role of the federal government is considered paramount, a relatively centralized tax system, and a correspondingly large fiscal gap, will be required to insure that the federal government plays a

leading role in achieving objectives of redistribution and that the same standards of equity across individuals apply in all provinces. If, on the other hand, one adopts the view that provincial governments should largely play this role, then the optimal fiscal gap will be much smaller.

Since taxation has substantial redistributive consequences across individuals, achieving federal equity objectives entails that the federal tax structure be relatively dominant in the overall tax system. Moreover, given that several provincial expenditure programs result in considerable redistribution, especially in the areas of health care, education and social assistance, achieving federal equity objectives may also require that the federal government be able to exert a certain degree of influence over these programs to insure some minimum level of uniformity across provinces (Banting and Boadway, 2004). In turn, the federal government will only be able to exert influence if it contributes significantly to the financing of these programs through transfers to provincial governments (Lazar, St-Hilaire and Tremblay 2004b). Again, doing so would require a relatively large vertical fiscal gap.

THE LEGITIMACY OF THE FEDERAL OCCUPATION OF THE TAX ROOM

The actual fiscal gap in the federation is determined by the taxation and expenditure decisions of both levels of government. In effect, the federal government can choose to occupy a larger share of the tax room, create a large vertical fiscal gap and exercise a strong spending power. Of course, whether the federal government has the legitimacy to do so is the litigious issue.

General support for equalization certainly provides legitimacy for some minimal vertical fiscal gap, i.e. the minimal asymmetry between the federal government's revenues and own-purpose expenditures required to finance the equalization program. Furthermore, the numerous inefficiencies that arise in provincial tax policies under a highly decentralized tax structure would seem to provide legitimacy for a federal occupation of the tax room somewhat greater that what would be required to finance equalization and expenditures in areas of federal jurisdiction. A more centralized tax structure leads to more cooperative policy outcomes and can potentially make all provinces better off, which, arguably, provides the federal government some legitimacy to occupy a relatively important share of the tax room.

The legitimacy of the federal role in achieving objectives of equity and redistribution, especially when it requires that the federal government exercise influence in areas of provincial jurisdiction, as well as the relatively larger vertical fiscal gap that it necessitates, are more difficult to defend. Such a role entails a strong federal spending power and it may considerably restrict

provincial autonomy. In contrast to federal interventions that aim at inducing more policy cooperation among provinces, federal interventions to achieve objectives of redistribution do not necessarily have the potential to make all provinces better-off. Federal standards of equity may simply be in conflict with the preferences of a particular provincial electorate. Restricting provincial autonomy in such a case may not be legitimate.

REVENUE-SHARING

Under current Canadian fiscal federalism arrangements – in which the federal government has a high level of discretion in setting transfers to provinces – the federal spending power effectively becomes stronger as the size of the vertical fiscal gap increases. Hence, there is a trade off between achieving more efficiency in tax policy, which requires a large vertical fiscal gap, and the autonomy of provincial governments in the conduct of economic and social policy. The adoption of revenue-sharing arrangements between the federal and provincial governments would offer a way around this trade-off.[6] It would allow an easing of the tensions related to the vertical fiscal gap and the associated federal spending power, while increasing the efficiency of tax policy and the ability to achieve more cooperative policy outcomes in the federation.

Under a revenue-sharing arrangement, the federal and provincial governments would share the revenues from a particular tax base according to a specific rule. The details of the sharing rule could be determined through federal-provincial negotiations. However, to maximize the benefits of a centralized tax system, the tax base and tax rates would have to be uniform across the country and should therefore be ultimately set by the federal government, subject to consultation with the provinces. Note that such a revenue-sharing arrangement is very different than a transfer of tax points, which in addition to decentralizing revenues also decentralizes the power to define a larger share of the tax base and to set future tax rates.

In the short run, consumption taxes would probably be the best candidates for such an arrangement (Boadway 2006). A unique national value-added tax could be created to replace the current GST and HST as well as all provincial retail sales taxes and value-added taxes, with the revenues shared between both levels of government. This new revenue-sharing arrangement could be combined with a reduction of the Canada Health Transfer (CHT) and of the Canada Social Transfer (CST). Of course, the sharing formula and the reduction in federal transfers could be chosen so that provincial governments see their

[6] Boadway (2006) also proposes the adoption of a revenue-sharing arrangement between the federal and provincial governments.

total share of public funds increase, decrease or remain unchanged. In the longer-run, a revenue-sharing system for corporate taxation would be desirable as well.

The adoption of revenue-sharing arrangements would provide numerous advantages relative to either a transfer of tax room, an increase in federal cash transfers, or the status quo.

First, the creation of a unique national value-added tax, levied at a uniform rate across the country, would greatly improve the efficiency of the internal economic union (Boadway 2006). In particular, replacing the present disparate provincial retail sales tax system – the incidence of which falls disproportionately on business inputs and which disadvantages domestic producers vis-à-vis foreign firms – by a uniform value-added tax, would yield significant efficiency gains.[7] A transfer of consumption tax points to provinces would tend to forego these gains and exacerbate existing inefficiencies. Similarly, as Boadway has noted (2006), the administration of harmonized, but decentralized, value-added tax systems by the provinces would be difficult because of collection and compliance issues. Any further decentralization of consumption taxes would therefore make the prospect of adopting harmonized value-added taxes even more unlikely.

Second, it would eliminate destructive competition in provincial tax policies, which would be particularly welcome in the area of corporate taxation. Again, a transfer of tax room would do the opposite. With greater tax-policy decentralization, one expects that the mobility of tax bases would induce provincial governments to choose their tax policies strategically. Indeed, there is empirical evidence of strategic tax setting by provincial governments. For example, Hayashi and Boadway (2001) and Calvlovic and Jackson (2003) have found evidence of interprovincial competition in corporate income-tax rates in Canada. Moreover, in addition to generating inefficient tax competition among provincial governments, decentralized corporate taxation also creates opportunities for income shifting and tax avoidance by firms that operate in more than one province. Mintz and Smart (2003) report evidence of income shifting across Canadian provinces and find that income shifting has a substantial effect on the size of provincial corporate tax bases. A unique national corporate tax system at a uniform rate and with revenues shared between the federal and provincial governments would solve both of these problems.

[7] The efficiency gains resulting from the tax substitution would be reduced, however, if the national value-added tax resulted in reductions in the already low Alberta personal and corporate income tax rates, reductions that would tend to distort the interprovincial allocation of savings and investment.

Third, combined with a reduction in federal transfers to provinces, a revenue-sharing arrangement would effectively weaken the federal spending power without further decentralizing taxation. A larger share of federal-provincial transfers would be determined by rules rather than at the discretion of the federal government. An alternative way to restrict the federal spending power, and which has been advocated for some time, would be to impose formal rules on the exercise of the spending power, rules that could either take the form of an administrative arrangement or be written in the Constitution. However, it is not clear that we should go as far as introducing institutional rigidities that would constrain the current and future use of a potentially important policy instrument. As mentioned earlier, there are some strong economic rationales behind federal intervention in areas of provincial jurisdiction in particular situations. Moreover, the history of Canadian fiscal federalism has demonstrated how the federal spending power can be a useful policy instrument to adapt to changing circumstances. In my view, adopting a rules-based revenue-sharing scheme would be a more sensible and far-sighted approach to constrain the federal spending power, if there is any desire to do so.

Fourth, it would mitigate the apparent commitment problem of the federal government in its fiscal relations with the provinces and the adverse incentives of provincial governments that are likely resulting from the instability of transfers. The instability of fiscal arrangements observed in the last decade or so raises tensions in federal-provincial relations. It also leads provinces to act in a non-cooperative manner in order to attract larger transfers from the federal government (Smart 2005). Revenue-sharing schemes would tend to alleviate these problems by introducing more rules-based transfers in fiscal arrangements.

Finally, relative to a transfer of tax room to provinces, a revenue-sharing arrangement could reallocate any given share of public funds to provincial governments without increasing pressure on the equalization system, provided that the provincial share of revenues is allocated on an equal per capita basis. In fact, relative to current fiscal arrangements, such a system would actually increase equalization between provinces that receive equalization and provinces that do not, as well as between non-recipient provinces themselves. As argued by Courchene (2006), Canada's approach to equalization under-equalizes at the top, and the problem will only get worse as the fiscal capacities of provinces that are well endowed in fossil fuel continue to rise. Revenue-sharing would mitigate this problem. An alternative way to allocate the provincial share of revenues would be to provide each provincial government with a given share of the revenues collected within its borders, i.e. to share the revenues between the federal and provincial governments on an origin basis. Although in this case the revenue-sharing scheme would not attenuate the problem of under-equalization at the top, it would still generate the other benefits discussed above, and adopting such a sharing rule may make the revenue-sharing arrangement more acceptable to all provinces. Of course, a revenue-sharing

formula could be designed to achieve any point between the two extremes, and that would ultimately be determined through federal-provincial negotiation.

CONCLUSION

The growing trade flows and the increasing mobility of labour and capital strengthens the importance of adopting cooperative and harmonized fiscal policies in the federation. At the same time, the pursuit of national efficiency and equity objectives tends to result in federal influence on the design of economic and social policy, which raises tensions in intergovernmental relations. As a way to ease these tensions without compromising economic efficiency, Canada should adopt formula-based revenue-sharing arrangements, ideally over both consumption taxes and corporate income taxes. Revenue-sharing would represent a reasonable compromise between the proposals to increase federal transfers in their current form or to reallocate tax room to provinces, and would be in line with the "open federalism" commitment of the current federal government.

An alternative avenue may be to adopt asymmetric fiscal arrangements. Some of the tensions associated with the current intergovernmental fiscal structure may well come from the fact that the optimal fiscal gap, or the optimal level of fiscal decentralization, likely varies across provinces, for a number of reasons (Tremblay 2006). For instance, the intensity of tax competition problems may not be as great in regions where the mobility of tax bases is subject to greater costs or frictions. In the case of Quebec, for example, there are linguistic and cultural barriers that may well restrict, at least to some extent, both the in-migration and the out-migration of labour. Interprovincial differences in particular institutions of the labour market and of the legal system may also limit the mobility of labour and capital. More importantly perhaps, the legitimacy of the federal spending power and the restrictions it can impose on provincial autonomy may be particularly difficult to defend in Quebec.

If the optimal fiscal gap is not the same throughout the federation, fiscal balance would in principle require asymmetric fiscal arrangements. For instance, it could require greater decentralization of taxation in Quebec than in the other provinces. As an example, a transfer of tax points between the federal and provincial governments could take place in Quebec, along with a reduction of federal transfers that would leave the total revenues of the Quebec government unchanged.

However, asymmetric fiscal arrangements would raise a few problems that should be closely examined before moving in that direction. For one, asymmetries in fiscal arrangements may further reduce the ability of governments to achieve cooperative policy outcomes. In particular, asymmetric

decentralization would make it more difficult to coordinate and harmonize tax policies across provinces, independently of the overall level of decentralization, and it would likely increase the efficiency costs of tax competition. For another, there may be a risk that asymmetries in fiscal arrangements would weaken the ability of the federal government to implement interprovincial redistribution in the future, especially if horizontal imbalances become larger. If this is so, national objectives of equity and redistribution may be difficult to conciliate with asymmetric fiscal decentralization.

REFERENCES

Banting, K. and R. Boadway. 2004. "Defining the Sharing Community: The Federal Role in Health Care." In *Money, Politics and Health Care*, ed. H. Lazar and F. St-Hilaire. Montreal: Institute of Research on Public Policy.

Bird, R. and P.P. Gendron. 2000. "CVAT, VIVAT, and dual VAT: Vertical 'Sharing' and Interstate Trade." *International Tax and Public Finance* 7: 753–761.

Boadway, R. 2001. "Inter-Governmental Fiscal Relations: The Facilitator of Fiscal Decentralization." *Constitutional Political Economy* 12: 93–121.

— 2004. "Should the Canadian Federation be Rebalanced?" Working paper 2004(1). Kingston: Institute of Intergovernmental Relations, Queen's University.

— 2006. "Two Panels on Two Balances." *Policy Options* 27: 40–45.

Boadway, R. and F. Flatters. 1982. "Efficiency and Equalization Payments in a Federal System of Government: A Synthesis and Extension of Recent Results." *Canadian Journal of Economics* 15: 613–633.

Boadway, R. and J.F. Tremblay. 2006. "A Theory of Fiscal Imbalance." *FinanzArchiv – Public Finance Analysis* 62: 1–27.

Bordignon, M., P. Manasse and G. Tabellini. 2001. "Optimal Regional Redistribution Under Asymmetric Information." *American Economic Eeview* 91: 709–723.

Cavlovic, A. and H. Jackson. 2003. "Bother Thy Neighbour? Intergovernmental Tax Interactions in the Canadian Federation." Working paper 2003–09. Ottawa: Department of Finance.

Courchene, T. 2006. "Variations on the Federalism Theme." *Policy Options* 27: 46–54.

Dahlby, B. 2005. "Dealing with the Fiscal Imbalances: Vertical, Horizontal, and Structural." Working paper. Toronto: C.D. Howe Institute.

Dahlby, B. and S. Wilson. 1994. "Fiscal Capacity, Tax Effort and Optimal Equalization Grants." *Canadian Journal of Economics* 27: 657–672.

Hayashi, M. and R. Boadway. 2001. "An Empirical Analysis of Intergovernmental Tax Interaction: The Case of Business Income Taxes in Canada." *Canadian Journal of Economics* 34: 481–503.

Keen, M. and S. Smith. 1996. "The Future of the Value-added Tax in the European Union." *Economic Policy* 23: 375–411.

— 2007. "VAT Fraud and Evasion: What Do We Know, and What Can Be Done?" IMF working paper 07/31. Washington: International Monetary Fund.

Lazar, H., F. St-Hilaire and J.F. Tremblay. 2004a. "Vertical Fiscal Imbalance: Myth or Reality?" In *Money, Politics and Health Care,* eds. H. Lazar and F. St-Hilaire. Montreal: Institute for Research on Public Policy.

— 2004b. "Federal Health Care Funding: Toward a New Fiscal Pact." In *Money, Politics and Health Care,* eds. H. Lazar and F. St-Hilaire. Montreal: Institute for Research on Public Policy.

Lockwood, B. 1999. "Inter-regional Insurance," *Journal of Public Economics* 72: 1–37.

McLure, C. 2000. "Implementing Subnational Value Added Taxes on Internal Trade: The Compensating VAT." *International Tax and Public Finance* 7: 723–740.

Mintz, J. and M. Smart. 2003. "Income Shifting, Investment, and Tax Competition: Theory and Evidence from Provincial Taxation in Canada." ITP Paper 0402. Rotman School of Management, University of Toronto.

Oates, W. 1972. *Fiscal Federalism.* New York: Harcourt, Brace & Jovanovich.

Persson, T. and G. Tabellini. 1996. "Federal Fiscal Constitutions: Risk Sharing and Redistribution." *Journal of Political Economy* 104: 979–1009.

Poschmann, F. and S. Tapp. 2005. "Squeezing Gaps Shut: Responsible Reforms to Federal-Provincial Fiscal Relations." *Commentary no. 225.* Toronto: C.D. Howe Institute.

Smart, M. 2005. "Federal Transfers: Principles, Practice, and Prospects." Working paper. Toronto: C.D. Howe Institute.

Tiebout, C. 1956. "A Pure Theory of Local Expenditures," *Journal of Political Economy* 64: 416–424.

Tremblay, J.F. 2006. "Le déséquilibre fiscal et le fédéralisme canadien." Forthcoming in *Le fédéralisme, le Québec et les minorités francophones du Canada,* ed. L. Cardinal. Éditions Prise de Parole.

Vigneault, M. 2007. "Grants and Soft Budget Constraints." In *Intergovernmental Fiscal Transfers: Principles and Practices,* eds. R. Boadway and A. Shaw. Washington: The World Bank.

Wilson, J. D. 1986. "A Theory of Interregional Tax Competition." *Journal of Urban Economics* 19: 296–315.

Wilson, J. D. 1999. "Theories of Tax Competition." *National Tax Journal* 52: 269–304.

Zodrow, G. and P. Mieszkowski. 1986. "Pigou, Tiebout, Property Taxation and the Underprovision of Local Public Goods." *Journal of Urban Economics* 19: 356–370.

9

Equalization Reform in Canada: Principles and Compromises

Joe Ruggeri

Ce document présente une nouvelle approche d'intégration des revenus des ressources naturelles dans le programme de péréquation. Après avoir mis l'accent sur un examen historique de la manière dont les ressources ont interagi avec le programme de péréquation, l'analyse propose un nouveau modèle en trois étapes. L'étape 1 serait de déterminer quelles provinces sont admissibles à la péréquation et, à cette fin, 100% des revenus des ressources naturelles seraient considérées et entreraient dans la formule. Toutefois, pour déterminer quel montant total des paiements de la péréquation doit être alloué aux provinces bénéficiaires, la formule de péréquation utilisée dans l'étape 2 exclurait les revenus des ressources naturelles. Puis, durant l'étape 3, on soustrairait la différence moyenne entre ces deux (170$ par habitant dans l'exemple du document) de l'étape 1 pour déterminer le montant réel de paiement de péréquation. Le document compare ensuite les résultats ainsi obtenus à partir de ce nouveau modèle, au modèle figurant dans le budget de 2007.

INTRODUCTION

After nearly fifty years of life as a formula-based program driven by evolving interprovincial differences in fiscal capacity, equalization was severed from its foundations in 2004 by a unilateral federal decision that established both the total level of the entitlements in 2004–05, their growth over time, and the interim allocation among provinces for three years. Under the new framework,

I wish to thank Nigel Burns, Tom Courchene and Peter Kieley for providing helpful comments while acknowledging their disagreement with some of the views expressed in this paper.

the federal government (a) set the total level of entitlements for 2005–06 at $10.9 billion, and guaranteed that no province would receive less than had previously been announced; (b) set a guaranteed growth rate of total entitlements at 3.5 percent per year; (c) used fixed shares for receiving provinces for the first two years of the new program, later extended also to 2006–07, to allocate the total amount; and (d) in March 2005 established a Panel of Experts "to review a broad range of issues" related to equalization. Two months later, the Council of the Federation established its own Advisory Panel on Fiscal Imbalances with a broader mandate which included an evaluation of both horizontal and vertical fiscal imbalances.

These two Panels have released their reports, which are identified in this paper as the federal report and the provincial report, respectively. They contain specific suggestions for reforming the equalization program, which can be placed under three separate headings: (a) principles; (b) the treatment of resource revenues and the structure of the formula; and (c) secondary adjustments. This paper addresses the first two items. With respect to the first item, I argue that the principles selected in these two reports are directed at the structure of the program and not at its raison d'être. I suggest that greater emphasis should be placed on the fundamental rationale for the existence of the equalization program and that this rationale is inextricably linked to our collective view of the role of government. With respect to the formula, I argue that the two reports offer compromises that, while holding back the cost of the program for the federal government, add some inequities (federal report) or facilitate discretionary decisions (provincial and federal reports). I suggest that there is no need for compromises if we let the program run on automatic pilot and focus on two consistent options: (a) the ten-province standard with full inclusion of resource revenues (the option preferred by the provincial Panel); and (b) a two-stage approach that provides an explicit separation of the effects of resource revenues on total entitlements and their allocation among receiving provinces.

PRINCIPLES

In developing a package of reforms, the federal and provincial reports start by identifying a list of fundamental principles. A comparison of these principles is shown in table 1. The principles selected by the federal Panel of Experts are listed on pages 42 and 43 of the report. The provincial report identifies explicitly only three principles – fairness, transparency and affordability – when it presents its analysis of potential options (Advisory Panel 2006, 80). However, one can also find references to other principles scattered throughout Chapter 6 and other parts of the report. Of the 12 principles listed in table 1, ten pertain strictly to the structure of the program. Only two of them – sharing

Table 1: Principles for Reforming Equalization Listed in the Federal Report and the Provincial Report

Principles	Federal report	Provincial report
Consistency with Canada's Constitution	X	X
Fairness	X	X
Adequacy	X	X
Responsiveness	X	X
Policy neutrality and sound incentives	X	
Equity between receiving and non-receiving provinces	X	
Simplicity	X	
Transparency	X	X
Predictability and stability	X	X
Affordability	X	X
Accountability	X	X
Sharing	X	

the benefits of Canadian citizenship and consistency with the Constitution – touch on the fundamental purposes of the program.

Consistency with the Constitution is interpreted in the general sense of citizenship rights by the Provincial Advisory Panel, which states on page 14 of its report that "the constitutional principle is grounded in widespread public support for the notion that the benefits of Canadian citizenship should be comparable across the country no matter which province a person lives in." The federal Panel of Experts is more specific, stating on page 26 of its report that the purpose of equalization outlined in section 36(2) of the Constitution "is on making sure that all provinces have the fiscal capacity to deliver reasonably comparable education, health care, social services, roads and transportation services to their residents at reasonably comparable levels of taxation." The principle of sharing is explicitly identified in the provincial report, but as one of the core values held by Canadians.

While a primary focus on principles related to the structure of the program is useful in the development of formulas for determining entitlements, it also tends to direct our attention away from the fundamental principles upon which this program rests. These principles were not developed as abstract notions produced by academic theorizing. They were born of a vision of Canada created collectively by millions of Canadians as they reflected on the experience of their daily life and worked on their dreams for a better future. That vision of Canada, which has evolved over the entire span of the country's history, was translated into a certain view of the role of government and materialized

into a set of government programs. That history shows the resilience of Canadian federalism, as it responded to internal developments and external shocks, because of the collective will of Canadians with diverse origins to build a country where their children and grandchildren could prosper and live in liberty and peace with their neighbours, move freely from coast to coast, and share the benefits of citizenship regardless of where they settled.

For the first 70 or so years of Canada's history, this vision of a "North strong and free" was associated with a belief that prosperity would spread to all provinces and they would be able to finance the public services demanded by their citizens. This was the period of *disentanglement* in the fiscal activities of federal and provincial governments, an approach to federalism that was consistent with both current fiscal ideologies and existing fiscal realities. The spending responsibilities of government in general were very limited and provincial governments had little involvement in what we now call "social programs." On the revenue side, disentanglement was consistent with constitutional provisions that gave broad access to taxation to both federal and provincial governments.

While disentanglement did not imply the absence of federal transfers to the provinces, it incorporated an understanding that these transfers would decline over time as provinces developed their own revenue structures and economic growth generated the necessary tax bases for fiscal self-sufficiency. Accordingly, federal transfers to the provinces, which in 1874 had amounted to 56.7 percent of provincial revenues and 20.4 percent of federal revenues, by 1930 accounted for only 9.7 percent of provincial revenues and 3.6 percent of federal revenues.

The resilience of this type of fiscal federalism in Canada was tested by a variety of internal pressures and external shocks. The dream of unbounded prosperity that had accompanied the birth of the nation had been shattered by numerous recessions and a disastrous Great Depression, while the stability of the fiscal arrangements was tested by the need to finance two world wars. The response to these shocks resulted in ad hoc changes to the original fiscal arrangements. World War I led to the imposition of personal income taxes by the federal government. The Great Depression gave justification to constitutional changes that transferred to the federal government full responsibility for unemployment insurance and concurrent power over old age pensions. The financing of World War II led to special fiscal arrangements that gave the federal government exclusive power over the collection of personal and corporate income taxes and inheritance taxes in exchange for cash payments.

From a fiscal federalism perspective, the hardest blow came from the Great Depression, which devastated the finances of federal and provincial governments. Hard pressed to balance their budgets, both orders of governments searched for new revenue sources. The result was a "jungle" of uncoordinated taxes. By 1939, federal and provincial governments imposed personal and

corporate income taxes and sales taxes. In addition, the federal government levied custom and excise duties and the provinces levied motor fuel taxes, real property taxes, and collected revenues from natural resources. An attempt at rationalizing the country's revenue system was made in 1935 at a Dominion-Provincial Conference, but without concrete results. A similar fate awaited the meetings of a permanent committee of Dominion-Provincial Ministers of Finance. In 1937, the federal government appointed the Royal Commission on Dominion-Provincial Relations, commonly known as the Rowell-Sirois Commission, to look into issues of taxation, government spending, the public debt, federal grants and subsidies and the constitutional allocation of revenue sources. The Commission presented its report in May 1940. From the perspective of this paper, the most important recommendation was for the payment by the federal government of "national adjustment grants," a set of unconditional transfers aimed at equalizing provincial fiscal capacity. These "equalization grants" were not simply an attempt to redress existing horizontal fiscal imbalances within the framework of a given federal revenue structure. Rather, they represented a major shift towards fiscal centralization because in return the federal government would have acquired exclusive jurisdiction over personal and corporate income taxes and succession duties, at the cost, however, of ceding the right to levy sales taxes to the provinces. Efforts at implementing the Commission's recommendations were interrupted by World War II, which led to a different kind of fiscal arrangement, the "temporary wartime experiment" known as tax rental agreements.

By the beginning of the postwar period, it had become evident that the conditions that could support a policy of disentanglement no longer existed. The end of World War II exposed the need for a national effort to transform the wartime economy into a peacetime economy. This national effort, in turn, required close cooperation among all governments. It also required an expansion in the role of government, an expansion that was facilitated by the rapid non-inflationary growth of the domestic economy, which boosted government revenues and strengthened federal spending powers. As a result, during the period from the early 1950s to the beginning of the 1970s, there was a proliferation of Canada's social programs. Non-contributory Old Age Security pensions started to be paid in 1952. Coverage under the Unemployment Insurance program was expanded in 1965 and again in 1971. The compulsory Canada Pension Plan, with equal contributions by employers and employees, was introduced in 1966. The federal Hospital Insurance and Diagnostic Services Act took effect in 1958 and was followed ten years later by the introduction of Medicare (publicly funded medical care). The early 1960s also witnessed the official birth of regional development policies with the introduction of the agricultural *Rehabilitation and Development Act* in 1962, followed seven years later by the creation of the Department of Regional Economic Expansion.

During this period there was also a major shift in the approach to fiscal federalism, which resulted in the consolidation of some programs and a change in the financing of others. In 1966 federal grants for a variety of small provincial social assistance programs were consolidated into a single program called the Canada Assistance Plan (CAP) with a 50/50 sharing of eligible expenditures between federal and provincial governments. One year later, federal per capita grants to universities were replaced by a 50/50 cost-sharing agreement with the provinces. A similar cost-sharing arrangement was made for medical care costs with federal funding contingent on a province meeting four requirements: comprehensiveness of service coverage, universality of access, public administration, and full interprovincial portability. These new intergovernmental fiscal arrangements, which required joint financing and some degree of policy coordination, represented a drastic departure from the principle of disentanglement. A final attempt at restoring disentanglement was made by Prime Minister Lester Pearson in 1966 (the opting out option) when he offered a package of tax point transfers in exchange for full provincial responsibility for financing the shared-cost programs. The rejection of this offer by the provinces reaffirmed the new structure of fiscal federalism and institutionalized two new principles of fiscal federalism in Canada: (a) interdependence, and (b) equal partnership.

The principle of interdependence reflected the explicit recognition that economic and social developments in Canada had created conditions that required a higher degree of cooperation and policy coordination between the senior orders of government. The expanded role of government and the new fiscal arrangements resulted in three categories of government spending. The first category may be called "federal programs" because it includes only those spending programs that are constitutionally assigned to the federal government and are financed entirely by it. By analogy, we may call the second category "provincial programs": those spending programs constitutionally assigned to the provinces and financed by their own revenue. I call the third category "national programs" because they reflect the principle of interdependence underlying the post-war intergovernmental fiscal relations. These are spending programs that are constitutionally the responsibility of the provinces, but are financed jointly by federal and provincial governments because they benefit all Canadians in accordance with their rights of citizenship. In the joint financing of national programs, federal and provincial governments in the 1950s and 1960s chose the principle of equal partnership. This principle was applied through cost-sharing agreements that entrenched equal contributions by both orders of government.

The creation of national programs brought to the fore the need to address horizontal fiscal imbalances through a formal program. If Canadians have the right to publicly financed universal health care and education and to a social safety net regardless of their economic status or place of residence, then all

provincial governments, which are constitutionally responsible for these programs, must have the necessary fiscal means to deliver these programs at comparable national standards. It is no mere coincidence that a formal equalization program was introduced in 1957, in the early stages of the expansion of the role of government in Canada, and its dimensions were expanded during the following 25 years.

The evolution of fiscal federalism during the first century of Canada's history highlights two fundamental issues. First, the institutions and programs of fiscal federalism are largely determined by the general scope of government. When the scope of government is very limited, fiscal disentanglement is a feasible option. The federal government delivers and pays for federal programs and the provinces deliver provincial programs and finance them with their own revenues. This arrangement may no longer be feasible when the scope of government expands considerably and includes large spending programs, such as the provision of universal and publicly funded health care and education, which are constitutionally under provincial jurisdiction. Second, the scope of government also determines the significance of vertical and horizontal fiscal imbalances. When the limited scope of government facilitates disentanglement, the concept of vertical fiscal imbalance is no longer meaningful if both orders of government have broad access to all tax bases. A limited scope of government also weakens the rationale for a formal program to address horizontal fiscal imbalances. If provinces have only a few spending responsibilities, such as those directed primarily at local matters like road building, maintenance and the protection of persons and property, it may be hard to argue for equalization-type federal transfers. I doubt that equalization would have been enshrined in the Constitution if its purpose were to ensure that all provinces have "the fiscal capacity to deliver reasonably comparable ... roads and transportation services to their residents at reasonably comparable levels of taxation," to paraphrase the Constitution.

When we debate equalization, it may be helpful to remind ourselves and others that this cornerstone of Canadian federalism rests on a particular view of the role of government and the rights of citizenship, which include the rights to universal and publicly funded education and health care and to a public safety net that cushions the effects of drastic reductions in a person's or family's economic conditions. It will also be helpful to remember that these citizenship rights do not exist in a vacuum but arise out of fundamental values held by the population. In Canada, these values were given substance by a collective commitment to five fundamental principles of human and social development: (a) economic justice, which promotes equality of opportunity for all Canadians, a principle enshrined in the constitution; (b) social justice, which aims at reducing inequality of economic outcomes; (c) promotion of human rights, expressed in Canada's support for the United Nations declarations that acknowledge that "everyone has the right to a standard of living

adequate for the health and well-being of himself and his family"; (d) social cohesion, enhanced by programs that institutionalize some form of wealth sharing among Canadians; and (e) effective democracy, promoted by strengthening the ties that bind Canadians across the country and their sense of belonging to a wider community than their place of residence. These principles should remind us that, when we take sides in debates about reforms to equalization, we do not simply address technical issues. While issues such as transparency and incentives or disincentives for provincial governments are not irrelevant, ultimately the debate on equalization is about different views of federalism and the role of government and different visions of Canada.

COMPROMISES

Intergovernmental discussions on equalization since its inception have been centred on three issues: (a) the list of revenues to be equalized; (b) the standard to which revenues are equalized; and (c) the treatment of resource revenues. The specific formulas developed over time and revised periodically represent compromises among various approaches to these issues. Initially, the equalization program included three revenue sources: personal income taxes, corporate income taxes, and succession duties. The list of revenues rose to 16 in 1967 and to 30 in 1982. The standard initially was the average of the two richest provinces, which at the time were Ontario and British Columbia. It then was changed to a ten-province standard in 1962 and continued at that level for 20 years, with a temporary return to the top-two average during 1964–67. In 1982, the expansion of the list of revenues was accompanied by a change to a five-province standard (British Columbia, Saskatchewan, Manitoba, Ontario and Quebec). Resource revenues were added to the list of revenues to be equalized in 1962, but with a 50 percent inclusion rate. The inclusion rate was raised to 100 in 1967, was reduced to 33 percent for oil and gas revenues in 1974, and restored to 50 percent in 1977. In 1982, the change from a ten-province to a five-province standard was accompanied by a full inclusion of resource revenues. Since the energy crisis of the early 1970s, the changes in the structure of the equalization program have been partly driven by a need for a compromise that accommodates the volatile nature of resource revenues within the framework of equalization. This spirit of compromise is also visible in the recommendations of both the federal and provincial reports. A summary of the main recommendations contained in the two reports is shown in table 2.

The two reports agree entirely on two elements of reform: (a) a return to a ten-province standard, and (b) the need for some form of averaging to reduce volatility. They also agree on the importance of a comprehensive revenue coverage, but differ in the details. The provincial report limits itself to the

Table 2: Main Recommendations on Equalization in the Federal and Provincial Reports

Element	Recommendation	
	Federal report	*Provincial report*
Standard coverage	Ten provinces Simplified representative tax system, exclusion of user fees	Ten provinces Comprehensive revenue coverage
Treatment of resource revenues	50 percent inclusion	100 percent inclusion
Caps	A receiving province cannot have higher fiscal capacity than the lowest non-receiving province; potential federal cap on total entitlements	Cap on total entitlements based on federal affordability determined through negotiations between federal and provincial governments
Volatility	Use of three-year moving average combined with two-year lagged data	Use of a three-year moving average on data lagged two years

general statement that "the ten-province standard with comprehensive revenue coverage provides the most accurate and fairest measurement of fiscal disparities" (Advisory Panel 2006, 81). The federal report recommends some fundamental changes to the representative tax system. First, it compresses the current list of revenues into five major categories: personal income taxes, business income taxes, sales taxes, property taxes, and natural resource revenues. Second, it replaces the current approach to property taxes with a new measure based on market value assessment for residential property. Third, it eliminates user fees. Fourth, it uses actual natural resource revenues. The two reports differ drastically with respect to the treatment of resource revenues and caps on entitlements. The federal panel evaluated a variety of arguments on the treatment of natural resources and opted for a compromise solution involving a 50 percent inclusion rate. The provincial panel evaluated the same arguments and opted for full inclusion. Both panels performed simulations of the proposed approach and compared the results to the current system, in terms of total costs to the federal government and changes in entitlements for individual provinces. Each panel found that the results for the proposed approach without caps were inconsistent with some of their stated principles.

In the case of the federal report, the proposed changes excluding the cap would result in an increase in total entitlements of $1,692 million in 2007–08 (Expert Panel 2006, table 10, 137). More importantly, it would raise the fiscal capacity of Newfoundland and Saskatchewan above that of Ontario (ibid.), a result that "runs counter to a fundamental principle of equity that should underlie any changes to the Equalization program" (ibid., 61). As a solution to this cross-over problem, the federal panel recommends a cap that ensures that no receiving province has a post-equalization fiscal capacity higher than that of the receiving province with the lowest fiscal capacity (currently Ontario). In determining the level of the cap, however, 100 percent of a province's resource revenues would be included in the calculations. Under this compromise solution, the treatment of resource revenues affects total entitlements and their allocation among provinces in different ways. The inclusion of 50 percent of resource revenues affects directly the level of total entitlements and the allocation of this amount to receiving provinces with moderate or negligible resource revenues. The cap reduces the additional equalization for 2007–08 under the federal Panel from $1,692 million to $887 million. The allocation to resource-rich receiving provinces is affected by the 100 percent inclusion of resource revenues in the calculation of a province's fiscal capacity in determining the cap.

In effect, the proposed equalization system has two standards: a ten-province standard for receiving provinces with little or no resource revenue, and an Ontario standard for the resource-rich receiving provinces. Moreover, differences remain in the after-equalization fiscal capacity of non-resource-rich receiving provinces. This result is shown in table 3, where the fiscal capacity after equalization for fiscal year 2007–08 is shown as a percent of Ontario's fiscal capacity.

Table 3: Fiscal Capacity after Equalization as percent of Ontario's Fiscal Capacity under the Federal Proposal, 2007–08

Province	Fiscal capacity after equalization relative to Ontario
Newfoundland	100.0
PEI	95.6
Nova Scotia	97.1
New Brunswick	96.3
Quebec	96.8
Ontario	100.0
Manitoba	96.6
Saskatchewan	100.0
Alberta	169.9
British Columbia	105.8

The provincial panel also recognizes that the combination of a ten-province standard and 100 percent inclusion rate for resource revenues will lead to a substantial increase in total equalization entitlements. It estimates that what it calls "the fairest and most transparent formula for determining the overall level of equalization and for allocating payments among the provinces" (Advisory Panel 2006, 84) will result in additional equalization payments by the federal government in the amount of $5.7 billion in 2005–06. To address potential federal concerns about this large increase in entitlements, the panel recommended scaling down the standard through federal-provincial negotiations. For example, reducing the standard by one percent would lower its value in 2005–06 from $6,207 to $6,135 and would reduce per capita entitlement in each equalization-receiving province by $62. Under the cap, the standard remains a ten-province average, but equalization falls short of this standard for all provinces.

While both reports have to introduce caps in order to constrain the potential increase in total entitlements resulting from their recommendations, the rationales for these caps differ and so do the effects on provincial entitlements. The provincial report suggests only one general cap: a scaling down of the standard, which would lower the per capita entitlements of each receiving province by an equal amount. The federal report potentially contains two caps: one based on equity between receiving and non-receiving provinces and the other on federal affordability. The main purpose of the first cap is to prevent a "have-not" province from being transformed into a "have" province by equalization. It affects only the resource-rich receiving provinces that would have after-equalization per capita fiscal capacity higher than that of the non-receiving province with the lowest fiscal capacity. The second cap addresses a vague notion of federal affordability. If the resulting total entitlements after the selective cap "exceed what the federal government is prepared to spend on Equalization in any given year, it should explicitly scale back the entitlements to receiving provinces on an equal per capita basis" (Expert Panel 2006, 45).

The approach to the general caps in the two reports also indicates different views of intergovernmental relations as they apply to equalization. Equalization is strictly a federal program. The federal government collects revenues from all Canadian taxpayers and transfers a portion of it to the governments of provinces with below-average fiscal capacity. The federal panel takes a strict interpretation of the federal nature of this program and acknowledges explicitly that the determination of total entitlements is a prerogative of the federal government. The report, however, suggests that, in exercising this prerogative, the federal government should not act arbitrarily, but "should outline the parameters for determining the affordability of the Equalization program as part of a number of steps to improve the transparency and governance of the program" (Expert Panel 2006, 45). The provincial report implicitly acknowledges that equalization is a federal program when it raises the issue of affordability for

the federal government. However, it also acknowledges implicitly that, while equalization is a federal program, it is fundamentally an instrument of fiscal federalism and its parameters should not be determined unilaterally by the federal government. Therefore, it recommends that "the degree of scaling should be negotiated between the two orders of government" (Advisory Panel 2006, 88).

In my view, the principle of affordability in the context of equalization has less conceptual validity than the principle of equity, for various reasons. First, increases in total entitlements in the range produced by the simulations in the federal and provincial reports are less than the projected levels of the federal surplus. Therefore, if part of this surplus were used to finance increases in equalization payments, there would be no interference with federal spending priorities. In the context of budget surpluses it is difficult to give a meaningful interpretation to the concept of affordability. Second, even in the absence of federal budget surpluses, the issue is one of policy priorities rather than affordability. If the federal government has sufficient financial resources to finance tax cuts, it cannot claim that it cannot afford to raise the level of equalization payments. Third, the share of equalization payments in federal budgetary revenues is substantially below its historical value, as shown in table 4. This table provides evidence on the decline in the share of federal budgetary revenues claimed by equalization payments. During the first 16 years starting in 1982–83, this share was 6 percent or more. During the first decade it averaged nearly 7 percent and ranged between 8 and 6 percent. During the second decade the average fell to 6.1 percent and the range shifted down and narrowed to between 6.6 and 5.6 percent. This share is currently slightly under 5 percent and is projected to decline further, reaching 4.8 percent in 2011–12 if total entitlements increase at 3.5 percent per year for the entire period. The decline would be more significant if the potential growth of federal revenues under the current fiscal structure were not curtailed by proposed tax cuts.

The compromise solutions presented in the two reports have different implications for the equalization program. In the federal proposal, the treatment of resource revenues influences the total entitlements in two stages, first with the inclusion of 50 percent of those revenues and later with the cap. The cap, in turn, creates three types of provinces: (a) non-receiving provinces; (b) receiving provinces facing an Ontario standard; and (c) receiving provinces facing a ten province standard. The provincial proposal opens the door to the kind of federal unilateralism that followed the 1977 agreement on Established Program Financing. Under the provincial proposal, the total level of entitlements is exogenously determined through negotiations. Since equalization is strictly a federal program, and since the Constitution mandates neither a specific formula nor a specific level of federal payment, provinces have no leverage other than political pressures that the federal government may feel from the general public, which depend partly on the stage of the election cycle. According to

Table 4: Equalization Payments as Percent of Federal Budgetary Revenues: Actual 1982–83 to 2006–07 and Projected 2007–08 to 2011–12

Fiscal year	Equalization as percent of budgetary revenues	Fiscal year	Equalization as percent of budgetary revenues
1982–83	7.21	1998–99	5.8
1983–84	8.01	1999–2000	6.18
1984–85	7.53	2000–01	5.63
1985–86	6.62	2001–02	5.61
1986–87	6.66	2002–03	4.65
1987–88	6.79	2003–04	4.38
1988–89	6.83	2004–05	5.08
1989–90	6.74	2005–06	4.91
1990–91	6.68	2006–07	5.03*
1991–92	6.08		
1992–93	6.25	2007–08	4.91**
1993–94	6.51	2008–09	4.92**
1994–95	6.58	2009–10	4.93**
1995–96	6.24	2010–11	4.89**
1996–97	6.00	2011–12	4.84**
1997–98	6.01		

*As proposed in the 2006 budget and includes one-time adjustments.
**Based on revenue projections included in the 2006 Economic and Fiscal Update and on a 3.5 percent annual growth rate of entitlements with a base year 2005–06.

Source: Finance Canada, *Budget 2006*, table A3.2; Finance Canada, *2006 Economic and Fiscal Update;* Finance Canada, *Fiscal Reference Tables.*

the provincial report, interprovincial differences in fiscal capacity, measured on the basis of a comprehensive list of revenues including 100 of resource revenues, determine how this predetermined level of entitlements is allocated among receiving provinces. While the selective cap under the federal proposal affects the entitlements of the resource-rich receiving provinces only, the general cap under the provincial proposal (and potentially also under the federal proposal) reduces per capita entitlements by equal amounts for each province.

In my view, these two reform proposals represent a laborious effort at finding a workable compromise that provides receiving provinces with some gains from equalization reform while containing the increase in the financial commitment of the federal government. These attempts at compromises lead to an equalization system that incorporates either arbitrary components (the 50 percent inclusion of resource revenues in the federal proposal) and complex effects

of resource revenues (the special cap in the federal proposal) or an arbitrary determination of the total entitlements (the general cap under the provincial and federal proposals). In the next section I will discuss two options that do not require compromises and place the equalization program on automatic pilot.

REFORM WITHOUT COMPROMISES

CONCEPTUAL ISSUES

The history of equalization in Canada shows how periodic reforms have been influenced by the desire to accommodate natural resource revenues. The recent proposals for reform are no exception. In determining the proper treatment of resource revenues, the federal report stresses a variety of issues. First, it emphasizes ownership: "first and foremost is the fact that, constitutionally, provinces own natural resources within their boundaries. As owners, the provinces determine when and under what conditions a particular natural resource will be developed. This is different from other sources of revenues that are owned privately and simply taxed by provincial governments" (Expert Panel 2006, 57). Second it stresses the volatility of prices. Third, it points out "wide variations in costs of production." Fourth, it emphasizes "uncertainty over the potential volume of production, and significant changes in profitability." Finally, the report acknowledges that "there are public costs involved in providing the necessary infrastructure to develop natural resources as well as in monitoring and regulating environmental impacts."

When one evaluates these and other factors that potentially may influence the way in which resource revenues ought to be treated in the equalization program, it is important to separate them into two main categories, according to the issue they address: (a) those that address the question of whether resource revenues should be included in the list of revenues to be equalized, and (b) how should the tax bases for natural resources be measured if those revenues are included. In the list of factors determining the status of resource revenues found in the federal report, only the first one is fundamentally linked to the structure of the program. It relates to the fact that fluctuations in resource revenues affect interprovincial differences in fiscal capacity and total equalization entitlements without corresponding changes in the federal government's revenues. All the other factors are relevant only for the way the resource tax bases are calculated and do not affect the decision whether resource revenues should be included in the list of revenues to be equalized. They become operational only if resource revenues are included.

Resolving the question under (a) requires that we address the following two questions: (i) do resource revenues increase a province's fiscal capacity? and (ii) should the constitutional constraint on the federal government's

capacity to raise revenues from natural resources be considered in determining the federal commitment to the program? The reason it is important to deal explicitly with both questions is that resource revenues, when they are fully or partially included in the list of revenues to be equalized, affect jointly the number of receiving provinces, their entitlements and the total federal payments.

The debate among provinces has focused on the first question. Some provinces, notably Saskatchewan and Newfoundland, have given a clear "no" to this question by arguing that non-renewable resources should be excluded from the formula used to calculate equalization payments. In this case, the second question becomes redundant. Other provinces, such as New Brunswick and Prince Edward Island, have answered the first question with a "yes" by arguing for full inclusion of resource revenues in an equalization formula with a ten-province standard. The absence of a cap on total entitlements in their position suggests a "no" to their answer to the second question. The federal government has been focusing on the second question for most of the history of equalization. The periodic changes in the standard and the treatment of resource revenues, and in particular the recent approach to setting unilaterally the level and annual growth of total payments, may be interpreted as ad hoc solutions to the second question.

The federal and provincial panels were faced with a variety of conflicting interests. Resource-rich receiving provinces want resource revenues to be excluded from the equalization calculation while other receiving provinces want full inclusion. The federal government wants to cap the growth and fluctuations in its payments and Ontario opposes increases in total equalization payments before adjustments are made to federal payments for national programs. Their reports offer compromise solutions to what may be seen as "irreconcilable" differences. Both reports give an explicit "yes" response to the first question and an implicit "yes" to the second question through the suggested general caps. With respect to the first question, they differ in the way the resource tax bases would be calculated, a difference that has substantial effects on both total entitlements and their allocation among receiving provinces.

It seems to me that the search for compromises is largely conditioned by a reluctance to separate the effects of the inclusion of resource revenues on total entitlements on the one hand and on the allocation of a given level of entitlements on the other. As will be shown in the rest of this paper, the need for compromises would be eliminated if we answered questions (i) and (ii) with an explicit yes and did not impose additional conditions. Answering "yes" to the second question acknowledges explicitly that the provincial ownership of these resources should be a major determinant of how these revenues ought to be treated for equalization purposes. While ownership of these resources improves a province's fiscal position, thus affecting its fiscal capacity, it does not

generate direct revenues to the federal government, which benefits from the development of these resources only through the increase in federal tax revenues, mainly from personal and corporate income taxes. When these resource revenues are included in the equalization formula, increases in their values, as would occur through higher prices, would raise the level of federal equalization payments without a corresponding increase in its revenues. In this case, the federal government would be required to make additional payments because of changes in a tax base that does not affect its fiscal capacity, interpreted as the revenues that it can raise by applying its "national" tax rates to its constitutionally unconstrained revenue sources. It is true that the federal government does not occupy other tax fields where provincial or local governments are present. But this absence results from a deliberate policy choice, not from a constitutional constraint. If we answer yes to both questions, a consistent approach to equalization reform involves a two-stage process. The first stage determines total entitlements on the basis of (a) a comprehensive list of revenues, but excluding resource revenues, and (b) a ten-province standard. The second stage allocates this formula-driven total among receiving provinces based on their relative fiscal capacity that this time includes resource revenues. Details of this suggested approach are discussed in the following sub-section.

A TWO-STAGE APPROACH

The elements of the suggested two-stage approach are presented in table 5. The fundamental difference between this option and the traditional approaches (including those contained in the federal and provincial reports) is the separation between the calculation of total entitlements and their allocation among receiving provinces. This separation is accomplished by excluding resource revenues from the calculation of total entitlements (thus insulating federal payments from fluctuations in resource revenues, which do not affect federal revenues) and including them in the allocation of this total among receiving provinces. This approach to the allocation of total entitlements is identical to that recommended in the provincial report and similar to that of the federal panel and is based on a similar rationale: resource revenues accruing to equalization-receiving provinces raise their capacity to finance public services at given tax rates; therefore, they should be included in the determination of their fiscal capacity.

The determination of equalization entitlements under the two-stage approach requires data routinely collected for the equalization program under the pre-Renewal formula and would involve similar calculations. The required steps are outlined in part B of table 5. The initial step is the calculation of per capita entitlements by province under a ten province standard and the inclusion of resource revenues. This is a fundamental step, which incorporates two major

Table 5: Elements of a Two-Stage Approach to Equalization

A. Main elements

1. Standard	Ten-province
2. Revenues	Comprehensive list of revenues
3. Determination of total entitlements	Based on relative fiscal capacities calculated from a comprehensive list of revenues that *excludes* resource revenues.
4. Allocation of total entitlements among receiving provinces	Based on relative fiscal capacities calculated from a comprehensive list of revenues with *full inclusion* of resource revenues.
5. Caps	None
6. Averaging	May not be needed

B. Calculation steps

1. Calculate per capita entitlements by province under full inclusion of resource revenues.

2. Calculate total entitlements under full inclusion of resource revenues and under zero inclusion.

3. Calculate the equal per capita adjustment factor as the difference in total entitlements between the full inclusion and the zero inclusion of resource revenues divided by the population of the receiving provinces in the full inclusion case.

3. Reduce the per capita entitlements by province in step 1 by the adjustment factor.

4. Multiply the adjusted per capita entitlements in step 3 by the population of each receiving province to determine total entitlements.

elements of the suggested approach to equalization: (a) the use of a ten-province standard and (b) the full inclusion of resource revenues to determine the allocation of total entitlements among receiving provinces. The second step is the determination of the adjustment factor. This factor is calculated by first taking the difference between total entitlements under the full inclusion of resource revenues and their total exclusion and then dividing this difference by the

population of the receiving provinces in the full inclusion case. The number of receiving provinces may be lower after the adjustment. This lower number is determined by the size of the adjustment factor relative to the per capita entitlements before the adjustment, but cannot influence the calculation of the adjustment factor. The third step is the calculation of the adjusted per capita provincial entitlements by subtracting the adjustment factor from the per capita entitlements under full inclusion. The final step is the calculation of the total entitlements by receiving province as the product of a province's adjusted per capita entitlement and its population.

An illustrative example of this calculation, which uses the information contained in the provincial report, is shown in table 6. Before discussing this example, it is necessary to elaborate on two issues: (a) the meaning of full inclusion of resource revenues, and (b) the equal per capita adjustment. With respect to the first issue, the use in my illustrative example of the information from the provincial report takes advantage of the convenience of readily available data and does not imply unquestioned acceptance of the existing approach to the measurement of the natural resource bases. The treatment of natural resources in the allocation of a given level of total entitlements conceptually allows two options only: full inclusion or total exclusion. Either we subscribe to the notion that resource revenues affect a receiving province's fiscal capacity (in which case they are fully in) or we reject that notion (in which case

Table 6: Calculation of Equalization Entitlements by Province:
Two-Stage Approach, 2005–06

Province	Per capita entitlements, $ 100% inclusion	Average adjustment	Two-stage approach	Total entitlement $million
NFLD	1,503	170	1,333	687
PEI	2,166	170	1,996	275
NS	1,693	170	1,523	1,429
NB	2,034	170	1,864	1,402
Quebec	921	170	751	5,705
Man.	1,609	170	1,439	1,694
Sask.	153	170	0	0
BC	445	170	275	1,168
Total				12,360*

*This total differs from the total in table 6.6 of the provincial report because the amount of equalization lost by Saskatchewan due to the adjustment factor is less than the reduction that would have occurred under the adjustment.

they are totally out). Where there is room for debate is on how we measure those bases once we opt for inclusion. These are technical issues that require technical solutions. In my view, compromise solutions such as the 50 percent inclusion proposed by the federal report are not satisfactory. The issue is not to determine which proportion of resource revenues should be included in the equalization formula, but what is the most accurate way of measuring the resource revenue bases. In the end, the feasible technical solution may not be perfect, but the effort itself will help improve our understanding of the factors that affect the fluctuations in this revenue base. However this base is measured, it must be included in its entirety in the calculations of the fiscal capacity of receiving provinces for the purpose of allocating a given amount of total entitlements.

The use of an equal per capita adjustment in the determination of the final per capita entitlements by receiving provinces follows the approach suggested by the provincial report in its example of a scaled-down ten-province standard (Advisory Panel 2006, table 6.9, 87) and also suggested in the federal report for the potential general cap (ibid. 45). The main property of this equal per capita adjustment, as will be shown later, is its capacity to maintain internal consistency by ensuring that, through equalization, all receiving provinces reach the same fiscal capacity under the chosen standard.

In table 6, the first column shows the per capita entitlements under a ten-province standard and the full inclusion of resource revenues (found in table 6.1 of the provincial report). The second column shows the adjustment factor calculated as the difference between total entitlements with and without resource revenues (tables 6.2 and 6.6 in the provincial report) divided by the population of the receiving provinces under full inclusion of resource revenues. The third column shows the per capita entitlements that would be received, measured by the difference between the first and second columns. The final column shows total entitlements as the product of a province's per capita entitlements and its population. In the next sub-section these results are compared with those under the pre-renewal approach, the proposal by the federal panel and the preferred option by the provincial panel.

COMPARISON OF SELECTED OPTIONS

A consistent comparison of the provincial entitlements under the different approaches to equalization discussed in this paper is not feasible for a variety of reasons. First, as pointed out in the provincial report, the current allocation under the new framework is temporary because "the final allocation mechanism under the New Framework has yet to be determined." Therefore, we would be comparing permanent versus interim arrangements. Second, even under the new framework, we have two conflicting allocations. One is the actual distribution of payments in 2005–06, and the other is a revised version used by the federal report as its base case, which reflects "a fully implemented

2004 Renewal formula." Third, a direct comparison with the provincial proposal is not possible because the provincial report does not contain a specific recommendation for the total level of entitlements. If the recommended level were the same as that used in the two-stage approach, the results would be identical to mine. Fourth, each option has a different level of total entitlements. Finally, the provincial report separates basic equalization and the equalization associated with federal transfers for health care, post-secondary education and social services. In order to facilitate comparisons with the provincial report, which contains the information used in my calculations, I also confined my analysis to basic equalization. The federal report shows results only for the combination of the above two components. In order to provide a consistent comparison for fiscal year 2005–06, I subtracted from the results presented in the federal report the associated equalization shown in table 6.1 of the provincial report.

With these caveats in mind, the allocation of different levels of total entitlement under the pre-renewal system, which contains full inclusion of resource revenues and a five-province standard, the federal proposal, the preferred provincial proposal (with 100 percent inclusion of resource revenues and no scaling down), and the two-stage proposal is shown in table 7 and the differences from the two-stage approach are shown in table 8. The two-stage approach uses the same measure of the resource revenue bases for illustrative purposes only.

The first column of table 8 shows that, compared to the pre-renewal system, the two-stage proposal provides increases in entitlements to all provinces. Three-quarters of the increase would accrue to Quebec and British Columbia. Compared to the federal proposal, the two-stage approach would reduce

Table 7: Comparison of Entitlements under Alternative Approaches, 2005–06

Province	Entitlement, $millions pre-renewal	Federal	Provincial	Two-stage
NFLD	588	767	775	687
PEI	249	227	299	275
NS	1,247	1,082	1,588	1,429
NB	1,257	1,187	1,530	1,402
Quebec	4,235	5,740	6,991	5,705
Man.	1,467	1,430	1,894	1,694
Sask.	0	374	152	0
BC	348	0	1,890	1,168
Total	9,391	10,807	15,119	12,360

Table 8: Difference in Provincial Entitlements from the Two-Stage Proposal: 2005–06, $Million

Province	Difference between two-stage proposal and pre-renewal	Federal proposal	Provincial proposal
NFLD	99	(80)	(88)
PEI	26	48	(24)
NS	182	347	(159)
NB	145	215	(128)
QC	1,470	(35)	(1,286)
MB	227	264	(200)
SK	0	(374)	(152)
BC	820	1,168	(722)
Total	2,969	1,553	(2,759)

entitlements for Newfoundland and Saskatchewan (and to a much lesser extent Quebec) and increase them for the rest of the provinces. The largest increase would accrue to British Columbia. Compared to the preferred provincial proposal, all provinces would experience reductions in entitlements. Nearly three-quarters of the reductions would be borne by Quebec and British Columbia.

Table 9 compares the fiscal capacity among provinces for three options before and after equalization. The first option is the continuation of the pre-renewal arrangements (called pre-R) and the second option is the preferred provincial option. The relevant data for these two options are found in table 6.2 of the provincial report. The third option is the two-stage approach introduced in this paper. For each option, this table shows per capita fiscal capacity before equalization in the first row, per capita equalization entitlements in the second row and after-equalization fiscal capacity in the third row. The fourth row shows a province's after-equalization fiscal capacity as a percentage of the average for the selected standard. For the two-stage approach, the first row is based on table 6.2 of the provincial report and the third column of·table 6 of this paper. A meaningful comparison with the federal option is not possible because data on pre-equalization per capita entitlements are available only for 2007–08 but include associated equalization for which the federal report shows no information and the provincial report shows details only for 2005–06. Information on the after-equalization per capita fiscal capacity under the federal proposal is shown in table 3.

Table 9: Fiscal Capacity under Selected Options: 2005–06, $ Per Capita

Options	NFLD	PEI	NS	NB	PQ	ON	MB	SK	AB	BC
Pre-R										
Before	5,402	4,740	5,212	4,871	5,985	7,009	5,297	6,752	11,158	6,460
Equal.	1,140	1,803	1,330	1,671	558	0	1,246	0	0	82
After	6,542	6,543	6,542	6,543	6,543	7,009	6,543	6,752	11,158	6,542
%FPS	100.0	100.0	100.0	100.0	100.0	107.1	100.0	103.2	170.6	100.0
Prov.										
Before	5,402	4,740	5,212	4,871	5,985	7,009	5,297	6,752	11,158	6,460
Equal.	1,503	2,166	1,693	2,034	921	0	1,609	1,536	0	445
After	6,905	6,906	6,905	6,905	6,905	7,009	6,905	6,905	11,158	6,905
%TPS.	100.0	100.0	100.0	100.0	100.0	101.5	100.0	100.0	161.6	100.0
2-St.										
Before	5,402	4,740	5,212	4,871	5,985	7,009	5,297	6,752	11,158	6,460
Equal.	1,333	1,996	1,523	1,864	751	0	1,439	0	0	275
After	6,735	6,736	6,735	6,735	6,736	7,009	6,736	6,752	11,158	6,735
%TPS	100.0	100.0	100.0	100.0	100.0	104.1	100.0	100.3	165.7	100.0

A comparison of tables 3 and 9 combined with the information on the elements of each proposal presented in this paper allows an evaluation of the four proposals for internal consistency, interpreted in terms of both the standard to which fiscal capacity is being equalized and the relationship between a receiving province's fiscal capacity and that under the chosen standard. There is general agreement among equalization experts that, as pointed out in the federal report, "a 10-province standard is a 'natural' standard that reflects the reality of the financial circumstances of all 10 provinces" (Expert Panel 2006, 45). A ten-province standard has long been advocated by the vast majority of provinces. In the words of one provincial minister of finance, "a national-average standard would more accurately reflect the level of fiscal disparities throughout the country and is more consistent with the intent of the constitutional commitment" (Volpe 2005). Whatever standard is adopted, internal consistency requires that equalization entitlements bring the per capita fiscal capacity of all receiving provinces to this standard.

As shown in tables 3 and 9, only the preferred provincial option and the two-stage approach meet the two criteria for full consistency: they use a ten-province standard and raise the per capita fiscal capacity of all receiving provinces to the national average. The federal proposal has a ten-province standard, but is internally inconsistent because it leads to differences in after-equalization per capita fiscal capacity among receiving provinces. The five-province standard is internally consistent, as equalization raises the per

capita fiscal capacity of all receiving provinces to the standard, but it has an arbitrary standard implemented as a convenient tool for reducing federal equalization payments. As noted in the federal report, "the five province standard ... was introduced for a single, but important, purpose – to decrease the federal government's overall costs for Equalization at a time when Alberta's fiscal capacity was increasing dramatically because of high oil prices" (Expert Panel 2006, 45).

No mention has been made so far of the need for a cap on a province's per capita entitlement because the example in table 9 shows that the common after-equalization per capita fiscal capacity in all receiving provinces is lower than that of the lowest non-receiving province. While the two-stage approach increases the likelihood of this outcome, thus reducing in practice the need for a cap because higher provincial resource revenues do not affect total entitlements but reduce the entitlements of resource-rich receiving provinces, it does not eliminate it entirely. I concur with the view of the federal report that an outcome where a receiving province ends up with a higher fiscal capacity than a non-receiving (contributing) province is inconsistent with the purpose of the equalization program. It needs to be stressed, however, that a gap on entitlements aimed at preventing such a perverse outcome has different implications in the two-stage approach than in the option suggested by the federal report. In the latter, the cap is a corrective measure aimed at resource-rich receiving provinces to offset the effect of a 50 percent inclusion rate. It results in two separate standards: one for resource-rich provinces, and a lower one for the remaining provinces. Under the two-stage approach suggested in this paper, the cap would apply to all receiving provinces, thus maintaining the equal treatment of all provinces. It would operate as a ceiling on the ten-province standard that would apply uniformly to all provinces.

The two fully consistent options result in increases in total equalization payments, but of different amounts, compared to the entitlements under the five-standard regime that existed before the new framework. In 2005–06, the increase in total entitlements would amount to $5.7 billion under the preferred provincial option and to $3 billion under the two-stage approach. Since, in the calculations shown in table 5, I start with the preferred provincial option and scale it down using for the adjustment the same approach employed in the provincial report, one may be tempted to view the two-stage option as a special scale down of the preferred provincial option. That interpretation would be incorrect. The difference between the two approaches is conceptual, not financial. The scaling down under the compromise provincial proposal results in an arbitrary or negotiated level of total entitlements, which involves an adjustment to a value determined on the basis of two fundamental principles: (a) resource revenues are part of provincial fiscal capacity, and (b) provincial ownership of these resources and constitutional constraints on the federal government's ability to enter the resources tax base do not affect the magnitude of the federal commitment to equalization. Therefore, resource revenues

affect both total entitlements and their location among receiving provinces. The two-stage approach reaffirms the first principle, but excludes the second one. It explicitly incorporates the notion that provincial ownership of natural resources does affect the magnitude of the federal government's commitment. As a result, resource revenues are excluded in the determination of total entitlements (the federal government's commitment), but are included in the allocation of this total among the receiving provinces (full provincial fiscal capacity).

It is worth stressing at this point that both options are within the fiscal capacity of the federal government. As pointed out earlier, the increases in federal payments associated with these two options are substantially less than the projected federal surplus over the next five years (and beyond in the absence of discretionary policies). The estimated increase under the two-stage approach is equal to the contingency reserve which is automatically used for debt repayment. The total entitlements under the two-stage approach would represent 5.1 percent of federal budgetary revenues (6.1 if we include associated equalization), a total ratio nearly equal to the average over the decade from 1992–93 to 2001–02.

In addition to being consistent and compromise-free, these options possess the desirable property of running on automatic pilot. Under either option, both total entitlements and their distribution among receiving provinces are automatically determined. This property minimizes federal-provincial discord and limits inter-governmental debates on equalization to technical issues on the proper measurement of tax bases. The two-stage option has the additional property of minimizing fluctuations in total entitlements since these fluctuations are largely caused by swings in resource revenues as shown in figure 2 of Annex 7 in the federal report. According to this report, "the much greater volatility of measured natural resource capacity ... is mostly the result of world commodity prices, but it also reflects the multiple types of resource revenues (e.g., auction revenues, royalties, etc.) yielding different levels of fiscal capacity at different times. This volatility can result in large and unpredictable swings in equalization entitlements, complicating the process of financial planning for provinces. Whether the RTS revenue bases are retained or replaced by an alternative measure, this volatility in Equalization payments will continue unless new mechanisms are put in place" (Expert Panel 2006, 114). The two-stage approach is one such mechanism which, by insulating total entitlements from fluctuations in resource revenues, would provide stability to the growth of federal payments and might eliminate the need for complex moving average procedures.

DYNAMICS

Comparisons among different proposals for a single year are useful in highlighting the implications of some of their special features, but cannot serve as

a basis for fundamental reforms of the equalization program. For example, the calculations for 2005–06 show that British Columbia would be a major beneficiary of the two-stage approach. Yet, the federal report indicates that British Columbia is rapidly moving towards have province status and would have a minimal equalization entitlement as early as 2007–08 under the existing new framework arrangements. Therefore, its potential gains under the two consistent options would be severely curtailed.

This brings me to a fundamental issue in the design of public policy in general and fiscal arrangements in particular. Equalization is a highly dynamic program driven by complex interactions among interprovincial differences in population, economic performance and fiscal structures. In the future, these interactions will be dominated by interprovincial changes in population dynamics and associated labour market developments, and economic and fiscal performance. These dynamic elements of the program were given little attention by the two reports and in the design of the new framework. For example, the annual growth rate of 3.5 percent for total entitlements under the new framework is lower than the projected growth rate of nominal GDP over the same period and beyond. This means that the new framework implicitly incorporates the assumption of shrinking economic and fiscal disparities. Projected demographic and economic trends, however, indicate that the opposite is likely to happen. In a separate paper (Ruggeri 2006, Chapter 4) I have shown how demographically driven changes are likely to generate widening interprovincial disparities over the long-term. Some indication of this future trend can be found in the federal report. As shown in table 10, under the federal proposal, per capita equalization entitlements will increase for all receiving provinces except the two resource-rich provinces. Moreover, for the Maritime provinces, these increases are substantial and amount to nearly 15 percent in two years.

Table 10: Per Capita Equalization Entitlements under the Federal Panel's Recommendations: 2005–06 and 2007–09, $

Province	Entitlements 2005–06	2007–08	Change
NFLD	1,664	933	-731
PEI	1,847	2,079	232
NS	1,326	1,560	234
NB	1,708	1,945	237
QC	837	917	80
MN	1,366	1,528	162
SK	457	157	-300

In theory, either one of the two consistent options should automatically adjust for the effects of demographic and labour market dynamics on fiscal capacity. Fulfilling the intent of section 36(2) of the Constitution by equalizing fiscal capacity to the national average assumes implicitly equal per capita spending by provincial governments. Unequal provincial trends in demographic variables, specifically the growth and age structure of the population, will likely generate widening disparities in per capita spending by provincial governments. While equalization may not be the appropriate program for incorporating the effects on the spending side, ignoring the issue is not an appropriate response. Therefore, I recommend that federal and provincial governments undertake jointly a thorough study of the implications of population dynamics – including population growth, population aging, and migration – for labour market conditions, economic performance, fiscal capacity and spending pressures in each province. This study becomes more relevant and more urgent if the negotiated reform of the equalization program includes a compromise formula that imposes limits on the growth of total entitlements.

CONCLUSIONS

This paper contains a brief evaluation of the equalization reform proposals presented in the reports released by the federal Panel of Experts and by the provincial Advisory Panel on Fiscal Imbalances. It focuses on two aspects of these reports: (a) the principles underlying the suggested proposals, and (b) the compromises incorporated in the proposed formulas.

With respect to the first item, I show that most of the principles used in these reports relate to the structure of the program. I suggest that greater emphasis needs to be placed on the fundamental underpinnings of equalization. In that respect, I argue that the debate on equalization reform reflects fundamentally different views of federalism and the role of government and different visions of Canada. With respect to the second item, I show that the recommended approaches include unnecessary compromises and introduce arbitrary elements. Pointing out that it is not meaningful to speak about federal affordability in the presence of projected long-term federal surpluses, I suggest that the two consistent reform options are the preferred provincial option (ten-province standard and full inclusion of resource revenues without caps) and the two-stage approach outlined in this paper. The latter option determines total entitlements on the basis of a ten-province standard and a comprehensive list of revenues that excludes resource revenues, but allocates this formula-driven total on the basis of the relative fiscal capacity of receiving provinces where fiscal capacity is now measured by including resource revenues. Under these two options, both total entitlements and their allocation

among receiving provinces are formula-driven and, therefore, minimize discretionary decisions.

I finally note that future demographic trends and associated labour market developments will have a significant impact on fiscal federalism by generating widening disparities in economic performance, fiscal capacity, and spending pressures. As a foundation to the development of long-lasting programs of fiscal federalism, I recommend the undertaking of a joint federal-provincial-territorial study of the economic and fiscal implications of projected interprovincial changes in the level and structure of the population.

REFERENCES

Advisory Panel on Fiscal Imbalance. 2006. *Reconciling the Irreconcilable: Addressing Canada's Fiscal Imbalance.* Ottawa: The Council of the Federation.

Expert Panel on Equalization and Territorial Formula Financing 2006. *Achieving a National Purpose: Putting Equalization Back on Track.* Ottawa: Department of Finance.

Ruggeri, J. 2006. *Canadian Federalism at the Cross-Road.* Fredericton: Policy Studies Centre.

Volpé, J. 2005. *Presentation to the Expert Panel on Equalization and Territorial Formula Financing,* 6 (quoted in the federal report, 45).

V

Equalization: The Offshore Accords

10

Equalization 2007: Natural Resources, the Cap, and the Offset Payment Agreements

James P. Feehan

Le gouvernement fédéral a annoncé une nouvelle structure pour son programme de péréquation dans le budget fédéral de 2007. Le point le plus controversé des innovations concernait le traitement des revenus des ressources naturelles. La totalité ou la moitié des revenus des ressources naturelles de la province, dépendant quelle fraction est plus avantageuse pour la province, sera exclue de la détermination de son droit de péréquation, tant qu'un certain plafond, ou seuil, ne soit atteint. De plus, ce nouveau programme introduit des paiements compensatoires liés aux recettes de la production d'énergie en mer en Nouvelle-Écosse et à Terre-Neuve-et-Labrador (requis par les accords bilatéraux entre le gouvernement fédéral et ces deux provinces). Le document fournit des renseignements de base et les implications découlant de l'exploitation du nouveau programme de péréquation. Il conclut que le nouveau système de péréquation conduit à : une formule plus complexe; des contradictions avec le décalage des accords; et, surtout, un plafond trop sévère. Toutefois, des ajustements à certains paramètres clés, plutôt que de gros changements à la structure seraient suffisants pour atténuer ces résultats négatifs.

INTRODUCTION

On 19 March 2007, the Minister of Finance, James Flaherty, presented the federal government's budget for 2007–08. That budget document included a new design for the equalization program, which is the federal government's

Helpful comments from John Allan, Melvin Baker, Michael Clair, Thomas Courchene, Wade Locke and David Vardy are gratefully acknowledged. Also, officials with Finance Canada kindly addressed some technical questions relevant to this paper. The responsibility for any errors is the author's alone.

system of unconditional payments to fiscally weak provincial governments. An important change to that program involved how provinces' natural resource revenues are counted when assessing a province's fiscal health. Also, associated with the budget were amendments to equalization offset payment arrangements. Those arrangements are based on two bilateral agreements signed by the federal government, one with the government of Nova Scotia and one with the government of Newfoundland and Labrador. They provide partial compensation to those provinces for any declines in equalization payments to them that occur during the initial years of oil and gas production taking place off their coasts.

These changes to the offset arrangements and the new equalization formula sparked considerable debate. The governments of the three provinces most affected, Saskatchewan, Nova Scotia, and Newfoundland, have been highly critical. The issues, however, go beyond three provinces' discontent with the prospect of receiving lower transfer payments from the federal government. They have potentially far-reaching implications for two important questions of federalism. The first question is one that has been long standing: which level of government has jurisdiction and taxing power over natural resources? The second question is, what scope does the federal government have to unilaterally re-interpret its bilateral agreements with provincial governments?

The main purpose of this paper is to provide an explanation of how these questions have been provoked by Budget 2007. To do so, this chapter i) reviews the history and nature of the offset agreements, including their relationship to equalization; ii) summarizes the expert advice and political positioning that influenced the 2007 budget; and iii) elaborates on the changes to the offset payments and on the new equalization formula. Key issues are discussed further, followed by the chapter's conclusion.

OFFSHORE REVENUES AND THE OFFSET PAYMENT AGREEMENTS

The offset payment agreements stem from the dispute between the federal government and provincial government of Newfoundland and Labrador over the ownership of natural resources contained in the continental shelves off the coasts of Labrador and the island of Newfoundland. Prior to the 1960s that matter was largely dormant, but during the 1970s it became contentious as oil prices rose and there was considerable interest in exploration off those coasts. In 1979, the Hibernia oil field was discovered off the east coast of the island of Newfoundland. However, development of that commercial discovery could not proceed until the question of jurisdiction was resolved. That heightened the disagreements, which involved both constitutional and political dimensions.

The constitutional question of ownership was settled in 1984. The Supreme Court of Canada in Ottawa ruled against Newfoundland and in favour of the federal government. Political settlements followed. In 1985, Newfoundland

reached the Atlantic Accord with the federal government. In 1986, Nova Scotia, which had also recently discovered more modest offshore resources, came to a similar agreement, the Offshore Accord. Both Accords were comprehensive documents, and among the many provisions in each was a section devoted to so-called equalization offset payments. In 2005, again with Newfoundland as the lead advocate, the federal government entered into another pair of agreements with the two provinces. These 2005 agreements, which are effectively identical, provided for additional equalization offset payments.

In what follows, "offset agreements" refers collectively to the separate components of the Atlantic Accord and the Offshore Accord that deal with offset payments and to the two 2005 agreements. The remainder of this section elaborates on these agreements.

NEWFOUNDLAND'S ATLANTIC ACCORD AND NOVA SCOTIA'S OFFSHORE ACCORD

Under the Atlantic Accord of 1985, the Canada-Newfoundland Offshore Petroleum Board was established as a federal-provincial agency charged with the management of offshore oil and gas development, production and operation.[1] Also, the Accord permitted the provincial government to impose taxes on offshore oil and gas production as if they were located on land, i.e., as if the province owned them.[2] As a result, the province would receive "offshore revenues" through royalties and corporate income taxes and other applicable provincial taxes.

Another crucial element of the Atlantic Accord was a set of provisions dealing with equalization payments. Since the beginning of the equalization program in the 1950s, Newfoundland had been a recipient of equalization payments. Both the provincial and federal governments recognized that once oil revenues began to accrue to Newfoundland, there would be automatic reductions in equalization payments to it. The equalization formula in the mid-1980s was such that the net increase in Newfoundland's revenues could be almost negligible. In other words, for every dollar of offshore revenue collected by the provincial government, the province's equalization entitlement would, other things equal, fall by approximately one dollar. This phenomenon is often

[1] It was later renamed the Canada-Newfoundland and Labrador Offshore Petroleum Board, following the change of the official name of the province from Newfoundland to Newfoundland and Labrador in 2001.

[2] In 1987 the governing legislation was proclaimed. The federal parliament and the Newfoundland legislature concurrently passed the *Canada-Newfoundland Atlantic Accord Implementation Act* and the *Canada-Newfoundland Atlantic Accord Implementation Newfoundland Act*, respectively. In each Act's preamble, each party agreed not to amend its respective legislation without the approval of the other.

referred to as a "clawback" effect. The Atlantic Accord addressed this by providing for a transitory or adjustment period during which "equalization offset payments" would be made by the federal government to Newfoundland to partially compensate for any equalization losses. The length of this period was set at 12 years, beginning once Hibernia's cumulative production had reached a specified threshold.

The Atlantic Accord's offset payment itself is governed by a formula. In any year during the twelve-year window, if there is a decline in the aggregate equalization payment to the province, then an offset payment is made. That payment is a proportion of the decline in the equalization payment where the proportion varies with time and depends on the province's fiscal strength relative to other provinces'.

In 1986, Nova Scotia and the federal government signed the Offshore Accord. It also created a joint management regime for oil and gas development off Nova Scotia's coast and provided for offset payments. The window for such payments was ten years, starting after production reached a specified level. The formula is not the same as the one in Newfoundland's Atlantic Accord but is similar to it: a payment is proportional to any year-over-year decline in the aggregate equalization payment to Nova Scotia where the proportion is set to decline over time.

THE 2005 ADDITIONAL OFFSET AGREEMENT

When the Atlantic Accord Agreement was signed in 1985, both levels of government expressed great satisfaction with it and it is fair to say that there was widespread optimism in Newfoundland. Not only was there Hibernia, but two other oil fields, Terra Nova and White Rose, had been discovered in 1984. The outlook for a new prosperous oil industry was promising.

That optimism was premature. World crude oil prices fell sharply after 1985, and were generally below US$20 per barrel for the rest of the 1980s.[3] Moreover, the Hibernia development was a large one, requiring considerable capital expenditures over several years before production could begin. To induce an oil industry consortium to proceed with the development of Hibernia, the provincial government put a favourable provincial royalty regime in place and the federal government provided a capital subsidy. With these measures in place, work on the Hibernia development began in the early 1990s.[4] Oil

[3] See, www.eia.doe.gov/pub/internation/iealf/table71.xls, US Department of Energy.

[4] Afterwards, the federal government had to come to the rescue when one of the members of Hibernia's development consortium, Gulf Oil, decided to withdraw from the project in 1992. The federal government bought out some of Gulf's stake, giving it an equity stake of 8.5 percent.

production finally began in late 1997. Under the terms of the 1985 Atlantic Accord, the start year for the twelve-year window during which equalization offset payments could take place was fiscal year 1999–2000. While oil prices had recovered somewhat by 2000, the outlook was very different than it had been in 1985. A similar situation occurred in Nova Scotia where market conditions, delays, and low initial levels of gas production also led to a more modest outlook than was initially forecast.

With the clock ticking on the twelve years during which offset payments could be made, the Newfoundland government of the time anticipated that offshore oil revenues would be modest, at least in the immediate years, and therefore the value of the offset payments would be small. The then premier, Roger Grimes, raised these concerns with federal authorities.[5] Those concerns were reinforced by the findings of a provincial royal commission. In its final report, the Royal Commission on Strengthening and Renewing Our Place in Canada (2003) argued that the offset provisions of the Atlantic Accord were failing to ensure that Newfoundland was the principal beneficiary from offshore development.[6] That report projected that offshore oil revenue would be modest in the first years of the twelve-year window so that, even with offset payments covering a large percentage of any equalization losses, the dollar amounts of the offset payments would be small. It predicted that the federal government would obtain the greater share of total tax revenues due to its own taxation – especially its corporate taxes applicable to the oil companies – and through its savings, net of offset payments, in equalization payments to the provincial government. Specifically, over the life of the three operating offshore fields, it was forecast that the federal government would receive 76.6 percent and the provincial government the remaining 23.4 percent of the total tax take.[7] The Royal Commission Report (2003, 148) recommended that "the federal and provincial governments enter into immediate negotiations to revise the Atlantic Accord to ensure that a far greater share of net government revenues will be retained by the province."

As a result of a provincial election held in October 2003, the Progressive Conservative Party under its leader Danny Williams came to power. The new administration shared the view that its net-of-equalization revenue from

[5] There was some sympathy from the Senate. The report of the Senate Standing Committee on National Finance (2002), recommended, among other things, that there be a review of the accords to determine whether the equalization offset provisions were having the intended effects.

[6] Those arguments were, in part, based on the reports prepared for the Royal Commission by Crosbie (2003) and Norris (2003).

[7] See Norris (2003), 114.

offshore oil, and from non-renewable natural resources generally, would be too low. Its election platform had been critical of the equalization clawback, associated with increases in provincial revenue from oil, natural gas and other minerals; and it pledged to convince the federal government to remove non-renewable natural resource revenue from the calculation of provinces' equalization payments.[8]

Soon after taking office, and consistent with the advice of the Royal Commission, Premier Williams began advocating for changes to the Atlantic Accord. With a federal general election called for 28 June 2004, he pressed federal party leaders on matters of specific importance to the province, particularly the question of offshore revenues and the Atlantic Accord. In early June, and still during the campaign, Prime Minister Paul Martin stated publicly that he had accepted a proposal from Williams for changes to the Atlantic Accord's offset payment formula. Shortly thereafter, Williams wrote to Martin, stating:

> Our proposal is for the current time limited and declining offset provisions in the Atlantic Accord to be replaced by a new offset provision continuing over the life of the offshore petroleum production which would provide a payment equal to 100% of the amount of annual direct provincial offshore revenues, which are clawed back by the equalization program.[9]

On 28 June, the federal Liberals were returned to power but without a majority of the seats in the House of Commons. Thereafter, Premier Williams pursued Prime Minister Martin to act on the proposal laid out in the premier's June letter. A formal response came in October via a letter from the federal minister of finance, Ralph Goodale. It came on the eve of a First Ministers' meeting in Ottawa. The Goodale offer was for 8 years of additional equalization-offset payments whereby the annual payment would be

- either the amount necessary to compensate Newfoundland for 100% of equalization losses resulting from offshore petroleum revenues, or
- the preceding amount reduced to the extent, if any, to which the sum of Newfoundland's fiscal capacity plus equalization payments received by it plus any offset payments received under the 1985 Accord plus any additional offset payments exceeded the fiscal capacity of Ontario, all expressed in per capita terms.

Goodale's proposed "Ontario cap" sparked an angry reaction from Premier Williams, who left Ottawa in protest, refusing to participate in the First Ministers' meeting. Williams asserted that the proposal to which the Prime Minister

[8] See http://www.pcparty.nf.net/plan2003.htm
[9] Letter to Prime Minister Martin from Premier Danny Williams, 10 June 2004.

had agreed in June did not include a cap on offset payments, did not include reference to another province's fiscal capacity, and did not include a time limit.[10] Over the next few months, there were well publicized exchanges between the two governments; Nova Scotia was also concurrently seeking similar redress and, while acting roughly in tandem with Newfoundland, was much less aggressive in its approach.

Another federal proposal was put forward to the province in December. Williams rejected it as also substantially falling short of what was promised. In protest, the provincial government temporarily removed the Canadian flag from provincial buildings, which brought considerable media and public attention to the dispute. However, talks resumed and an agreement was signed on 14 February 2005.

The agreement was to run concurrently with the Atlantic Accord rather than being an amendment to it. Its key elements are as follows:

- It covers an eight-year period, namely 2004–05 to 2011–12, which is one year beyond the end-year for offset payments under the 1985 Atlantic Accord.
- The federal government will pay the provincial government an amount equal to the loss in equalization resulting from its offshore revenues, where the calculation of the loss is based on the equalization formula in place at the time.
- To achieve that objective, the federal government would make whatever additional payment was needed to top up the offset payments already provided for under the Atlantic Accord.
- In any year from 2006–07 to 2011–12, the additional offset payment defaults to zero for that year if Newfoundland does not qualify for receipt of an equalization payment under the equalization formula in place at the time.[11]

This agreement also provided for a possible eight-year extension, running from 2012–13 to 2019–20. The condition for such an extension is that Newfoundland be a recipient of equalization in 2010–11 or 2011–12 *and* its per capita debt servicing charges not be lower that those of at least four other provinces in 2011–12. An identical agreement was reached with Nova Scotia at the same time, and both agreements were embodied in a single piece of federal legislation in 2005.

[10] See Newfoundland and Labrador Information Services, (NLIS 7) "Text of speaking noted delivered at a news conference held today (October 27) by Premier Danny Williams in St. John's," Government of Newfoundland and Labrador.

[11] If Newfoundland failed to qualify for equalization in 2011–12, then there would be a transitional payment for that year.

In sum, the 2005 agreements meant that up to and including the fiscal year 2011–12, the total annual offset payment in per capita terms, T, would be the sum of the per capita offset payment as already provided for under the Atlantic Accord (Offshore Accord for Nova Scotia), denoted by C, plus the new additional offset payment per capita, A. Thus,

$$T = C + A, \tag{1}$$

where A is the amount needed to make the sum on the right-hand-side of (1) equal to the difference between the province's per capita equalization payment calculated as if it had no offshore revenues and its actual per capita equalization payment for the year in question. An important caveat, however, is that for any year, if the actual equalization payment is zero then A defaults to zero for that year as well. Thus, A is given by

$$A = (E_{NOR} - E) - C, \text{ as long as } E > 0, \tag{2}$$

where E denotes the actual per capita equalization payment and E_{NOR} represents the per capita equalization payment calculated as if there were no offshore revenue.

A numerical example, based on hypothetical figures, may help illustrate this formula. Assume that the provincial population is 500,000. Suppose that in some year, Newfoundland qualifies for only a modest amount of equalization, say $50 million. Therefore, its per capita equalization is $100.[12] Also, assume that its compensatory payment under the Atlantic Accord is $15 million, which is $30 per capita, and suppose that its hypothetical equalization payment had there been no offshore revenues is $900 million, or $1,800 per capita. So, in this case, the per-capita additional offset payment, A, would be

$$A = \$1,800 - \$100 - \$30 = \$1,670.$$

That translates into an aggregate additional offset payment of $835 million, i.e., $1,670 per person multiplied by 500,000 people.

The 2005 agreements represented substantial gains for Nova Scotia and especially for Newfoundland. Indeed, anticipating its value to Newfoundland, the federal government made an advance payment to the province of $2 billion.[13] Yet, it was a compromise from Williams' position in two ways. First,

[12] With total equalization at $50 million and a population of 0.5 million, the per-capita payment is $50 million/0.5million = $100 per person.

[13] It was also a gain for Nova Scotia, which received an advance payment of $830 million. That smaller amount reflects the fact that Newfoundland's offshore resources are anticipated to be much richer.

the agreement did not guarantee that additional offset payments would be made for the entire life of offshore petroleum production. Rather, it added one more year to the original twelve and it conditionally provided for a possible further eight-year extension. Secondly, and more significantly, the payment of an additional offset payment in any year was contingent on the province qualifying for equalization payment in that year. Newfoundland had argued that it should be entitled to the difference between its actual equalization entitlement, even if it is zero, and the equalization payment it would have had if there were no offshore revenues.[14]

EQUALIZATION RENEWAL AND THE EXPERT PANEL

October of 2004 was eventful not only due to the Newfoundland-Canada conflict sparked by the Goodale proposal. At the same time, the federal government announced a major review for the entire equalization program.

Up to then, the amount and allocation of equalization payments were based on a five-province standard.[15] Any province that did not have the per capita revenue-raising ability of the average of five specified provinces would be entitled to an equalization payment aimed at making up the deficiency; a province that was above the standard would not be a recipient.

However, in late October, the federal government announced increased payments to each recipient province for 2005–06, and it made a commitment to increase the total aggregate funding for equalization payments by 3.5 percent annually thereafter. It also established a panel of experts, The Expert Panel on Equalization and Territorial Formula Financing, to advise it on the appropriate mechanism for determining how equalization envelopes would be shared among provincial governments in the future.

ELECTION 2006

Before the Expert Panel's report was completed, a federal election had been called. Election-day was 21 January 2006. The Liberal Party's minority government was defeated and replaced by another minority government under the Conservative Party. Early in the election campaign, Premier Williams wrote a

[14] In a letter dated 3 January 2005 to the Prime Minister, Premier Williams argued that the equalization clawback of natural resource revenues is at its peak when the province's equalization entitlement approaches zero and therefore offset payments continue to be necessary.

[15] A ten-province standard had been used for most years prior to 1982.

letter to the leaders of the three national parties in which he identified specific issues of importance to the province and requested the leaders' positions on them.[16] One of the issues was equalization. The Williams' letter complained of the historical inadequacy of equalization and advocated:

- abandoning the fixed-envelope approach adopted in October of 2004;
- the use of a 10-province standard for determination of equalization;
- extending the measure of fiscal capacity to include an adjustment for debt and debt servicing cost; and
- comprehensive revenue coverage, which would include 100 percent of all renewable and non-renewable natural resources revenue sources.

The three leaders of the main federal parties did respond. Conservative Party leader, Stephen Harper, who would emerge as the new prime minister, sent a response letter in which he referred to the fiscal imbalance between the federal and provincial levels of government in Canada and made a general commitment to change equalization to ensure that provinces would have the ability to develop their economies and sustain social services. Also in regard to equalization, his letter made two specific commitments:

- to exclude non-renewable natural resource revenues from the equalization formula; and
- to ensure that no province was adversely affected from changes to the equalization formula.

As for the other responses to the Williams' letter, the leader of the Liberal Party, then Prime Minister Martin, noted that there were already significant benefits under the 2005 agreement, and he did not commit to further changes, pointing to the need to hear from the Expert Panel. For his part, New Democratic Party leader Jack Layton endorsed an equalization formula based on the ten-province standard with a better measure of fiscal capacity and expressed the view that equalization reform should contribute to fairness and equity across Canada. Neither of those two leaders made any specific commitment on the treatment of natural resource revenues. However, Harper's two specific commitments were to become intertwined with the Expert Panel's advice on how to redesign the equalization program.

THE PANEL'S PROPOSED FORMULA

The new minority government did not implement any changes to the equalization program in its first budget, preferring to await the advice of the Expert

[16] See www.releases.gov.nl.ca/releases/2006/exec/0103n01.pdf

Panel. That report was released in June 2006. It was the culmination of exten-
sive consultations and research, with substantial assistance from the federal
government's Department of Finance.

The Panel recommended a ten-province standard and advised that equali-
zation be simplified by reducing the number of distinct provincial revenue
sources used in determining fiscal capacity from 33 by aggregating them into
5 categories. Also, to avoid volatility and to improve predictability, the Panel
recommended that fiscal capacities be calculated using a three-year weighted
average of their annual values.[17]

As for the equalization formula itself, the Panel's advice added complex-
ity. It involved a two-tier process with two notions of fiscal capacity and two
notions of a standard. To help explain the first tier, the following definitions
are useful:

> *Tier 1 Fiscal Capacity Per Capita (F_1):* This is the sum of: (a) 50 percent of
> a province's per capita natural resource revenues and (b) its per capita tax
> yields from four other major revenue sources – taxes on personal income,
> taxes on business income, consumption taxes, and property taxes.[18]

> *The Tier 1 Standard Per Capita (S_1):* This is the sum of the tier 1 fiscal
> capacities of all ten provinces divided by their total population.

The first tier calculation determines which provinces are potentially eligi-
ble for an equalization payment. Any province with a per capita tier 1 fiscal
capacity less than the tier 1 standard might receive an equalization payment.
The provinces that do not meet this tier 1 requirement are automatically ruled
out; for want of an identifying term, these provinces can be called the "refer-
ence provinces."

At the second tier, the actual equalization payment due for other provinces
is calculated. To explain that calculation, it is useful to introduce the follow-
ing concepts:

> *Tier 2 Fiscal Capacity Per Capita (F_2):* This is the sum of: (a) 100 percent
> of a province's per capita natural resource revenues, and (b) its per capita
> tax yields from the four other major revenue sources.

> *The Tier 2 Standard Per Capita (S_2):* From among the tier 2 fiscal capaci-
> ties of the reference provinces, this is the lowest one.

[17] The weights are 50 percent for the annual value lagged two years and then 25
percent for each of the two years prior to that.

[18] The tax yields are based on the revenue the province would have if it applied
national average tax rates to its corresponding tax bases.

For each province not in the reference group, an actual equalization payment per capita, denoted by E, is calculated according to the following formula:

$$E = (S_1 - F_1) - max[0, (F_2 + S_1 - F_1 + T - S_2)]. \tag{3}$$

The first expression on the right-hand-side in (3), namely $(S_1 - F_1)$ is simply the excess of the tier 1 standard over the province's tier 1 fiscal capacity. For example, if a province has a tier 1 fiscal capacity of $6,000 per capita and the tier 1 standard is $7,000 per person then the difference is $1,000. Whether that province will actually receive $1,000 per person then depends on the value of the second expression in (3).

That second expression reflects the workings of the cap. It is the maximum of two numbers: zero, and the amount given by $(F_2 + S_1 - F_1 + T - S_2)$. If the second amount is negative, there is no deduction; i.e., the maximum of zero and a negative number is zero. In terms of the preceding example, the province would actually receive $1,000 per person. That is the case where the cap is not binding.

Now consider the situation where the cap is binding. The cap itself is S_2. For the cap to be binding, a province's $F_2 + S_1 - F_1 + T$ must exceed S_2. Recall that F_2 is the province's tier 2 fiscal capacity; $S_1 - F_1$ is its maximum potential equalization payment, and T, which is relevant only for Nova Scotia and Newfoundland, denotes its offset payment. If the sum of these amounts exceeds the cap then a reduction kicks in. To continue with the example in which $S_1 - F_1 = \$1,000$, assume as well that the province's tier 2 fiscal capacity is $6,900 and that it does not have an offset agreement so $T = 0$. Then $F_2 + S_1 - F_1 + T = \$6,900 + \$1,000 + \$0 = \$7,900$. If the tier 2 standard, S_2, is $7,200 then the cap applies. The Panel's formula, (3), would determine the per-capita equalization payment as:

$$E = \$1000 - max[0, \$7,900 - \$7,200] = \$1,000 - \$700 = \$300.$$

Notice that adding this $300 to this province's tier 2 fiscal capacity of $6,900 gives $7,200, which coincides with the cap. In effect, the equalization payment is "clawed back" so that its post-equalization position cannot be greater than the cap.

RATIONALIZING A CAP

One way to defend a cap is to argue on efficiency grounds. In a nutshell, that argument is based on the following proposition. If a province is over-equalized – in the sense that its equalization payment gives it a greater overall fiscal capacity than average – then it can offer more public services and/or lower tax rates. Such an attractive fiscal regime might attract labour from other provinces. That inflow would be economically inefficient since it is the result of a transfer payment from the federal government rather than being based on greater economic opportunities.

The Expert Panel, however, relied on another argument. Its rationale for the cap was based on an appeal to interprovincial equity: no equalization-receiving province ought to have a post-equalization per capita fiscal capacity greater than that of any non-recipient province. This proposition has some merit. This is especially so where an equalization formula fully excludes any major revenue source, such as natural resource revenue. In such a situation, a resource-rich province could have substantially more per capita own-source revenue than a non-recipient province and still be receiving equalization payments. A cap mechanism is an effective, albeit very blunt, instrument for dealing with that apparent inequity.

Saskatchewan stood out as the province most likely to be adversely affected by the cap. It has traditionally been a recipient of equalization but is well off in terms of natural resource revenues. Its rising oil and gas revenues made the cap a likely prospect.

The Panel's proposed cap also had negative implications for the offset-payment agreements. The offset payments themselves would not be capped but, in conjunction with the cap, they would be used to determine the magnitude of any reduction in equalization payments. This can be seen in the Panel's formula, as given in (3), via the presence of T. The larger the value of T, the more likely the cap will apply and the larger would be the consequent reduction in the equalization payment.

While it was entirely within the mandate of the Expert Panel to recommend an equalization reduction mechanism based on a cap, its advice to include offset payments in that calculation is questionable. Offset payments are not part of the equalization program and are governed by separate legislation. They are payments outside of that program and follow from bilateral agreements between the federal government and two provincial governments. No other type of federal transfer payments to provincial governments is included in the Panel's proposed reduction calculation. Indeed, the sole purpose of offset payments is to offset reductions in equalization payments.

Yet, the Panel's report expressed a broad interpretation of its mandate:

> The Panel views the Offshore Accords as inextricably related to the Equalization program. Although they are delivered under the authority of their own specific legislation, they are calculated on the basis of Equalization entitlements with and without offshore oil and gas resources. Their magnitude and timing (with the exception of the prepayment provisions of the 2005 Offshore Accords) depend on the structure of the Equalization program. As well, and most importantly from the perspective of the fiscal capacity calculation, they are unconditional grants to the governments of the provinces concerned. They are, therefore, available to provide public services, and consistent with the principles and practice of the Equalization program, they increase the fiscal capacity of the receiving provinces.

For these reasons the Panel considers it appropriate to include entitlements un-
der the Offshore Accords to measure post-Equalization fiscal capacity for the
purposes of applying the fiscal capacity cap. (Expert Panel 2006, 138)

Still, it is surprising that, rather than considering these bilateral agreements
as constraints, the Panel recommended that offset payments be incorporated
in the equalization formula. Moreover, doing so creates a mathematical in-
consistency. In order to calculate the equalization payment using the Panel's
proposed formula, as given by (3), one needs to know the offset payment, T.
However, the offset payment is determined by the equalization payment via (2).
This creates a circularity problem: the value of T is required to calculate E,
but E must be known to calculate T.[19] In contrast, the offset agreements clearly
lay out a sequential calculation; the equalization payment is calculated first
and then the amount of the equalization is used to calculate the offset payments.

Nevertheless, the Panel's report was adamant that the offset payments be
part of the equalization formula. Apparently, the Panel's belief is that the off-
set agreements, despite their express purpose, were a policy mistake; a mistake
that compromised the principles of equalization. As the Panel's report states:

> If Newfoundland and Labrador's fiscal capacity after Equalization is higher than
> the lowest non-receiving province, the cap should apply regardless of the Off-
> shore Accords and the province should not receive Equalization payments that
> put them above the cap. The Panel understands that, under their 2005 Accord,
> Newfoundland and Labrador is protected from losses in Equalization payments.
> It's up to the federal government to determine how this should be resolved. In
> the Panel's view, the principles of Equalization should not be compromised nor
> should the Equalization program be adjusted to accommodate the Offshore
> Accords.

This strong stance has rather sweeping implications for federalism. It sug-
gests that if a federal-provincial agreement comes to be perceived as a mistake
on the part of the federal government, then the federal authorities ought to
change it unilaterally. (Expert Panel 2006, 62)

THE 2007 BUDGET

The Panel's proposed cap with its 100 percent clawback rate was met with
criticism from the two provinces that would be most adversely affected:

[19] It is possible to calculate an offset payment and an equalization payment that are
mutually consistent but that requires an iterative mathematical calculation.

Saskatchewan and Newfoundland.[20] Premier Williams was especially sharp in his criticism. He urged the federal government not to accept that proposal and to announce what it intended to do with the equalization formula.[21] In the following months, as the federal government worked towards a formula to be announced in its 2007 budget, relations continued to be strained.[22]

That budget unveiled a new equalization formula that is even more complex than had been proposed by the Panel.

THE NEW EQUALIZATION FORMULA

The new formula encompasses the Panel's recommended formula based on its two-tier process, but extends it in ways that, to some degree, accommodate resource-rich provinces generally and the two provinces with offset agreements specifically.

The general accommodation of resource-rich provinces is achieved via a bifurcation process. That is to say, each province can proceed through the two-tier equalization process along two different paths. One path is exactly as recommended by the Panel, with 50 percent of natural resource revenues included in the tier 1 standard, S_1, and the measure of a province's tier 1 fiscal capacity, F_1, where they are the same as recommended by the Panel. The other path entails using a tier 1 standard, S_1', and a tier 1 measure of fiscal capacity, F_1', that both fully exclude natural resource revenues but are otherwise the same as in the first path.

Using either path, a province proceeds to the second tier as long as in the first tier its fiscal capacity is less than the corresponding standard. Provinces that make it to the second tier might receive an equalization payment. And there are two possible ways of calculating that payment.

To facilitate later discussion it is useful to represent the second tier's two alternate payments in a generalized framework. The per-capita payment, E, is either X or Y where:

$$X = (S_1 - F_1) - \max[0, \alpha(F_2 + S_1 - F_1 + \beta T - S_2)], \qquad (4a)$$

[20] It was not clear whether Nova Scotia's more modest offshore revenues would be sufficient to bring it above the cap.

[21] See "Equalization report disturbing, Williams says," www.cbc.ca/Canada/Newfoundland-labrador/story/2006/06/06/nf-equalization-20060606.html

[22] See "Rift widens between Harper, Williams," 16 October 2006; "May take anti-Harper campaign on the road, Williams," December 2, 2006; "Williams, Calvert form alliance over equalization," 19 December 2006, and "Williams seeks MPs' support in Harper fight," 22 December 2006. All available at www.cbc.ca/canada/Newfoundland-labrador/

and

$$Y = (S_1' - F_1') - \max[0, \alpha'(F_2 + S_1' - F_1' + \beta T' - S_2)]. \qquad (4b)$$

The actual formula is somewhat simpler than this format because it takes α, β and α' as each being equal to 1, i.e., unity. The use of these Greek symbols here is to serve the purpose of generalization: β represents the proportion of any offset payment included in the calculation of the reduction; and α (α') determines the rate of reduction in an equalization payment when a province's post-equalization fiscal capacity exceeds S_2, the tier 2 standard.

Turning to the actual formulas, notice that with $\alpha = \beta = 1$, (4a) becomes identical to (3), the formula recommended by the Expert Panel. The other possible payment formula, (4b), is new but it has the same structure as (4a). The difference is that S_1' and F_1' correspond respectively to S_1 and F_1 excluding the 50 percent of natural resource revenues that were included in them.[23] Under this regime, Y, as determined by (4b), is allocated to a province if $(S_1 - F_1) < (S_1' - F_1')$; otherwise the province is paid X. However, a province is permitted to elect to receive X even if allocated Y. Of course, if the greater value of X and Y is not a positive number then the equalization payment defaults to zero.

The "either/or" calculation embodied in the new equalization process can be related to the government's election commitment to remove all non-renewable natural resource revenue from the equalization formula. It does so via (4b). In fact, in one sense it goes further than that election commitment because the first part of the calculation in (4b) allows for the exclusion of all natural resource revenue, not just revenue from non-renewable natural resources. However, this generosity in the treatment of these revenues is limited by the cap. Natural resource revenues that take a province beyond that threshold are effectively nullified by a dollar-for-dollar loss in the equalization payment.

ANOTHER OPTION FOR THE "OFFSET" PROVINCES

In addition to introducing the "either/or" enhancement, Budget 2007 provided a special deal for the two provinces entitled to offset payments. Newfoundland and Nova Scotia are given the right to stay with what may be called the "fixed envelope" formula. That formula is a continuation of the 2004 arrangement in which an aggregate amount for equalization payments is set as a starting

[23] T' is used rather than T because the offset payment varies with the use of S_1' and F_1' instead of S_1 and F_1.

point, and then that amount automatically grows at an annual rate of 3.5 per-cent.[24] Each province's share of that aggregate is based on its per capita fiscal capacity relative to those of the other provinces, given the pre-determined aggregate amount.[25] The average of the three prior years' fiscal capacities is used to allocate funds in any given year. Also, this formula uses a measure of fiscal capacity that includes all natural resource revenue.[26]

Let F represent a province's per capita fiscal capacity as measured by that formula, and let S denote the per capita standard. Then, as long as a province's fiscal capacity is less than the standard, the province is entitled to a per capita equalization payment given by:

$$E = S - F \qquad (5)$$

An apparent advantage of (5) is that the offset payment is not included in this formula's measure of fiscal capacity. No matter how large the offset payment may be, it cannot lead to a reduction in E. In other words, it becomes possible to be in recipient of equalization and exceed the cap. However, neither S nor F is the same as, or directly proportional to, the standards or fiscal capacity measures in the new formula. Therefore, it is impossible to tell whether (5) is more advantageous for any particular year in the future. Also, once a province indicates by a certain time that it will stay with the fixed-envelope formula for a coming year then it receives the associated payment even if, afterwards, it turns out that the new formula would have been a better choice.

These opting-out arrangements for Newfoundland and Nova Scotia are not permanent. Either province is irreversibly brought into the new formula if in any year after 2007–08 it decides to receive a payment based on that formula. Also, if either province does not meet the conditions required under the 2005 agreements for an extension beyond 2011–12 then the new formula will auto-matically apply to it thereafter.[27] Even if either province does qualify for the

[24] The reference amount is a notional figure since actual payments to the other provinces are based on the new framework.

[25] In this case the per capita standard is endogenous. It is simply the amount, S, such that the sum of the differences between S and each province's per capita fiscal capacity, over all provincial populations, equals the total amount available for equali-zation payments.

[26] It also retains the so-called generic solution, which allows a province to exclude 30 percent of a revenue source when that province has 70 percent or more of the corresponding national tax base. In practice, the generic solution has applied only in a few cases, all of which involve natural resources.

[27] That timing could be delayed by a year if the province qualified under that accord for a transitional payment in 2011–12.

extension, it would come under the new formula if it does not qualify for an additional offset payment or a transitional payment during the extension period.

The federal government's rationale for this treatment of Newfoundland and Nova Scotia is that the 2005 agreements were signed when the fixed-envelope formula was in effect. Therefore, allowing those provinces the option to continue under that formula is its way of respecting the 2005 agreements.[28]

AMENDMENTS TO THE BILATERAL AGREEMENTS

The Budget also brings about two significant amendments to the legislation that implements the 2005 Offset Agreements. One affects the qualification criterion and the other involves the calculation of the additional offset payment. The generalized framework of (4a) and (4b) help in explaining each change.

Consider, first, the amendment to the eligibility requirement. The existing legislation provides that for any fiscal year from 2006–07 to 2011–12 inclusive, if Newfoundland (Nova Scotia) does not receive an equalization payment in that year then it will not receive an additional offset payment either. The amendment affecting this eligibility requirement changes the definition of "equalization payment." Regardless of whether either province is covered by the new formula or stays with the fixed-envelope one, the equalization payment *for the purpose of the eligibility requirement* is now calculated according to the new formula but with T removed. For convenience, assume that (4a) applies. Then this "equalization payment," which will be denoted as X^*, is determined by

$$X^* = (S_1 - F_1) - \max[0, (F_2 + S_1 - F_1 - S_2)]. \qquad (6)$$

Notice that in the generalized format of (4a), this is equivalent to setting $\alpha = 1$ and $\beta = 0$. The eligibility requirement is then simple. If X^* is positive, the province is deemed eligible for the additional offset payment. Otherwise, it is not eligible.

Use of X^* conveniently solves the circularity problem as noted in Part 3. That is to say, it avoids the logical conundrum of making eligibility for receipt of the offset payment a function of the offset payment. Nevertheless, the reality is that in general, X^* is not the actual equalization payment. To underscore this observation, note that it is possible that if either province opts for the fixed-envelope formula then it might be receiving an equalization payment but X^* might not be a positive number. This means that the province

[28] See Budget 2007 (Annex 4), "Fulfilling the Commitment to Respect the Offshore Accords," Department of Finance Canada, www.budget.gc.ca/2007/bp/bpa4e.html.

would be receiving an equalization payment but, *for the purpose of the eligibility requirement*, be deemed as not receiving an equalization payment!

The second change to legislation implementing the 2005 agreements involves the calculation of the offset payment. As part of the process of determining the offset payment one must know the equalization payment. This second amendment specifies that, for the purpose of determining the offset payment, the "equalization payment" must be calculated using the following formula:[29]

$$X^{**} = (S_1 - F_1).\qquad(7)$$

In terms of the generalized framework, this is equivalent to making $\alpha = 0$ in (4a).[30]

THE KEY ISSUES AND POSSIBLE RESOLUTION

The cap in the equalization formula and these changes to offset payment arrangements were met with a great deal criticism from the provinces affected: Saskatchewan, Nova Scotia, and Newfoundland. The most vociferous opposition came from Newfoundland.[31] Politics aside, it is worthwhile to identify the pertinent issues and suggest resolutions.

THE INTERPLAY WITH NATURAL RESOURCE REVENUES

The new equalization formula's incorporation of a cap is directly tied to that formula's treatment of provinces' natural resource revenues. As already pointed out, if all natural resource (and other revenues) are included in the equalization formula then the type of cap under discussion serves no purpose. However, in the new program, its presence is due to the fact that the equalization formula

[29] Actually, the amendment makes it the larger of $(S_1 - F_1)$ and $(S_1' - F_1')$ but with the provision that the province can elect to receive the former. Since the latter excludes all natural resource revenues, including offshore revenues, it is unlikely ever to be the advantageous choice.

[30] The Atlantic Accord is also amended to make this "equalization payment" the basis for offset payment calculations embodied in it.

[31] Its provincial government placed advertisements in national newspapers claiming that the Prime Minister had not kept his commitments on equalization and the Atlantic Accord. Counter-advertisements of denial were placed by the federal government in newspapers across the province.

excludes all natural resource revenues for those provinces that benefit from that exclusion, and excludes 50 percent otherwise.

Thus, a natural question is: why not include all natural resource revenues in the formula in the first place? This is a contentious question; that is to say, more contentious than for most other revenue sources. It is a long-standing matter of intergovernmental conflict and academic debate in Canadian fiscal federalism.[32] A brief listing of some alternate views on this question is order.

On the one hand, some have argued that natural resource revenue sources should not be included in equalization at all. Sometimes that stance is based on constitutional grounds, where proponents cite the constitution's provisions on provincial ownership of natural resources and the protection of provincial property from federal taxation.[33] Other arguments are based on practical considerations: that natural resources, at least non-renewable ones, are depleting assets, which makes them different from other revenue sources; that including them in equalization would create poor incentives for equalization-receiving provincial governments to develop untapped resources; or that in some provinces the revenues from such resources represent the only hope to ever catch up to the more prosperous provinces.

On the other hand, there are compelling arguments for full inclusion. The principle that the federal government make equalization is constitutionally mandated, which provides the basis for a constitutional argument. There is an equity argument along the lines put forward by the Expert Panel. Also, as mentioned earlier, there is an efficiency argument based on the notion that without comprehensive revenue coverage, there could be over-equalization and a consequent inefficient movement of labour across the provinces.

In practice, natural resource revenue sources have typically been partially equalized. The reason for this different treatment relative to other revenue sources probably reflects some compromise between the competing viewpoints. However, perhaps a more crucial factor has been cost. Since the early 1970s oil and gas resources have generated substantial revenues for those provinces where they are located in abundance. With a very uneven distribution of these resources across the provinces, the implied aggregate amount of equalization, under full inclusion, would entail a substantial budgetary cost. This has led the federal government to include only some portion of provinces' natural resource revenues in its equalization calculus. As chronicled in Courchene (1984), during the 1970s the federal government took various ad hoc measures

[32] See Courchene (1984) for an extensive history to the 1980s. For a recent overview see Feehan (2005).

[33] One could argue that reducing equalization payments in proportion to increases in a province's natural resource revenue is equivalent to a federal tax on that revenue.

to ensure that natural resources were not fully equalized. A more long-lasting solution to the cost question was adopted in 1982 when the standard for determining equalization payments was changed from a ten-province one to a five-province one, where resource-rich Alberta was strategically excluded.

Not surprisingly, the Expert Panel had to revisit the issue of the treatment of natural resource revenues. It recommended that 50 percent of natural resource revenues be included when measuring a province's fiscal capacity. The Panel rationalized that rate as a reasonable compromise in light of the various competing arguments.[34] Once it departed from the idea of full inclusion, it concluded, on equity grounds, that a reduction adjustment, based on a cap, was in order. The result was its two-tier process.

The government adopted that framework for its new formula but goes further. It also allows for 100 percent exclusion for those provinces that would consequently benefit. The latter serves to strengthen the equity argument in favour of a cap. In fact, the federal government explicitly cites interprovincial equity as the reason for adoption of the cap:[35]

> When the excluded resources are included in the measure of total fiscal capacity, it is possible that Equalization Payments may have raised a province's total fiscal capacity above that of a non-receiving province. This would cause a situation that would be unfair to the residents of the non-receiving provinces, whose taxes are also used to fund payments to provinces better off than their own.

Had the federal authorities not allowed for the option of full exclusion then the case for a reduction mechanism would be weakened. Suppose the 50 percent rule applied to all provinces. Then a recipient province loses 50 cents in equalization per dollar increase in natural resource revenue. That makes it difficult to catch up to the tier 2 standard and limits the scope to exceed it. Moreover, as its natural resource revenues increase, a province in that position becomes more likely not to qualify for an equalization payment in the first place. Using this logic, as the inclusion rate rises from 50 percent towards full inclusion, the case for a cap progressively weakens. On the other hand, as that rate goes further below 50 percent, it is more difficult to argue against some form of equalization clawback. Arguing against any reduction mechanism when resource revenue is entirely excluded is practically an untenable position.

There is also a precedent for the use of a reduction mechanism tied to natural resource revenues. Courchene (1984) recounts that episode. In 1962, natural

[34] See pp. 108–109 of its report for a succinct and clear explanation of the Panel's.
[35] Budget Plan, Annex 4 (Budget 2007), *Restoring Fiscal Balance for a Stronger Federation*, p. 17. www.budget.gc.ca/2007/bp/bpa4e.html.

resource revenues were fully included in the equalization formula. However, in 1963, following a change in government at the federal level, natural resource revenues were no longer to be equalized. Concurrently, the federal government introduced a reduction mechanism tied to natural resource revenues. The reduction was set at 50 percent of the excess of the three-year average of a province's per capita resource revenue over the corresponding national figure; for provinces with no excess the reduction was zero.

In short, there is an equity basis for the use of a reduction mechanism as well as a precedent for doing so. However, a cap, which means an extreme 100 percent clawback rate, is open to criticism.

RE-ASSESSING THE CAP

Consider, first, the level of the cap. The federal government accepted the Panel's advice on what the cap should be – the lowest of the per capita tier 2 fiscal capacities from among the reference provinces identified in the tier 1 process.[36] The value of those provinces' tier 2 per capita fiscal capacities is simply the equivalent of tier 1 fiscal capacity with the other 50 percent of natural resource revenues added in. There is no addition of other revenue capacities, notably user fees and hydro-rents. From 1982 to 1999 all user-fee revenues had been included in the equalization formula and 50 percent of such revenues were included thereafter. The new formula, consistent with the Panel's advice, no longer includes such revenue. Hydro-rents refer to the potential revenue that a province might have realized if its Crown-owned Hydro corporations did not follow a low-pricing strategy for electricity. This issue is a long-standing one, being highlighted by the Economic Council of Canada.[37] The Expert Panel (2005, 113) was aware of this issue but pointed out that the measurement issues would be complex and controversial, and recommended against doing so. Indeed, the problems with measuring natural resource rents extends to all natural resources and prompted the Panel to recommend that actual natural resource revenue be used in the formula as a proxy for rent. These complications and omissions mean that tier 2 fiscal capacity is not a full measure of fiscal capacity. It is imperfect.

Next, consider the rate of reduction. Under the new formula, whenever a recipient province's tier 2 fiscal capacity exceeds the cap the reduction in that province's equalization is 100 percent of the amount above the cap. This is an

[36] The reference provinces are those for which $S_1 < F_1$ holds.

[37] The Economic Council of Canada (1984, 51) suggested that the main beneficiaries of this failure to include hydro-rents in the calculation of equalization entitlements were Quebec and Manitoba.

extreme clawback rate. As Don Drummond (2007, 21) puts it, "the cap is too severe." Use of a less blunt reduction mechanism, which entails re-interpreting S_2 as a trigger rather than a cap, might be more appropriate for a number of reasons.

First, past practice suggests the use of a smaller proportion. As already recounted, the reduction mechanism introduced in 1963 used a rate of 50 percent. And the so-called generic solution in the previous formula used 70 percent. Introduced in the mid-1990s, the generic solution applied when a single province had 70 percent or more of a particular revenue source, which limited it to only some types of natural resource revenues. Either approach can lead to an equalization recipient having a post-equalization fiscal capacity higher than a non-recipient's.

Secondly, as Smart (2007) points out, the cap's 100 percent clawback rate creates disincentive effects for provinces finding themselves in that troublesome space between tier 1 and tier 2 of the equalization formulation. Such provinces have an incentive not to realize potential natural resource revenue if the potential increase is not so large as to take them well beyond the cap. This perverse incentive effect may be reinforced if significant public infrastructure investment has to be made in conjunction with potential resource developments.

Thirdly, a 100 percent clawback rate creates an asymmetry. On the one hand, the clawback reduces equalization on a dollar-for-dollar basis once an upper threshold, namely S_2, is exceeded. On the other hand, there is no mechanism that compensates on a dollar-for-dollar basis for resource revenues below a lower threshold.

There is a fourth reason for tempering the clawback rate: it is desirable to have one equalization framework. Lowering the clawback rate makes it more attractive for Nova Scotia and Newfoundland to choose the new formulas rather than stay with the fixed-envelope one. The fact that these two provinces are permitted to stay out of the new formulas, and thereby potentially exceed the cap, proves that the 100 percent rate is not sacrosanct.

To gain some insight into how a modestly lower clawback rate affects interprovincial equity, a numerical illustration is helpful. Recall the example used earlier in this chapter. A province had a tier 1 fiscal capacity of $6,000 and a tier 2 fiscal capacity of $6,900; the tier 1 standard was $7,000; and the tier 2 standard, S_2, was $7,200. Also, the example assumed that (4a) with $\alpha = 1$ was the applicable formula. Suppose, however, α is set to 0.6, which implies a post-S_2 clawback rate of 80 percent.[38] Then, this province's equalization payment would be:

$$E = \$1,000 - \max[0, 0.6(\$7,900 - \$7,200) = \$1,000 - \$420 = \$580.$$

[38] See footnote 21. Also note that for an equivalent rate of clawback the value of α' in (4b) must be 0.8.

As a result, its post-equalization fiscal capacity would be \$7,480, i.e., \$580 + \$6,900. That is only about 3.8 percent more than the second tier standard of \$7,200. Thus, with such a clawback rate, the scope for a province to be receiving equalization and be substantially ahead of that standard is very limited. There is room to move down from the 100 percent. Courchene (2007) proposes a rate of two-thirds. Others may argue for lower or higher rates but something less than 100 percent is warranted.

Any reduction, however small, in the clawback rate mitigates its adverse consequences. How low a rate is needed to attract Nova Scotia and Newfoundland into the new formula is a more difficult issue. The more the rate comes down, the greater the deviation from interprovincial equity. However, if the clawback calculation does not involve offset payments, then a smaller reduction than otherwise would be sufficient to bring the offset provinces into the new formula. Whether this ought to be the case is one of the subjects of the next subsection.

INTERPLAY WITH OFFSET PAYMENT AGREEMENTS

It is helpful to use the generalized equations of (4a) and (4b) to highlight the interrelation between the offset agreements and the new equalization formula.

To start, consider the 2005 agreements' implications for the equalization formula. As argued earlier, those agreements require that the offset payments be determined after the actual equalization is finalized. In terms of (4a) and (4b) that means that α should be zero. In other words, the offset payment should not be included in the determination of the equalization payment. In bald contradiction, the new equalization formula takes β as equal to one. However, the federal government does diminish that contradiction by allowing the relevant provinces, Nova Scotia and Newfoundland, to choose to remain with the fixed-envelope formula, which does include the offset payments. This manoeuvre takes the dilemma out of federal hands and puts it into provincial ones. If either Newfoundland or Nova Scotia chooses the new formula then, by implication, that province is betting that it will gain more than had it remained with the fixed envelope formula. Still, it can be a tough gamble because once either chooses the new formula it cannot revert.

Next, consider the compatibility of the new equalization formula with the amendments to the offset-payments agreements. The federal legislation that implements the 2005 agreements specifies that the additional offset payment for any year must be based on "the equalization formula in effect at that time."[39]

[39] See *Nova Scotia and Newfoundland and Labrador Additional Fiscal Equalization Offset Payments Act*, Sections 8 and 22, covering Nova Scotia and Newfoundland, respectively.

However, as also described earlier, the amendments to the legislation use different variations of the new formula for the eligibility criterion and for the calculation of the offset payment. If either province opts to remain with the fixed-envelope formula, then that leads to the question as to what is "the" equalization formula in effect at that time.

That problem carries over to the case where both provinces do opt into the new formula. Assume that they do and are governed by the calculation based on 50 percent inclusion of natural resource revenues. That means that their actual equalization payments are determined by (4a) with α and β both equal to one. On the other hand, as explained earlier, the eligibility criterion for an offset payment would be based on (4a) with α set to one but α equal to zero. And the calculation of the offset payment would use an equalization payment based on (4a) but with α equated to zero. Thus, there are three notions of equalization payment at play! Each corresponds to using different values for α and β. They are summarized in the table below.

Equalization payment, based on (4a):	α	β
Actual payment	1	1
To determine eligibility for additional offset payment	1	0
To calculate the offset payment	0	Not applicable

The contradictions highlighted in the table need to be eliminated. The 2005 agreements provide a guide for the value of β. It should be zero throughout, i.e., the offset payment should not enter the equalization formula. As for α, the 2005 agreements require the use of *the* equalization formula in effect at the time. That implies that α should take the same value in all three cases, although the choice of that value lies with the federal government. It has been argued in the preceding subsection that neither one nor zero is appropriate.

CONCLUSION

The federal government's new equalization formula and its changes to the offset-payment agreements build on the Expert Panel's recommendations in ways intended to be more accommodating to resource-rich provinces and to the two provinces with offset agreements. Yet, the results are a frustratingly more complex formula, inconsistencies with the offset agreements, and, above all, a cap that is too severe.

The basic framework of the new formula is a reasonable one but modifications are needed. On the one hand, arguing against a clawback mechanism that takes account of natural resources revenues when, in the first instance, all natural resource revenue is excluded from equalization, is an untenable position. On the other hand, the federal government should, firstly, respect the limitations imposed on it by bilateral agreements, and, secondly, re-assess the clawback rate on provinces' natural resource revenues. In brief, it is time for the parties to rethink the alphas and betas.

REFERENCES

Courchene, T.J. 1984. *Equalization Payments: Past, Present and Future*. Ontario Economic Council: Toronto.

— 2007. "A Blueprint for Fiscal Federalism" *Policy Options* (April): 16–24.

Crosbie, J.C. 2003. "Overview Paper'on the 1985 Canada-Newfoundland Atlantic Accord." Prepared for the Royal Commission on Renewing and Strengthening Our Place in Canada. Available at www.gov.nl.ca/publicat/royalcomm/research/Crosbie.pdf

Drummond, D. 2007. "The Equalization Standard," In P. Boothe and F. Vaillancourt, eds. *A Fine Canadian Compromise: Perspectives on the Report of the Expert Panel on Equalization and Territorial Funding Financing*. Institute for Public Economics and CIRANO. Edmonton: University of Alberta.

Economic Council of Canada. 1982. *Financing Confederation: Today and Tomorrow*. Supply and Services: Ottawa.

Expert Panel on Equalization and Territorial Formula Financing (2006) *Achieving a National Purpose: Putting Equalization Back on Track*. Department of Finance Canada: Ottawa.

Feehan, J. P. 2005. "Equalization and the Provinces' Natural Resource Revenues: Partial Equalization Can Work Better." In *Canadian Fiscal Arrangements: What Works, What Might Work Better*, ed. H. Lazar. Montreal and Kingston: McGill-Queen's University Press.

Norris, D. 2003. "The Fiscal Position of Newfoundland and Labrador." Prepared for the *Royal Commission on Renewing and Strengthening Our Place in Canada*. Available at www.gov.nl.ca/publicat/royalcomm/research/Norris.pdf

Royal Commission on Renewing and Strengthening Our Place in Canada. 2003. *Our Place in Canada: Main Report*. St. John's: Queen's Printer.

Senate Standing Committee on National Finance. 2002. "The Effectiveness of and Possible Improvements to the Present Equalization Policy." Ottawa: Senate of Canada.

Smart, M. 2007. "Equalization and Resource Taxation." In P. Boothe and F. Vaillancourt, eds. *A Fine Canadian Compromise: Perspectives on the Report of the Expert Panel on Equalization and Territorial Funding Financing*. Institute for Public Economics and CIRANO. Edmonton: University of Alberta.

Williams, D. 2004. Letter to Prime Minister Paul Martin. Available at www.releases.gov.nl.ca/releases/2004/exec/june10.pdf

11

Changes to Canada's Major Federal-Provincial Transfer Programs: Implications for the Maritime Provinces

Paul A.R. Hobson and L. Wade Locke

Cet article évalue les implications du fédéralisme fiscal du budget fédéral de 2007 pour les provinces maritimes. Un résultat clé de l'analyse des auteurs est que, bien que les provinces maritimes soient mieux loties, au départ, dans le cadre du nouveau programme de péréquation, à la longue, et cumulativement, la formule de 2004 dominerait. Pourquoi alors, les auteurs questionnent, est-ce que la structure de 2004 n'est disponible que pour la Nouvelle-Écosse et Terre-Neuve-et-Labrador? Ils analysent aussi les implications de la conversion des transferts canadiens en matière de programmes sociaux, et (plus tard) des transferts canadiens en matière de santé, à l'égalité par habitants des transferts de fonds. Ils notent qu'ici, la redistribution des fonds sera vers l'Ontario et l'Alberta, et que les trois provinces maritimes en perdront, comparé aux provinces à haut revenu par habitant. Cet article termine en portant attention sur les implications moins évidentes de la nouvelle formule de péréquation.

INTRODUCTION

Budget 2007 presented a new equalization program for Canada. This was not the program for which any of the three Maritime provinces had advocated. While all three had wanted the return to the ten-province standard that was part of the new equalization program, they had also lobbied for 100 percent inclusion of natural resource revenues in the determination of provincial fiscal capacities. Despite these efforts, equalization entitlements are to be calculated based on a formula that includes only 50 percent of natural resource

revenues in the measurement of provincial fiscal capacities.[1] In addition, a total fiscal capacity cap was introduced, designed to ensure that equalization payments do not raise any province's total fiscal capacity above that of any non-receiving province. Where a province's total fiscal capacity – measured as the sum of non-resource revenue fiscal capacity, natural resource revenue fiscal capacity (100 percent inclusion), per capita offset payments arising from the Nova Scotia and Newfoundland and Labrador Accords, and per capita equalization entitlements (pre-cap) – exceeds that of the lowest non-receiving province, equalization payments will be reduced; indeed, they may be completely eliminated.

Although reaction to these changes was strong in Nova Scotia, they were quite muted in Prince Edward Island and New Brunswick. The Government of Nova Scotia seemed prepared to accept the new equalization program in principle, but argued that any clawback of offshore revenues resulting from the operation of the total fiscal capacity cap should be restored to the province under the terms of the Canada-Nova Scotia Offshore Petroleum Resources Accord and the subsequent *Nova Scotia and Newfoundland and Labrador Additional Fiscal Equalization Offset Payments Act.*

Special provision was made, however, for Nova Scotia, whereby the province was given the option of remaining under the fixed framework with an opportunity to permanently opt into the new equalization program at a future date.[2] With this the province faced a choice between two packages: its equalization entitlement under the fixed framework and the associated offset payment under the Accord, without any cap on total fiscal capacity, and its equalization entitlement under the new equalization program along with the associated offset payment under the Accord, but with a fiscal capacity cap.

For Nova Scotia there was, in fact, no issue for 2007–08. The province was allowed to elect to receive an equalization payment of $1,308 million under the fixed framework and an associated offset payment of $130 million under the Accord, or an equalization payment of $1,465 million under the new equalization program and an associated offset payment of $68 million under the Accord. In total, the province is better off under the latter ($1,533 million versus $1,438 million, a difference of $95 million). In electing to receive the

[1] There is, in fact, a variant on the formula which provides for 100 percent exclusion of natural resource revenues for purposes of determining fiscal capacity. A province's equalization *entitlement* is to be determined as the greater of the two amounts resulting from the application of the two versions of the formula. A province may, however, elect to have its equalization entitlement computed according to the 50 percent inclusion formula, should this prove to be to its overall benefit.

[2] Identical provision was made for Newfoundland and Labrador.

latter set of payments, the province is not deemed to have opted into the new equalization program – put differently, they were simply asked to choose between two sets of numbers. Beyond 2007–08, however, the province must make its choice between the fixed framework and the new equalization program; if at any point in the future it chooses the new equalization program, then it will be deemed to have opted in permanently.

The issues surrounding the new equalization program, particularly the total fiscal capacity cap, are dominated by those associated with accommodating natural resource revenues. The total fiscal capacity cap is inexorably tied to the issue of natural resource revenues. By design, it is only the inclusion of 100 percent of natural resource revenues and any associated offset payments through the Accords in the calculation of total fiscal capacity that can trigger the cap process. As such, the cap process would seem to undermine the intent of the Accords in both Nova Scotia and Newfoundland and Labrador.[3]

Modelling both the new equalization program and the option of the fixed framework is essential to understanding the issues around the choice that Nova Scotia must make and whether the other Maritime provinces are better off with the new equalization program than under the fixed framework, had the same option been presented to them.

While it has not received much debate publicly, Budget 2007 also began a process of converting the Canada Social Transfer (CST) and the Canada Health Transfer (CHT) to equal per capita cash bases. This has significant implications for provincial fiscal capacities, since the per capita value of the associated tax points under both CST and CHT varies across provinces. The former method of taking into account the value of the tax points in determining the allocation of CST and CHT cash across provinces provided an additional source of equalization of fiscal capacities across provinces. For CST, this has now been eliminated; similarly, for CHT it will be eliminated in 2014. Notwithstanding that the associated tax points are eligible for equalization, the residual method of calculating per capita cash entitlements raised all provinces (not just those that receive equalization) to a top-province standard, thereby ensuring an equal per capita total – cash plus the value of the tax points – allocation. Thus, in 2006–07, while Ontario received less cash per capita than

[3] The specific and stated intent of the accords were (1) under the Nova Scotia Accord, it specified that the Accord was to provide "100 per cent protection from Equalization reductions resulting from the inclusion of offshore resource revenues in the Equalization program," and (2) for Newfoundland and Labrador, it specified that the Accord was to provide "additional offset payments to the province in respect of offshore-related Equalization reductions, effectively allowing it to retain the benefit of 100 per cent of its offshore resource revenues."

equalization-receiving provinces (all but Ontario and Alberta in that year), it received more than Alberta, the province with the highest per capita value for the associated tax points. Any equal per capita cash transfer is equalizing, given disparities in fiscal capacities across provinces; one that is biased in favour of those provinces with fiscal capacities below the top province is even more equalizing.

This paper evaluates the impact of both the equalization provisions and the CST provisions contained in Budget 2007 on total fiscal capacities in each of the Maritime provinces. We begin by simulating the equalization outcomes for all provinces through 2019–20. The year 2019–20 becomes the relevant time horizon because Budget 2007 creates a loop between equalization payments and payments under the offshore accords between the federal government and the provinces of Newfoundland and Labrador and Nova Scotia. Under current legislation, these accords expire in that year. Equalization choices that must be made by Newfoundland and Labrador and Nova Scotia under Budget 2007 cannot be divorced from the implications for Accord payments. And the choices made by those provinces may well cause other provinces to ask why they were not offered the same option.

We provide estimates for equalization payments to each of the Maritime provinces under both the fixed framework and the new equalization program. We then provide estimates for per capita cash CST and CHT entitlements. Together with equalization entitlements, this allows us to model fiscal capacities across provinces.

SIMULATION METHODOLOGY

The basic framework utilized for calculating equalization entitlements (pre-cap) and equalization payments (post-cap) was taken from the Budget Plan and the *Budget Implementation Act*. The oil revenue for Newfoundland and Labrador was calculated based on a publicly available oil price forecast and production profiles.[4] The assumed exchange rate was $0.87 US/CDN and the annual inflation rate was 2 percent. As well, an additional $150 million in non-oil fiscal capacity was added to the Newfoundland and Labrador estimates to reflect the impact of Voisey's Bay and other new mines starting in the province. The natural gas revenue for Nova Scotia was projected forward

[4] Oil prices were based on Sproule's 28 February 2007 forecast and the production profile was based on a Canada-Newfoundland and Labrador Offshore Petroleum Board forecast given at Petroleum Research Atlantic Canada's Small Field Development Conference in St. John's on 25 March 2007.

based on the assumed decline path for royalties that gave a total provincial royalty of $2.4 billion for the life of the Sable project and an additional 15 percent to account for provincial corporation income taxes that would be payable. It was assumed that per capita non-oil and gas fiscal capacity grew at 1.4 percent per annum from the levels utilized in the federal budget.[5] The non-oil-and gas fiscal capacities for every province were taken from information obtained from Finance Canada for the most recent years utilized in the budget. The relative fiscal capacities across provinces were held constant over time, except for the effects of oil and gas revenues.

EQUALIZATION OUTCOMES AND THE MARITIME PROVINCES

NOVA SCOTIA

Table 1 and Appendix 2, tables A2-1 through A2-3, provide estimates for Nova Scotia under each of the fixed framework and new equalization programs, under both the 50 percent and 0 percent inclusion options. As was mentioned above, for 2007–08 Nova Scotia is better off under the new equalization formula. Since, in any event, the province had the option under Budget 2007 of receiving an equalization payment of $1,465 million (calculated according to the O'Brien formula) and an associated offset payment of $68 million under the Accord rather than payments calculated under the fixed framework, its decision to take the deal in 2007–08 is clearly rational. Moreover, in so doing, the province is not deemed to have opted in to the new equalization program.

For 2008–09, the situation is more problematic. The province is better off in total taking the $1,578 million under the new equalization program than $1,514 million under the fixed framework. To do so, however, requires that the province opt into the new equalization program, forever forfeiting its right to the fixed framework. In 2009–10, however, the province would be better off in total under the fixed framework, as, indeed, it would be in every fiscal year through 2019–2020. The additional $64 million in revenues in 2008–09 under the new equalization program is more than offset by the loss of $96 million in 2009–2010 from having given up the fixed framework option. For

[5] The 1.4 percent growth assumption was based on the actual growth rate in non-offshore oil and gas fiscal capacity in the last 10 years for Canada as a whole. To test the sensitivity of the results to this assumption, a 2 percent growth assumption was also utilized. While the specific numerical estimates were altered, the basic conclusion remained intact. That is, the conclusions reached in this paper were not changed by varying the growth assumption from 1.4 percent to 2 percent.

Table 1: Nova Scotia Equalization Estimates

Year	Fixed framework $	New program $	Difference $
2007–08	1,438	1,533	95
2008–09	1,514	1,578	64
2009–10	1,565	1,469	-96
2010–11	1,630	1,454	-176
2011–12	1,680	1,474	-206
2012–13	1,720	1,574	-146
2013–14	1,765	1,660	-105
2014–15	1,808	1,715	-93
2015–16	1,855	1,738	-117
2016–17	1,900	1,762	-138
2017–18	1,942	1,785	-157
2018–19	1,982	1,807	-175
2019–20	2,022	1,830	-193
Sum	22,821	21,378	-1,443

Note: Column totals may not be exact due to rounding.

Nova Scotia, then, remaining with the fixed framework would appear to be the rational choice. Our estimates suggest that, in total, through 2019–20, the province would receive $22,821 million as opposed to $21,378 under the new equalization program, a difference of $1,443 million.

It is true that the province would receive more equalization under the new equalization program in each of fiscal 2009–10 and 2010–11, but the accompanying reductions in offset payments under the Accord render the province better off in total only in 2007–08 and 2008–09 under the new equalization program.[6] And, as mentioned above, opting into the new equalization program in 2008–09 would leave the province worse off in subsequent fiscal years relative to the fixed framework.[7]

[6] See tables A2-1 and A2-2.

[7] It is interesting to note that, under the new equalization program, Nova Scotia would be better off in total under the O'Brien formula than under the 0 percent inclusion formula, even though its equalization payment would be greater under 0 percent inclusion than under O'Brien in each of 2009–10 through 2011–12. In order to receive that benefit, the province would have to request that its payment be calculated under O'Brien rather than the 0 percent formula.

It is also interesting to note that, under the new equalization program, the fiscal-capacity cap bites in each year from 2009–10 through 2013–14. The equalization reduction due to the cap claws back $142 million of the provinces' offset payment of $167 million in 2009–10. Similarly, in 2010–11, $167 million of the $178 million in offset payment is lost through the operation of the cap. Figure 1, below, illustrates the clawback for 2010–2011.

Step 1 illustrates the calculation of Nova Scotia's (pre-cap) equalization entitlement – the difference between the ten-province standard and Nova Scotia's own-source fiscal capacity, measured as the sum of its non-resource fiscal capacity and 50 percent of its resource fiscal capacity.

Step 2 illustrates the calculation of Nova Scotia's total fiscal capacity – measured as above but with the addition of the remaining 50 percent of its fiscal capacity (excluded from the calculation of its equalization entitlement) and any offset payments made pursuant to the off-shore Accords.

Step 3 illustrates the total fiscal capacity for the lowest non-receiving province (Ontario).

Step 4 illustrates how the equalization reduction is calculated to ensure that Nova Scotia's equalization payment does not raise its total fiscal capacity above the level of the lowest non-receiving province. While this is formally accomplished via a reduction in equalization (compare step 2 and step 4 of figure 1), it can also be viewed as equivalent to a clawback on offset payments made under the Accord. For 2010–11, for example, this clawback on offset payments is estimated to be $167 million.

Figure 1: The Total Fiscal Capacity Cap

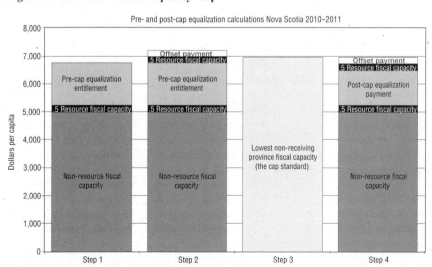

For 2010–2011, this amounts to a clawback on offset payments made under the Accord estimated to be $167 million.

Between 2009–2010 and 2013–14 (a five-year period), equalization reductions due to the cap are estimated to amount to $611 million. This can be interpreted to be a $611 million clawback on the $786 in offset payments under the Accord projected for the same period – in other words, 78 percent of the Accord payment is clawed back through equalization reductions.

If the spirit and the letter of the Accords were to protect against such clawbacks through equalization, then, in our opinion, there is a legitimate case to be made for further additional offset payments under the Accord legislation.

In total, between 2009–10 and 2013–14, the equalization reductions due to the cap would amount to $611 million. Set against offset payments of $1,208 million over the same period, this amounts to a clawback of 51 percent of offset payments over that period.

NEW BRUNSWICK

Budget 2007 places New Brunswick under the new equalization program, ostensibly because it yields a higher equalization payment. Indeed, as shown in table 2, this is the case in 2007–08 and 2008–09. For 2007–08, the province

Table 2: New Brunswick Equalization Estimates

Year	Fixed framework $	New program $	Difference $
2007–08	1,435	1,477	41
2008–09	1,486	1,513	27
2009–10	1,543	1,539	-4
2010–11	1,600	1,549	-51
2011–12	1,638	1,573	-66
2012–13	1,670	1,595	-76
2013–14	1,707	1,615	-92
2014–15	1,743	1,637	-106
2015–16	1,782	1,658	-124
2016–17	1,819	1,680	-139
2017–18	1,854	1,702	-152
2018–19	1,888	1,723	-165
2019–20	1,924	1,744	-179
Sum	22,090	21,005	-1,085

Note: Column totals may not be exact due to rounding.

receives an additional $41 million in equalization payments (relative to what would have been received under the fixed framework) and for 2008–09 it receives an additional $27 million. In subsequent years, however the province receives less equalization than under the fixed framework. Projected through to 2019–20, the province would be worse off by $1,085 million.

PRINCE EDWARD ISLAND

As with New Brunswick, Budget 2007 places Prince Edward Island under the new equalization program, again ostensibly because it yields a higher equalization payment. As shown in table 3, this is the case in 2007–08 and 2008–09. For 2007–08, the province receives an additional $3 million in equalization payments (relative to what would have been received under the fixed framework) and for 2008–09 it receives an additional $4 million. In subsequent years, however the province receives less equalization than under the fixed framework. Projected through to 2019–20, the province would be worse off by $196 million.

Table 3: Prince Edward Island Equalization Estimates

Year	Fixed framework $	New program $	Difference $
2007–08	291	294	3
2008–09	301	305	4
2009–10	312	311	-1
2010–11	323	314	-9
2011–12	330	319	-11
2012–13	336	323	-13
2013–14	344	328	-16
2014–15	351	332	-19
2015–16	358	336	-22
2016–17	365	341	-25
2017–18	372	345	-27
2018–19	379	350	-29
2019–20	386	354	-32
Sum	4,448	4,253	-196

Note: Column totals may not be exact due to rounding.

TOTAL FISCAL CAPACITIES

The traditional way of representing provincial fiscal capacities has been to use the definition of fiscal capacity utilized for purposes of determining equalization entitlements. Thus, for example, if only 50 percent of resource revenues were included in the determination of equalization entitlements within resource categories, this would be the measure used for representing resource fiscal capacity. Adding equalization entitlements to such a measure, then, shows equalization at work – raising fiscal capacity in each recipient province to the equalization standard. Thus, all recipient provinces are seen to have a uniform fiscal capacity after equalization.

This is not pertinent to the system under Budget 2007, since there are now potentially three equalization systems at work. For 2007–08, for example, our overall analysis suggests that Newfoundland and Labrador remains under the fixed framework, which calculates fiscal capacities including 100 percent of natural resource revenues, Prince Edward Island, Nova Scotia, New Brunswick, Quebec and Manitoba function under the 50 percent natural resource inclusion formula, and Saskatchewan and British Columbia function under the 0 percent natural resource revenue inclusion formula (excluding all natural resource revenues in determining equalization entitlements). There is, therefore, no single measure of fiscal capacity that can be used to make comparisons across provinces.

In fact, what Budget 2007 does is it defines a new and (almost) uniform measure of fiscal capacity for purposes of determining a province's eligibility to *receive* an equalization payment, namely total fiscal capacity. As discussed previously, total fiscal capacity is the sum of non-resource revenue fiscal capacity, natural resource fiscal capacity (100 percent inclusion), per capita payments under the Accords (specific to Newfoundland and Labrador and Nova Scotia), and per capita equalization entitlements (pre-cap). In order to be eligible to receive an equalization payment, no province's total fiscal capacity, so measured, can exceed that of the lowest non-receiving province (Ontario). This is almost a uniform measure only because Newfoundland and Labrador and Nova Scotia have the option of having equalization payments determined under an extension of the fixed framework, which would not include Accord payments in the determination of eligibility to receive equalization payments.

The calculation of equalization entitlements is purely a side calculation under the new program. Actual payments are governed by the cap process. As mentioned previously, the cap process can result in a province's equalization payment being reduced, indeed eliminated, relative to its pre-cap entitlement.

In order to capture equalization at work, we therefore use the Budget 2007 measure of total fiscal capacity, inclusive of Accord payments, to compare outcomes across provinces before and after equalization payments.

Figure 2 shows total fiscal capacities in 2007–08 for each of the Maritime provinces and for the 10 provinces combined. Non-resource (NR) fiscal capacity dominates the calculation in all cases. For PEI, resource (R) fiscal capacity is negligible and for both Nova Scotia and New Brunswick resource fiscal capacities are small relative to non-resource fiscal capacities. In all three cases, equalization payments constitute an important component of total fiscal capacity.

Figure 2: Total Fiscal Capacities, 2007–08

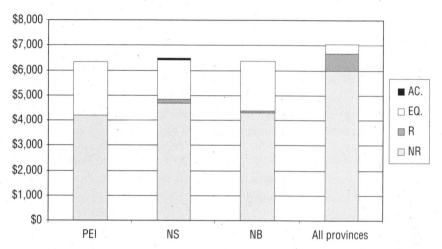

As expected, even after equalization there is a disparity in fiscal capacities among the three Maritime provinces, and all three remain well below that for all provinces combined. It seems odd as a principle of federalism that total fiscal capacities can differ among equalization-receiving provinces, but that equalization payments to any province cannot cause total fiscal capacity to exceed that of the lowest non-receiving province. That is to say, it is somewhat incongruous that Nova Scotia can have a higher total fiscal capacity than either New Brunswick or Prince Edward Island, inclusive of equalization payments, but cannot exceed that of Ontario.

Appendix 3 provides a breakdown of total fiscal capacities for each of the three Maritime provinces through 2019–20, based on the new program. The patterns illustrated in figure 2 prevail through to 2017–18, in which fiscal year (as a consequence of the assumption that Nova Scotia's off-shore revenues dry up in 2015–16) New Brunswick assumes the mantle of the Maritime province with the highest fiscal capacity.

THE CST AND CHT

Table 4 provides an estimate of cash transfers to each of the Maritime provinces under CST and CHT through 2013–14, the year to which these transfers are both now legislated. In particular, Budget 2007 legislates CST through 2013–14; previous legislation would have expired in 2008–09. CHT had been legislated through to the same year under a previous budget. An increase in CST cash transfers of $300 million had been previously legislated for 2007–08, to be allocated to provinces and territories in accordance with their respective population shares. A further $687 million was allocated in Budget 2007 to equalize per capita cash transfers under the CST across all provinces and territories.[8] For 2008–09, a further $800 million is provided for post-secondary education under the CST as well as $250 million for child care. Beyond 2008–09, the CST is to be escalated at 3 percent per annum through 2013–14.

In considering these additional cash infusions, two competing visions of horizontal equity are relevant. The first of these calls for equality of total per capita entitlements, and would bring the sum of the per capita cash transfer, the per capita tax-point transfer, and the associated equalization up to the level of the richest province, i.e., Alberta. With this equality achieved, the logic of this approach would require that any additional cash infusions be allocated on an equal per capita basis. The competing view of equity implicitly assumes that the equalization formula already and fully addresses the issue of differences in the value of transferred tax points; horizontal equity in the allocations of CST entitlements thus requires equal per capita cash transfers.

Acceptance of the second view of horizontal equity is clearly implied by the $687 million provided in the 2007 budget to bring Alberta and Ontario to the per capita cash transfer level of the rest of the provinces. This is the amount

[8] Previously, per capita cash transfers under the CST were calculated as the difference between an equal per capita total entitlement and the province's per capita value of a portion of the associated income tax points (inclusive of associated equalization). The associated income tax points go back to tax point transfers between the federal government and the provinces under earlier post-secondary education funding arrangements and the transition to Established Programs Financing (EPF) in 1977. Per capita total entitlement was calculated as a province's population share of the sum of total cash to be allocated and the total value of the designated portion of the associated tax points (inclusive of equalization). Since the equalized value of the tax points per capita differed across province/territories, so too did the per capita cash transfer. In particular, all three Maritime provinces have below average income tax capacities inclusive of equalization and, accordingly, received above average cash per capita.

necessary to correct what adherents to this view of equity consider to be the past inequity of unequal per capita cash transfers. It is thus an amount that would not be on the table were the first view of horizontal equity – equal *total* per capita entitlements – still dominant. It is still the case, however, that the end result of this amount not being distributed on an equal per capita basis is a deterioration in the relative position of the Maritime provinces.

Table 4 provides some estimates of this deterioration. Panel A and Panel C present the total and per capita values of the CST cash transfers to the Maritime provinces for the new version (only the $300 million is allocated on an

Table 4: Canada Social Transfer (Cash)

Panel A: Total Entitlements ($ millions)			Panel B: Total Entitlements ($ millions) (with equal per capita sharing of the $687 million)				
PEI	*NS*	*NB*		*PEI*	*NS*	*NB*	
2006–07	$39	$264	$212	2006–07	$39	$264	$212
2007–08	$40	$270	$217	2007–08	$43	$292	$235
2008–09	$44	$300	$241	2008–09	$48	$322	$259
2009–10	$46	$309	$248	2009–10	$49	$332	$267
2010–11	$47	$318	$256	2010–11	$51	$342	$275
2011–12	$49	$328	$264	2011–12	$52	$352	$283
2012–13	$50	$338	$271	2012–13	$54	$363	$291
2013–14	$52	$348	$280	2013–14	$55	$374	$300
Total	$366	$2,475	$1,989	Total	$390	$2,642	$2,121
	Population shares			Difference	$23	$166	$132
	0.004	0.029	0.023				

Note: Column totals may not be exact due to rounding.

Panel C: Per Capita Entitlements ($)			Panel D: Per Capita Entitlements (with equal per capita sharing of the $687 million)				
PEI	*NS*	*NB*		*PEI*	*NS*	*NB*	
2006–07	$282	$282	$283	2006–07	$282	$282	$283
2007–08	$289	$289	$289	2007–08	$312	$313	$313
2008–09	$321	$321	$322	2008–09	$344	$345	$345
2009–10	$331	$331	$331	2009–10	$355	$355	$356
2010–11	$341	$341	$341	2010–11	$365	$366	$366
2011–12	$351	$351	$352	2011–12	$376	$377	$377
2012–13	$362	$361	$362	2012–13	$388	$388	$389
2013–14	$373	$372	$373	2013–14	$399	$400	$400

equal per capita basis to the Maritime provinces with no allocation from the $687 million). Panels B and D show the corresponding values for the traditional approach (where both the $300 million and the $687 million are allocated equally per capita). Equal per capita allocation would have provided PEI with an additional $3 million (approximately) annually through 2013–14 (compare Panels A and B), with the cumulative total of $23 million over the 7 years appearing as the last row of Panel B. For Nova Scotia, the equivalent amount is an additional $22 million annually, or $166 million over 7 years (again Panels A and B). For New Brunswick, it would have been an additional $18 million annually or $132 million over 7 years.

The first or traditional version of horizontal equity will continue to apply to the CHT until 2014, at which point the system will convert to equal per capita cash transfers. Since the overall CHT cash transfer is more than double the overall CST cash transfer, the funds needed to generate equal per capita cash transfers across all provinces will be correspondingly greater than the $687 million needed for CST equality.

By way of a concluding comment, the allocation of the $687 million of new CST money to bring Ontario and Alberta cash transfers to the level of the other provinces (rather than allocating it on the traditional basis of equal cash transfers across *all* provinces) has served to increase the disparities in provincial fiscal capacities. Specifically, the provincial fiscal capacity in each of the Maritime provinces would have increased by $24 per capita in 2008–09 (compare Panels C and D for 2007–08, with a bit of rounding error), relative to what currently exists. Moreover, the commitment in Budget 2007 to similarly place the CHT on an equal per capita cash footing will magnify these disparities.

CONCLUSION

It is worthwhile to attempt to summarize the overall impact of Budget 2007 for the practice of equalization in Canada. In effect, Budget 2007 introduces an entirely new standard for eligibility to receive an equalization payment. That standard is a lowest non-receiving-province standard: only provinces with a total fiscal capacity – measured as non-resource fiscal capacity plus resource fiscal capacity (100 percent inclusion) and any per capita payments under the Accords – below that of the lowest non-receiving province (Ontario) are eligible to receive an equalization payment. Historically, any province with a measured fiscal capacity for purposes of determining equalization entitlements that is below the equalization standard has been eligible to receive an equalization payment. This is now no longer the case.

For those provinces that are deemed eligible to receive an equalization payment, the amount of that payment is determined by formula: a ten-province

standard with fiscal capacities measured either as non-resource fiscal capacity alone or as non-resource fiscal capacity plus 50 percent of resource fiscal capacity. Those provinces with measured fiscal capacity below the standard are eligible for an equalization payment that is the higher of the two amounts. However, should the payment for which a province is eligible raise its total fiscal capacity above that of the lowest non-receiving province, that payment is reduced accordingly.

What is being described here is, effectively, a two-stage process. First, determine a province's eligibility to receive an equalization payment (total fiscal capacity before equalization that is below that of the lowest non-receiving province). Second, if a province is eligible to receive an equalization payment, determine the amount in accordance with the new program. While the measure of fiscal capacity used to calculate equalization entitlements will be of import at this stage (in terms of the standard and amounts of entitlements), this involves only a side calculation in determining the ultimate measure of fiscal capacity, namely total fiscal capacity before and after equalization payments. It is this measure that is to be used to compare provinces' fiscal capacities.

In this paper, we have attempted to evaluate the impact on total fiscal capacities in each of the three Maritime provinces resulting from the equalization provisions contained in Budget 2007 and from changes to the CST. We began by simulating the equalization outcomes for all provinces through 2019–20. Equalization choices that must be made by Nova Scotia under Budget 2007 cannot be divorced from their implications for Accord payments. And the choices made by Nova Scotia may well cause other provinces to ask why they were not offered the same.

Accordingly, we provided estimates for equalization payments to each of the three Maritime provinces under both the fixed framework and the new program. The results indicate that New Brunswick, Prince Edward Island and Nova Scotia are better off under the new program for two years only, and thereafter they are disadvantaged, relative to the fixed framework.

Furthermore, we have attempted to illustrate the questions that must be addressed by Nova Scotia in making the choices with which they were presented in Budget 2007. For other provinces no choices had to be made, but, had they been treated equally with their companion provinces, they too might have opted to remain under the fixed framework. In particular, we have tried to give some context to the notion that no province should be made worse off under the new equalization program presented in Budget 2007.

Budget 2007 raises very different issues for Newfoundland and Labrador and Nova Scotia. For Newfoundland and Labrador, it's all about equalization. Only a formula based on 0 percent resource revenue inclusion (and no total-fiscal-capacity cap) would have kept the province in equalization. A pre-cap trigger on additional offset payments would, however, have kept the province

in the Accord. None of this was on offer, however. Clearly, the 0 percent re-source inclusion and no cap on total fiscal capacity would similarly have been attractive to Saskatchewan.

For Nova Scotia, on the other hand, it's all about the Accord. As we under-stand the Nova Scotia government's position, it is that the receipt of its offshore revenues is projected to cause the province to exceed the cap and thereby reduce the province's equalization payment. It is then argued that the 2005 Agreement protects the province from any such reduction by requiring that Ottawa make additional offset payments. This argument appears to us to be entirely valid.

It may, however, be more than just about the Accord: as we have illustrated, the province may well be better off remaining under the fixed framework. If it were to do so, there would be two equalization programs in operation. It is hard to imagine such a system being allowed to continue under subsequent budgets. It would, for example, be simple to restrict growth in equalization payments under the fixed framework to be no greater than what they would have been under the new equalization program.

Generally, under Budget 2007, respecting the Accords would have required a positive pre-cap equalization-eligibility trigger for Accord payments. Fur-ther, provision should have been made that any equalization reductions resulting from the application of the fiscal-capacity cap would be compen-sated for through additional offset payments.

Finally, we have provided estimates of cash transfers under CST and CHT through 2013–14 for each of the Maritime provinces. In addition, we have estimated that, had the $687 million that was earmarked to equalize per capita cash transfers under the CST during 2007–08 been distributed on an equal per capita basis, Prince Edward Island would have benefited to the tune of $23 million over 7 years ($3 million annually), Nova Scotia by $166 million ($22 million annually), and New Brunswick by $132 million ($18 million annu-ally). These are significant amounts. Moreover, equal per capita distribution would have further mitigated disparities in overall fiscal capacities across provinces.

APPENDIX 1
THE OFFSHORE ACCORDS

The Atlantic Accord, signed in 1985, and the Canada-Nova Scotia Offshore Petroleum Resources Accord, signed in 1986, gave Newfoundland and Labrador and Nova Scotia, respectively, the right to collect royalties and to levy taxes on offshore operations as if the resources were on provincial land. In addition, the Accords provide equalization offset provisions to compensate for potential reductions in equalization payments as these additional revenues come on stream.

CANADA-NOVA SCOTIA PETROLEUM RESOURCES ACCORD

The equalization protection provided under the Nova Scotia Accord commenced in 1993–94 with the Panuke-Cohasset project. The formula applied to equalization offset protection was relatively straightforward. In the first year, the offset grant would be calculated as the difference between provincial equalization entitlements that would accrue to the province under the assumption that 100 percent and 10 percent of the offshore revenues were considered, which effectively means that 90 percent of these revenues were protected from equalization losses. In each subsequent year, an additional 10 percent of the revenue was considered in calculating the equalization losses, so that by the tenth year, there was no equalization offset protection available under the Nova Scotia Accord. Notwithstanding that the equalization protection under the Nova Scotia Accord was triggered by the Panuke-Cohasset project, the 2004 federal budget reset the start date for Nova Scotia's equalization offset protection under its Accord.[9] This change recognized that the Nova Scotia Accord did not provide very much in the way of benefits to the Nova Scotia treasury. Moreover, the equalization protection provided with this new start date meant that Nova Scotia received equalization offsets over and above those provided under the Generic Solution until 2006–07.

THE 2005 NOVA SCOTIA AND NEWFOUNDLAND AND LABRADOR ADDITIONAL FISCAL EQUALIZATION OFFSET PAYMENTS ACT

The 2005 Nova Scotia and Newfoundland and Labrador Additional Fiscal Equalization Offset Payments Act provided for additional equalization offset

[9] The 2000–01 start corresponds to the commencement of natural gas production from the Sable project – first gas was delivered ashore in late 1999.

payments to Nova Scotia and Newfoundland and Labrador to ensure that each province would continue to receive 100 percent of the benefit of its offshore revenues. That is, offset payments would ensure no clawback of offshore revenues through equalization.

Specifically, s.8 of the Act reads as follows:

> The additional fiscal equalization offset payment that shall be made to the Province for a fiscal year corresponds to the amount determined by the Minister in accordance with the formula

$$(A - B) - C$$

> where

>> A is the fiscal equalization payment that may be made to the Province for the fiscal year *under the equalization formula in effect at that time, calculated as if the Province did not have any offshore revenue or petroleum production*;

>> B is the fiscal equalization payment that may be made to the Province for that fiscal year *under the equalization formula in effect at that time*; and

>> C is the fiscal equalization offset payment for that fiscal year [italics added].

These *additional* equalization offset payments ensure that, should there be a *change* in the equalization formula, the Province will be fully compensated for any resulting clawback of offshore revenues.

There are, however, restrictions under the Act. Most importantly, that "[f]or any given fiscal year between April 1, 2006 and March 31, 2012, the Province will not receive the additional fiscal equalization offset payment [calculated as above] ... *if it does not receive a fiscal equalization payment for that fiscal year*" [italics ours].

The Budget Implementation Bill (Bill C-52) made certain changes to *The 2005 Nova Scotia and Newfoundland and Labrador Additional Fiscal Equalization Offset Payments Act*. Specifically, additional offset entitlements are to be calculated on a pre-cap basis – that is, as the difference between equalization entitlements based on a ten-province standard and with 0 percent inclusion of natural resource revenues and equalization entitlements based on a ten-province standard and 50 percent inclusion of natural resource revenues (the O'Brien formula). In addition, a province is deemed to be ineligible for a payment under the Act if its total own-source fiscal capacity (non-resource plus resource fiscal capacity) exceeds that of the lowest non-equalization receiving province.

Under Budget 2007, the inclusion of 100 percent of offshore oil and gas revenues in the determination of total fiscal capacity for purposes of the cap

can result in a province with a positive equalization entitlement (pre-cap) receiving a reduced equalization payment or no equalization payment. Yet, under the 2005 Act, the province is entitled to additional offset payments to compensate for any such reduction. Moreover, 100 percent inclusion of off-shore oil and gas revenues may result in a province having a fiscal capacity, measured as the sum of non-resource fiscal capacity and resource fiscal capacity, that exceeds that of the lowest non-receiving province, thereby making the province ineligible for an equalization payment (even though it has a positive entitlement pre-cap). This would make the province ineligible for an additional offset payment also, yet it clearly contradicts the notion that such payments should be calculated as the difference between the equalization payment it would obtain *under the equalization formula in effect at that time, calculated as if the province did not have any offshore revenue or petroleum production* and the equalization payment it obtains *under the equalization formula in effect at that time.*

Moreover, the definition of fiscal capacity for purposes of the trigger that would invoke the restriction on additional offset payments mentioned above under Bill C-52 violates the Accord, since it can deny a province its additional offset payment precisely because it has offshore oil and gas revenue. While this may not be a matter of immediate concern to Nova Scotia, it most certainly is to Newfoundland and Labrador. Newfoundland and Labrador is in the peculiar position that it can be denied additional offset payments precisely because it has offshore oil revenues – the ultimate clawback, and precisely that which the Accords were intended to ensure against.[10]

Under Budget 2007, respecting the Accords would have required a positive pre-cap equalization eligibility trigger for Accord payments. Further, provision should have been made that any equalization reductions resulting from the application of the fiscal capacity cap would be compensated for through additional offset payments.

[10] To be sure, the long-standing position of the Government of Nova Scotia – that equalization should be based on a ten-province standard with 100 percent inclusion of resource revenues – would ensure that a province with a fiscal capacity, measured as the sum of non-resource fiscal capacity and resource fiscal capacity, above that of the lowest non-receiving province, and therefore above the equalization standard, would not qualify for an equalization payment and would, therefore, not be eligible for an additional offset payment. But that is not the Budget 2007 equalization program.

APPENDIX 2
NOVA SCOTIA: THE FIXED FRAMEWORK COMPARED
WITH THE NEW PROGRAM

Table A2-1: Nova Scotia: Fixed Framework

Year	Gas revenue	Offset payments	Equalization	Total
2007–08	$483	$130	$1,308	$1,921
2008–09	$386	$274	$1,240	$1,900
2009–10	$309	$329	$1,236	$1,874
2010–11	$247	$360	$1,270	$1,878
2011–12	$198	$288	$1,392	$1,877
2012–13	$158	$230	$1,490	$1,878
2013–14	$127	$184	$1,581	$1,892
2014–15	$101	$147	$1,661	$1,909
2015–16	$0	$118	$1,737	$1,855
2016–17	$0	$70	$1,831	$1,900
2017–18	$0	$31	$1,911	$1,942
2018–19	$0	$0	$1,982	$1,982
2019–20	$0	$0	$2,022	$2,022
Sum	$2,010	$2,161	$20,660	$24,831

Note: Column totals may not be exact due to rounding.

Table A2-2: Nova Scotia: New Equalization Program (50% Option)

Year	Gas revenue	Offset payments	Post–cap equalization	Total	Equalization reduction
2007–08	$483	$68	$1,465	$2,016	$0
2008–09	$386	$88	$1,490	$1,965	$0
2009–10	$309	$167	$1,301	$1,778	$142
2010–11	$247	$178	$1,277	$1,701	$167
2011–12	$198	$181	$1,293	$1,671	$173
2012–13	$158	$144	$1,429	$1,732	$97
2013–14	$127	$116	$1,544	$1,786	$33
2014–15	$101	$92	$1,623	$1,817	$0
2015–16	$0	$74	$1,664	$1,738	$0
2016–17	$0	$59	$1,703	$1,762	$0
2017–18	$0	$28	$1,757	$1,785	$0
2018–19	$0	$12	$1,795	$1,807	$0
2019–20	$0	$0	$1,830	$1,830	$0
Sum	$2,010	$1,208	$20,170	$23,388	$611

Note: Column totals may not be exact due to rounding.

Table A2-3: Nova Scotia: new equalization program (0% Option)

Year	Gas revenue	Offset payments	Post–cap equalization	Total	Equalization reduction
2007–08	$483	$0	$1,219	$1,702	$0
2008–09	$386	$0	$1,238	$1,624	$0
2009–10	$309	$0	$1,244	$1,553	$0
2010–11	$247	$0	$1,245	$1,492	$0
2011–12	$198	$0	$1,262	$1,460	$0
2012–13	$158	$0	$1,280	$1,438	$0
2013–14	$127	$0	$1,298	$1,425	$0
2014–15	$101	$0	$1,316	$1,417	$0
2015–16	$0	$0	$1,335	$1,335	$0
2016–17	$0	$0	$1,353	$1,353	$0
2017–18	$0	$0	$1,372	$1,372	$0
2018–19	$0	$0	$1,391	$1,391	$0
2019–20	$0	$0	$1,411	$1,411	$0
Sum	$2,010	$0	$16,965	$18,975	$0

Note: Column totals may not be exact due to rounding.

APPENDIX 3
TOTAL FISCAL CAPACITIES BY REVENUE CATEGORY

Fiscal Capacities by Revenue Category by Province
2007–08 to 2019–20

		NS	NB	PEI
2007–08	Non-resource fiscal capacity per capita	$4,669	$4,299	$4,177
	Resource fiscal capacity per capita	$159	$98	$6
	Post-cap equalization per capita	$1,564	$1,964	$2,133
	Accord fiscal capacity per capita	$73	$0	$0
	TOTAL	$6,465	$6,361	$6,316
2008–09	Non-resource fiscal capacity per capita	$4,808	$4,436	$4,293
	Resource fiscal capacity per capita	$202	$101	$6
	Post-cap equalization per capita	$1,592	$2,015	$2,205
	Accord fiscal capacity per capita	$94	$0	$0
	TOTAL	$6,697	$6,552	$6,504
2009–10	Non-resource fiscal capacity per capita	$4,918	$4,546	$4,397
	Resource fiscal capacity per capita	$377	$104	$6
	Post-cap equalization per capita	$1,391	$2,052	$2,251
	Accord fiscal capacity per capita	$179	$0	$0
	TOTAL	$6,866	$6,702	$6,653
2010–11	Non-resource fiscal capacity per capita	$4,989	$4,613	$4,457
	Resource fiscal capacity per capita	$400	$105	$6
	Post-cap equalization per capita	$1,365	$2,067	$2,273
	Accord fiscal capacity per capita	$190	$0	$0
	TOTAL	$6,944	$6,785	$6,735
2011–12	Non-resource fiscal capacity per capita	$5,058	$4,678	$4,519
	Resource fiscal capacity per capita	$406	$107	$6
	Post-cap equalization per capita	$1,383	$2,098	$2,307
	Accord fiscal capacity per capita	$193	$0	$0
	TOTAL	$7,041	$6,883	$6,832

... continued

		NS	NB	PEI
2012–13	Non-resource fiscal capacity per capita	$5,129	$4,743	$4,582
	Resource fiscal capacity per capita	$327	$108	$6
	Post-cap equalization per capita	$1,529	$2,128	$2,340
	Accord fiscal capacity per capita	$155	$0	$0
	TOTAL	$7,140	$6,979	$6,928
2013–14	Non-resource fiscal capacity per capita	$5,201	$4,810	$4,647
	Resource fiscal capacity per capita	$263	$110	$6
	Post-cap equalization per capita	$1,652	$2,155	$2,370
	Accord fiscal capacity per capita	$124	$0	$0
	TOTAL	$7,240	$7,074	$7,022
2014–15	Non-resource fiscal capacity per capita	$5,274	$4,877	$4,712
	Resource fiscal capacity per capita	$212	$111	$6
	Post-cap equalization per capita	$1,736	$2,183	$2,401
	Accord fiscal capacity per capita	$99	$0	$0
	TOTAL	$7,321	$7,172	$7,119
2015–16	Non-resource fiscal capacity per capita	$5,348	$4,945	$4,778
	Resource fiscal capacity per capita	$172	$113	$6
	Post-cap equalization per capita	$1,780	$2,212	$2,433
	Accord fiscal capacity per capita	$79	$0	$0
	TOTAL	$7,379	$7,270	$7,217
2016–17	Non-resource fiscal capacity per capita	$5,423	$5,014	$4,845
	Resource fiscal capacity per capita	$139	$114	$6
	Post-cap equalization per capita	$1,821	$2,242	$2,465
	Accord fiscal capacity per capita	$63	$0	$0
	TOTAL	$7,446	$7,370	$7,316
2017–18	Non-resource fiscal capacity per capita	$5,498	$5,085	$4,912
	Resource fiscal capacity per capita	$70	$116	$7
	Post-cap equalization per capita	$1,879	$2,270	$2,497
	Accord fiscal capacity per capita	$30	$0	$0
	TOTAL	$7,477	$7,471	$7,416

... continued

		NS	NB	PEI
2018–19	Non-resource fiscal capacity per capita	$5,575	$5,156	$4,981
	Resource fiscal capacity per capita	$36	$118	$7
	Post-cap equalization per capita	$1,920	$2,299	$2,529
	Accord fiscal capacity per capita	$13	$0	$0
	TOTAL	$7,544	$7,572	$7,517
2019–20	Non-resource fiscal capacity per capita	$5,653	$5,228	$5,051
	Resource fiscal capacity per capita	$9	$119	$7
	Post-cap equalization per capita	$1,957	$2,327	$2,561
	Accord fiscal capacity per capita	$0	$0	$0
	TOTAL	$7,619	$7,675	$7,618

Note: Column totals may not be exact due to rounding.

VI

Cities, Local Government, and Federalism

12

Rethinking Fiscal Federalism in Canada: A Local Government Perspective

Anwar Shah

Cet article présente une perspective internationale des récentes évolutions survenues au Canada en matière de fédéralisme fiscal. La première partie du document complimente le Canada sur la prise d'initiatives (par exemple, le retour à une péréquation fondée sur un système basé sur des principes) qui contribuent au rôle constant du Canada comme modèle décentralisé de fédération. La deuxième partie, toutefois, fait valoir que le Canada a besoin de se concentrer davantage sur les défis qui affectent les gouvernements locaux. À ce titre, la troisième partie porte sur une série de modèles de gouvernance pour les administrations locales et conclut que le modèle centré sur le citoyen est à privilégier. La dernière section présente ensuite un tableau de comparaison entre ce modèle centré sur le citoyen et les approches plus traditionnelles d'administration locale et de gouvernance.

Fiscal arrangements in most federations require revisiting from time to time to remain current for a changing world. The Government of Canada has recently brought out two influential papers (see the budget paper, Canada 2006a, and the O'Brien Report, Canada 2006b) to initiate discussion for a nation-wide consensus for directions of change. This paper provides perspectives on rethinking fiscal federalism taking the budget paper and O'Brien report as the starting point for such discussions.

The budget paper has provided us a candid and thoughtful review of the state of fiscal federalism in Canada. We learn that the Canadian federal system – which was seen to be "a text-book case of the better practice in fiscal federalism" (Boadway 2007) – has been derailed by federal unilateralism since 2004, and the budget paper provides a vision as to how to put the system back on track. The five principles enunciated by the budget paper (Canada, 2006a, 55) to develop a comprehensive approach to reform are used as the organizing

principles in our discussion of the pathways to reform. Addressing these five principles will constitute the first part of the chapter. This will be followed by a focus on alternative approaches to local government and governance in the global era.

REFLECTIONS ON CANADIAN FISCAL FEDERALISM

ACCOUNTABILITY THROUGH CLARITY OF ROLES AND RESPONSIBILITIES

The budget paper (2006a) proposes to refocus the federal government's role in areas of exclusive or primary jurisdiction, e.g. defense, security, national police, immigration settlement, aboriginal population, external assistance and transfers to the people and the provinces. Shared-cost programs will require the consent of the majority of provinces and the right to opt out with compensation. In areas of shared rule, it proposes to develop a consensus on clarifying roles and responsibilities of the various orders of government.

These are very welcome initiatives. It should be noted at the outset that Canada is one of the most highly decentralized federations, as indicated by the share of sub-national expenditures in total expenditures (see figure 1). The provincial-local orders of government in Canada enjoy a higher degree of revenue autonomy (see figure 2) and relatively wider and autonomous taxing powers than in most mature federations (see figures 3 and 4). The Canadian system is based on a separation of fiscal powers and independence and autonomy of federal and provincial orders of government in the exercise of these powers. Fiscal conservatism, combined with a high degree of political accountability and capital market discipline, has ensured accountable governance in Canada. Further, the constitutional division of powers in Canada conforms reasonably well to fiscal federalism principles with very few exceptions. Notable exceptions include provincial powers to regulate labor and capital markets, taxes on mobile bases such as capital income, and provincial ownership of natural resources. Among these exceptions, as noted by Boadway (2007), the case for reassignment of capital and labor market regulation to the federal government is the strongest. Another line of argument to rethink assignments is based on the notion of large vertical fiscal gaps in Canada.

Table 1 presents data on these gaps for the year 2005. These gaps are relatively much smaller compared to other mature federations. In Canada, sub-national governments raise 54 percent of consolidated revenues and have 64 percent of consolidated expenditures, leaving a vertical gap of 10 percent to be financed by federal transfers. Compare this to a 70 percent gap for Belgium, 65 percent for Germany, 40 percent for Australia, and 18 percent for the USA. Such a fiscal surplus enables the federal government of Canada to secure a

Figure 1: Sub-National Expenditures as a Percentage of Total Government Expenditures in 2001

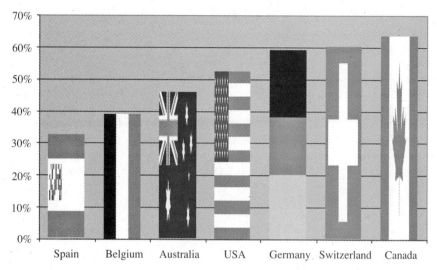

Source: International Monetary Fund, Government Finance Statistics, various years

Figure 2: Sub-National Own-Resources as a Percentage of Sub-National Expenditures in 2001

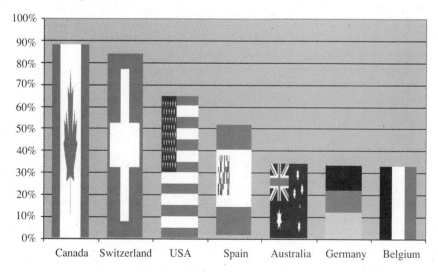

Source: International Monetary Fund, Government Finance Statistics, various years

Figure 3: Transfers as a Percentage of Sub-National Expenditures in 2001

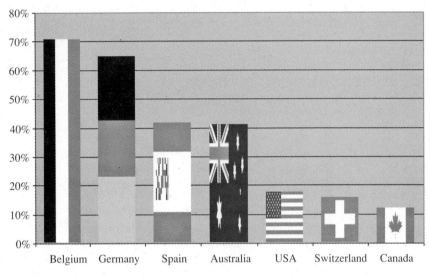

Source: International Monetary Fund, Government Finance Statistics, various years

Figure 4a: Sub-National Own-Resources as a Percentage of Total Government Revenues in 2001

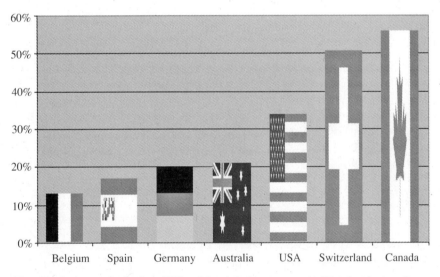

Note: The basic year for Spain is 2000 and the shared taxes are consolidated under transfers.
Source: International Monetary Fund, Government Finance Statistics, various years

Figure 4b: Specific Purpose Transfers as a percentage of Transfers in 2001

Source: International Monetary Fund, Government Finance Statistics, various years

common economic union through tax harmonization, fiscal equalization, national minimum standards in merit goods, and removal of barriers to factor mobility, while respecting provincial-local autonomy. While one can argue that tax abatements to reduce this fiscal gap would enhance accountability, it will come at some cost to Canadian economic and social citizenship. Therefore, on balance, one may argue to "jealously guard" the federal spending power as suggested by Boadway (Canada 2006a, 98).

Table 1: Vertical Fiscal Gap in Canada – 2005

	Revenue share	*Expenditure share*	*Fiscal gap*
Federal	0.46	0.36	-0.10
Prov/State	0.44	0.52	0.08
Local	0.10	0.12	0.02

Source: Boadway 2007

The case for rethinking the division of powers is strongest when one considers mega changes being introduced by globalization and the information revolution. Together, these forces are leading to (a) ever expanding roles of supranational regimes, with associated democratic deficits; (b) a shrinking role for the federal government in its traditional areas of responsibility; (c) an enhanced and redefined role for all levels of government in local governance; and (d) a steady erosion of roles and diminished relevance of the provinces – the intermediate level of government – with the potential emergence of an "hour-glass" model of federalism. It should be noted, however, that while globalization and the information revolution tend to erode the traditional functions of the federal government, they also require enhanced roles in education and training to maintain international competitiveness, and in dealing with the emerging digital and economic divides within nations, together with their implications for social policy and social risk management. It is important to have a strategy to lead and manage this change so as to forestall the possibility of ad hoc adaptive responses potentially undermining the overall balance of power desired by the society.

PREDICTABLE LONG TERM FISCAL ARRANGEMENTS

Canada during the past half-century maintained one of the simplest, most elegant, principled and purpose-driven intergovernmental finance systems in the world. During the past two years this system experienced a bump in the road, but the budget paper has made a commitment to bring it on track. The very welcome Report of the Expert Panel on Equalization and Territorial Formula Financing (the "O'Brien Report") provides specific guidance to achieve this in two major program areas. They have argued for a return to a principled rule-based and formula-driven approach to equalization payments. They have also made useful suggestions for simplification and transparency of the approach to equalization. In particular, they have argued for fiscal capacity equalization based upon a national average standard using a simplified five-base representative tax approach and by including 50 percent of resource revenues and excluding user fees. They also rejected the idea of fiscal need equalization in the interest of simplicity and transparency. Likewise, they rejected the setting up of an arms-length grants commission on accountability grounds. Their arguments are well supported by the lessons from international experience as documented in Shah (2007a, 2007b), which show that the fiscal-needs approach and growing complexity of the equalization approaches recommended by the Commonwealth Grants Commission of Australia have been the source of much discontent with equalization in that country. In view of this, the Panel's recommendations here ought to be accepted.

The Canada Health Transfer (CHT) is well structured as an equal per capita transfer with conditions related to ensuring universal access. The Canada Social

Transfer combines federal financing of post-secondary education and welfare. Separate more-focused transfers for each program would serve program objectives better. The post-secondary education transfer (CPSET) could focus on ensuring all Canadians equitable access to quality college and university education regardless of the place of residence. The federal government could provide per student grants that would use weighted populations of post-secondary enrollments, with greater weights assigned to medicine, engineering, science and technology students. This grant should be conditional on assurance that out-of-province students receive equal treatment in university/college admissions by grant recipients. The Canada Welfare Transfer (CWT) could be a matching transfer up to a minimum standard defined by the federal government in consultation with the provinces and could be given in advance upon the economic and demographic profile and past history of each province with end-of-year adjustment made based upon the actual number of social welfare recipients. For public transit, housing and infrastructure, matching assistance may be considered with the matching rate to vary inversely with the provincial/local fiscal capacity.

A COMPETITIVE AND EFFICIENT ECONOMIC UNION

Canada has a constitutional guarantee of free mobility of goods. It has a relatively harmonized tax system which permits local autonomy and flexibility while minimizing compliance costs. The CHT and CST further advance economic union by encouraging provinces not to impose residency requirements for provincial programs. The Agreement on Internal Trade also advances the goals of free mobility of goods and services. The USA has a non-harmonized tax system and is considered a tax jungle exacting a high toll from business and individuals in compliance costs. Australia and Germany limit provincial-local autonomy in the interest of uniformity. In Canada, there are arguably fewer impediments to mobility of factors than in other federations. Among the most important residual impediments are the provinces' ability to regulate securities and labor markets, especially professions, and the lack of a formal mechanism to settle intergovernmental disputes. The budget paper has identified steps to deal with the certification of professional qualifications – an important impediment to mobility of professionals.

EFFECTIVE COLLABORATIVE MANAGEMENT OF THE FEDERATION

Intergovernmental forums have worked well in the past. Greater reliance on these forums and required regular meetings would help advance this goal. Federal adherence to the Social Union Framework Agreement will strengthen trust. In addition, consideration may be given for the institution of a formal mechanism for the resolution of intergovernmental conflicts.

FISCAL RESPONSIBILITY AND BUDGET TRANSPARENCY

Canada has had a long history of fiscal discipline without having any formal fiscal rules at the federal level, although most provinces have lately introduced fiscal rules to limit deficit financing. Experience elsewhere has demonstrated that fiscal rules can play an important role in restraining pork-barrel politics under coalition governments. Under a majority party rule, success of such rules depends upon commitment by the leadership of the majority party. Having a medium term expenditure framework and budget transparency is helpful under any political regime, since such a framework enables the civil society to play a meaningful role in government accountability. On this issue, a bolder approach than the one outlined in the budget paper would be called for. This would entail:

a. medium term expenditure framework for budgeting;
b. introducing performance-based budgeting and a managing-for-results human resource management framework as in New Zealand;
c. requirement to publish annual externally audited financial statements giving the net worth of the government by all orders of government; and
d. Web posting of all budgetary data and calculations, financial statements and service delivery performance reports.

This completes my assessment of Canadian fiscal federalism as it relates to the proposals by the Equalization Panel and the 2006 budget documents. My focus is now directed to a much neglected area of Canadian federalism, namely local governance.

ADAPTING TO A CHANGING WORLD – WHAT ROLE FOR LOCAL GOVERNMENTS?

The information revolution and economic liberalization have accentuated the critical importance of the quality of local governance not just for the quality of life of individuals and communities but, equally as important, for the economic prosperity of nations in a globalized world. This requires revisiting the role of local governance in ensuring that local governments both create public value and provide strategic vision and leadership to enhance the international competitiveness of Canada. Such rethinking has profound implications for the roles and responsibilities of various orders of government. The following paragraphs provide a brief synthesis of the conceptual literature, in order to provide a framework to guide a rethinking of fiscal arrangements that would bring these into conformity with a changing world. The objective here is simply to highlight the importance

of this topic and principles to guide discussions so that a consensus for initiating a national dialogue on this issue can be developed in Canada.

ROLES AND RESPONSIBILITIES OF LOCAL GOVERNMENTS: ANALYTICAL UNDERPINNINGS

There are five perspectives on models of government relating to the roles and responsibilities of local government: (a) traditional fiscal federalism, (b) new public management (NPM), (c) public choice, (d) new institutional economics (NIE), and (e) network forms of local governance. The federalism and the NPM perspectives are concerned primarily with market failures and how to deliver public goods efficiently and equitably. The public choice and NIE perspectives are concerned with government failures. The network forms of governance are concerned with institutional arrangements to overcome both market and government failures.

LOCAL GOVERNMENT AS A HANDMAIDEN OF A HIGHER GOVERNMENT ORDER: TRADITIONAL FISCAL FEDERALISM PERSPECTIVES

The fiscal federalism approach treats local government as a subordinate tier in a multi-tiered system and outlines principles for defining the roles and responsibilities of orders of government (see Shah 1994 for such a framework for the design of fiscal constitutions). Hence, one sees that in most federations, as in Canada and the United States, local governments are extensions of state governments (dual federalism). In a few isolated instances, as in Brazil, they are equal partners with higher level governments (cooperative federalism), and in an exceptional case, Switzerland, they are the main source of sovereignty and have greater constitutional significance than the federal government. Thus, depending on the constitutional and legal status of local governments, state governments in federal countries assume varying degrees of oversight of the provision of local public services. In most federal countries, local governments have limited tax autonomy and even more limited exposure to competition within and beyond government. Further, their roles are circumscribed by provincial/state interventions. These interventions often constrain local choices to innovate and to advance local economic development.

Fiscal federalism perspectives in practice have resulted in some major difficulties because the practice seems to emphasize fiscal federalism's structures and processes as ends rather than as means to an end. There are well structured intergovernmental forums and endless meetings of officials focused primarily on dividing the fiscal pie (some would say "spoils"), often creating a paralysis of decision making rather than helping to advance service delivery objectives. Collective action in the interest of the common good is often not

feasible because of the tragedy-of-the-commons effects associated with common-pool resources. Such arrangements increase transaction costs for citizens and diffuse accountability as they provide cover to politicians and bureaucrats to shift burdens elsewhere. These structures and processes were designed as a response to market failures and heterogeneous preferences with little recognition of government failures or the role of entities beyond government. Further, these structures and processes pre-date the information revolution; system inertia and political-legal constraints have prevented adaptation to changing circumstances. The NPM and the NIE literature (synthesized in the following paragraphs) sheds further light on the origins of these difficulties. This literature highlights the sources of government failures and their implications for the role of local government.

LOCAL GOVERNMENT AS AN INDEPENDENT FACILITATOR FOR CREATING PUBLIC VALUE: NEW PUBLIC MANAGEMENT PERSPECTIVES

Two interrelated criteria have emerged from the NPM literature in recent years determining, first, what local governments should do and, second, how they should do this better.

In discussing the first criterion, the literature assumes that citizens are the principals but have multiple roles as governors (owner-authorizers, voters, taxpayers, community members); activist-producers (providers of services, co-producers, self-helpers obliging others to act); and consumers (clients and beneficiaries). In this context, significant emphasis is placed on the government as an agent of the people to serve public interest and to create public value. Moore (1996) defines "public value" as measurable improvements in social outcomes or quality of life. He argues further that, rather than diverting resources from the private sector, local governments should make more use of resources that come as free goods –namely, resources of consent, goodwill, Good Samaritan values, community spirit, compliance, and collective public action. This argument suggests that the role of public managers in local governments is to tap these free resources and push the frontiers of improved social outcomes beyond what may be possible with meager local revenues. Thus, public managers create value by mobilizing and facilitating a network of providers beyond local government. Democratic accountability ensures that managerial choices about creating public values are based on broad consensus by local residents (see Goss 2001). Thus, the local public sector continuously strives to respect citizen preferences and to be accountable to them. This environment, focused on creating public value, encourages innovation and experimentation, bounded by the risk tolerance of the median voter in each community.

The main current of the NPM literature is concerned not with what to do but with how to do it better. It argues for an incentive environment in which

managers are given flexibility in the use of resources but at the same time are held accountable for results. Top-down controls are thus replaced by a bottom-up focus on results.

LOCAL GOVERNMENT AS AN INSTITUTION TO ADVANCE SELF-INTEREST:
THE PUBLIC CHOICE APPROACH

The public choice literature endorses the self-interest doctrine of government and argues that various stakeholders involved in policy formulation and implementation are expected to use opportunities and resources to advance their self-interest. This view has important implications for the design of local government institutions. For local governments to serve the interests of people, they must have complete local autonomy in taxing and spending and they must be subject to competition within and beyond government. In the absence of these prerequisites, local governments will be inefficient and unresponsive to citizen preferences (Boyne 1998). Bailey (1999) advocates strengthening exit and voice mechanisms in local governance to overcome government failures associated with the self-interest doctrine of public choice. He suggests that easing supply-side constraints for public services through wider competition will enhance choice and promote exit options and that direct democracy provisions will strengthen voice (see also Dollery and Wallis 2001). The NIE approach discussed below draws on the implications of opportunistic behavior by government agents for the transaction costs to citizens as principals.

THE GOVERNMENT AS A RUNAWAY TRAIN: NIE CONCERNS WITH
THE INSTITUTIONS OF PUBLIC GOVERNANCE

The NIE provides a framework for analyzing fiscal systems and local empowerment and for comparing mechanisms for local governance. This framework is helpful in designing multiple orders of government and in clarifying local government responsibilities in a broader framework of local governance. According to the NIE framework, various orders of governments (as agents) are created to serve the interests of the citizens as principals. The jurisdictional design should ensure that these agents serve the public interest while minimizing transaction costs for the principals.

The existing institutional framework does not permit such optimization, because the principals have bounded rationality; that is, they make the best choices on the basis of the information at hand but are ill-informed about government operations. Enlarging the sphere of their knowledge entails high transaction costs, which citizens are not willing to incur. Those costs include participation and monitoring costs, legislative costs, executive decision-making costs, agency costs or costs incurred to induce compliance by agents with the

compact, and uncertainty costs associated with unstable political regimes (Horn 1997; Shah 2005). Agents (various orders of governments) are better informed about government operations than principals are, but they have an incentive to withhold information and to indulge in opportunistic behaviors or "self-interest seeking with guile" (Williamson 1985, 7). Thus, the principals have only incomplete contracts with their agents. Such an environment fosters commitment problems because the agents may not follow the compact.

The situation can be further complicated by three factors – weak countervailing institutions, path dependency, and the interdependency of various actions. Countervailing institutions, such as the judiciary, police, parliament, and citizen activist groups, may be unable to restrain rent-seeking by politicians and bureaucrats. Historical and cultural factors and mental models, by which people see little benefits to and high costs of activism, prevent corrective action. Further, empowering local councils to take action on behalf of citizens often leads to loss of agency between voters and councils, because council members may interfere in executive decision making or may get co-opted in such operations while shirking their legislative responsibilities. The NIE framework stresses the need to use various elements of transaction costs in designing jurisdictions for various services and in evaluating choices between competing governance mechanisms.

LOCAL GOVERNMENT AS A FACILITATOR OF NETWORK FORMS OF LOCAL GOVERNANCE

To overcome the commitment problem, one possible solution is to introduce a market mechanism of governance whereby a contract-management agency enters into minding contracts with all partners – i.e. various orders of government and non-governmental providers. However, this solution is unworkable because the potential number of contingencies may simply be too large to be covered by such contracts. A second approach to overcome obstacles to horizontal coordination – the so-called hierarchical mechanism of governance – relies on institutional arrangements to clarify roles and responsibilities and to establish mechanisms for consultation, cooperation and coordination, as done in some federal systems. Such institutional arrangements entail high transaction costs and are subject to a high degree of failure attributable to the conflicting interests of partners.

In view of the high transaction costs and perceived infeasibility of market and hierarchical mechanisms of governance for partnerships of multiple organizations, a network mechanism of governance has been advanced as a possible mode of governance for such partnerships – the kind to be managed by local governments. The network form of governance relies on trust, loyalty, and reciprocity between partners with no formal institutional safeguards. Networks formed on the basis of shared interests (interest-based networks) can provide a stable form of governance if membership is limited to partners that

can make significant resource contributions and if there is a balance of powers among the members. Members of such networks interact frequently and see co-operation in one area as contingent on cooperation in other areas. Repeated interaction among members builds trust. Hope-based networks are built on the shared sentiments and emotions of members. Members have shared beliefs in the worth and philosophy of the network goals and have the passion and commitment to achieve those goals. The stability of such networks is highly dependent on the commitment and style of their leadership (Dollery and Wallis 2001, 139).

Local government has an opportunity to play a catalytic role in facilitating the roles of both interest-based and hope-based networks in improving social outcomes for local residents. To play such a role, local government must de-velop a strategic vision of how such partnerships can be formed and sustained. But then the local government would require a new local public management paradigm. Such a paradigm demands local government to separate policy ad-vice from program implementation, assuming a role as a purchaser of public services but not necessarily a provider of them. Local government may have to outsource services with higher provision costs and subject in-house pro-viders to competitive pressures from outside providers to lower transactions costs for citizens. It also must actively seek the engagement of both interest-based and hope-based networks to supplant local services. It needs to develop the capacity to play a mediating role among various groups.

TOWARD A FRAMEWORK FOR RESPONSIVE, RESPONSIBLE, AND ACCOUNTABLE LOCAL GOVERNANCE

A SYNTHESIS

We have reviewed ideas emerging from the literature on political science, economics, public administration, law, federalism, and the NIE with a view to developing an integrated analytical framework for the comparative analysis of local government and local governance institutions.

The dominant concern in this literature is that the incentives and account-ability framework faced by various orders of government is not conducive to a focus on service delivery consistent with citizen preferences. As a result, corruption, waste, and inefficiencies permeate public governance. Top-down hierarchical controls are ineffective; there is little accountability because citi-zens are not empowered to hold governments accountable.

Fiscal federalism practices around the world are focused on structures and processes, with little regard for outputs and outcomes. These practices support top-down structures with pre-eminent federal legislation (that is, federal legislation overrides any sub-national legislation). The central government is at the apex, exercising direct control and micromanaging the system. Hierar-

chical controls exercised by various layers of government have an internal rule-based focus with little concern for their mandates. Government competencies are determined on the basis of technical and administrative capacity, with almost no regard for client orientation, bottom-up accountability, and lowering of transaction costs for citizens. Various orders of government indulge in uncooperative zero-sum games for control.

This tug-of-war leads to large swings in the balance of powers. Shared rule is a source of much confusion and conflict, especially in federal systems. Local governments are typically handmaidens of states or provinces and given straitjacket mandates. They are given only limited home rule in their competencies. In short, and as Courchene (2003, 22) has noted, in this system of "federalism of governments, by governments and for governments" citizens tend to have limited voice and exit options and local governments tend to get crushed under a regime of intrusive controls by higher levels of government.

The governance implications of such a system are quite obvious. Various orders of government suffer from agency problems associated with incomplete contracts and undefined property rights, as the assignment of taxing, spending, and regulatory powers remains to be clarified – especially in areas of shared rule. Intergovernmental bargaining leads to high transaction costs for citizens. Universalism and pork-barrel politics result in a tragedy of the commons, as various orders of government compete to claim a higher share of common-pool resources. Under this system of governance, citizens are treated as agents rather than as principals.

On how to reverse this trend and make governments responsive and accountable to citizens, the dominant themes emphasized in the literature are the subsidiarity principle, the principle of fiscal equivalency, the creation of public value, results-based accountability, and the minimization of transaction costs for citizens, as discussed earlier. These themes are useful but should be integrated into a broader framework of citizen-centered governance, to create an incentive environment in the public sector that is compatible with a public sector focus on service delivery and bottom-up accountability. Such integration is expected to deal with the commitment problem in various levels of government by empowering citizens and by limiting their agents' ability to indulge in opportunistic behaviour.

CITIZEN-CENTERED LOCAL GOVERNANCE

Reforming the institutions of local governance requires agreement on basic principles. Three basic principles are advanced to initiate such a discussion:

- *Responsive governance.* This principle aims for governments to do the right things – that is, to deliver services consistent with citizen preferences.

- *Responsible governance.* The government should also do it right – that is, manage its fiscal resources prudently. It should earn the trust of residents by working better and costing less and by managing fiscal and social risks for the community. It should strive to improve the quality and quantity of and access to public services. To do so, it needs to benchmark its performance with the best-performing local government.
- *Accountable governance.* A local government should be accountable to its electorate. It should adhere to appropriate safeguards to ensure that it serves the public interest with integrity. Legal and institutional reforms may be needed to enable local governments to deal with accountability between elections – reforms such as a citizen's charter and a provision for recall of public officials.

A framework of local governance that embodies these principles is called "citizen-centered governance." The distinguishing features of citizen-centered governance are:

- citizen empowerment through a rights-based approach (direct democracy provisions, citizens' charter);
- bottom-up accountability for results;
- evaluation of government performance as the facilitator of a network of providers by citizens as governors, taxpayers, and consumers of public services.

The framework emphasizes reforms that strengthen the role of citizens as the principals and create incentives for government agents to comply with their mandates.

The commitment problem may be mitigated by creating citizen-centered local governance – by having direct democracy provisions, introducing governing for results in government operations, and reforming the structure of governance, thus shifting decision making closer to the people. Direct democracy provisions require referenda on major issues and large projects and require that citizens have the right to veto any legislation or government program. A "governing for results" framework requires government accountability to citizens for service delivery performance. Hence, citizens have a charter defining their basic rights as well as their rights of access to specific standards of public services. Output-based intergovernmental transfers strengthen compliance with such standards and strengthen accountability and citizen empowerment (Shah 2006a).

IMPLICATIONS FOR DIVISION OF POWERS WITHIN NATIONS: ROLE REVERSALS
FOR CENTRAL AND LOCAL GOVERNMENTS

The framework described above has important implications for reforming the structure of government. Top-down mandates on local governance will need

to be replaced by bottom-up compacts. Furthermore, the role of local government must be expanded to serve as a catalyst for the formulation, development, and operation of a network of both government providers and entities beyond government. The traditionally acknowledged limited technical capacity of local government becomes less relevant in this framework. More important are its institutional strengths as a purchaser of services and as a facilitator of alliances, partnerships, associations, clubs, and networks for developing social capital and improving social outcomes. Two distinct options are possible in this regard, and both imply a pivotal role for local governments in the intergovernmental system. The options are (a) local government as the primary agent, subcontracting to local, state, and federal or central government authorities and engaging networks and entities beyond government, and (b) local, state, and national governments as independent agents.

Option A: Local governments as primary agents of citizens. In this role, a local government serves as (a) a purchaser of local services, (b) a facilitator of networks of government providers and entities beyond government, and (c) a gatekeeper and overseer of state and national governments for the shared rule or responsibilities delegated to them. This role represents a fundamental shift in the division of powers from higher to local governments. It has important constitutional implications. Residual functions reside with local governments. State governments perform inter-municipal services. The national government is assigned redistributive, security, foreign relations, and interstate functions such as harmonization and consensus on a common framework. The Swiss system bears close affinity to this model.

Option B: Various orders of government as independent agents. An alternative framework for establishing the supremacy of the principals is to clarify the responsibilities and functions of various orders as independent agents. This framework limits shared rule. Finance follows function strictly, and fiscal arrangements are periodically reviewed for fine-tuning. Local governments enjoy home rule, with complete tax and expenditure autonomy. The Brazilian fiscal constitution incorporates some features of this model, albeit with significant deviations.

Feasibility of options. Option A is well grounded in the history of modern governments and is most suited for countries with no history of internal or external conflict in recent times. It is already practiced in Switzerland. War, conquest, and security concerns have led to a reversal of the roles of various orders of governments and to a reduction in local government functions in more recent history. Globalization and the information revolution have already brought pressures for much larger and stronger roles for local governments. Although a majority of governments have done some tinkering

with their fiscal systems, the radical change recommended here is not in the cards anywhere. This is because the unlikelihood of overcoming path dependency – a tall order for existing institutions and vested interests – makes such reform infeasible. Under such circumstances, option B may be more workable, but here the clarity of responsibilities may not be politically feasible. In general, there is unlikely to be the political will to undertake such bold reforms. Piecemeal adaptation of this model will nevertheless be forced on most countries by the effects of globalization and by citizen empowerment, facilitated by the information revolution.

Summing up, a synthesis of the conceptual literature suggests that the modern role of a local government is to deal with market failures as well as government failures (see table 2). This role requires a local government to operate as a purchaser of local services, a facilitator of networks of government providers and entities beyond government, and a gatekeeper and overseer of state and national governments in areas of shared rule. Local government also needs to play a mediator's role among various entities and networks to foster greater synergy and harness the untapped energies of the broader community for improving the quality of life of residents. Globalization and the information revolution are reinforcing those conceptual perspectives on a catalytic role for local governments.

This view is also grounded in the history of industrial nations and ancient civilizations in China and India. Local government was the primary form of government until wars and conquest led to the transfer of local government responsibilities to central and regional governments. This trend continued unabated until globalization and the information revolution highlighted the weaknesses of centralized rule for improving the quality of life and social outcomes. The new vision of local governance (table 2) presented here argues for a leadership role by local governments in a multi-centered, multi-order, or multi-level system. This view is critical to creating and sustaining citizen-centered governance, in which citizens are the ultimate sovereigns and various orders of governments serve as agents in the supply of public governance.

IMPLICATIONS FOR CANADA

In Canada, local governments have no constitutional status and, compared to other industrial countries, play a much smaller role – 12 percent of consolidated expenditures vs. 22 percent in the USA, 28 percent in the OECD, 42 percent in Sweden and 52 percent in China. Similarly, when local expenditures are expressed relative to GDP, at 6 percent Canada again trails other countries; for example, the comparable figure in the USA is 11 percent, 13 percent in the OECD countries, 21 percent in Japan, and 31 percent in Denmark (see figures 5 and 6). A larger autonomous role for local governments would further the budget paper objectives of strengthening responsive,

Table 2: The Role of a Local Government under the New Vision of Local Governance

Old view: 20th century	New view: 21st century
Is based on residuality and local governments as wards of the state	Is based on subsidiarity and home rule
Is based on principle of *ultra vires*	Is based on community governance
Is focused on government	Is focused on citizen-centered local governance
Is agent of the central government or of a state or province	Is the primary agent for the citizens and leader and gatekeeper for shared rule
Is responsive and accountable to higher-level governments	Is responsive and accountable to local voters; assumes leadership role in improving local governance
Is direct provider of local services	Is purchaser of local services
Is focused on in-house provision	Is facilitator of network mechanisms of local governance, coordinator of government providers and entities beyond government, mediator of conflicts, and developer of social capital
Is focused on secrecy	Is focused on letting the sunshine in; practices transparent governance
Has input controls	Recognizes that results matter
Is internally dependent	Is externally focused and competitive; is ardent practitioner of alternative service delivery framework
Is closed and slow	Is open, quick, and flexible
Has intolerance for risk	Is innovative; is risk taker within limits
Depends on central directives	Is autonomous in taxing, spending, regulatory, and administrative decisions
Is rules driven	Has managerial flexibility and accountability for results
Is bureaucratic and technocratic	Is participatory; works to strengthen citizen voice and exit options through direct democracy provisions, citizens' charters, and performance budgeting
Is coercive	Is focused on earning trust, creating space for civic dialogue, serving the citizens, and improving social outcomes
Is fiscally irresponsible	Is fiscally prudent; works better and costs less
Is exclusive with elite capture	Is inclusive and participatory
Overcomes market failures	Overcomes market and government failures
Is boxed in a centralized system	Is connected in a globalized and localized world

Source: Shah 2006a

Figure 5:Comparative Perspective on Local Government Share of Consolidated Public Expenditures, 2000

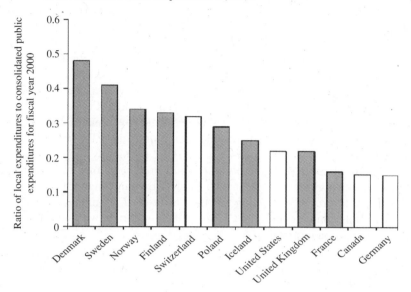

Source: Shah 2006b

Figure 6: Local Expenditures as a Share of National GDP, 2001

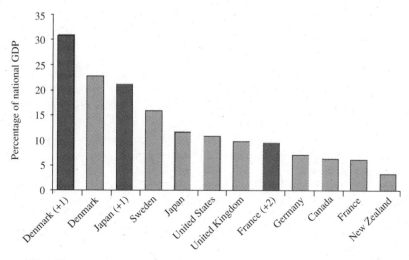

Source: Shah 2006b

responsible and accountable governance in Canada. A home rule for local governments, including recognition of their vital role in economic development, would strengthen Canada's competitive edge in the global economy. Here, the role local governments have played in shaping the emerging economic leadership of China in a global economy is quite instructive (Qiao and Shah 2006). The New Deal for Cities and Towns is a welcome initiative, but various options need to be examined to provide local government with dynamic productive tax bases to assure security of financing local services. In this context, one possibly attractive option is to have the federal excises on gasoline reassigned to local governments. In addition, local governments may be given exclusive access to property taxes and an option to levy flat rate local surcharges on the personal income tax base. These are simply some conjectural thoughts to initiate a dialogue on an issue of vital economic and social significance with high stakes for Canada's future. Strengthening local governance as opposed to province-building has the potential of strengthening both the political and economic union in Canada. Much important work remains to be done and must be undertaken with a sense of urgency.

REFERENCES

Andrews, M. and A. Shah. 2005. "Citizen-Centered Governance: A New Approach to Public Sector Reform." In *Public Expenditure Analysis*, ed. A. Shah. Washington, DC: World Bank.

Bailey, S. 1999. *Local Government Economics: Theory, Policy, and Practice.* Basingstoke, U.K.: Macmillan.

Boyne, G. 1998. *Public Choice Theory and Local Government.* Basingstoke, U.K.: Macmillan.

Boadway, R. 2007. "Fiscal Federalism in Canada." In *The Practice of Fiscal Federalism*, ed. A.Shah. Kingston and Montreal: McGill-Queen's University Press.

Breton, Albert. 1995. *Competitive Governments.* Cambridge, U.K.: Cambridge University Press.

Canada. Department of Finance. 2006a. *Restoring Fiscal Balance in Canada. Focusing on Priorities. Budget 2006.* Ottawa: Department of Finance.

— 2006b. *Achieving a National Purpose: Putting Equalization Back on Track. Expert Panel on Equalization and Territorial Formula Financing.* Ottawa: Department of Finance.

Courchene, T.J. 2003. "Federalism and the New Economic Order: A Citizen and Process Perspective" (Keynote Address to the Forum of Federations Conference on "Federalism in the Mercosur: The Challenges of Regional Integration." 26–27 June 2002: Porto Alegre, Brazil). Institute of Intergovernmental Relations Working Paper. Available at http://www.iigr.ca

Dollery, B. and J. Wallis. 2001. *The Political Economy of Local Government*. Chel-tenham, UK: Edward Elgar.

Goss, S. 2001. *Making Local Governance Work*. New York: Palgrave.

Horn, Murray. 1997. *The Political Economy of Public Administration*. Cambridge, UK: Cambridge University Press.

Moore, Mark. 1996. *Creating Public Value*. Cambridge, MA: Harvard University Press.

Qiao, B. and A. Shah. 2006. "Local Government Organization and Finance in China." In *Local Government Organization and Finance*, ed. A. Shah. Washington, DC: World Bank.

Rhodes, R.A.W. 1997. *Understanding Governance: Policy Networks, Governance, Reflexivity, and Accountability*. Buckingham, UK: Open University Press.

Shah, A. 1994. *The Reform of Intergovernmental Fiscal Relations in Developing and Emerging Market Economies*. Washington, DC: World Bank.

— 2005. "On Getting the Giant to Kneel. Approaches to a Change in the Bureaucratic Culture." In *Fiscal Management*, ed. A. Shah. Washington, DC: World Bank

— ed. 2006a. *Local Governance in Developing Countries*. Washington, DC: World Bank.

— ed. 2006b. *Local Governance in Industrial Countries*. Washington, DC: World Bank.

— 2007a. "A Practitioner's Guide to Intergovernmental Fiscal Transfers." In *Intergovernmental Fiscal Transfers: Principles and Practice*, eds. R. Boadway and A. Shah. Washington, DC: World Bank.

— 2007a. "Institutional Arrangements for Intergovernmental Fiscal Transfers and a Framework for Evaluation." In *Intergovernmental Fiscal Transfers: Principles and Practice*, eds. R. Boadway and A. Shah. Washington, DC: World Bank.

Stoker, G. ed. 1999. *The New Management of British Local Governance*. London: Macmillan.

Williamson, O. 1985. *The Economic Institutions of Capitalism*. New York: Free Press.

13

Major Cities as a National Priority

Anne Golden

Bien que le statut du Canada comme nation urbaine soit incontestable, les besoins distincts des six grandes villes du Canada sont largement ignorés, grâce à un déficit chronique de ressources et un manque de pouvoir de gouvernance nécessaire. Ni la politique budgétaire ou la gestion des ressources ne sont disponibles pour répondre aux fardeaux en plein essor des logements à loyers modérés et de la santé publique générés par nos villes qui continuent d'être les principaux aimants pour diverses populations et nombre d'immigrants. S'ajoutant à ces difficultés de nos grandes villes sont celles associées avec les coûts plus élevés du vieillissement des infrastructures, des populations mobiles, et des menaces de sécurité internationale. Il est clair que les grandes villes doivent faire face à des défis plus complexes que les autres municipalités, compte tenu, en particulier, de ce principe de financement « une taille seulement » d'égalité, jumelé à la déférence des divisions constitutionnelles des pouvoirs qui les relèguent au bas de l'ordre du jour politique. Le phénomène de convergence aura également un impact sur l'allocation national des ressources aux régions des grandes villes, en particulier étant donné leur impact économique critique sur les provinces. Ainsi, cet article réclame une évaluation des besoins futurs pour permettre des investissements stratégiques dans les grandes villes, tout en veillant à ce que ce nouveau financement influence une grande variété d'actifs urbains pour stimuler la croissance économique. Au-delà d'une interprétation strictement constitutionnelle de la résolution de problèmes, et compte tenu de la portée nationale des défis auxquels sont confrontés les grandes villes, cet article presse Ottawa à agir plus délibérément pour faire progresser la santé des villes canadienne, plutôt que de continuer à étreindre sa participation décousue et indirecte avec ces locomotives de prospérité nationale.

INTRODUCTION

Tackling the challenges facing Canada's cities is an enormous task. It calls for a new national strategy to prioritize investments in cities that is based on

leveraging unique economic potential and contributions, *as well as* on meeting significant needs. It will involve a comprehensive set of plans and actions, and a firm commitment from all levels of government and all sectors of society. While the remainder of this volume deals with the challenges and policy options for what The Conference Board of Canada defines as Canada's *major* cities, this chapter lays the groundwork for the fundamental shift in understanding and attitude needed to create a receptive audience for the recommendations that follow.

Four sea changes in attitude are required to overcome the barriers blocking our major cities' – and our nation's – potential for success. Citizens and leaders at all levels of government and civic enterprise must:

- realize that Canada has changed from a predominantly rural to an urban nation;
- recognize the distinctive needs and potential of Canada's major cities;
- understand that helping our major cities succeed is a "win-win" proposition for all Canadians; and
- accept that Canada's sustainable prosperity depends on national investment and involvement in our major cities.

AN URBAN NATION

Canada's self-image is still shaped more by its expansive wilderness geography than its vibrant urban landscape. Author George Elliot Clarke described this contrast between image and reality in his 2006 LaFontaine-Baldwin Symposium speech:

> Our national self-image has been so indelibly constructed by the iconic Group of Seven painters and Emily Carr, not to mention by the designers of our coins, paper money, and postage stamps, we imagine ourselves as a wilderness people, not a heavily urbanized one. (I do think it's wonderful, immediate satire that the Queen is backed up, on our coins, by a maple leaf, a sailing ship, and animals: the surrealism of removing the Queen from Windsor Castle and plunking her down in the wilderness renders the Royal Canadian Mint a version of the Royal Canadian Air Farce.) ... Nevertheless, we must never forget that the vast majority of us live in cities – despite what our national self-image suggests. (Clarke 2006)

When the precedent-setting 1849 *Baldwin Act* – which defined the role, function and structure of local government – was enacted, local governments were preoccupied with the issues of the day, "notably drunkenness and profanity, the running of cattle or poultry in public places, itinerant salesmen, the repair of roads, and the prevention or abatement of charivaries, noises and

nuisances."[1] At that time, Canada was indeed a rural-dwelling nation, with less than 15 percent of the population living in urban areas.

Canada's status as a predominantly urban nation is indisputable. However, our rural underpinnings are still evident in our vision of ourselves, in our self-limiting aspirations as a globally competitive nation and in our reluctance to address the plight – and the potential – of our major cities.

Canada's electoral system has evolved in response to the country's geography to enable representation from every corner. As a result, some electoral districts are huge and sparsely populated: Nunavut, at 2.1 million square kilometres, contains 26,745 people, while the average big city riding includes 107,518 people.[2] Perhaps this would matter less if strong urban voices in Parliament promoted discussion about the future of our cities and their place in the growing debate about our national goals. In today's globally competitive and connected world, our major cities' distinctive needs require national attention – and action – so they can realize their potential as drivers of sustainable prosperity.

SIZE MATTERS: THE DISTINCTIVE NEEDS OF CANADA'S BIG CITIES

The distinctive needs of Canada's six big cities are being ignored. Chronically short of resources and poorly equipped with governance powers, our big cities are struggling to fulfill their potential as engines of national prosperity. Citizens and leaders alike must recognize that big cities are intrinsically different from smaller cities and towns in both their higher economic potential and their greater needs.

Canada's big cities, similar to their counterparts around the globe, attract diverse populations – some seek opportunities; others seek specialized services available only in dense conurbations. The wonderfully complex and polyglot societies that characterize our big cities demand a wide range of services, which are often costly to provide. Big cities are magnets for the majority of immigrants to Canada, as well as for low-income individuals who seek employment and specialized services. The resulting concentration of individuals with special needs (e.g., social housing, public health, immigrant settlement)

[1] FCM, *Early Warning*, p. 1. Charivari, according to the *Shorter Oxford English Dictionary*, means: "a serenade of rough music, made with kettles, pans, tea trays, etc., used in France, in derision of incongruous marriages (1735)."

[2] Calculated by the Conference Board using 2006 Elections Canada data.

generates higher per capita costs than those in smaller municipalities (Bird and Slack 2007, 15). Big cities also face higher per capita costs for police and fire services – to serve dense and diverse populations (Slack et al. 2006, 17) – and for labour and rents – to provide municipal services and to house operations (Courchene 2005, 31). For certain types of services, it may be the case that diseconomies of scale exist, causing the per capita cost of servicing to jump as urban populations cross specific thresholds of size and density.[3]

Beyond service costs, big cities face higher infrastructure costs for expensive mass transit systems and amenities to service sprawling new suburbs. To be attractive to highly mobile talent in an era of global competition for labour, big cities must also invest in quality-of-life amenities, including parks, recreational facilities and the cultural facilities that only big cities can sustain (Bird and Slack 2007, 15).

Big cities need more resources, more autonomy and more influence on senior government decision-making to deal with a broad spectrum of policies and programs stemming from myriad issues: vast numbers of new immigrants; mobile youth and Aboriginal populations; rapid increases in population, businesses and cars; and international security threats, to name just a few. "Big cities face most, if not all, of these challenges in an order of magnitude much greater than other municipalities do" (Roberts and Gibbins 2005, 5). Tackling these challenges – which are becoming more complex and wide-ranging each year – cannot be done effectively unless big cities have the governance capacity to set long-term agendas and to influence decisions taken by the other levels of government on matters that affect them directly. Yet, as Canadian economist Tom Courchene has noted, "Canadian cities currently have little in the way of political, economic or fiscal manoeuvrability" (Courchene 2001, 34).

In reviewing what sets Canada's big cities apart, it is important to bear in mind the extraordinary scale of our three big city-regions: Toronto, Montreal and Vancouver. Their size and influence vault them into a special category of economic importance with distinctive investment needs for settling the tremendous numbers of immigrants they attract, for building the integrated mass transit systems their sprawling populations require and for providing the world-class arts facilities suitable to their status as global cities.

In comparing the populations of rural regions, smaller communities and major city-regions, the population in major city-regions is younger and more diverse. It comprises a much higher proportion of immigrants, more single-

[3] For a discussion of the conflicting evidence about diseconomies and economies of scale in service provision for big cities, see Bird and Slack (2006, 16–17). They note that operating expenditures in London (UK) are roughly 30 percent higher than the average spending for all local UK governments.

parent families and more housing renters, and is characterized by more poverty as well as affluence. In short, as recent demographic research has shown, "city-regions really are socially and economically unique" (Reed 2003, 7).

Canada's global competitors are already taking this point to heart. From a 2004 study finding that the larger European cities are generally the most economically competitive, the UK government drew itself a clear policy implication: "All cities matter. But the larger [cities] have the potential to contribute significantly and as a consequence are an appropriate target for a sustained government strategy" (ODPM 2004, 68). Elsewhere in Europe, countries are investing strategically in cities to boost national economic performance. The lessons surely hold for Canada as well.

UNDERSTANDING THE DYNAMIC POTENTIAL OF CANADA'S HUB CITIES

In Canada, the call for concentrating strategic investment in big cities was championed in 2001 by writer/activist Jane Jacobs and five big-city mayors. Together, they launched the "C5 agenda," which contended that Canada's economic growth would be best served through public investment in the country's biggest cities. This argument was revisited in a recent research paper that asserted that Canada's economic success is bound up in the performance of six broadly defined city-regions: Toronto, Vancouver, Montreal, Ottawa–Gatineau, Calgary and Edmonton (Slack et al. 2003).

Although these cities are undoubtedly among Canada's most economically robust, their status alone does not establish that their performance is driving economic success in the country as a whole. Citizens of Saskatchewan or the Atlantic provinces might reasonably ask how they would benefit directly from a focus on big cities outside their province or region. Similarly, small towns in Ontario, British Columbia or Quebec might well wonder whether their economic growth would be better promoted by a direct injection of funds rather than a purported "ripple-out effect" from the growth of Toronto, Vancouver or Montreal.

For that reason, the Conference Board set out to investigate the relationship between the successes of big and small communities across the country (Lefebvre and Brender 2006). The research study addressed three questions:

- Is there evidence that the growth of Canada's hub cities has positive effects on the economic performance of smaller communities?
- How widely do these effects ripple out from hub cities to smaller communities?
- If federal and provincial governments allot strategic funding for cities with the aim of producing a truly pan-Canadian boost in economic growth across big and small communities alike, which cities should be targeted for strategic infusions of funds?

The very significant finding of this research was that *when hub cities grow and prosper, their success boosts the economic performance of smaller communities in their region.* This discovery was achieved by looking at convergence in the economic growth of hub Canadian cities and their provincial or regional hinterlands.

THE CONVERGENCE PHENOMENON IN CANADA

In economic terms, convergence is a phenomenon observed in the relative economic development of two or more economies. To say that there is convergence between the growth of a richer economy and that of a poorer one is to say that as each grows, the "catching up" of the poorer economy narrows the disparity over time. There has been extensive research into convergence between countries because of the light it sheds on trends in global economic development: models of international convergence suggest that the economic growth of rich countries helps, rather than thwarts, that of poorer ones.

In Canada, decades of research prior to 1990 found persistent disparities in the economic growth of various regions. Since the early 1990s, though, studies have noticed convergence among provinces across diverse measures of economic growth. However, previous research does not demonstrate whether convergence among Canada's provinces is driven by the overall economic performance of these provinces or mainly by their major cities, where so much of the provincial economic activity is generated. If it is actually major city-regions that are converging, this finding would suggest that the best policy course might be to devote a greater share of national resources to the economic powerhouses and to let their success leverage the catch-up of the others. Conversely, if Canada's major cities are not converging with each other, a more diffuse resource allocation would be optimal.

CONVERGENCE OF URBAN AND REGIONAL ECONOMIES

The Conference Board of Canada's research into this question began by identifying those Canadian census metropolitan areas (CMAs) that are national and provincial leaders in terms of their growth in real gross domestic product (GDP) per capita.[4] Each CMA was examined to determine the extent – if any – of convergence between these lead cities and other communities, both nationally and intra-provincially. Economic data were reviewed from 1987 to 2004.

[4] The criterion of real GDP per capita was chosen as a measure of economic prosperity because it is widely regarded as the broadest measure of overall economic wealth in a given jurisdiction.

At the intra-provincial level, the cities of Montreal, Toronto, Winnipeg and Vancouver clearly emerge as the economic leaders in their respective provinces. Elsewhere, Calgary, Edmonton, Regina and Saskatoon were determined to be leaders in Alberta and Saskatchewan; these CMAs provided the basis for testing for convergence with other communities within their own provinces. In the Atlantic provinces, Halifax is the only CMA commanding a substantial enough share of provincial GDP to serve as a convergence yardstick; accordingly, it was decided to test for convergence between Halifax and communities in the entire Atlantic region. These criteria produced the nine hub cities that were studied for convergence. An examination of pan-Canadian economic performance shows that convergence is not occurring between Calgary (the national leader in GDP per capita) and the eight other hub cities; in fact, that gap is growing, not shrinking. Although smaller Canadian communities are converging relatively quickly toward the country's 27 CMAs as a whole, the gap between Calgary and all other Canadian municipalities is closing slowly, at best.[5]

Matters are very different, however, at the provincial (or in the case of the Atlantic provinces, regional) level. Evidence of convergence exists between the real GDP per capita of Halifax and that of other communities in the Atlantic provinces. Similarly, in each of the other Canadian provinces, convergence is occurring between real GDP per capita growth in the hub city CMAs and the smaller cities and communities in their respective provinces.

These findings clearly demonstrate that:

- economic growth in each of the nine Canadian hub cities generates an *even faster* rate of economic growth in other communities within their province or region;
- intra-provincial convergence is a much stronger force than national convergence; and
- there is a *lower limit* for the number of cities in which new strategic funding should be focused (determined by the number of hub cities).

Given the policy objective of producing *country-wide* economic growth, it makes more sense to invest strategically in all of Canada's major cities rather than only in the five or six largest CMAs.[6]

[5] While explanations are conjectural, this finding likely reflects the influence of interprovincial trade barriers, commodity price cycles and, above all, limited labour mobility among Canadian provinces.

[6] Of course, certain kinds of resources should be concentrated in the very biggest cities, since only they have populations large enough to warrant high-cost investments such as integrated mass transit systems or major cultural institutions. In general, however, a strategic city investment focus needs to be broadened.

POLICY IMPLICATIONS: DEFINING THE FOCUS

In highlighting the distinctive needs of Canada's big cities and the unique economic contribution of Canada's hub cities identified through our convergence research, this volume makes a strong case for prioritizing this combined group of cities – which we identify as *major* cities (Halifax, Montreal, Ottawa–Gatineau, Toronto, Winnipeg, Regina, Saskatoon, Calgary, Edmonton and Vancouver) – for national strategic investment and focus. Smaller cities and towns, and indeed the country as a whole, will thrive fully when their growth is fuelled by that of the country's major cities. *Helping Canada's major cities reach their potential is therefore a win-win proposition for all citizens.* A wider endorsement of this view by citizens and leaders alike will open the way for a more strategic approach to investment in Canada's major cities.

In exploring the policy implications of this argument, it must be conceded that not every smaller community in Canada will benefit from targeted investments in our major cities.[7] As smaller and more remote communities continue to experience a decrease in population, some of them will see their economic strength dwindle while others will retain their economic viability and quality of life. As a few experts have pointed out, there is a great need for policy research on the matter of helping such communities downsize with dignity (Slack et al. 2006 and Bourne 2003).

Another important caveat is that although convergence research strongly supports strategic funding for major cities, it is also consistent with strategies that would allocate resources to smaller cities and towns to help them realize their economic potential – for instance, fast growing cities such as Abbotsford in British Columbia, or Kitchener–Waterloo and Oshawa in Ontario. Natural resource towns, such as Fort McMurray, Alberta, also need support, since many are under immense pressure to build adequate infrastructure to support their booming industries. Other resource towns, such as Stephenville in Newfoundland and Labrador, must renew their economy in the face of mill closures.[8] That said, crafting a sound policy approach to strategic investments in Canada's major cities is paramount.

[7] It is worth noting that some of the communities that converge do so because their population is declining, not because of rapid rate increases in GDP.

[8] The issue of strategic investment in resource towns is considered in Volume II, *Mission Possible: A Canadian Resources Strategy for the Boom and Beyond.*

A NEW STRATEGIC INVESTMENT APPROACH FOR MAJOR CITIES: OPENING THE DISCUSSION

The particularly Canadian approach to funding – based on a one-size-fits-all principle of equality that ignores special needs or potential contribution to national well-being – is stifling our major cities. (See appendix "Federal Transfers and Cities.") Citizens and leaders alike must recognize that these cities are intrinsically different from smaller cities and towns in both their higher economic potential and their greater spending requirements. Canadians must recognize that it is to the collective long-term benefit of all citizens to support government funding policies that will give major cities the resources they require to succeed.

The adoption by federal and provincial governments of a more effective funding strategy for major cities will result in better use of public money. Such a new approach must concentrate as much on maximizing the benefits of every invested dollar as on addressing urgent needs. It must be based on criteria that consider economic, social, environmental and public health benefits, as well as spending needs.

To kick-start the public discussion, the Conference Board proposes that strategic investment in major cities be based on a new approach incorporating these basic elements:

- needs assessments based on future needs, existing unmet needs and the backlog of unfunded or underfunded infrastructure;
- needs and benefits assessments covering broad city-regions and outlying areas;
- assessments that include evaluations of the economic, social and environmental consequences of *failure* to make investments;
- funding levels that take into account economies or diseconomies of scale;
- priority consideration of urgent public health and safety needs; and
- demonstration of a city's capacity to use funds effectively.

WHAT SHOULD NEW FUNDING FOR MAJOR CITIES BE SPENT ON?

New funding for the major cities should seek to leverage a wide range of urban assets to boost economic growth. Recent research indicates that cities' economic performance depends not just on business activity per se, but also on the quality-of-life assets that attract mobile workers and affect corporate decisions on business location and expansion.[9] Cities' success and prosperity

[9] This thesis has been most prominently advanced in Florida, *The Rise of the Creative Class*. For its application to the Canadian context see, for example, FCM, *Quality of Life*.

also depend on the availability of affordable housing and the existence of infrastructure adequate to support modern communications, transportation and utilities. The backlog in maintenance of existing infrastructure, as well as the need for new infrastructure to accommodate growth, currently imposes a huge burden on Canada's major cities, where infrastructure needs are the most extensive and costly.

A prerequisite to meeting infrastructure needs is a clearer estimate of the cost of dealing with the infrastructure gap. Over the past few years, numerous studies and reports have attempted to gauge the size of the gap in Canada; results ranged from $50 billion to $125 billion, depending on the years, measures, trade-offs, sectors and technological and regulatory changes considered in the calculations (Mirza et al. 2003 and Vander Ploeg 2006).[10] This $75-billion span is too imprecise to offer direction for targeting infrastructure investment or for balancing infrastructure investment needs with other funding priorities. Rather, a quantifiable assessment could be achieved through a micro-level national survey detailing immediate, mid-term and long-range high priority infrastructure investment needs by type.

GETTING A COHERENT GOVERNMENT COMMITMENT TO THE CITIES AGENDA

Some positive steps have been taken recently, such as the federal government's decision to give municipalities a share of the gasoline tax for new infrastructure investment and the 2006 budget commitments to infrastructure, immigrant settlement and support, affordable housing and transportation. The Government of Ontario's passage in 2006 of the new *City of Toronto Act* was a milestone for municipal governance.

That said, however, Canadian governments are far from making a comprehensive commitment to cities' prosperity. Reliance on a one-size-fits-all approach, coupled with deference to the constitutional division of powers, has relegated major cities to the lower end of the policy agenda. Most advocates of the "cities agenda" were dismayed when the long-talked-of "New Deal for Cities" materialized as a "New Deal for Cities and Communities" in 2005, with gas tax funds for new infrastructure being allocated on a per capita basis to communities of all sizes. Furthermore, there is no effective federal-provincial approach to an urban agenda. Some provincial governments are

[10] A new study released in November 2007 by the Federation of Canadian Municipalities estimates the gap to be $123B (see Federation of Canadian Municipalities 2007).

content with the status quo. With the economic and population growth in cities feeding federal tax coffers and saddling municipalities with the larger share of the costs, Ottawa has little incentive to adopt new arrangements.

But this sort of fiscal arrangement is immensely short-sighted. As author Neil Bradford warns:

> At present, the problems of ageing infrastructure, insufficient affordable housing, spatially concentrated poverty, traffic congestion and lowered air quality are piling up at the doorstep of the municipal governments. However, the implications reach well beyond the boundaries of the locality and the powers of municipal authorities. Lost human capital, increased social tensions, and foregone economic opportunity will take their toll on the overall quality of life of the provinces and all of Canada. (Bradford 2005, 2)

To be sure, Canadian governments are not alone in their failure to adopt a coherent urban policy amid the realities of globalization and market restructuring. Even the United Kingdom, which in some respects is far ahead of Canada on the urban agenda, is playing catch-up to other European governments farther advanced on this front. A report coming out of the UK's Office of the Deputy Prime Minister makes the point that not all parts of the British government have absorbed the importance of an urban agenda, noting that "the economic conditions and contribution of cities need to be nearer the top of the collective governmental agenda" (OPDM 2004, 68). Canadian governments need to take these words to heart, as well, and move beyond the rigidly formalistic view that constitutional writ prevents Ottawa from playing any role in advancing the urban agenda.

WHY CANADA'S MAJOR CITIES ARE OTTAWA'S BUSINESS

Many thoughtful observers do believe in the paramount importance of strictly observing the letter of the *British North America Act*. One of the most articulate is columnist Jeffrey Simpson, who argues the following: "There are responsibilities Canada's Constitution gives to Ottawa, and others to the provinces. By statute and practice, cities are creatures of provinces, not the federal government. If cities need help, and they do, then provinces should come to their rescue" (Simpson 2002). And if the status quo is truly dysfunctional, such observers continue, there are two alternatives: either reform provincial electoral systems to give cities their proportional weight in legislatures, or rewrite the Constitution to give cities their own power and authority.

This argument advances purity of logic at the expense of realism – and does so in two key respects. First, it is obvious that reopening the Constitution would cause untold agonies of time and effort. As for the worthy aim of adjusting electoral ridings to ensure representation by population, that is

unlikely to be realized any time soon. For the foreseeable future, Canada's cities are stuck with being under the constitutional thumb of provincial governments.

Second, the strict constitutionalist argument assumes that federal involvement in cities would upset a status quo of clearly demarcated spheres of action. The fact of the matter, however, is quite different: Ottawa is already involved on myriad policy fronts. As Judith Maxwell (past president of the Canadian Policy Research Networks) has pointed out:

> . . . despite the constitutional division of powers, there is no question that the federal government is one of the key actors in Canada's cities by virtue of the fact that so many people live in cities and so much economic activity takes place there. The government is an actor as an employer, as a regulator, as a source of transfer payments to individuals, and as a taxing authority which sets many of the incentives with respect to social and economic behaviour. (Maxwell 2002)

Given that both the expectations of our cities and the problems they face are of national scope, Canadians would be best served by changing practice to meet present needs rather than adhering to a purist interpretation of constitutional writ. Many of the challenges facing cities already intersect with areas of federal responsibility, so the change must come from Ottawa acting more deliberately to advance the health of Canada's cities. If the federal government were simply to be more effective in carrying out the functions for which it has responsibility – from immigrant settlement and urban Aboriginal programs to infrastructure – our major cities would be vastly better off.

A larger point of principle remains to be made: it would be paradoxical to expect Ottawa to restrict itself to indirect ways of helping cities out of deference to constitutional roles prescribed in 1867, an era when conditions were entirely different. All intelligent human arrangements must evolve in response to changing conditions. No observer of Canadian and global trends would today design a constitution that forbade federal involvement in the engines of national prosperity. It is, after all, a two-way street: flourishing cities help Ottawa achieve its overall economic and social objectives for the country.

APPENDIX – FEDERAL TRANSFERS AND CITIES[11]

The federal government plays a valuable role in providing cities with assistance in the form of grants and other transfer payments, usually funnelled through the provinces. Many of these programs are targeted to high-priority urban issues (such as affordable housing through the Affordable Housing Trust,

[11] Source: The Conference Board of Canada.

and public transit through the Public Transit Capital Trust and the gas tax revenue transfer). Generally, these funds are allocated to provinces on a per capita basis; the provinces then distribute these funds to municipalities – also using a per capita formula.[12] While a per capita formula may appear equitable (the assumption being that large cities with large populations will get a larger portion of the funds, which will allow them to meet their greater needs), it ignores the distinctive and more intense needs of major cities, and hence is merely proportional rather than equitable.

In certain cases, the federal government has made exceptions to the per capita distribution rules to recognize special needs – usually to address rural, remote or low-population circumstances. Federal investments in infrastructure, for example, stipulate "... the need for less-populated jurisdictions to have sufficient funds for significant infrastructure investments."[13] Other programs – such as the federal gas tax transfer and the Public Transit Capital Trust – include minimum funding levels for small provinces and territories and (or) small cities. While recognizing these special needs is laudable, the special needs of major cities continue to be ignored or exacerbated by both the per capita distribution rule and the exceptions to the rule.

Other national programs designed to support all Canadians also have the end effect of discriminating against major cities and their residents. The employment insurance (EI) program, for example, allocates enriched benefits to seasonal workers (mainly found in rural communities) and ignores the many disadvantaged unemployed workers in major urban centres. As a result, only 22 percent of unemployed persons in Toronto receive regular EI benefits. In sharp contrast, more than 75 percent of unemployed people in Prince Edward Island and Newfoundland and Labrador receive regular EI benefits.

These examples underline the fact that many of the current federal fiscal transfer programs have built-in biases (either inadvertent or deliberate) against major Canadian cities and their residents. The federal government should re-examine all of the programs that transfer funds to cities – directly and indirectly – to ensure that these programs meet the priority strategic requirements of major cities.

[12] While the majority of provinces use a per capita distribution formula for allocating federal transfers, in some instances provinces have put aside a portion of the funds to be allocated on the basis of specific needs. In Ontario, for example, the 5 cents per litre announced in the 2005 federal budget was to be distributed to municipalities on a per capita basis, while the additional 1 cent per litre agreed upon as part of the federal budget negotiations was to be delivered on the basis of transit ridership. See Ontario Good Roads Association, "Road and Bridge Projects and Gas Tax Funding."

[13] Infrastructure Canada, *Government on Track.*

REFERENCES

Bird, R.M., and E. Slack. 2006. "An Approach to Metropolitan Governance and Finance." July 2006. Unpublished manuscript, forthcoming in *Environment and Planning* (2007).

Bourne, L. S. and J. Simmons. 2003. "New Fault Lines? Recent Trends in the Canadian Urban System and Their Implications for Planning and Public Policy." *Canadian Journal of Urban Research* 12.

Bradford, N. 2005. *Place-based Public Policy: Towards a New Urban Community Agenda for Canada*. Ottawa: Canadian Policy Research Networks.

Clarke, G.E. 2006. "Imagining the City of Justice" [online]. Speech given at LaFontaine-Baldwin Symposium held at Calgary, 10 March 2006 [cited September 13, 2006]. Retrieved from www.lafontaine-baldwin.com/speeches/george-elliott-clarke-calgary-2006/

Courchene, T.J. 2005. "Citistates and the State of Cities: Political-Economy and Fiscal-Federalism Dimensions." *IRPP Working Paper Series 2005–03*. Montreal: Institute for Research on Public Policy.

— 2001. *A State of Minds: Towards a Human Capital Future for Canadians*. Montreal: Institute for Research on Public Policy.

Federation of Canadian Municipalities. 2005. *Quality of Life in Canadian Communities: Dynamic Societies and Social Change*. Quality of Life Theme Report #2. Ottawa: FCM.

— 2007. *Danger Ahead: The Coming Collapse of Canada's Municipal Infrastructure*. Ottawa: FCM.

Lefebvre, M. and N. Brender. 2006. *Canada's Hub Cities: A Driving Force of the National Economy*. Ottawa: The Conference Board of Canada.

Maxwell, Judith. December 2002. "Foreword." In *Aboriginal Communities and Urban Sustainability*, eds. K.A.H. Graham and E. Peters. Ottawa: Canadian Policy Research Networks.

Mirza, S.M. and M. Haider. March 2003. *The State of Infrastructure Policy in Canada*. Report submitted to Infrastructure Canada.

Office of the Deputy Prime Minister. January 2004. *Competitive European Cities: Where do the Core Cities Stand?* London, England: ODPM.

Reed, P. 2003. "Fault Lines and Enclaves: The Rise of City-Regions in Canada." *Ideas That Matter* 3(1): 4–8.

Roberts, K. and R. Gibbins. 2005. *Apples and Oranges: Urban Size and the Municipal-Provincial Relationships*. Calgary: Canada West Foundation.

Simpson, J. 2002. "Save Our Cities, Yes; Get Ottawa Involved, No." *The Globe and Mail*, 25 May, A19.

Slack, E., et al. 2006. *Large Cities Under Stress: Challenges and Opportunities*. Report prepared for the External Advisory Committee on Cities and Communities, February 2006.

— 2003. *Vibrant Cities and City-Regions: Responding to Emerging Challenges*. Paper prepared for the Panel on the Role of Government, Province of Ontario. Toronto: Enid Slack Consulting Inc.

Vander Ploeg, C. 2006. *New Tools for New Times: A Sourcebook for the Financing, Funding and Delivery of Urban Infrastructure*. Calgary: Canada West Foundation.

14

Global Futures for Canada's Global Cities

Thomas J. Courchene

Propulsé par l'élan découlant du principe de subsidiarité et des exigences de l'économie fondée sur la connaissance (knowledge-based economy, ou KBE), les régions urbaines mondiales (global city regions, ou GCRs) sont de plus en plus saluées comme la nouvelle force dynamique de l'ère de l'information. Au Canada, les villes qui pourraient être considérées comme régions urbaines mondiales sont financièrement faibles dans le contexte international et sans constitution juridictionnelle dans le contexte canadien. Le rôle de cet article est de documenter l'ampleur du fossé entre le potentiel mondial des régions urbaines mondiales et leur réalité canadienne, et d'en tirer des conclusions et implications pour amener ces régions urbaines mondiales plus pleinement et formellement dans le fonctionnement de la fédération canadienne.

INTRODUCTION

Propelled by the momentum arising from the principle of subsidiarity and the dictates of the knowledge-based economy (KBE), global city-regions (GCRs) are increasingly hailed as the new dynamic motors of the information era. In Canada, the cities that would qualify as GCRs are fiscally weak in the

This is a reproduction of a similarly titled piece which appeared in the Institute for Research on Public Policy's *Policy Matters* series (2007, Vol. 9, No. 2). The original version was presented at the Institute of Intergovernmental Relations October 2006 conference "Fiscal Federalism and the Future of Canada." I wish to acknowledge the support of the SSHRCC Major Collaborative Research Initiative (MCRI) (Multi-Level Governance) and encouragement from the MCRI leader Robert Young. It is also a pleasure to thank John Allan for valuable comments, and also Jeremy Leonard and Francesca Worrall for their substantive and stylistic input.

international context and jurisdictionally constitutionless in the Canadian context. The role of this paper is to document the extent of the gulf between the global potential of GCRs and their Canadian reality, and to draw implications and conclusions from them.

Accordingly, I begin by focusing on the range of factors and forces flowing from the knowledge-based era that underpin the economic and political ascendancy of GCRs. Then I compare Canadian and international cities in terms, first, of their expenditures and, second, of their access to broad-based taxation. To anticipate the evidence, not only do Canadian cities fare poorly against their European counterparts, but they also come out decidedly second against American cities in terms of their fiscal autonomy.

In the remainder of the paper I address a range of options for bridging this potential-reality gap. In terms of the contribution that reworking federal-municipal relations could make, I look in turn at Ottawa's gas-tax sharing; at removing the blatant discrimination in the qualification for employment insurance (EI) benefits in selected GCRs; at the proposals emanating from the 2006 External Advisory Committee on Cities and Communities; and finally, at the implications of the fiscal imbalance for increasing the revenue flexibility of cities.

While cities would no doubt welcome greater involvement and cooperation with Ottawa in terms of both powers and revenue, the underlying reality is that cities are, constitutionally, creatures of the provinces. It is the creative reworking of provincial-municipal relations that ultimately holds the most promise for enabling Canada's cities to achieve their potential in the KBE. Following these lines, the analysis focuses on the Greater Toronto Charter as a (probably extreme) model of a set of exclusive and concurrent powers that would privilege GCRs. If one were to imagine what sort of event would trigger this power shift, it would be a province, say Alberta, deciding to share personal income taxes with, say, Edmonton and Calgary, and perhaps with other cities on an opt-in basis. While we await this and other decisive tipping points to privilege Canada's global city-regions, there are several smaller, but nonetheless significant, milestones in the direction of empowering Canada's GCRs, which I will highlight.

CANADA'S GLOBAL CITY-REGIONS IN COMPARATIVE CONTEXT

THE DYNAMIC MOTORS OF THE KNOWLEDGE-BASED ECONOMY

The new global order – globalization and the information revolution, which together will be referred to as the knowledge-based economy, or KBE – is leading to the economic, political and even democratic ascendance of Canada's global city regions, or GCRs. In terms of the globalization component of the KBE, the GCRs, in their roles as dynamic economic engines and export platforms, are spearheading the integration of their provinces and regions into NAFTA economic

space. This secures the GCRs' pride of place in conventional economic geography, or in what Manuel Castells (2001) refers to as the "the space of places."

Knowledge-Information Revolution

The knowledge-information-revolution component of the KBE adds an entirely new dimension to the significance of GCRs. Knowledge and human capital are increasingly important drivers of well-being and are at the cutting edge of competitiveness. And, because it is in the GCRs that one finds the requisite dense concentrations of human capital – information technology, research and development, high-value-added services, and so on – GCRs can become the coordinating and integrating networks in their regional economies, and the national nodes in the international networks that drive growth, trade and innovation. Thus, GCRs are also the key players in this new economic geography – Castells' "space of flows."

Subsidiarity

Underlying both the KBE and the new role of GCRs is the emergence of individuals as the principal beneficiaries of the information revolution, thanks in large measure to the democratization of technology and the rise of the Internet. This empowerment of individuals and their virtually unlimited access to information breathes new life into the principle of subsidiarity. The result will be to "push down to the local level and to individuals more power and resources than ever before" (Friedman 1999, 293). To be sure, subsidiarity also has a "passing upward" component, where the appropriate locus for regulating highly mobile activity is rising in the jurisdictional hierarchy, as exemplified in the creation of the euro. *Glocalization* is a convenient term that captures both the "passing upward" and "passing downward" components of the KBE, a duality anticipated over a decade ago by Horsman and Marshall, when they noted that "citizens...will seek political solutions, and democratic accountability, at ever more local levels as the world economy moves toward an ever greater level of integration" (1994, xv). This is an essential component of the argument that the GCRs will also experience a democratic ascendency.

In a recent paper, Vander Ploeg also focuses on the transition of GCRs, or big cities, into their new role as international "gateways":

> It is important to understand that Canada's traditional comparative economic advantage has always revolved around ready access to an abundance of natural resources, an ample supply of, and reasonable costs for, medium-skilled labour, relatively cheap sources of energy, and proximity to the US market. These conditions favoured the building of a resource and manufacturing-based economy. But this is giving way – significant manufacturing activity has gone offshore

and most of it will not soon return. As a result, "higher-ordered" producer services and activities that spin around knowledge and skills (e.g., idea generation and knowledge transfer, product engineering and design, prototype construction and testing), as well as the service industries that support those activities (e.g., financing, marketing, advertising), are becoming much more important . . . Increasingly, the opportunities for our future economic success are tying in with the new global and knowledge-based information economy. In this economy, comparative advantage shifts to the big cities, which are home to the young, educated, and highly skilled workers demanded by this type of economy, as well as the capital, investment, and entrepreneurs that drive it. Big cities are not only the locus of research, development, and innovation, they also serve as the gateways to global trade. (2005, 5)

"Gateway" is an apt term indeed, since it can encompass both the "space-of-places" and the "space-of-flows" roles of CGRs.

Human Capital as the Creative Driver

Richard Florida's *The Rise of the Creative Class* (2002) has taken the primacy of human capital one step further: just as the concentration of mineral deposits will attract mining companies, so concentrations of talented and creative people will attract knowledge-intensive companies. And the cities that come out on top will be those that fare best in terms of what Florida refers to as the three "Ts": technology (as measured by innovation and high-tech industry concentration); talent (as measured by the number of people in creative occupations); and tolerance (as measured by the amenities and opportunities available for every possible lifestyle). Florida labels this the "creative capital" theory of economic growth. Research undertaken by Gertler et al. (2002) indicates that Canada's GCRs rank very high in North America in terms of tolerance, but lag in the two other "Ts." This is consistent with evidence produced by Martin and Milway (2003): that the gap between Ontario's per capita GDP and that of the average US state is an *urban* gap. They go on to argue that closing this gap requires adressing four factors: attitudes toward the KBE, manifested, for example, in lower university enrolment in Ontario; investment (private investment to enhance productivity and public investment to increase education and human capital); incentives/motivation (higher tax rates); and fiscal and governance structures. While some of these factors are beyond the jurisdiction of cities (e.g., marginal income tax rates), others are not. With appropriate governance structures, not only can cities create environments that will score high on the tolerance scale, they can also go a considerable way toward framing policies that allow the three "Ts" to interact and create a learning environment. In other words, given the requisite instruments, cities

can enhance their own ability to be attractive to the clustering of both human and physical/financial capital.

This idea is a variant of one expressed in a somewhat earlier literature, which stressed that competitiveness and social cohesion are both important in determining a region's success – or that, as Pastor says, "doing good and doing well can go hand in hand." Pastor goes on to note that "the Silicon Valley Leadership Group has lobbied for higher (not lower) taxes in order to fund public transportation, coalesced with community groups to lobby for affordable housing, and generally maintained a positive relationship with the public sector." He quotes the Alliance for Regional Stewardship as saying that such stewardship must "work at the creative intersection of the inter-related issues of economic development, social equity, community liveability and participatory governance by lending initiative and building partnerships with other sectors and organizations" (2006, 294). It is difficult to imagine that this horizontal coordination could occur anywhere but at the GCR/city level.

Hub Cities and Convergence

Finally (but hardly exhaustively), Brender and Lefebvre, in *Canada's Hub Cities: A Driving Force of the National Economy*, present some evidence of the increased importance of what they refer to as "hub cities" (2006). These are the eight large cities – Vancouver, Edmonton and Calgary, Regina and Saskatoon, Winnipeg, Toronto, and Montreal – that function as the economic drivers of their provinces, and a ninth city, Halifax, that functions as a hub city for the Atlantic provinces. They conclude that Canada's hub cities are not receiving the investment they need to fulfill their roles as the economic drivers of regional and national prosperity. This conclusion follows from the principal finding of the study, namely that the "growth in a province's or region's hub city... drives an even faster rate of growth in smaller communities within the same province or region" (2006, i). Moreover, the evidence suggests that this convergence appears to be contained within the regions: there is no evidence of convergence across the hub cities, nor is there evidence that focusing only on Vancouver, Montreal and Toronto would produce a boom across all provinces. The principal policy implication is that Canada needs a strategically focused big-cities or hub-cities agenda. In the words of Brender and Lefebvre:

> [A]llotting strategic funding to all of Canada's hub cities based on their needs would indeed produce a nationwide "boost" for them and for smaller communities alike. Such a strategic needs-based approach to hub city investment would also yield a bigger economic impact than the per capita funding approach used in the federal government's 2005 budget, which allocated a gas tax rebate to Canadian communities on a uniform per capita basis. (2006, ii)

The message so far is two-fold. First, Canada's GCRs hold the promise for success in the KBE. Richard Harris captured this when he asserted that the collective future of Canadians depends on how our large cities will perform relative to their US counterparts (2003, 50). Second, our GCRs are falling short of this promise.

As backdrop to the reworking of the division of money and powers in the federation – so as to enable the GCRs to achieve their potential as the dynamic motors of the KBE – it is instructive to compare the existing revenue and expenditure powers of Canada's GCRs with those of international GCRs.

MUNICIPAL EXPENDITURES IN GCRS: AN INTERNATIONAL COMPARISON

If we first look at the expenditures of Canada's municipal governments, we see that they vary considerably across provinces (table 1). In 2001, local governments in Ontario led the pack (with nearly $2,000 per capita), Alberta's were in second place (with $1,581), and PEI's were in last place (with $378). A major reason for the higher spending of Ontario municipalities is that, unlike local governments in other provinces, they are responsible for a significant number of social services (24.7 percent of total expenditures for Ontario's local governments, with Nova Scotia's in second place, but well behind, at 4.5 percent). Nova Scotia's local governments lead in terms of educational expenditure, with 14.2 percent of their expenditures in this area, compared with a maximum of 1 percent for the other provinces. Hence, in the international comparisons that follow, readers should keep in mind that while there are differences in expenditure allocations internationally, there are also very significant differences across Canadian cities.

Figure 1 presents expenditures per capita (in euros) for selected OECD GCRs. These data capture "overall expenditure assignments" in these metropolitan areas. Toronto (with spending of roughly €2,000) and Montreal (with roughly €1,500) are well down the list, with Amsterdam topping the rankings with over €7,000 per capita.

The first point to note is that the majority of the GCRs that spend more euros per capita than Toronto are located in unitary states. Perhaps this is not surprising, because if unitary states like Holland, Denmark, Finland, Sweden, Japan and France (all of whose cities rank above Toronto) want to devolve responsibilities to a lower level of government, by default this has to be the local level. This raises important questions with respect to Canada's GCRs and its cities in general: Why does decentralization in Canada appear to stop with the provinces? Are we truncating the operation of the principle of subsidiarity at the provincial level, when experience elsewhere suggests we could bring the provision of goods and services much "closer to the people?" And if so, why? I shall attempt to address these questions below.

Table 1: Level and Allocation of Municipal Government Expenditures, by Province and for Canada, 2001

	NL	PE	NS	NB	QC	ON	MB	SK	AB	BC	Canada
Expenditure per capita (C$)	767	378	1,020	865	1,284	1,948	1,091	1,141	1,581	1,284	1,545
Allocation (%)											
General services	16.2	12.9	10.4	11.1	12.2	8.9	13.6	12.4	12.2	10.0	10.4
Protection	4.7	23.1	21.1	21.0	16.7	13.4	19.7	17.6	14.3	18.8	15.1
Transportation	28.6	21.5	16.9	20.2	27.2	18.1	23.4	31.7	28.3	16.5	21.4
Health	0.1	0.1	0.1	0.4	0.2	3.5	2.2	0.6	1.5	1.8	2.2
Social services	0.2	0.0[1]	4.5	0.0	1.4	24.7	0.3	0.5	1.5	0.2	12.5
Education	0.1	0.0[1]	14.2	0.0[1]	0.1	0.0[1]	0.0[1]	0.0[1]	0.3	0.0[1]	0.3
Conservation and development	0.7	1.7	0.8	2.4	2.8	1.6	2.4	3.6	3.4	1.4	2.1
Environment	22.1	12.7	16.8	25.3	12.0	13.3	17.4	15.4	13.9	20.4	14.4
Recreation and culture	14.5	21.9	10.7	12.6	12.4	8.7	9.4	14.2	13.7	19.5	11.5
Housing	0.6	0.0	0.2	0.3	2.9	5.0	0.4	0.4	0.7	0.6	3.2
Regional planning	1.2	2.3	1.5	2.0	2.5	0.1	2.3	1.7	3.0	2.3	1.3
Debt charges	11.1	3.7	3.7	4.2	9.4	2.3	8.5	1.7	7.1	6.3	5.0
Other	0.0[1]	0.0[1]	0.0[1]	0.2	0.0[1]	0.2	0.4	0.1	0.0[1]	2.2	0.4
TOTAL[2]	100.0	100.0	100.0	100.0	100.0	100.0	100.0	100.0	100.0	100.0	100.0

[1] Proportion is negligible (less than 0.05 percent)
[2] Figures may not add up to 100 because of rounding

Source: Based on data from Statistics Canada. Reprinted from McMillan 2006, table 1, 49

Figure 1: Global City Regions[1] Per Capita Expenditures in OECD, Various Years (euros)

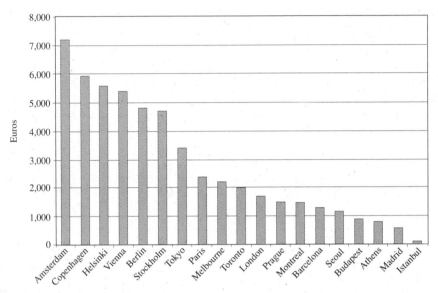

[1] Financial years: Budapest (2003); Istanbul, Toronto, Prague, Barcelona, Copenhagen (2004); Athens, Berlin, Melbourne, Paris, Helsinki, Stockholm (2005); Amsterdam, Vienna (2006). Demarcation of the cities is according to municipal boundaries (except for Melbourne, which refers to the city centre municipality)

Source: Based on OECD data and financial statements from the cities concerned. Reprinted from Chernick and Reschovsky 2006, figure 3.6

Berlin and Vienna are the only two cities in federal states that have per capita expenditures above Toronto's. In large measure, Germany and Austria fall into the "administrative federalism" camp, which means that legislation promulgated by the upper levels of government is largely implemented (administered) by lower levels. Consider the German federation, as described in the following excerpt from an excellent survey of Germany by Hrbek and Bodenbender:

> The wide range of tasks and duties of municipalities reflects a basic feature of intergovernmental relations in Germany. Whereas legislation is primarily the responsibility of the federal level, the sub-national level is responsible for administrative tasks, including the implementations of federal laws and policies...The Länder have mostly delegated administrative functions to the local level... Altogether, between 70 and 80 percent of all legal provisions of the Federation and the Länder are implemented by the local authorities. (169–70, 2007)

Indeed, the authors go on to note that "the federal level is constitutionally denied the right to have administrative offices of its own at the sub-Länder level, except for a constitutionally minimal number of functions such as customs and border police."

In terms of specific functions assigned to the local level, the authors elaborate as follows:

> [The provision of public goods and services by the local authorities] includes the following areas: museums, theatres, schools, sports and recreation grounds, hospitals, construction, habitation, sewage, waste disposal, electricity, gas and water support, public transportation, promotion of trade and business, measures related to immigration policy and social assistance . . . Local authorities are the major providers of public utilities. Over 60 percent of all public investments are carried out by the local authorities . . . In 2002, the Federal had 490,000 civil servants (this includes the armed forces) and the Länder 2.1 million employees (this includes personnel in schools and tertiary education). The municipalities and counties had a workforce of 1.4 million which accounted for almost 35 percent of the bureaucracy. (170–71)

Finally, Hrbek and Bodenbender note that of the 300 European Union (EU) directives relating to the internal EU market, approximately 120 are to be implemented by the German municipalities. This is *glocalization* at its finest: powers are passed upward to the EU from Berlin (i.e., from federal Germany) and then downward to the German local authorities for implementation.

By way of an intriguing aside, students of Canadian federalism often argue that Canada is the most decentralized federation in the world. From the perspective of the most commonly cited aspect of this issue – the percentage of overall expenditures and own-source revenues that is collected and/or allocated at the subnational level – this is probably correct. However, the Germans could mount a persuasive, two-pronged counterargument in claiming the opposite. First, the länder have a veto (via the *Bundesrat*) over all federal legislation touching upon their roles and responsibilities, whereas Canada's provinces have no role at all in our central governing institutions. In this (admittedly narrow) sense, Canada is arguably the most *centralized* modern federation in the world. Second, the German federation embodies the principle of subsidiarity to a much greater degree than does Canada.

This caveat aside, given the large disparities in per capita spending across the GCRs shown in figure 1, it follows that the tax assignments must also vary substantially. To this I now turn.

TAX ASSIGNMENTS IN CANADIAN AND INTERNATIONAL GCRS

Table 2 shows the level and allocation of municipal revenues across the various provinces. Property-associated taxes account, on average, for 52.2 percent

Table 2: Level and Allocation of Municipal Government Revenues, by Province and for Canada, 2001

	NL	PE	NS	NB	QC	ON	MB	SK	AB	BC	Canada
Revenue per capita (C$)	704	437	1,013	839	1,293	1,914	1,120	1,062	1,739	1,137	1,513
Own-source revenue (%)											
Property and related taxes	54.3	62.3	73.7	55.1	64.3	48.3	46.7	54.3	44.4	53.0	52.2
(Real property taxes)	(36.3)	(61.2)	(58.0)	(47.7)	(44.2)	(42.2)	(35.3)	(45.4)	(31.6)	(46.3)	(41.9)
Consumption taxes	0.1	0.0	0.0	0.0	0.0	0.0	1.4	3.6	0.0	0.2	0.1
Other taxes	1.0	0.5	0.1	0.5	0.3	1.3	1.1	0.8	1.6	2.4	1.2
Sales of goods and services[1]	16.4	26.9	16.4	25.3	16.5	23.9	23.4	24.3	26.1	29.3	23.0
Investment income	1.9	1.6	3.5	1.0	2.0	4.1	8.0	4.4	10.3	8.5	4.9
Other	0.6	1.5	0.2	0.5	2.3	1.7	0.8	1.0	1.6	0.6	1.6
Total own source[2]	74.3	92.8	94.0	82.4	85.5	79.3	81.5	88.5	84.1	94.2	83.0
Transfers											
General purpose	6.3	3.3	2.7	12.4	1.9	2.3	7.9	4.6	0.9	1.1	2.4
Specific purpose	19.4	3.9	3.3	5.2	12.6	18.3	10.6	6.9	15.0	4.7	14.6
Federal	2.9	0.3	0.5	1.0	0.2	0.3	1.1	2.1	0.5	0.5	0.4
Provincial	16.5	3.6	2.8	4.2	12.4	18.0	9.5	4.9	14.5	4.3	14.2
Total transfers[2]	25.7	7.2	6.0	17.6	14.5	20.7	18.5	11.5	15.9	5.8	17.0
TOTAL REVENUE[2]	100.0	100.0	100.0	100.0	100.0	100.0	100.0	100.0	100.0	100.0	100.0

[1] Includes user fees, charges and so forth
[2] Figures may not sum exactly because of rounding

Source: Based on data from Statistics Canada. Reproduced from McMillan 2006, table 2, 51

of per capita revenues for all municipalities (last column). This varies from a low of 44.4 percent in Alberta to 73.7 percent in Nova Scotia. In Canada as a whole, revenue from sales of goods and services represents just under one-quarter of municipal revenues, while transfers from other levels of government account for 17 percent, the overwhelming amount of which are (1) from the provinces and (2) in the form of specific-purpose transfers. (More detailed data relating to taxation sources for selected Canadian cities will be presented later.)

Turning now to the international context, table 3 presents data on the range of taxes available to local authorities in selected OECD countries. The first 5 countries are federations, while the remaining 10 are unitary states. The differences across the federations are quite astounding. Local authorities in Australia and Canada have no access to income taxes and are almost wholly reliant on property taxes (100 percent in Australia). In sharp contrast, local authorities in Germany and Switzerland obtain upwards of four-fifths of their tax revenues from income taxes, and only 15 percent from property taxes. The United States is somewhere in between these two extremes, but closer to the

Table 3: Local Tax Sources in Selected OECD Federations and Unitary States

	Tax source as a proportion of total local tax revenues				*Local taxes as a proportion of GDP*
	Income	*Sales*	*Property*	*Other*	
Federations					
Australia	0.0	0.0	100.0	0.0	1.1
Canada	0.0	1.5	92.7	5.7	3.3
Germany	79.1	5.7	15.0	0.2	2.8
Switzerland	84.3	0.3	15.4	0.0	5.2
United States	6.3	21.0	72.8	0.0	3.5
Unitary states					
Denmark	93.6	0.1	6.3	0.0	15.8
France	0.0	10.2	50.6	39.1	4.7
Hungary	0.1	76.6	22.6	0.7	1.7
Italy	12.9	14.9	17.3	54.9	4.9
Japan	47.2	20.8	31.1	1.0	7.2
Netherlands	0.0	37.1	62.8	0.0	1.2
Spain	26.4	35.4	34.6	3.5	5.7
Sweden	100.0	0.0	0.0	0.0	15.8
Turkey	27.7	30.1	2.3	39.9	4.7
United Kingdom	0.0	0.0	99.5	0.5	1.4

Source: Based on data from the OECD. Reprinted from Chernick and Reschovsky 2006, table 5

Canadian/Australian model. In the unitary states' GCRs, income taxes are the dominant tax source in Denmark and Sweden, accounting for just over 15 percent of GDP in both countries. Indeed, as Lotz (2006, chap. 7) notes, one can make a convincing case that there is a "Nordic model" of local government financing (and also of decentralization in general). Defining Nordic as encompassing Norway and Finland in addition to Sweden and Denmark, Lotz notes that income taxes account, on average, for 91 percent of local taxes, with property taxes accounting for 7 percent and "other taxes" accounting for the remaining 2 percent (239). There are seven other countries, all unitary states, whose local authorities rely to varying degrees on sales taxes – with Hungary (76.6 percent) and France (10.2 percent) at the extremes. Finally, the United Kingdom, where property taxes account for 99.5 percent of its tax sources, falls into the "Anglo" camp (Australia, Canada and the United States).

Focusing only on the five federations, Australia, Canada and the United States are English common-law countries, whereas Switzerland and Germany are underpinned by civil law. It is well known that common-law regimes tend to be associated with individualist capitalism and tend to have equity markets as the principal source of corporate finance, whereas civil-law regimes tend to be associated with communitarian capitalism and credit-based, bank-dominated financing for corporations (Zysman 1983, tables 6.1 and 6.2). Looking at the sources of revenue of Canadian provinces (see table 2), this comparison might be extended to link common-law regimes with reliance on property tax, and civil-law regimes with reliance on income tax. (As noted above, the common-law characteristics also extend to the United Kingdom and, although it is not included in table 3, to New Zealand as well.) The linkage between local governments and property taxes makes considerable sense since (1) property taxes are an ideal revenue base for local governments because they are immobile, and (2) the traditional role of local governments (in Canada at least) was to provide property-based services – fire protection, policing, water, and sewage, garbage collection, lighting, and the like – and what better source of revenue for this than property taxes? Nevertheless, there is a limit to the amount of revenues that can be raised through property taxes. Lotz (2006, 238) notes that, according to the OECD, over the medium term, no country has revenues from property taxes in excess of 3 percent of GDP. Canada is arguably at this limit now. (This is especially true of Ontario, which is in the throes of a property-tax revolt.) What this means is that were reliance on own-source revenues at the local level in Canada to increase, this increase would presumably have to come from tax sources *other than property tax*. Phrased differently, even if Sweden (Stockholm) were intent on resorting to property taxation at the local level, it would still have to get access to a wider range of tax sources, since its local taxes exceed 15 percent of GDP, five times beyond the supposed limit for property taxes. The important policy implication flowing from this observation is that if Ottawa and/or the provinces are

not willing to transfer broad-based tax room (incomes taxes or sales taxes) to the municipalities, it is difficult to conceive of Canada's GCRs ever achieving meaningful revenue autonomy.

CANADA AND THE UNITED STATES COMPARED

While both Canadian and US cities rely heavily on property taxes as a taxation source, Canada's cities do to a much greater extent – 92.7 percent, compared with 72.8 percent for the United States (table 3). The reason for this is that American cities have much greater access to sales taxes than Canadian cities do – 21.0 percent compared with 1.5 percent (see table 3). By way of elaboration, Vander Ploeg (2005) presents some highly informative comparisons between Calgary and Edmonton, on the one hand, and Denver and Seattle, on the other. These comparisons are reproduced in the four panels that comprise figure 2.

Panel A presents the revenue sources (taxes and transfers) available to Calgary, Edmonton, Denver and Seattle. Seattle has access to 8 taxes in addition to those available to Alberta's big cities, not to mention several other tax options that it has elected not to access. And, while Calgary and Edmonton do share in Alberta's provincial fuel tax, Seattle has a share of 10 of the taxes of Washington state. In terms of "other revenue sources," the cities have similar revenues at their disposal. Panel B, which shows Edmonton's and Denver's tax revenue profiles, illustrates just how dramatically taxation patterns can differ. In Edmonton, property taxes account for 93.8 percent of the city's overall tax revenues, whereas they account for only 21.1 percent of Denver's total tax take. Nearly two-thirds of Denver's revenues come from a general retail sales tax.

The implications of these differences, and especially the fact that Denver and Seattle have access to broad-based tax sources that grow in line with the economy, are quite remarkable. Edmonton's growth in per capita tax over the decade of the 1990s comes in at just under 16 percent, in line with its growth in (residential and business) property tax. However, Denver's growth in per capita tax over the 1990s is nearly 60 percent, pulled up by the 93.1 percent growth in general sales tax (panel C). Panel D reveals how this access to growth taxes ends up being transferred into per capita capital spending – Denver's increase in per capita capital spending is nearly double Calgary's. These are most significant differences, given that one of the principal challenges facing Canada's GCRs is being able to compete head-on with American GCRs.

TOWARD FISCAL AND POLITICAL SELF-DETERMINATION FOR CANADA'S GCRS

Vander Ploeg's analyses and charts have important policy implications. Clearly, access to a range of broad-based taxes is not just a European phenomenon: it applies to some US cities as well. Moreover, the evidence suggests that having

Figure 2: Municipal Tax Tools in Calgary and Edmonton, Alberta; Denver, Colorado; and Seattle, Washington

Panel A. Financial Tools Available to Calgary, Edmonton, Denver and Seattle

	Calgary and Edmonton	Denver	Seattle
Local taxes in play	Property tax Business tax (property-based) Franchise and utility taxes	Property tax Franchise and utility taxes General retail sales tax Sales tax on lodging Sales tax on restaurants/alcohol Sales tax on off-sales of alcohol Sales tax on vehicle rentals Sales tax on aviation fuel Sales tax on entertainment events Employee head tax Auto Ownership tax	Property tax Franchise and utility taxes General retail sales tax Sales tax on entertainment events Sales tax on gambling Sales tax on restaurants, bars, pubs Sales tax on car rentals Gross receipts business tax Motor vehicle excise tax Real estate excise tax
Tax-sharing	Provincial fuel tax	State fuel tax State tobacco tax State vehicle registration tax State lottery revenue tax	State liquor tax State fuel tax State lodging tax State insurance premium tax State general retail sales tax State leasehold excise tax State hazardous waste tax State utility tax State timber tax State solid waste tax
Other taxes not currently in use		Real estate transfer tax Almost any tax except income taxes	Employee head tax Various types of business taxes Head tax (or poll tax)
Other revenue sources	Federal grants Provincial grants User fees Investment income Licences, permits, fines	Federal grants State grants User fees Investment interest Licences, permits, fines	Federal grants State grants User fees Investment income Licences, permits, fines

Sources for panels A, B, C, and D: Derived by CWF from Annual Financial Reports of the cities of Edmonton and Calgary (1990–2003) and the Consolidated Annual Financial Reports of the Cities of Seattle and Denver. Additional data was secured from the local government electronic financial databases maintained by the States of Washington and Colorado. Adapted from Vander Ploeg 2005, figure 6, 38

Figure 2 (Continued)

Panel B. Tax Revenue Profile, Edmonton and Denver, 2000 (percent)

Total municipal tax revenue

Edmonton

Property tax (general residential and commercial)	71.8
Property tax (square footage business tax)	16.9
Property tax (local improvement taxes)	5.1
Franchise and utility taxes	5.6
All other taxes	0.6

Denver

General retail sales tax	63.5
Property tax	21.1
Employment head tax	6.4
Selective sales tax on hotels and lodging	4.7
Franchise and utility taxes	3.1
All other taxes	1.2

Panel C. Growth in Per Capita Taxes Collected, Edmonton and Denver, 1990–2000 (percent)

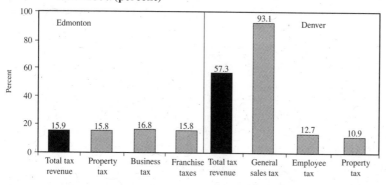

Panel D. Growth in Per Capita Capital Spending, Calgary and Denver, 1990–2000 (percent)

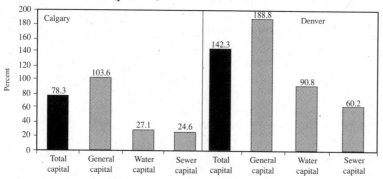

access to broader-based taxation is arguably the key to addressing Canadian GCRs' capital-infrastructure deficit.

However, the broader reality is that there remains an enormous gulf between the economic and political potential of GCRs in the KBE, on the one hand, and the access to money and power of Canada's GCRs, on the other. Indeed, not only do our GCRs rank very low internationally in terms of fiscal flexibility, but they are arguably the weakest, constitutionally, in the developed world. Thus, it should not be surprising that there are numerous voices calling for a rethinking and reworking of the role of our GCRs in our political, institutional and fiscal federalism. Among the most energetic and outspoken advocates of more powers for Canada's cities is Alan Broadbent, who writes as follows in terms of the relationship between cities and their provincial political masters:

> Canadian cities are creatures of the provinces. The amount of power and authority granted to them by the provinces, whether ample or not, is beyond their control. The provinces have the ability to dissolve municipalities and dismiss their governing councils. The provinces have the ability to dictate the size and structure of city governments, to set the conditions of their ability to raise capital, and to apply duties and obligations to them. The cities have no independent constitutional ability to resist whatever conditions the provinces opt to create for them.
>
> The situation is problematic for cities in Canada, one of the most highly urbanized countries in the world. Its cities, particularly the large cities of Toronto, Montreal, and Vancouver, are the economic, social, and cultural engines of the entire country. Within these urban regions are contained the principal forces which make Canada an effective and competitive modern nation. Yet the cities have very little control over their decisions. They have limited ability to leverage their assets and to maximize their potential. (2000, 1)

Broadbent goes on to note that among the reasons why Canadian cities come up short in terms of what self-determination they do have is that they typically have "weak mayor" systems, a situation that is further complicated by the fact that their governance typically does not have the discipline associated with party systems.

In terms of their relationship with the federal government, it is clear that Canada's GCRs (and municipalities generally) will never achieve the powers of the local authorities in Germany. Canada is a legislative federation, not an administrative federation and, as such, implementation is not routinely delegated to local authorities. However, there is plenty of scope between the polar positions of not allowing the central government to employ bureaucrats in the political boundaries of local governments (as is the case in Germany), and not allowing local officials to deliver or implement *any* federal programs. For example, our immigration-receiving cities have greater knowledge, experience

and motivation than does Ottawa to ensure that Canada's immigrants are successfully integrated into their cultural and labour-market milieux; yet, they have precious little say in these matters, let alone in the allocation of immigration-settlement monies or in ensuring that these immigration settlement monies are appropriately coordinated with the myriad of other services to which immigrants and refugees need to have access.

At the same time, one needs to respect the perspective of University of Western Ontario political scientist Andrew Sancton (2004) on this issue. After noting that "of course, our big city municipalities should be free from oppressive provincial regulation," and "of course [cities] should have access to a more diversified tax base," he comments:

> My position is that cities are far too important for municipal purposes alone. Policies of federal and provincial governments have always been crucial to the well-being of our cities and will continue to be, so we cannot define constitutionally who is responsible for what with respect to all the demands on government within our cities. The governance of cities will always be multilevel. (np)

These perspectives suggest that addressing the concerns of the GCRs in the KBE must involve creative processes as well as redesigned structures. This is the task of the remainder of this paper.

FEDERAL-MUNICIPAL RELATIONS

During the short-lived Paul Martin government, Finance Minister Ralph Goodale's 2004 budget introduced a "New Deal for Canada's Communities," which included GST/HST exemptions for cities, enhanced infrastructure funding, federal gas-tax sharing, enhanced participation by municipal representatives in federal budget consultations, the creation of the External Advisory Committee on Cities and Communities (more on this later), and the appointment of a Parliamentary Secretary (and later a Minister of State) for Infrastructure and Communities. These initiatives ushered in an exciting era for cities, large and small. Even though the excitement has been turned down a notch or two under the Harper government, some recent developments merit highlight.

SHARING THE FEDERAL GAS TAX

While much has been made of Prime Minister Paul Martin's high-profile initiative to share the federal gasoline tax with the cities, one assumes that the GCRs were hardly pleased with it. This is because putting the transfer on an equal-per-capita basis, by province, effectively converts it into a program of equalization from GCRs to smaller cities, since gas taxes are disproportionately collected

from GCRs. What the GCRs want, and arguably need, are tax transfers on a derivation basis, i.e., on the basis of what was actually collected from them in the first place. If the federal government finds it politically difficult to depart from equal-per-capita transfers by province, then the appropriate way out is to transfer the equivalent aggregate number of tax points or derivation-based tax shares to the provinces, which will in turn be committed to allocating them to their cities and local governments. To be sure, there is still no guarantee that these tax revenues will end up in municipalities on a derivation basis, but it is more likely that they will. For example, Ontario allocates 30 percent of its gas tax transfers on the basis of population and 70 percent on the basis of public transit ridership. Moreover, the prospect that investing in hub cities will have very substantial "trickle down" or convergence effects on smaller municipalities should also play a role in convincing provinces to privilege their GCRs or hub cities (Brender and Lefebvre 2006).

Federal gas-tax sharing did, however, provide an important catalyst for similar action by the provinces (e.g., Manitoba and Ontario). (Note that other provinces, such as British Columbia, Quebec and Alberta, already shared some gas taxes.) Indeed, the example of gas-tax sharing may well incite the provinces to share income taxes or sales taxes with municipalities.

EMPLOYMENT INSURANCE AND WORKING INCOME TAX BENEFITS

The funding and distribution of benefits associated with Canada's employment insurance (EI) program have long been a major concern for most of the GCRs. This came to the fore recently in the context of *Time For A Fair Deal*, the 2006 report of the (Toronto) Task Force on Modernizing Incomes Security for Working-Age Adults (MISWAA). Specifically, the task force noted that only 22 percent of the unemployed in Toronto are eligible for EI, compared with the national average, which is in the 43 percent range, and the even higher eligibility rates for cities like Saint John and St. John's (figure 3). And, because access to the EI component of training is only available to those eligible for EI, a larger share of the unemployed in Toronto (and in many other cities, as figure 3 reveals) must be drawing upon provincial welfare or training funds rather than EI benefits or EI training funds. For a variety of reasons, this policy surely qualifies as unacceptable. The first reason is that it means that Canadians in similar situations are being treated differently under a national program. This is in part why many Canadians view EI as running afoul of interregional equity. The second reason is that the cost of living is higher in large cities like Toronto, so EI-related discrimination is especially inappropriate (Task Force 2006). The final reason relates the value system implicit in our social policy. We tend to congratulate ourselves because our medicare system is citizen-based, unlike in the United States, where health-care coverage is largely employment-based (in the sense that one needs a good job to fully access

Figure 3: Proportion Unemployed Receiving Regular Employment Insurance Benefits, by Major City, Canada, 2004

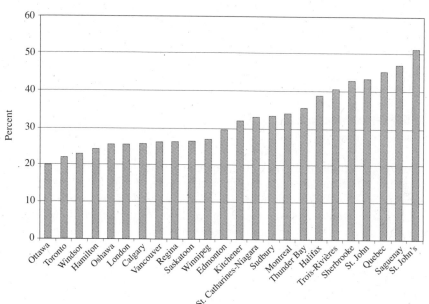

Source: Battle, Mendelson, and Torjman 2006

American social benefits). This linking of federal training funds to EI eligibility, rather than to the needs of similarly situated Canadians, represents a move toward the US value system as it relates to social benefits.

In light of all of this, the task force proposed several recommendations, including the following (where their term "working income supplement" is identical to what we are calling the working income tax benefit [WITB]):

A new refundable tax benefit should be created consisting of a basic tax credit for all low-income working-age adults and a working income supplement for low-income wage earners. Most Task Force members believe this new benefit should be federally financed and administered.[1] (2006, 32)

[1] The Task Force elaborates as follows:
- Basic Refundable Tax Credit: A new income-tested refundable tax credit for low-income working-age adults, including persons with disabilities. The maximum benefit would be $1,800/year ($150/month). It would begin to be recovered at $5,000/year in household income and would reduce to zero by $21,500/year in household income.

It also recommended that EI eligibility rates become standardized across Canada. Its preferred option is to extend the existing regional preferences (relating to entry and duration of benefits) uniformly across the country. With respect, my preference would be to standardize upward, as it were, and to remove the regional provisions that reward short-term labour-force attachment. One might maintain the current EI contribution rates, but roll the resulting "excess premiums" into a payroll tax dedicated to training for all Canadians or perhaps as a payroll tax dedicated to financing the WITB.

What is most intriguing about these proposals is the call for Ottawa to play a larger role in income-distribution among the unemployed and the working poor. Arguably, this would be entirely salutary for Canada's GCRs (and cities generally), because one legitimate fear is that powerful cities would put efficiency and wealth creation before income distribution in terms of their overall priorities. To a considerable degree, such a focus on efficiency would be essential, since GCRs in the KBE are the wellspring of competitiveness and innovation. Moreover, given the recent volatility of regional fortunes and the resulting interregional migration, it seems that helping citizens adjust to variations in regional economic conditions should not fall as much as it currently does on the provinces, and especially not on the GCRs. With Ottawa already playing an income-support role for the children and the elderly, it might also consider extending its income-distribution role to the working poor in the form of a working income tax benefit. In other words, for cities to succeed in ensuring "place prosperity," the senior levels of government need to play a larger role in ensuring "people prosperity."

FISCAL IMBALANCE, THE GST AND GCRS

Prime Minister Harper's commitment to open federalism is a commitment, in part at least, to respect the Constitution, including the provision that essentially makes cities the creatures of the provinces. Presumably this means it is unlikely that Prime Minister Harper will embrace federal-municipal tax sharing à la Paul Martin. On the other hand, the Conservatives are about to embark on

• Working Income (Tax) Benefit: A new working income supplement delivered through the tax system. Minimum work hours to qualify would be 50 hours/month or a household income of $400/month or $4,800/year. The maximum benefit would be $2,400/year ($200/month). When integrated with the refundable tax credit, it would bring a single adult earning minimum wage and working average hours (32 hours/week) from an income of just under $13,000/year to an income level of approximately $16,000/year. This benefit would also reduce to zero at $21,500/year in household income (2006, 32).

an initiative that will serve to increase the options for, if not the likelihood of, a tax transfer to the provinces, which could then be passed on to the cities.

Specifically, the 2006 federal budget background paper, *Restoring Fiscal Balance in Canada* (Finance Canada 2006), asserts that for any federal action to redress the fiscal imbalance, there would have to be a provincial quid pro quo. One element of this quid pro quo would have to be a commitment on the part of the provinces to harmonize provincial sales taxes. Obviously, this would mean harmonizing the provincial PSTs with the GST for Ontario, Manitoba, Saskatchewan, British Columbia and PEI (since Quebec's and the rest of Atlantic Canada's provincial sales taxes are already harmonized, and Alberta, with no PST, can be viewed as also falling into the harmonized camp). This would be an excellent policy in its own right, since there are substantial competitive gains to be had from converting the PSTs to a GST format (such as an overall reduction in corporate taxes, since typically PSTs tax capital inputs and intermediate inputs generally). This situation would not occur under a GST, because these input taxes would be eligible for rebates. Moreover, according to Bird and Smart (2006), the GST provinces have had larger increases in investment than the PST provinces. The roadblock preventing provinces from capturing these gains is a political one: converting a PST to a GST may run up against considerable public resistance. In this light, Ottawa's insistence that sales tax harmonization be part of the quid pro quo for addressing fiscal imbalance may well pave the political way for the provinces to make the conversion.

If this were to occur, it would open up the possibility of a GST tax transfer to the provinces. Arguably, the GST is an appropriate choice for a derivation-based tax transfer or even tax sharing. One reason for this is that per capita GST revenues would be distributed more equally among provinces than would personal income taxes and corporate taxes. Moreover, since Prime Minister Harper has promised a further cut in the GST – from 6 percent to 5 percent – this could take the form of vacating GST tax room to the provinces as part of a larger GST transfer. This GST transfer to the provinces could then be transferred on to the cities. This would be the "double devolution" recommended by the Harcourt Report, to which I now turn.

THE EXTERNAL ADVISORY COMMITTEE ON CITIES AND COMMUNITIES

As already noted, among the city/municipal initiatives the Martin government undertook in its 2004 federal budget was the establishment of the External Advisory Committee on Cities and Communities (EACCC), which was chaired by Mike Harcourt, former British Columbia premier and Vancouver mayor. The committee was charged with examining the future of Canada's cities and communities and developing a longer-term vision of the role that cities should play in sustaining our prosperity.

The report notes that the Europeans are more advanced than Canada in their embrace of subsidiarity and devolution, and it is convinced that some governance arrangements now in place (such as unfunded mandates) actually penalize the competitiveness of our people and places. All levels of government must become involved in correcting the situation; it says:

> The federal government must make sure that Canada collectively is a strong nation by allowing better local choices. Provinces and territories have crucial strategic roles in reconciling policies and programs for places. Intercity networks, city-region effects and city-to-rural connections are valuable aspects of development that are less than national in scope and more than municipal in their functioning. Municipalities have important roles in delivering services, providing leadership and vision, and regulating and taxing highly localized markets.
>
> To shape better cities and strong communities, federal capacities are needed to make connections, provincial and territorial powers are needed for strategic integration and municipal abilities are needed to engage with citizens and deliver change locally. Cooperative relationships are essential to good governance for places. To achieve the required outcome, it is the Committee's view that it will be essential to strengthen not only provincial and territorial roles, but even more to see stronger, confident provinces and territories devolving power and resources to municipalities – working with them and civil society in new governance partnerships tailored to city-regions and neighbourhoods. (EACCC 2006, 4)

While much of the case for privileging Canadian cities tends to focus on reworking the structure of federalism (i.e., devolving money and power to the cities), the Harcourt Report puts much more emphasis on the processes of federalism. The important implication of this is that cities can also have more say about their futures if they are integral players in multi-level cooperative and collaborative approaches to governance, to policy design and to policy implementation. Janice Gross Stein has called this "networked federalism" (2006).

Nonetheless, in order to underpin this process dimension of federalism, the Harcourt Report also calls for some structural innovation, namely a "double devolution" of money and responsibilities to the municipalities:

> The Committee therefore recommends a double devolution, shifting responsibilities and resources from the federal government to the provincial and territorial governments, and then from the provincial and territorial governments to the local level; the double devolution should ensure that choices about how to raise and use resources, including tax choices, move to the most appropriate local levels, where accountability to citizens is most direct.

By way of providing a rationale for this double devolution, the report adds:

> The first principal purpose of double devolution is to make sure that all orders of government, with relevant partners from business and civil society, work

together to implement governance arrangements that are locally appropriate, including arrangements dealing with significant city-region and neighbourhood issues that may not necessarily correspond with government boundaries. The second purpose of double devolution is to allow municipalities to develop a municipal taxation structure that gives them access to revenues, some of which grow with the economy while others provide a stabilizing influence. (5)

SUMMARY

Clearly, one could list many other federal programs, policies and processes that could enhance the autonomy and well-being of Canada's cities. I elaborated on some of these, such as the recommendations made by the TD Bank, in an earlier paper (2006). Nonetheless, the underlying reality is that increasing the cities' fiscal autonomy, enhancing their powers, and improving local democracy and accountability will depend on creative changes in provincial-municipal relations.

PROVINCIAL-MUNICIPAL RELATIONS

A WISH LIST FOR GLOBAL CITY REGIONS: THE GREATER TORONTO CHARTER

Alan Broadbent puts the GCR-province challenge in the following context:

There is a huge number of issues where the city is the key point of delivery, where it has greater knowledge and experience, or where it can exercise the flexibility and responsiveness that leads to better delivery . . . But the city cannot structure its own solutions, because these solutions must pass the test of acceptability by a level of government with less specific knowledge, experience, or motivation. (2000, 3)

Since many GCRs are, in fact, larger than the majority of provinces and have the critical civil-servant mass needed for effective policy design and delivery, granting them powers and responsibilities in line with cities elsewhere in the world ought to be eminently achievable.

In order to advance this goal, Broadbent and a group of city politicians, business people, NGOs and academics drafted what they called The Greater Toronto Charter. The key provision is that the greater Toronto region be empowered to govern and exercise responsibility over a broad range of issues, including:

child and family services; cultural institutions; economic development and marketing; education; environmental protection; health care; housing; immigrant and refugee settlement; land-use planning; law enforcement and emergency services; recreation; revenue generation; taxation and assessment; transportation; sewage treatment;

social assistance; waste and natural resource management; and water supply and quality management. (Greater Toronto Charter, 2001)

The requisite corollary provision of the charter is that the Toronto region would have to have the fiscal authority to raise revenues and to allocate expenditures with respect to the above powers/responsibilities.

Several comments are in order. The first is that the Charter focuses more on intergovernmental structures than processes. Second, it may be argued that the Charter is really a blueprint for a "city-state" (or city-province). Smaller centres would have neither the territorial scope nor the professional expertise to take on these powers. Third, and in terms of cities and multi-Hrbeklevel-governance or networked-federalism, these powers would not all be exclusive to cities. Many (perhaps most) would be shared, or concurrent powers. Indeed, some could be devolved administratively from other levels of government (as in the German federation). For example, Toronto, Montreal or Vancouver might decide to operate a "single window" for immigrant/refugee services, which could include some that currently fall under the senior orders of government. Finally, Canadian cities have more leeway than US cities to pursue their economic interests, because key elements of the social envelope, such as medicare and income support for children and seniors, are the responsibility of higher orders of government. In this regard, including social assistance in the responsibilities of cities could be problematic if the responsibility went beyond administration and coordination to embrace funding. Access to broad-based tax sources would help here, but there would still be a strong case for provincially financed social assistance (or greater federal financing, along the lines I suggested in the previous section).

With respect to funding, the Canadian model of provinces piggybacking on federal income taxes is successful at home and envied abroad. The time is ripe to replicate this at the municipal-provincial level. Presumably, this is what the Harcourt Report had in mind with the second part of the proposed double devolution. Obvious candidates for taxes to share are personal income taxes (PIT) and sales taxes (after the remaining PSTs have been converted to the GST). Initially, at least, the cities should settle for a fixed share of the tax on a derivation basis. After all, it took nearly 40 years for the provinces to win freedom to set tax rates and brackets under the shared PIT, so a settling-in period for the cities would be appropriate (and politically astute). Moreover, and again initially, the tax transfer need not represent additional revenues. Rather, its initial role could be to replace a portion of the current 40 percent of revenues (in the Greater Toronto Area) that come from provincial grants and to reduce reliance on property taxes, especially for the growing range of services that have little relation to property. However, over time the cities will become progressively better off, since they will have access to a growing tax base.

In the meantime, "there is no reason for the cities to wait for a handout," as Berridge asserts. Cities have many untapped or underutilized revenue sources –

user fees and benefit taxation, as well as properly priced local public services – and they could even request some of the taxes currently accessible to Seattle and Denver. Moreover, as Berridge says with respect to Toronto's utilities:

> Toronto is one of the few cities in the world that still operates these services (electricity, water, garbage, transit . . .) as mainline businesses. The ability to use the very substantial asset values and cash flows of these municipal businesses is perhaps the only financial option to provide the city-region with what is unlikely to be obtainable from other sources: its own pool of reinvestment capital...with remarkable leverage potential, both from public-sector pension funds and from private-sector institutions. (1999)

Cities would be better positioned financially and when they lobby the senior orders of government for more money and power if they utilized more fully the powers they already possess.

DEMOCRACY AND ACCOUNTABILITY

Even if it is true, as I posited earlier, that citizens are the principal beneficiaries of the information revolution, why push the principle of subsidiarity to the local level where democracy and accountability appear to be weaker than they are at higher government levels? Phrased differently, why has the recognized potential for democracy to thrive at the local level not materialized? One of the reasons may be that it is difficult for citizens to be enthusiastic about local democracy as long as city politicians are largely administrators of responsibilities and policies that are legislated (and funded) elsewhere. Much better, if this is the case, to join the city politicians and engage in rent-seeking at the provincial and federal doorsteps. However, with greater political autonomy involving enhanced responsibilities and greater revenue flexibility, the stage would then be set for more meaningful citizen engagement, since much more would be at stake at the city level. In a word, the result would be more local accountability and more democracy.

Along with this increased application of the principle of subsidiarity, there would also be an improvement in the dynamic efficiency of cities and their governance. This is because cities would approach their new-found responsibilities in a myriad of creative ways. This is competitive federalism at play in the cities' arena. Some might view this as needless variation. It is likely, however, to be the source of creative asymmetry, and novel ways to do things would emerge, the best of which would presumably be replicated in other cities.

BIG CITIES VERSUS SMALL CITIES

Implicit in the foregoing analysis is that GCRs are different from other cities and merit preferential treatment. But surely all cities, not just the GCRs, would

benefit from the dynamic-efficiency effects of acquiring greater money and power. Moreover, it might be difficult politically to privilege GCRs relative to smaller cities. In *Apples and Oranges? Urban Size and the Municipal-Provincial Relationship*, Roberts and Gibbins struggle with this very issue: are small cities similar enough to big cities so that they can be viewed as "small apples," or are they really "oranges"? The authors recognize that there is a need for a new relationship between big cities and the provinces, but they reject the two extreme approaches, namely, drawing a hard line between big cities and other municipalities, on the one hand, and treating all municipalities in the same way, on the other. Their compromise is what they call the "best-of-both-worlds solution," namely:

> An opt-in framework that is flexible enough to enable those municipalities that desire greater autonomy or new fiscal tools in certain areas to adopt them, but one that does not require those municipalities that do not possess the capacity to take on the roles sought by big cities to abandon the security of their current arrangement. (2005,1)

The result would be de jure symmetry but de facto asymmetry, or "variable geometry," as the Europeans would call it. And this, I would argue, would be good politics.

CONCLUSION

The daunting challenge is how to bridge the gap between the KBE potential of Canadian global city-regions and the ongoing Canadian reality, as well as the gap between Canadian and international GCRs. My reading of the literature is (1) that citizens and cities are indeed the principal beneficiaries of the KBE. (2) The democratization of information and the falling costs of telecomputation ensures that subsidiarity will prevails and bring government closer to the people, and (3) Given that human capital and associated KBE activities are concentrated in cities, this means that cities will increasingly drive productivity, innovation and living standards. Accordingly, GCRs need to be brought more fully and formally into the operations of Canada's political and fiscal federalism. If one then notes that most of the world's GCRs already have powers and responsibilities well in excess of those of Canada's GCRs, it would seem to follow that granting GCRs enhanced expenditure and revenue-raising responsibilities should be a slam dunk.

But it clearly is not a slam dunk politically. One reason for this is that at stake is a realignment of effective powers in the federation, which is tantamount to de facto, if not de jure, constitutional change. Governments do not part with such powers lightly, not only because they want to "protect their

turf," but also because arguably all the institutional structures and processes in our federation rest on the current distribution of powers. Indeed, while one may lament the continued gap between the potential and the reality of Canada's GCRs, constitutional change should be difficult, since at issue are society's underlying property rights, as it were.

On a more positive note, however, considerable progress is already apparent. The "New Deal for Canada's Communities" in the 2004 budget, in particular Ottawa's gas-tax sharing (despite the equal-per-capita allocation), was a very significant initiative, because it "embarrassed" the provinces into recognizing the potential of their cities. Moreover, several major institutions have put their research, reputation and influence behind a better deal for our cities – the TD Bank, the Canada West Foundation, the Conference Board of Canada, the Maytree Foundation and the Institute for Research on Public Policy, among others. In addition, Ontario has recently reworked its municipal act in directions that would allow Toronto, for example, to deal directly with Ottawa in certain areas. Thus, one can envision the implementation of certain federal programs or services being delegated to the cities, which would clearly enhance the cities' ability to coordinate, if not integrate, their various services. In tandem with many other developments, we are witnessing meaningful progress in terms of the structural and process dimensions of federalism. And from this there is no turning back.

However, the real breakthrough will probably have to come from the provinces. As was the case with Saskatchewan and Medicare, one province needs to embrace broad-based tax sharing with its GCRs and cities generally, and then the game would be afoot. And this will be about "when" and not "if," because all Canadians know that Canada needs globally competitive cities. If the provinces are not up to the challenge of privileging their GCRs, then Canadians and the GCRs must and will work together to ensure that subsidiarity privileges the cities, even if it means bypassing the provinces.

REFERENCES

Battle, Ken, Michael Mendelson, and Sherri Torjman. 2006. *Towards a New Architecture for Canada's Adult Benefits*. Ottawa: Caledon Institute of Social Policy.

Berridge, Joe. 1999. "There is No Need to Sit and Wait for a Handout." *The Globe and Mail*, 7 June.

Bird, Richard, and Richard Smart. 2006. "Transfer Real Taxing Power to the Provinces." *National Post*, 27 June, FP17.

Brender, Natalie, and Mario Lefebvre. 2006. *Canada's Hub Cities: A Driving Force of the National Economy*. Ottawa: The Conference Board of Canada.

Broadbent, Alan. 2000. "The Autonomy of Cities in Canada." In *Toronto: Considering Self Government*, edited by Mary Rowe. Owen Sound: The Ginger Press.

Castells, Manuel. 2001. *The Internet Galaxy*. New York: Oxford University Press.

Chernick, Howard, and Andrew Reschovsky. 2006. "Local Public Finance: Issues for Metropolitan Regions." In *Competitive Cities in the Global Economy*, edited by Lamin Kamal-Chaoui. Paris: OECD, 288–298.

Courchene, Thomas J. 2006. "Citistates and the State of Cities: Political-Economy and Fiscal- Federalism Dimensions." In *Municipal-Federal-Provincial Relations in Canada*, edited by Robert Young and Christian Leuprecht. Montreal and Kingston: McGill-Queen's University Press for the Queen's Institute of Intergovernmental Relations, 83–115.

External Advisory Committee on Cities and Communities (EACCC). 2006. Chaired by Michael Harcourt. *Restless Communities to Resilient Places: Building a Stronger Future for All Canadians*. Final report. Accessed 14 May 2007. http://www.infrastructure.gc.ca/eaccc-ccevc/rep-rap/summary_e.shtml

Finance Canada. 2006. "Restoring Fiscal Balance in Canada: Focusing on Priorities." Budget 2006. Ottawa: Finance Canada. Accessed 17 May 2007. http://www.fin.gc.ca/budget06/ fp/fptoce.htm

Florida, Richard. 2002. *The Rise of the Creative Class*. New York: Basic Books.

Friedman, Thomas L. 1999. *The Lexus and the Olive Tree: Understanding Globalization*. New York: Ferrar, Straus and Giroux.

Gertler, Meric, Richard Florida, Gary Gates, and Tara Vinodrai. 2002. "Competing for Creativity: Placing Ontario's Cities in the North American Context." A report prepared for the Ontario Ministry of Enterprise, Opportunity, and Innovation, and the Institute for Competitiveness and Prosperity.

Greater Toronto Charter. 2001. In *Towards a New City of Toronto Act*, with contributions by Alan Broadbent et al. Ideas that Matter. Toronto: Zephyr Press (page 40). Accessed 1 June 2007. http://www.ideasthatmatter.com/ cities/CityOfTorontoActJune2005.pdf

Harris, Richard G. 2003. "Old Growth and New Economy Cycles: Rethinking Canadian Economic Paradigms." In *The Art of the State: Governance in a World without Frontiers*, edited by Thomas J. Courchene and Donald J. Savoie. Art of the State III. Montreal: Institute for Research on Public Policy, 31–63.

Horsman, Mathew, and Andrew Marshall. 1994. *After the Nation State: Citizens, Tribalism and the New World Disorder*. London: Harper Collins.

Hrbek, Rudolph, and Jan Christoph Bodenbender. Forthcoming. "Federal-Municipal Relations: Germany." In *Spheres of Governance, Comparative Studies of Cities in Multilevel Governance Systems*, edited by Harvey Lazar and Christian Leuprecht. Montreal and Kingston: McGill-Queen's University Press for the Queen's Institute of Intergovernmental Relations.

Lotz, Jørgen. 2006. "Local Government Organizations and Finance: Nordic Countries." In *Local Governance in Industrial Countries*, edited by Anwar Shah. Washington: The World Bank, 223–64.

Martin, Roger, and James Milway. 2003. "Ontario's Urban Gap." *National Post*, 4 July.

McMillan, Melville L. 2006. "Municipal Relations with the Federal and Provincial Governments." In *Municipal-Provincial-Federal Relations in Canada*, edited by

Robert Young and Christian Leuprecht. Montreal and Kingston: McGill-Queen's University Press for the Queen's Institute of Intergovernmental Relations, 45–82.

McMillan, Melville L. 1997. "Taxation and Expenditure Patterns in Major City-Regions: An International Perspective and Lessons for Canada." In *Urban Governance and Finance: A Question of Who Does What*, edited by Paul Hobson and France St-Hilaire. Montreal: Institute for Research on Public Policy, 1–58.

Pastor, Manuel. 2006. "Cohesion and Competitiveness: Business Leadership for Regional Growth and Social Equity." In *Competitive Cities in the Global Economy*, edited by Lamia Kamal-Chaoui. Paris: OECD, 288–98.

Roberts, Kari, and Roger Gibbins. 2005. "Apples and Oranges? Urban Size and the Municipal-Provincial Relationship." Discussion paper, Canada West Foundation. Accessed 1 June 2007. www.cwf.ca/V2/files/Apples%20and% 20Oranges.pdf

Sancton, Andrew. 2004. "Governance and Cities: Constitutional Capacity Issues." Paper presented at the conference "Embracing the Urban Frontier: Capitalizing on Canada's Cities," Queen's School of Policy Studies, 30 April 30–1 May.

Stein, Janice Gross. 2006. "Canada by Mondrian: Networked Federalism in an Era of Globalization." In *Canada by Picasso: The Faces of Federalism*, by Roger Gibbins, Antonia Maioni and Janice Gross Stein, with an introduction by Allan Gregg. The 2006 CIBC Scholar-In-Residence Lecture. Ottawa: Conference Board of Canada, 15–58.

Task Force on Modernizing Income Security for Working Age Adults (MISWAA). 2006. *Time For A Fair Deal*. St. Christopher House, in partnership with The Toronto City Summit Alliance. Accessed 17 May 2007. www.stchrishouse.org/ get-involved/community-dev/Special%20Projects/ ModernizingIncomeSec/ MiswaaFinalReport.php

Vander Ploeg, Casey. 2005. "Rationale For Renewal: The Imperatives Behind a Big City Partnership." Western Cities Project Report no. 34. Canada West Foundation.

Zysman, John. 1983. *Government, Markets and Growth: Financial Systems and the Politics of Industrial Change*. Ithaca, NY: Cornell University Press.

VII

Federalism and the Spending Power

15

Fiscal Federalism and the Future of Canada: Can Section 94 of the Constitution Act, 1867 be an Alternative to the Spending Power?

Marc-Antoine Adam

C'est sans doute le débat autour du fédéralisme fiscal qui aura le plus marqué la dernière décennie au plan intergouvernemental. Dans la littérature spécialisée, on ne compte plus les critiques adressées au système : manque de transparence, manque de reddition de comptes, déficit démocratique, disputes inter-juridictionnelles stériles et tensions politiques constantes. Parallèlement, on remarque qu'au Canada, les rapports fédératifs semblent être de plus en plus détachés de la Constitution et ce phénomène n'est nulle part aussi manifeste qu'à l'égard de la gouverne de l'union sociale canadienne. Le présent chapitre suggère qu'il existe peut-être un lien étroit entre ces deux problématiques. Jusqu'ici, la principale thèse proposée pour servir de fondement juridique à l'union sociale canadienne a été celle du pouvoir illimité de dépenser. Or, cette thèse n'a jamais vraiment fait consensus, elle est en porte-à-faux avec plusieurs dispositions et principes constitutionnels et elle ne rend pas véritablement compte des pratiques intergouvernementales, davantage marquées par la négociation que par l'unilatéralisme. Devant ces nombreuses lacunes, ce chapitre propose un fondement juridique alternatif en s'appuyant sur la seule disposition du chapitre de la Constitution traitant du partage des compétence qui prévoit explicitement la possibilité pour l'État fédéral d'intervenir dans des domaines de compétence provinciale : l'article 94 de la Loi constitutionnelle de 1867. En posant clairement l'exigence du consentement des provinces concernées de même qu'en prenant acte de la particularité québécoise, cette disposition nous rapproche de la dynamique fédérale-provinciale des cinquante dernières années, elle fait écho aux limites historiquement recherchées au pouvoir de dépenser et elle confirme le caractère asymétrique du fédéralisme canadien. En somme, l'article 94 pourrait servir de cadre constitutionnel à un fédéralisme caractérisé à la fois par la flexibilité, le respect, la coopération et la primauté du droit.

The author wishes to thank his colleagues from the Quebec government, constitutional scholars from Laval and Montréal University and members from the

INTRODUCTION

In the past year, the 25th anniversary of the *Constitution Act, 1982* has fostered numerous analyses about the impact the *Charter of Rights and Freedoms* has had on Canadian governance and values over the last quarter century. Ironically, as the Charter pushed the principles of limitation on sovereignty, judicial review, constitutionalism and the rule of law to a level never seen before in a British parliamentary system, those very same principles were all but abandoned as regards federalism. In other words, while the idea that the Charter should set strict and enforceable limits to all aspects of government action has sunk deep in the Canadian psyche, relativism seems to have nearly completely overcome federalism.[1]

This inconsistency in our relationship with constitutional rules and the weakening of federalism in Canada may well be rooted in our failure to tackle adequately the issue of interdependence between the two orders of government as well as the conflicting desires – often opposing Quebec and the rest of Canada – for more or less pan-Canadian integration. As a result of this failure, a considerable gap has developed between the Constitution and the practice of federalism, now largely left to the forces of politics. As the raging debate over the fiscal imbalance witnessed during the past decade indicates, nowhere is this truer then in the governance of fiscal federalism and more generally of Canada's social union.

Using the fiscal imbalance debate as backdrop, this paper will first stress the need to go back to a rules-based federalism, more specifically a constitution-based federalism. With this need in mind, we will then turn our attention to the issue of the "unlimited" federal spending power which, essentially, is the only theoretical construct that has been advanced so far to bridge the gap between the Constitution and Canada's social union. We will ask both whether it is really compatible with our constitutional law and whether it faithfully reflects the practice on the ground, or for that matter, what Canadians truly want. After having identified important deficiencies with this thesis, the remainder of the paper will shed light on section 94 of the *Constitution Act, 1867* which could, it is contended, provide a better alternative to the spending power thesis as a potential legal foundation for Canada's social union.

Institute of Intergovernmental Relations, in particular its director, Tom Courchene, as well as Barbara Cameron of York University, for having contributed in various ways to the development of the ideas presented in this paper. Of course, the author assumes full responsibility for the views expressed.

[1] This irony was underlined recently by Hamish Telford (2005).

THE NEED FOR RULES

Over the last decade, academics have devoted much attention to "what works and what might work better" with respect to Canadian fiscal federalism (to borrow from the tile of one of the Institute of Intergovernmental Relations' publications).[2] The criticisms relating to fiscal federalism are numerous and often longstanding. To be sure, it is credited with great successes. But those achievements seem to belong to a now distant past. There is in the literature a perception that while the system might have been working relatively smoothly up until the late seventies – when public money was flowing – this has not been so much the case since. Hence, complaints of potential misspending and lack of transparency and accountability traditionally associated with fiscal federalism were more recently joined by other perceived shortcomings such as the lack of binding effect of intergovernmental agreements, the absence of dispute settlement mechanisms, the political tension and constant conflicts over jurisdiction and more generally the absence of rules, the lack of process and the lack of collaboration (Lazar 2000; Meekison, Telford, and Lazar 2004; Papillon and Simeon 2004; Leslie, Neumann and Robinson 2004; Noël 2005).

Although there seems to be a growing consensus over these weaknesses, at least in the academe, and no shortage of ideas to create new structures to address them (e.g. Burelle 1995; Courchene 1997; Frank 2004; Cameron 2004; Lazar 2005; Leclair 2006), fiscal federalism and Canada's social union appear forever impossible to regulate. This paper puts forward the idea that maybe our existing institutions are more adequate than we think in this respect; maybe the problem is that we disregard them.

Indeed, what is striking with Canadian federalism is that we try to govern this country without the assistance of a legal framework, i.e. the Constitution. With respect to federal-provincial issues, the conventional wisdom is, firstly, that our constitution is outdated and cannot provide satisfactory answers to the needs of today and, secondly, that it cannot be amended. Leaving aside the second of these two perceptions for a moment, let us challenge the first one.

[2] For example, most of the articles in the following publications of the Institute of Intergovernmental Relations were related in one way or another to fiscal federalism: *Canada: The State of the Federation 1999–2000: Toward a New Mission Statement for Canadian Fiscal Federalism*; *Canada: The State of the Federation 2002: Reconsidering the Institutions of Canadian Federalism*; *Canadian Fiscal Arrangements: What Works, What Might Work Better, 2005*; and of course the current issue of the *State of the Federation* series.

For many, Canada's Constitution, at least those sections dealing with federalism, is a liability. Its rigidity is an obstacle to Canadian nation building. It is considered to be divisive and focusing too much on it might even pose a threat to Canadian unity. Hence, the very term "constitution" has become a bad word in our vocabulary. Conversely, these same people are convinced that our ingenuity to skirt around the Constitution, or to "muddle through", as some put it, has made Canada a stronger country. Maybe ... but then, maybe not. It has been said that federalism is a "learning process of negotiation and conflict resolution" and that a "certain creative tension" is inherent in the federal system.[3] That we should constantly be negotiating is perhaps normal; that there should be no permanent agreed-upon rules to govern our negotiations and what we negotiate is more troublesome. But this is what a constitution is meant to provide: a set of fundamental rules or a framework within which the day-to-day political process can take place. Lack of agreement on day-to-day political issues is normal and healthy. Lack of agreement on the fundamental rules is a different matter. In fact, one could say that in our federation, because of this lack of agreed-upon fundamental rules, the management of what should be day-to-day political issues has a tendency to mutate into quasi-constitutional negotiations, with the ironical result that Canada, for wanting to avoid its constitution, finds itself locked in a state of permanent constitutional debate.

In November 2004, the Quebec government put forward five principles that ought to govern us to meet the challenges facing the Canadian federation. These are respect, flexibility, balance, cooperation and the rule of law.[4] Incidentally, shortly after this, Stephen Harper pledged that if he became Prime Minister of Canada, he would strictly abide by these same principles.[5] When mentioning the rule of law in the speech he delivered in Charlottetown on this topic, Quebec's Premier, Jean Charest, stressed the importance that the practice of Canadian federalism be grounded in the Constitution. He also said that

[3] These words come from speeches delivered by Stéphane Dion as federal minister for Intergovernmental Affairs: "Intergovernmental Relations Within Federations: Contextual Differences and Universal Principles," notes for an address at the International Conference on Federalism, Mont-Tremblant, Quebec, 6 October 1999 and "Federalism and Democracy: the Canadian Experience," notes for an address at the University of Manitoba, Winnipeg, Manitoba, 14 April 2000.

[4] "Rediscovering the Spirit of Federalism," speech delivered by Quebec Premier on the occasion of the 40th anniversary of the Confederation Centre of the Arts, Charlottetown, 8 November 2004.

[5] Presentation by the leader of the Conservative Party of Canada, Mr. Stephen Harper, made before the Quebec Chamber of Commerce, 19 January 2005.

resorting to law courts to settle a dispute is sometimes better than carrying a sterile political struggle on forever.

The rule of law and constitutionalism are principles of utmost importance for everybody; they afford stability and predictability. But they are even more vital for minorities because they protect them from the arbitrariness of the power holders of the day.[6] While in a democracy this might mean curbing the will of the majority at times, this result scarcely needs to be explained or justified as far as the *Charter of Rights and Freedoms* is concerned; it is broadly acknowledged and supported. However, we tend to overlook this same rational when it comes to the federal distribution of powers. As Hamish Telford has noted, because Quebec is the home of a "minority community" in this country, the federal distribution of power constitutes for Quebecers a form of constitutional protection in much the same way as the Charter (Telford 2005).

THE CONSTITUTION AND THE FEDERAL SPENDING POWER

A great deal of the controversy surrounding the notion of fiscal imbalance, at least the vertical imbalance, relates to diverging interpretations of the allocation of roles and responsibilities between the provinces and the federal government (Boadway 2005). These differences, in turn, are a direct result of the lack of legal certainty and political consensus concerning the federal spending power. In a sense one could view the federal spending power as the shaky foundation of fiscal federalism and Canada's social union.

In the early 2000s, in response to legal proceedings undertaken by labor unions in Quebec challenging the constitutionality of certain provisions of the *Employment Insurance Act*, the federal government argued that even if the impugned provisions were not deemed to fall under its jurisdiction over unemployment insurance they had to be declared valid owing to the federal spending power which "is in no way limited by the distribution of powers"

[6] The great classic on the rule of law is of course the British constitutionalist A.V. Dicey's *Law of the Constitution*, but for a more contemporary and Canadian account of this concept and that of constitutionalism, see the decisions of the Supreme Court of Canada in *Reference re: Secession of Quebec*, 1998, par. 70–78 and in *Reference re: Manitoba Language Rights*, 1985, par. 59–66. In this latter case, the rule of law was invoked to prevent what could have led to a legal vacuum pursuant to the breach of Manitoba's constitutional obligations with respect to bilingualism. The Court stressed that "the rule of law requires the creation and maintenance of an actual order of positive laws which preserves and embodies the more general principle of normative order. Law and order are indispensable elements of civilized life" (par. 60).

(Syndicat national des employés de l'aluminium d'Arvida inc. c. Canada (Procureur general)).[7] The attorney general for Quebec intervened in the proceedings to object to this sweeping claim.

In essence, Quebec's argument in this regard is that the federal spending power, as conceived by the federal government and its supporters, is not in the text of the Constitution, nor has it been formally recognized by case law, despite some comments delivered occasionally by justices of the Supreme Court of Canada.[8] These often short and rather vague comments are what we call *obiter dicta*.[9] They are not binding because they were expressed in circumstances where the spending power was not the object of the litigation, the Court didn't need to address this issue to settle the case and it was not presented with all the arguments related to it in an adversarial manner which, in our legal tradition, is considered to be a safeguard for sound case law. Incidentally, it was also the conclusion reached by the Quebec Commission on Fiscal Imbalance, led by Yves Séguin, which investigated this matter in 2002 (The *Federal Spending Power* Report – Supporting document 2, 2002; see also Lajoie 2006).[10]

In fact, as some authors have pointed out in recent years (Yudin 2002; Telford 2003; Kellock and Leroy 2007), the only authoritative case that dealt with the federal spending power is the 1937 decision of the Judicial Committee of the Privy Council rendered in the *Unemployment Insurance Reference* (before the Constitution was amended to transfer unemployment insurance to the federal parliament). In that case, the federal government was attempting to defend the validity of its legislation by construing it as taxation on the one hand and disposition of federal property on the other hand, and then by arguing that in disposing of such property, it was not constitutionally limited to federal objects. The Privy Council was not convinced by the federal characterization of the statute, but even supposing such characterization to be correct, it rejected

[7] This case is now under consideration before the Supreme Court of Canada SCC no. 31809 and SCC no. 31810. Permission to appeal to the Supreme Court of Canada is pending.

[8] See the legal memorandum filed before the Supreme Court by the Attorney General for Quebec in the above mentioned case.

[9] These comments are found in the following cases: *YMHA Jewish Community Centre of Winnipeg Inc.* v. *Brown*, 1989; *Reference re: Canada Assistance Plan*, 1991; *Finlay* v. *Canada (Minister of Finance)*, 1993; *Eldridge* v. *B.-C. (A.G.)*, 1997; *Auton (Guardian ad litem of)* v. *British Columbia (Attorney General)*, 2004; *Chaoulli* v. *Quebec*, 2005.

[10] The Commission examined all of the above mentioned Supreme Court cases except the two last ones rendered after the issuance of its report.

the federal claim that its power to dispose of federal property was not limited by the distribution of powers (*A.–G. Can* v. *A.–G. Ont,* 1937).[11]

What is striking about this case is the resilience of the unlimited spending power thesis despite its clear rejection by the Privy Council.[12] Clearly, what allowed the thesis to survive is the continuing and expanding practice of federal interventions in areas of provincial jurisdiction that came with the advent of the welfare state. In the legal literature, this led to some interesting intellectual gymnastics, first to skirt around the decision of the Privy Council[13]

[11] In the first decades following the *Unemployment Insurance Reference*, this interpretation of the decision rendered by the JCPC was clearly dominant among the authors, even though it displeased some: Keith 1937; Mercier Gouin and Claxton 1939; MacDonald 1941; Pigeon 1943; Kennedy 1944; Birch 1955, 162; Commission Tremblay 1956, 222–223; Ryan and Slutsky 1964; Beetz 1965; Dupont 1967.

[12] The ineffectiveness of the JCPC ruling in the *Unemployment Insurance Reference* with respect to the spending power has been noted by many authors: Beetz 1965; Laskin 1975, 638; Petter 1989; Tremblay 2000a, 255–256; Beaudoin 2000, 721.

[13] The process through which the actual ruling of the JCPC came to be disregarded by a majority of Canadian authors is fascinating. The first steps consisted in deeming the decision to be unclear and looking in the Supreme Court's motives before its appeal to the JCPC for guidance, while paying particular attention to the two dissenting Supreme Court judges. The JCPC comments on the spending power theory were also labelled as obiter by a number of commentators. Eventually, distinctions were put forward to argue that while the power of the federal government to spend "in areas of provincial jurisdictions" (one will note that the JCPC never wrote these words) may have been somewhat limited by the JCPC's decision, the bulk of it remained unfettered. Hence, a first criterion consisted in differentiating federal expenses funded from a special fund from those funded from the general consolidated revenue fund. A second, somewhat related, criterion consisted in differentiating pure federal expenses (which can nonetheless be conditional!) from expenses mixed with "compulsory" provisions such as the requirement to pay premiums contained in the impugned *Unemployment Insurance Act*. As time went by, the support for federal spending in areas of provincial jurisdiction became so strong in Canada, and its practice so common, that not only did these distinctions take hold, but by some ironical twist of history, the JCPC's decision even came to be presented by some authors as an outright recognition of such a power. On this evolution see Scott 1955; Smiley 1963; Hanssen 1966; La Forest 1981, 48; Beck and Bernier 1982, 339; Chevrette and Marx 1982, 1040–1041; Rémillard 1983, 355–356; Schwartz 1987; Choudhry 2002; Brun and Tremblay 2002, 443; Beaudoin 2004. With respect, these distinctions and the resulting interpretations of the JCPC's ruling miss a fundamental feature of the decision, which is that for the purpose of settling the case, Lord Atkin had accepted the federal attorney's

and second to skirt around the distribution of powers.[14] This is how state spending, and the legislation authorizing it, came to be differentiated from "compulsory regulation" and portrayed as a gift that could be made freely, irrespective of the assignment of responsibilities provided for in the Constitution (Hogg 1997, chap. 6). To achieve this result, first, words were read into sections 91 and 92 of the *Constitution Act, 1867*. Hence, these sections, effecting the distribution of powers, no longer covered all legislation *relating* to the matters listed, as is written and as the courts have taught us: they would only cover the legislation actively "regulating" these matters.[15] Second, it

request to sever the compulsory provisions pertaining to premiums from the spending provisions pertaining to benefits and regard each operation separately. The federal government's contention was that the former was a valid federal tax under s. 91(3) *Constitution Act, 1867*, arguing there should be no distinction between general taxation and taxation to constitute a specific fund. As concerns the second operation – the distribution of the benefits – the federal government argued it was valid owing to an unlimited federal spending power which it presented in these terms: "Parliament is not confined in the appropriation of the funds to objects which are within the enumerated heads of s. 91 of *The British North America Act*" (358). In the end, Lord Atkin found it unnecessary to resolve the issues raised by the characterization of the premiums as tax, because he flatly rejected the unlimited spending power thesis: "But assuming that the Dominion has collected by means of taxation a fund, it by no means follows that any legislation which disposes of it is necessarily within Dominion competence. It may still be legislation affecting the classes of subjects enumerated in s. 92, and, if so, would be ultra vires. [...] If on the true view of the legislation it is found that in reality in pith and substance the legislation invades civil rights within the Province, or in respect of other classes of subjects otherwise encroaches upon the provincial field, the legislation will be invalid. To hold otherwise would afford the Dominion an easy passage into the Provincial domain" (366–367). Interestingly, this case has more or less disappeared from much of the contemporary literature supporting the unlimited spending power thesis and has never been discussed, let alone overturned, in the subsequent judicial decisions which are alleged by many as having "recognized" such a power.

[14] For an early articulation of the unlimited spending power thesis, see Scott 1955. The most complete contemporary articulation is probably provided by Hogg 1997, ch. 6. Accordingly, it acts as the backdrop for the discussion set out in this paper.

[15] This narrow interpretation of the scope of the distribution of powers effected under ss. 91–92 limiting such distribution to "regulatory" powers of a "compulsory" nature and excluding spending legislation, be it direct or delegated, appears to enter in direct contradiction with the principle of the exhaustiveness of the distribution of

was argued that conditions attached to spending, however demanding and inescapable, are not "regulation," even if it admittedly indirectly achieves the same outcome. Lastly, we were told that the purpose of the spending is not to be taken into account even though purpose has always been a central element in determining the validity of legislation in disputes about the distribution of power.[16]

The underlying rationale provided for the unlimited spending power thesis was that we should distinguish situations when the state acts as a "public power," i.e. in a "compulsory" manner, from when it acts as a "private actor," such as when spending, lending and contracting. In the latter cases, it was argued, the state should be no more constrained by the Constitution than would a private individual (ibid.). Strangely, no one has ever seriously attempted a similar public/private distinction to argue that the Charter ought not to apply to a government spending program. Obviously, there is a double standard here.[17]

Taken to its logical conclusion, the unlimited spending power thesis would imply that the provision of public services of any kind would largely be excluded from the purview of the distribution of powers, for it is essentially spending. The fact that "compulsory" taxation provides the means for these services seems irrelevant to the proponents of this thesis, as does the fact that

powers established very early on by the JCPC: "Whatever belongs to self-government in Canada belongs either to the Dominion or to the provinces, within the limits of *The British North America Act*" (A.-G. Ont. v. A.G. Can (Reference Appeal) 1912, 581).

[16] One of the very first things law courts had to establish under division of power litigation was how they were going to analyze legislation in order to assess its conformity with the Constitution. Hence, the first step of the test developed by the courts consists in identifying the "pith and substance" of the legislation, and in doing so it was decided that the inquiry should go beyond examining the mere legal effects of the legislation and investigate its purpose. The logic here is to not only prevent direct infringements but also attempts to indirectly control matters within the jurisdiction of the other level of government. This is why, when analyzing the effects of a legislation, both legal and practical effects may be considered. Hogg has a good development on this (Hogg 1997, s. 15.5 (d) and (e)). For a relatively recent judicial statement of the test see *Kitkatla Band* v. B. C. [2002] 2 S.C.R. 146.

[17] This implicit differentiation in the appreciation of the domain of application of the Charter as compared to the distribution of powers is all the more inconsistent when one considers that s. 32 of the *Constitution Act, 1982*, which establishes the domain of application of the Charter, simply refers to the distribution of legislative powers contained in the *Constitution Act, 1867*.

the provision of public services is now the core mission of the modern state. Moreover, little explanation is provided to account for the presence of many items in sections 91 and 92, Constitution Act, 1867, which actually take the trouble of allocating exclusive public services/spending responsibilities between the federal and the provincial legislatures.[18] Nor are we told why exactly we needed to amend the Constitution to allow the federal government to take on unemployment insurance and old age pension.[19]

As we can see, the unlimited spending power thesis is at odds with many constitutional provisions and principles.[20] It should therefore come as no surprise that it is also sometimes seen by non-lawyers as defying common sense, as Donald Smiley once so eloquently put it: "Although it is not within my competence to judge the constitutionality of the various uses of this power, [...] it appears to a layman to be the most superficial sort of quibbling to assert that when Parliament appropriates funds in aid of say, vocational training or housing, and enacts in some detail the circumstances under which such moneys are to be available that Parliament is not in fact 'legislating' in such fields." (Smiley 1962, 61).

[18] For example, postal service (s. 91(5), marine hospitals (s. 91(11), ferries (s. 91(13), hospitals, asylums, charities and eleemosynary institutions (s. 92(7). Ss. 91(8) and 92(4) are also interesting in that they specify who has exclusive jurisdiction to pay which civil servants!

[19] Ss. 91 (2A) and 94A.

[20] Reference has already been made to the principles of constitutionalism and the rule of law and, in particular, the requirement to create and maintain "an actual order of positive laws which preserves and embodies the more general principle of normative order" (for an discussion of these principles in the context of the unlimited spending power thesis, see Gaudreault-Desbiens 2006). Of course the principle of federalism outlined in the *Secession Reference* (1998) should also be mentioned. One could also mention the principle according to which in Canada, executive power, including royal prerogative, is divided between the federal government and the provinces following the same line as legislative power. Hence, under Canadian federalism, both orders of government are said to be sovereign in their own areas of jurisdiction, in the same manner and to the same extent as independent States. And one of the central principles of sovereignty is precisely independence, i.e. protection from outside interference. Andrew Petter (1989) provides an excellent and thorough case of all the constitutional provisions and principles which militate against the unlimited spending power thesis. Many of the points made in this paper are found in his work.

WHAT DOES CANADA WANT?

In the end, the strongest argument in favor of the possibility for federal spending in areas of provincial jurisdiction remains the massive practice of it over the past half century. To be sure, this practice has been welcomed in many parts of Canada, but it also has been the source of many grievances in Quebec.[21]

But while there well may be broad support for some federal involvement in areas of provincial jurisdiction among Canadians outside Quebec, it is doubtful that this support would extend as far as to sustain the claim made by the federal government when it declares that its power to spend "is in no way limited by the distribution of powers." It is equally doubtful that this proposition is an accurate reflection of the practice of fiscal federalism and the governance of Canada's social union. Indeed, according to the unlimited spending power thesis, the distribution of powers is irrelevant – it doesn't matter – when it comes to spending measures. The federal Parliament and government can act freely. While this is certainly what happens when they spend in areas of federal jurisdiction, it must be conceded that interventions in areas of provincial jurisdictions are almost always the subject of discussions and negotiations with the provinces.[22] Hence, the distribution of power does seem

[21] The Quebec government has never recognized the existence in Canadian constitutional law of a federal spending power that would be unlimited by the distribution of powers: see Secrétariat aux affaires intergouvernementales canadiennes, 1998. Quebec's refusal to sign the Social Union Framework Agreement in 1999 was based on this position. For an analysis of this episode see Tremblay 2000b.

[22] Although it is safe to conclude that the federal government has always had the upper hand, historically, federal spending measures in areas of provincial jurisdiction have generally been the subject of federal-provincial discussions, if not negotiations. This was the case for the initial cost-shared programs in health care, post-secondary education and social welfare, which by definition involved interaction at some point. In fact, the bulk of federal-provincial relations today, with its hundreds of meetings at various levels yearly, are related to such exchanges. Even federal programs taking the form of direct transfers to individuals and organizations are often discussed (e.g. the Millennium Scholarship Fund). While there may be uncertainty about the respective constitutional rights of the federal government and the provinces over the issues being discussed and negotiated, few would dispute the requirement for such discussions and negotiations. In Quebec, there is even legislation in place requiring the authorization of the Quebec government or minister in many instances (*An Act Respecting the Ministère du Conseil Exécutif*, s. 3.6.2 and following). The federal government itself has on several occasions presented provincial consensus as a precondition for its interventions. The Social Union Framework Agreement was essentially an attempt to

to matter somewhat. Actually, if the unlimited spending power thesis were the law, it would mean that the federal government would have the power unilaterally to cut its entire funding to the provinces for health and post-secondary education and open up its own hospitals and universities instead. Conversely, nothing would prevent the provinces from having their own armies, their own postal services, their own currencies. Obviously, we are not there, and presumably, this is not what Canadians want.

In fact, the ideal of an absolute, unfettered federal power to encroach unilaterally by way of conditional spending upon areas of provincial jurisdiction was probably never widely supported as a sustainable proposition to guide Canadian federalism. Indeed, the unlimited spending power thesis is hardly compatible with the federal principle itself. This is why several of the rounds of constitutional negotiations Canada has experienced since the appearance of the concept have sought in one way or another to prescribe proper limits surrounding the use of the federal spending power.[23] In retrospect, that this course was chosen instead of an outright constitutional challenge may have been a mistake, for we all know what happened with the constitutional file. After the failure of the Charlottetown Accord, the same endeavor was again attempted through the administrative route with the disappointing and toothless Social Union Framework Agreement as a result.[24] Somehow, it seems that the incentive to find an effective, permanent and sustainable mechanism that would allow the federal government to play a constructive and collaborative role in areas of provincial jurisdictions has never been sufficiently strong, longwinded or shared to bear fruits. The temptations of unilateralism stirred up by the unlimited spending power thesis have always prevailed.

Yet, what many Canadians seem to be seeking is, first and foremost, collaboration between the two orders of government in the management of what they perceive as pan-Canadian issues. However, the problem with satisfying this desire is twofold. First, as mentioned, often it is not equally shared by

codify some of the "rules" in this respect. On this issue, see for example, Leslie, Neuman and Robinson 2004.

[23] This was the case for the Victoria Charter in 1971 with its provisions granting federal jurisdiction over social policy subject to provincial paramountcy. Even though the "spending power" terminology was not used, the intent was to allow the federal government to intervene in the social field subject to certain rules. The Meech Lake Accord in 1987 and the Charlottetown Accord in 1992 sought to accomplish the same thing, but this time, starting from the assumption that the federal Parliament already had such a power through spending programs and attempting to circumscribe its exercise.

[24] For an assessment of SUFA, see, for example, Leslie, Neuman and Robinson 2004.

Quebecers. To be sure, there have been some instances of opting out which have succeeded in smoothing over this difficulty, but these were ad hoc arrangements and only came after hard fought political battles.[25] And this leads to the second difficulty, which is the lack of a legal framework to sustain this vision of federalism in the Constitution, or so it seems.

Indeed unlike other federations, such as Germany for instance, Canada's constitutional architecture was not built around the model of intra-state federalism. It is rather a classic example of inter-state federalism. Accordingly, little seems to be provided in the way of legal principles to address the requirements of interdependence. We have just seen that the unlimited spending power thesis is not very helpful in this regard, for it essentially amounts to suggesting there is a huge legal vacuum at the heart of Canada's federal system, which, in turn, is hardly conducive to genuine principled collaboration. And without a sound legal basis, fiscal federalism and the management of Canada's social union are condemned to remain in the lawless realm of raw politics.

THE CONSTITUTION INSIDE THE CONSTITUTION

In a speech he delivered in February 2004 at the law faculty of the University of Toronto questioning the legal foundation of the federal spending power, Quebec's minister for intergovernmental affairs, Benoît Pelletier, presented many of the above arguments.[26] After his speech, an interesting discussion

[25] The major gains in this respect date back to the 1960s (Canada Pension Plan, healthcare, student aid, etc.) The level of political tension reached between Quebec's Lesage liberal government and Ottawa's Pearson liberal government before the first opting-out agreement could be secured in 1964 has been long forgotten, but it was quite considerable (Morin 1972, 19–31). More recent cases of "opting out" could include the Canada-Quebec agreement over manpower training in 1997, the Canada-Quebec agreement over parental leaves in 2004 and, to some extent, the side agreement over healthcare in 2004. The first of these was reached in the aftermath of the 1995 Quebec referendum's near victory of the sovereignist option following decades of discussions; the second, after the Quebec Court of Appeal had declared the federal regime unconstitutional further to legal proceedings undertaken by the government of Quebec (*Renvoi relative à la Loi sur l'assurance-emploi*, 2004).

[26] "A call into question of the foundations of the federal spending power." Speech delivered by Benoît Pelletier, Minister for Canadian Intergovernmental Affairs and Native Affairs during a conference on the theme of *Redistribution within the Canadian Federation*, University of Toronto, Faculty of Law, 6 February 2004.

followed among the participants. Reflecting on what had been said, Tom Courchene suggested that maybe a second look ought to be given to section 94 of the *Constitution Act, 1867*.

Section 94 is essentially the only provision[27] in the chapter of our Constitution dealing with the distribution of powers that truly contemplates the possibility for the federal government to intervene in an area of exclusive provincial jurisdiction, namely property and civil rights, which constitutes, as we know, the bulk of the provincial domain as well as one of the bases on which it was determined that social insurance was a provincial jurisdiction. Hence, federal spending programs pursuing provincial objects could possibly be respectful of the Constitution in some instances.

The juridical category of "property and civil rights," referred to both in section 94 and subsection 92(13), dates back to the *Quebec Act of 1774* when, after the British Conquest, French Law was restored in the province of Quebec in all matters but for criminal law, external trade and a few others. Thus, the notion of property and civil rights was from the beginning conceived as an inclusive category subject only to certain exceptions.[28] It is this original

[27] Some could also view the federal declaratory power under s. 92(10) and the federal remedial power under s. 93 in this light, however these are much more limited in scope and purpose than s. 94 of the *Constitution Act, 1867*.

[28] This is evidenced by the way the *Quebec Act, 1774*, is structured: establishing in section VIII in the broadest terms possible the general principle of the restoration of French law in all matters related to "property and civil rights" and than subsequently setting limits or carving out exceptions such as the one concerning criminal law. Indeed, the expression "property and civil rights" would have included criminal law had it not been for its expressed subtraction in section XI (see Hogg 1997, s. 2.3(a)). Interestingly, the expression "civil rights" was unofficially translated in 1774 as "droits de citoyen" (citizen rights) (see Tremblay 1967, 20). Accordingly, the conventional assimilation of the notion of "property and civil rights" to the field of "private law," as opposed to "public law," may be historically inaccurate. Aside from criminal law, there certainly were principles of English public law that were meant to continue to rule the inhabitants of Quebec, not necessarily because such principles, by definition, fell outside the scope of the expression "property and civil rights"; but rather because section VIII of the *Quebec Act* specified that the right of Quebecers "to hold and enjoy their Property and Possessions, together with all Customs and Usages relative thereto, and all their other Civil Rights [...] [as] determined [by] the Laws of Canada [i.e. old French law]" had to be exercised in a manner consistent "with their Allegiance to his Majesty, and Subjection to the Crown and Parliament of Great Britain." In other words, it is, one could say, only to the extent of an actual inconsistency with their duty of loyalty toward their new Sovereign, or otherwise in face of some threat to English sovereignty, that Quebecers were to be governed by English law as opposed

construction that has led courts to consider subsection 92(13) as a general power that acts as a residual clause in section 92, while some more specific headings contained in this section are intended to avoid the potential confusion that might arise from some of the assignments set out in section 91 exceptionally granting the federal Parliament limited powers in the field of property and civil rights.[29] With respect to section 94, this would imply that its actual scope probably extends to many of the enumerated heads of provincial jurisdiction.[30]

Section 94 allows the federal Parliament to legislate in relation to property and civil rights so long as the legislatures of the provinces where this federal legislation is to apply agree to it. In practice, the federal Parliament would adopt a piece of legislation after its having been discussed and agreed upon with the relevant provincial authorities, and this statute would subsequently be adopted by the provinces who wished to and, from there on, become valid and binding federal law on their territory (Scott1942). In fact, at the political level, the process could even be initiated by provincial governments calling upon the federal government to intervene. Hence section 94 is an opt-in formula that allows for asymmetrical federalism (Pelletier 2005; Laforest 2005; Brown 2005; Milne 2005; Smith 2005; Courchene 2006). Of course, the federal government could decide, for economic and political considerations of

to their own laws. The relatively narrow scope of this restriction was evidenced in a judgment rendered by the Judicial Committee of the Privy Council in 1835 with respect to a litigation arising out of Quebec where, in summary, it was held that by virtue of the *Quebec Act*, "the Prerogative of the Crown with regard to aliens [in this case the *droit d'aubaine*], must be determined by the laws of [Canada, i.e. old French law] and not by the law of England, which is only to be looked at in order to determine who are, and who are not, aliens" (*Donegani*, 1835).

[29] There are obviously many items other than s. 92(13) that deal with property and civil rights, for example, provincial undertaking (s. 92(10)), incorporation of companies with provincial objects (s. 92(11)), solemnization of marriage, etc. See Brun and Tremblay 2002, 476–477. In fact, the notion of property and civil rights is somewhat akin the notion of peace order and good government, both in view of its potentially very broad scope and in view of its relationship with other more specific categories in sections 91 and 92 (see previous note). As it turned out, it even came to compete with it as the main source and locus of residual power in Canadian federalism. See Hogg 2005, ss. 17.1 and 21(2).

[30] There is no reason to think that such matters (see previous note) would be excluded from the scope of s. 94. Quite the contrary, they could be viewed as ideal candidates for uniformity since it is often their proximity with matters conferred to the federal Parliament that has led to their specific mention in s. 92 as opposed to relying solely on the property and civil rights clause in subsection 92(13).

its own, to make its intervention under section 94 conditional upon a required number of provinces accepting to endorse it. It could even request that all the provinces to which this section applies be on board. But there is no legal requirement in this respect. In other words, section 94 is a flexible, enabling tool.

Section 94 specifically refers to three provinces: Ontario, Nova Scotia and New Brunswick. It is clear that the intention of the framers of the Constitution was to exclude Quebec from its ambit on account of its distinct civil law tradition. The provinces mentioned are in fact the three common law provinces of 1867. The weight of the historical evidence and expert opinion is that section 94 would now apply to all common law provinces (Scott 1942; La Forest 1975; Pelletier 1996, 270, *contra* Rowell-Sirois Commission 1940, vol. II, 74).[31]

The original purpose behind section 94 is quite obvious: the framers of confederation foresaw that despite the distribution of powers they agreed upon, there would eventually be a desire for further integration among the common law provinces. They also foresaw that this would not work well in Quebec, given its specificity. Over 140 years later, we can only be impressed at how the framers' predictions proved accurate.

The interesting thing about section 94 is that although it has never been used explicitly, many aspects of the underlying dynamics of fiscal federalism and the governance of Canada's social union are a reflection of the goal and the principles behind this section: the desire for greater uniformity, the need for collaboration and federal-provincial agreement and the possibility for Quebec to opt out. As some authors have pointed out, recent examples like the 2004 health accord with its Quebec addendum and the premiers' proposal for a federal pharmacare program excluding Quebec provide a good illustration of this (Milne 2005; Courchene 2006).

There is very little to be found in the legal literature about section 94.[32] In 1942, F.R. Scott devoted an important article to it, as he was seeking to find ways that would allow the federal government to play a leading role in building the welfare state following the decisions rendered by the Privy Council

[31] The best historical evidence that the original intent behind section 94 was that it would apply to all common law provinces is illustrated by the fact that the precursor of s. 94 in the Quebec Resolutions adopted in 1865 also listed Newfoundland and Prince Edward Island, which at that time were still taking part in the negotiations to become original members of the new federation.

[32] S. 94 has generated some interest in the political science literature in recent years. For an interesting discussion on this topic and its potential implications with respect to the 1982 patriation, see LaSelva 1996, 49–63.

about the distribution of powers in this area, including the *Unemployment Insurance Reference* (Scott 1942). In 1975, former justice Gerard La Forest also wrote about section 94. In the introduction to his paper, he noted how the interest in this area of the law had vanished and pointed at the spending power as a possible explanation (La Forest 1975). To be sure, both Scott and La Forest themselves became supporters of the unlimited spending power thesis (Scott 1955; La Forest 1981). But maybe section 94 was the more promising idea. Maybe the appealing magic of the unlimited spending power thesis has detracted us from more constructive and solid avenues.

If we were to rethink fiscal federalism and Canada's social union using section 94, rather than basing it on the unlimited spending power thesis, here are some of the potential benefits that could follow:

- We could stop pretending that public spending and legislating are two different things so that parliamentarians could reclaim their rightful place in our system, with the greater transparency and accountability that come with it.
- Federal interventions could go beyond mere spending and involve "compulsory regulation," thus allowing more effective, comprehensive and sound public policy.
- Outcomes would be legally binding and the law courts could settle potential disputes.
- The implicit acknowledgement that we are dealing with provincial jurisdiction and the constitutional requirement for provincial consent would eliminate federal unilateralism and shift the focus onto the merits of the public policy at stake rather than on jurisdictional disputes.
- The federal government could move forward with its interventions in some provinces without having to secure beforehand cross-Canada consent each time.
- This could possibly go a long way toward easing relations with Quebec, without changing the Constitution, without giving Quebec more powers, and without even preventing other provinces, if they so wish, from opting out as well.

SOME ISSUES FOR CONSIDERATION

Section 94 does raise a number of questions to which attention should be devoted if it were to be considered as a potential legal foundation for Canada's social union. Its wording dates from another period and is not always clear. Unlike other provisions of the Constitution, it has not benefited from successive judicial restatements carrying its meaning through to the 21st century. The following pages are an attempt to briefly explore some of these questions and provide suggestions as to how they could be addressed. While

this exercise may sometimes require us to move beyond the black letter words of section 94, it is contended that it nevertheless constitutes a much more straightforward account of Canada's Constitution than that provided by the unlimited spending power thesis.

The issue of financial compensation for non-participating provinces is one such question. Having been written in the 19th century with the liberal model in mind, section 94 is silent on this. In the context of today's social union, the absence of a right to compensation under section 94 would leave the door open to the same financial coercion presently associated with the unlimited spending power that plagues fiscal federalism. This in turn would hardly be faithful to the principle requiring individual provincial consent embedded in section 94. Hence, it is argued that a right to compensation should and could now be inferred from section 94 on federalism and equitable grounds, particularly if read together with section 36 of the *Constitution Act, 1982.*

Indeed, under the liberal conception of the role of the state prevailing in 1867, where social services were essentially being delivered by religious organizations and the private sector, there was not the same price tag associated with provincial jurisdictions as would later come with the welfare state. Accordingly, the potential fiscal prejudice that might be incurred by non-participating provinces was not readily foreseeable. The best evidence of this is provided by the case of Quebec which, as seen above, is formally excluded from any scheme set up under section 94 in order to protect its specificity. If the fiscal implications of section 94 had been apparent to its authors, surely something would have been done to prevent what otherwise would lead to an unconscionable result with respect to Quebec.

While the fiscal implications of the welfare state could not have been on the minds of the drafters of section 94 in 1867, they were very much on the minds of the drafters of section 36 of the *Constitution Act, 1982*. In fact, the historical origin of this latter constitutional provision can be traced back to the Rowell-Sirois Commission set up in the late 1930s precisely to address the challenges the welfare state posed to Canadian federalism (Courchene 1984, 21-26). One such challenge was to find how the principle of equity underlying the welfare state could be deployed in a manner consistent with the principle of diversity inherent to federalism.[33] Hence, subsection 36(1) generally com-

[33] Both the goal of equity and the need to preserve federalism are found in the terms of reference issued by the federal government upon the creation of the Commission (Rowell-Sirois Commission, vol. 1, 9–10). Despite the centralizing aspect of some of the Commission's recommendations, such as the transfer of unemployment insurance to the federal Parliament by constitutional amendment, the Commission's recommendation with respect to unconditional "National Adjustment Grants" was

mits both the federal Parliament and government, as well as the provinces, to "promoting equal opportunities for the well-being of Canadians," but "without altering the authority of Parliament or of the provincial legislatures ..." For similar reasons, subsection 36(2) further commits the federal Parliament and government to make unconditional equalization payments. Now, if Ottawa has a constitutional obligation to equalize the fiscal capacity of provinces so as to compensate for external inequalities among them, it would be strange, to say the least, that, meanwhile, it should be free to create between those same provinces, through section 94, fiscal inequalities of its own volition by not compensating Quebec or other provinces who exercised their constitutional right to make different choices in ensuring the well being of their residents (Forget 1986, 121). In other words, under section 94, it is the merits of uniformity – not money – that should be the driver.

Another complex issue with section 94 is the question of reversibility. Supposing the federal government did have recourse to it and some provinces did adopt the ensuing federal legislation, would it be possible for the parties subsequently to change their minds and return to the *status quo ante*? Here, there seem to be two points of view: one that regards recourse to this section as a constitutional amendment with a different name and concludes to its permanency (Rowell-Sirois Commission 1940, vol. 2, 74; Scott 1942); and one that sees it as legislative inter-delegation and leaves the door open to reversibility (La Forest 1975). The controversy seems to stem from the use of the word

clearly motivated by "the existence of pronounced differences in social philosophy between different regions in Canada" [and] "the presumption that existing constitutional arrangements [assigning social matters to the provinces] should not be disturbed except for compelling reasons" (ibid., vol. 2, 13). Hence, these payments to provinces "illustrate the Commission's conviction that provincial autonomy in the [social and education] fields must be respected and strengthened, and that the only true independence is financial security. [...] They are designed to make it possible for every province to provide for its people services of average Canadian standards and they will thus alleviate distress and shameful conditions which now weaken national unity and handicap many Canadians" (ibid., 125). In the Commission's view, it was clear that "while the adjustment grant proposed is designed to enable a province to provide adequate services (at the average Canadian standard) without excessive taxation (on the average Canadian basis) the freedom of action of a province is in no way impaired. If a province chooses to provide inferior services and impose lower taxation it is free to do so, or it may provide better services than the average if its people are willing to be taxed accordingly, or it may, for example, starve its roads and improve its education, or starve its education and improve its roads – exactly as it may do today" (ibid., 84).

"unrestricted" to describe the extent of the power devolved to the federal par-
liament under section 94 upon provincial adoption. Does it mean that this
power would be unaffected by a repeal of the provincial statute that gave rise
to it, or does it mean that once the power is granted, the federal Parliament
can amend its legislation at will without having to seek provincial approval
again but so long as the initial provincial statute remains in force?[34.]

Earlier drafts of section 94[35] as well as, to some extent, its actual word-
ing[36] tend to suggest the possibility of reversibility. But above and beyond
these clues, it is believed that practical considerations should be borne in mind
while tackling this issue. The fear that by using section 94, provinces might
be forever surrendering jurisdictional authority has been referred to as a pos-
sible reason why this section has never been used (Rowell-Sirois Commission
1940, vol. II, 74). Did this serve Canada well? While in 1867 Canada did not
have a home-based amending formula to revisit the distribution of powers, it

[34] The possibility that the term "unrestricted" would both mean an irreversible grant
of power to the federal parliament, akin to a constitutional amendment, and the un-
limited federal capacity thereafter to modify the law at will should be ruled out as it
would be tantamount to granting the federal parliament a tool to change the distribu-
tion of power at will in respect of property and civil rights: a proposition hardly
compatible with federalism and the economy of s. 94, requiring provincial consent
each time recourse is had to this section.

[35] The word "unrestricted" did not appear in article 29(33) of the *Quebec Resolu-
tion of 1865*, the predecessor of s. 94, which ended as follows: "but any Statute for
this purpose shall have no force or authority in any Province until sanctioned by the
Legislature thereof." In a subsequent text prepared for the London Conference the
following phrase was added: "and when so sanctioned the power of amending, alter-
ing or repealing such laws shall thenceforth be vested in the Parliament only."
(O'Connor 1939, 121) which in the final version of the *BNA Act* would be replaced by
the current notion of "unrestricted" power. Another reason to dismiss the interpreta-
tion of s. 94 as an "amending formula" based on historical text is the fact that the *BNA
Act* did in fact contain a provision expressly allowing provinces to effect "Amend-
ment from Time to Time, notwithstanding anything in this Act, of the Constitution of
the Province, except as regards the Office of the Lieutenant Governor" (s. 92(1)). It
begs the question then why s. 94 would have been devised as a separate provision,
crafted very differently and carefully avoiding the term "amendment."

[36] The word "unless" in the expression, "unless and until it is adopted and enacted
as Law by the Legislature thereof" could be an indication of the requirement of the
continuing consent of the provincial legislature for a federal law adopted under s. 94
to remain in effect in the province. In this respect, it should be noted that the word
"unless" was specifically added subsequent to the London Conference. Obviously
there was a problem with the word "until" standing alone.

now has one – which even allows for asymmetry – under sections 38 to 40 of the *Constitution Act, 1982*. And we know that constitutional amendments are not easy. Conversely, Canada still cruelly lacks a simple mechanism that would allow valid inter-delegation of legislative powers, unless section 94 was to partly provide for one.[37] Finally, Scott's characterization of section 94 as a constitutional amending formula led him to the conclusion that the federal Parliament had limited leeway to subsequently modify a statute adopted under that section for fear of violating the original intent (Scott 1942). We may wonder whether this is a happy consequence in a rapidly changing world. Incidentally, by stretching this reasoning, one could even imagine a careful drafting of such statute limiting its span in time so as to indirectly make it reversible!

The above mentioned issues, compensation and reversibility, are just illustrative of the need for further reflection and research on section 94. The exact scope of the notion of property and civil rights for the purpose of section 94 should also be investigated further. Another issue would be Quebec. Admittedly, there are federal programs that suit Quebec. What do we do then given the language of section 94? Possible solutions might again be found here, through the techniques of incorporation by reference and administrative inter-delegation well known to constitutional lawyers.[38] However, it goes beyond the ambition of this paper to provide complete answers to all of the issues involving section 94.

[37] The delegation of legislative authority from provincial legislatures to the federal Parliament or vice versa was deemed contrary to the Constitution in the well known *Nova Scotia Inter-delegation* case (1950). Despite subsequent cases that allowed the provinces and the federal Parliament to achieve very similar results through administrative delegation, incorporation by reference and conditional legislation, it is still the case today that "one legislative body cannot enlarge the powers of another by authorizing the latter to enact laws which would have no significance and validity independent of the delegation" (Hogg 1997, s. 14.7). The Fulton-Favreau constitutional amendment proposals sought to remedy this situation through a new constitutional provision inspired by section 94: section 94A. This provision clearly stipulated that its use was reversible. It would have also enlarged the domain of section 94 and made delegation from the federal Parliament to the provincial legislatures equally possible and it would have included Quebec (Hurley 1996, 187–188).

[38] See the discussion in the previous note. If by virtue of s. 94, the federal Parliament had legislated with respect to a given topic relating to property and civil rights and its legislation was in force in some provinces, the Quebec National Assembly could resort to inter-delegation to effectively opt in without violating the prohibition set out in the *Nova Scotia Inter-delegation* case (1950) since we would not be in a situation where the federal law "would have no significance and validity independent of the delegation." (Hogg 1997, s. 14.7)

CONCLUSION

The central point of this paper is to contend that: i) Canada's social union must rest on law; ii) the unlimited federal spending power thesis is not law; iii) the Constitution is actually richer than we think; and iv) we should give a serious look at section 94, as it might potentially offer a more solid and consensual foundation for Canada's social union.

While governments would obviously have a central role to play in reviving section 94, law courts should also take an interest in this forgotten provision of our Constitution. The argument could be made that we have in fact been implicitly using it in a number of cases. When he looked at this section in 1942, Scott suggested this very possibility, given the absence of any formalistic requirements governing section 94 other than federal enactment and provincial adoption. However, in the end, because he viewed the use of section 94 as a quasi-constitutional amendment carrying irreversible change, Scott believed there was little chance that a court would conclude to its application in any given case unless there was clear indication that this was the intention of the parties (Scott 1942). Of course, if section 94 were to be understood as a mere legislative inter-delegation mechanism, as is here suggested, a different attitude might arise.

As this article was being completed, the Quebec Court of appeal rendered its judgment on 15 November 2006 in the case referred to earlier, opposing Quebec labour unions to the federal government over the constitutionality of certain provisions of the *Employment Insurance Act* (*Syndicat national des employés de l'aluminium d'Arvida inc.* c. *Canada (Procureur général)* 2006), which is now under advisement before the Supreme Court of Canada.[39] Essentially, the Court of appeal validated all but four of the challenged provisions on the basis of the federal jurisdiction over unemployment insurance. The remaining four provisions related to manpower training, thus falling within the provincial jurisdiction over property and civil rights and education. The Court concluded nonetheless that they had validly been enacted by virtue of the federal spending power. In reaching this conclusion, the Court did refer to some of the obiter dicta made by the Supreme Court of Canada on the spending power as well as to the unlimited spending power thesis found in the literature, albeit with some degree of ambiguity. But more importantly, the Court stressed the fact that "all of these measures of a financial nature that cannot be justified pursuant to the federal jurisdiction over unemployment insurance are explicitly subject to the agreement of the provinces." From these "restrictions" the Court judged that the intent of the impugned provisions was

[39] SCC no 31809, and SCC 31810.

not to "assume" provincial jurisdiction and thus that they could not be deemed unconstitutional. But then, somewhat paradoxically, the Court added in its closing remarks on this subject: "That being so, the Court does not have jurisdiction to review the use the federal government makes of its spending power."

In one important respect, I believe the Quebec Court of appeal is quite right: provincial consent is the key. However, in a federation governed by constitutionalism and the rule of law, it is very hard to accept the proposition that law courts should have no responsibility in insuring respect of this principle. In fact, there appears to be a contradiction here between what the Court says and what it does. The reason for this contradiction lies in the inherent flaws of the legal theory called upon to support the federal intervention: the unlimited spending power thesis. This is a case where section 94 could potentially provide a legal base more consistent with the logic of the provisions under examination and the Court's ruling and, for that matter, with the Constitution.

Incidentally, the Quebec government found itself in a peculiar position in these proceedings because the challenged provisions related to an area where, after decades of bitter argument with Ottawa – which had been part of the Victoria and Charlottetown constitutional negotiations and led to one of the three promises made to Quebecers by Prime minister Jean Chrétien on the eve of the 1995 Quebec referendum on sovereignty – an agreement allowing Quebec to opt out and run its own manpower training programs had finally been reached a few years before.[40] The question is: was all this political tension necessary? When this case or a similar one is examined by the Supreme Court, it might be helpful to ask how the fathers of Confederation had arranged for these issues to be resolved.

REFERENCES

A.-G. Can v. *A.-G. Ont.* (*Unemployment Insurance Reference*) [1937] A.C. 355.

A.-G. N.S. v. *A.-G. Can.* (*Nova Scotia Inter-delegation*) [1951] S.C.R. 31.

A.-G. Ont. v. *A.G. Can* (*Reference Appeal*) [1912] A.C. 571.

Auton (Guardian ad litem of) v. *British Columbia* (Attorney General), [2004] 3 S.C.R. 657.

Beaudoin, G.-A. 2000. *Le fédéralisme au Canada*. Montreal: Wilson & Lafleur.

— 2004. "Un pouvoir limité." *La Presse*. 15 septembre.

[40] See the *Entente de principe* and the *Entente de mise en œuvre Canada/Québec relative au marché du travail* signed in 1997.

Beck, S.M. and I. Bernier, eds. 1982. *Canada and the New Constitution: The Unfinished Agenda*, Vol. 1. Montreal: IRPP.

Beetz, J. 1965. "Les attitudes changeantes du Québec à l'endroit de la Constitution de 1867." In *L'avenir du fédéralisme canadien*. eds. P.-A. Crépeau and C.B. Macpherson. Toronto and Montreal: University of Toronto Press/Presses de l'Université de Montréal.

Birch, A.H. 1955. *Federalism, Finance and Social Legislation in Canada, Australia and the United States*. Oxford: Clarendon Press.

Boadway, R. 2005. "The Vertical Gap: Conception and Misconception." In *Canadian Fiscal Arrangements: What Works, What Might Work Better*, ed. H. Lazar. Montreal and Kingston: McGill-Queen's University Press.

Brown, D. 2005. "Who"s Afraid of Asymmetric Federalism? – A Summary Discussion." In "2005 Special Series on Asymmetric Federalism." Working papers, ed. H. Lazar. Kingston: Institute of Intergovernmental Relations, Queen's University. Accessed online at http://www.iigr.ca/iigr.php/site/browse_publications?section=43

Brun, H. and G. Tremblay. 2002. *Droit constitutionnel*. 4th ed. Cowansville: Yvon Blais.

Burelle, A. 1995. *Le mal canadien: Essai de diagnostic et esquisse d'une thérapie*. Boucherville: Fides.

Cameron, D. 2004. "Inter-Legislative Federalism." In *Canada: The State of the Federation 1999-2000: Toward a New Mission Statement for Canadian Fiscal Federalism*, ed. H. Lazar. Montreal and Kingston: McGill-Queen's University Press.

Chaoulli v. *Quebec*, [2005] 1 S.C.R. 791.

Chevrette, F. and H. Marx. 1982. *Droit constitutionnel, notes et jurisprudence*. Montreal: PUL.

Choudrhry, S. 2002. "Recasting Social Canada: A Reconsideration of Federal Jurisdiction Over Social Policy." (2002) 52 U. of T. L. J. 163.

Commission on Fiscal Imbalance. 2002. The "Federal Spending Power" Report – Supporting document 2, Quebec.

Commission royale d'enquête sur les problèmes constitutionnels (Commission Tremblay). 1956. Rapport. Quebec.

Courchene, T. 1984. *Equalization Payments: Past, Present and Future*. Special Research Report. Ontario Economic Council.

— 1997. "ACCESS: A Convention on the Canadian Economic and Social Systems." In *Assessing ACCESS: Towards a New Social Union*. Kingston: Institute of Intergovernmental Relations, Queen's University.

— 2006. "Variations on the federalism theme." In *Policy Options/Options politique*, September. Available online at http://www.irpp.org/po/archive/sep06/courchene.pdf

Dicey, V.H. 1961. *Law of the Constitution*. 10th ed. London: MacMillan & Co Ltd.

Donegani v. *Donegani*, (1835) 12 E.R. 571 (P.C.).

Dupont, J. 1967. "Le pouvoir de dépenser du gouvernement fédéral: 'A Dead Issue?'" (1967) U.B.C.L.R./C. de D., 69.

Eldridge v. *B.C.* (A.G.), [1997] 3 S.C.R. 624.

Finlay v. *Canada* (Minister of Finance), [1993] 1 S.C.R. 1080.

Forget, C.E. 1986. "L'harmonisation des politiques sociales." In *Le fédéralisme fiscal*, M. Krasnick, MacDonald Report, vol. 65, Ottawa.

Frank, C.E.S. 2004. "A Continuing Canadian Conundrum: The Role of Parliament in Questions of National Unity and Processes of Amending the Constitution." In *Canada: The State of the Federation (2002): Reconsidering the Institutions of Canadian Federalism*, eds. J. P. Meekison, H. Telford and H. Lazar. Montreal and Kingston: McGill-Queen's University Press.

Gaudreault-Desbiens, J.-F. 2006. "The Irreducible Federal Necessity of Jurisdictional Autonomy, and the Irreducibility of Federalism to Jurisdictional Autonomy." In *Dilemmas of Solidarity: Rethinking Redistribution in the Canadian Federation*, eds. S. Choudhry, J.-F. Gaudreault-Desbiens and L. Sossin. Toronto: University of Toronto Press.

Hanssen, K. 1966. "The Constitutionality of Conditional Grant Legislation." (1966-1967) 2 Man. L. J. 191.

Hogg, P.W. 1997. *Constitutional Law of Canada*. Loose leaf ed. Toronto: Carswell.

Hurley, J.R. 1996. *Amending Canada's Constitution: History, Processes, Problems and Prospects*. Canada: Canadian Government Publishing.

Kellock, B.H. and S. Leroy. 2007. "Questionning the Legality of the Federal Spending Power." *Public Policy Sources* 89(October). Accessed online at http://www.fraser institute.org/COMMERCE.WEB/publication_details.aspx?pubID=4943.

Kelly, J.B. 2004. "Guarding the Constitution." In Canada : *The State of the Federation (2002): Reconsidering the Institutions of Canadian Federalism*, eds. J.P. Meekison, H. Telford and H. Lazar. Montreal and Kingston: McGill-Queen's University Press.

Keith, A.B. 1937. "A Comment from Great Britain," (1937) 6 C. B. Review, 428.

Kennedy, W.P.M. 1944. "The Interpretation of the British North America Act," (1944) 8 Cambridge L. J. 146.

KitKatla Band v. *B.C.* [2002] 2 S.C.R. 146.

La Forest, G.V. 1975. "Delegation of Legislative Power in Canada" (1975) 21 McGill L. J. 131.

— 1981. *The Allocation of Taxing Power under the Canadian Constitution*. 2nd ed. Toronto: Association canadienne d'études fiscales.

Laforest, G. 2005. "The Historical and Legal Origins of Asymmetrical Federalism in Canada's Founding Debates: A Brief Interpretive Note." In "2005 Special Series on Asymmetric Federalism." Working papers, ed. H. Lazar. Kingston: Institute of Intergovernmental Relations, Queen's University. Accessed online at http://www.iigr.ca/iigr.php/site/browse_publications?section=43

Lajoie, A. 2006. "The Federal Spending Power and Fiscal Imbalance in Canada." In *Dilemmas of Solidarity: Rethinking Redistribution in the Canadian Federation*. eds. S. Choudhry, J.-F. Gaudreault-Desbiens and L. Sossin. Toronto: University of Toronto Press.

LaSelva, S.V. 1996. *The Moral Foundation of Canadian Federalism: Paradoxes, Achievements and Tragedies of Nationhood*. Montreal and Kingston: McGill-Queen's University Press.

Laskin, B. 1975. *Canadian Constitutional Law*. Toronto: Carswell.

Lazar, H. 2000. "In Search of a New Mission Statement for Canadian Fiscal Federalism." In *Canada: The State of the Federation 1999–2000: Toward a New Mission Statement for Canadian Fiscal Federalism*, ed. H. Lazar. Montreal and Kingston: McGill-Queen's University Press.

— 2005. "Trust in Intergovernmental Fiscal Relations." In *Canadian Fiscal Arrangements: What Works, What Might Work Better*, ed. H. Lazar. Montreal and Kingston: McGill-Queen's University Press.

Leclair J. 2006. "Jane Austen and the Council of the Federation." *Constitutional Forum constitutionnel* 15(2): 51–61.

Leslie, P., R.H. Neumann and R. Robinson. 2004. "Managing Canadian Fiscal Federalism." In *Canada: The State of the Federation 2002: Reconsidering the Institutions of Canadian Federalism*, eds. J.P. Meekison, H. Telford and H. Lazar. Montreal and Kingston: McGill-Queen's University Press.

MacDonald, V.C. 1941. "Taxation Powers in Canada." (1941) 19 *Canadian Bar Review* 75.

Meekison, J.P., H.J. Telford and H. Lazar. 2004. "The Institutions of Executive Federalism: Myths and Realities." In *Canada: The State of the Federation 2002: Reconsidering the Institutions of Canadian Federalism*, eds. J.P. Meekison, H. Telford and H. Lazar. Montreal and Kingston: McGill-Queen's University Press.

Mercier Gouin, L. and B. Claxton. 1939. "Expédients constitutionnels adoptés par le Dominion et les provinces." Study for the Royal Commission on Federal-Provincial Relations (Rowell-Sirois). Ottawa.

Milne, D. 2005. "Asymmetry in Canada, Past and Present." In "2005 Special Series on Asymmetric Federalism." Working papers, ed. H. Lazar. Kingston: Institute of Intergovernmental Relations, Queen's University. Accessed online at http://www.iigr.ca/iigr.php/site/browse_publications?section=43

Morin, C. 1972. *Le Pouvoir québécois en négociation*. Montreal and Quebec: Les Edition du Boréal Express.

Noël, A. 2005. "'A Report that almost No One Has Discussed,' Early Responses to Quebec's Commission on Fiscal Imbalance.'" In *Canadian Fiscal Arrangements: What Works, What Might Work Better*, ed. H. Lazar. Montreal and Kingston: McGill-Queen's University Press.

O'Connor, W.F. 1939. Report Relating to the Enactment of the British North American Act, 1867, Canada.

Papillon, M. and Simeon, R. 2004. "The weakest Link? First Ministers' Conferences in Canadian Intergovernmental Relations." In *Canada: The State of the Federation 2002: Reconsidering the Institutions of Canadian Federalism*. eds. J.P. Meekison, H. Telford and H. Lazar. Montreal and Kingston: McGill-Queen's University Press.

Pelletier, B. 1997. *La modification constitutionnelle au Canada.* Scarborough: Carswell.

— 2005. "Asymmetrical Federalism: A Win-Win Formula!" In "2005 Special Series on Asymmetric Federalism." Working papers, ed. H. Lazar. Kingston: Institute of Intergovernmental Relations, Queen's University. Accessed online at http://www.iigr.ca/iigr.php/site/browse_publications?section=43

Petter, A. 1989. "Federalism and the Myth of the Federal Spending Power," (1989) 68 *Canadian Bar Review* 448.

Pigeon, L.-P. 1943. "Le Problème des amendements à la Constitution." *Canadian Bar Review* 437.

Quebec. *An Act Respecting the Ministère du Conseil Exécutif,* R.S.Q. L.R.Q. c. M-30.

Reference re: Canada Assistance Plan, [1991] 2 S.C.R. 525.

Reference re: Manitoba Language Rights, [1985] 1 S.C.R. 721.

Reference re: Secession of Quebec, [1998] 2 S.C.R. 217.

Rémillard, G. 1983. *Le fédéralisme canadien.* Montreal: Quebec/Amérique.

Renvoi relatif à la Loi sur l'assurance-emploi, [2004] R.J.Q. 399.

Rowell-Sirois Commission. 1940. Report of the Royal Commission on Dominion-Provincial Relations, Canada.

Russell, P.H. 1983. "Political Purposes of the Canadian Charter of Rights and Freedoms." *Canadian Bar Review* 61 (1983), 83.

Ryan, E.F. and B.V. Slutsky. 1964. "Canada Students Loan Act – Ultra Vires?" *UBC Law Review* 2: 299.

Schwartz, B. 1987. "Fathoming Meech Lake," (1987) 17 Man. L. J. 1.

Scott, F.R. 1942. "Section 94 of the British North America Act" (1942) 20 *Canadian Bar Review* 525.

— 1955. "The Constitutional Background of Taxation Agreements." (1955) 2 *McGill L. J.* 1.

Secrétariat aux affaires intergouvernementales canadiennes. 1998. Quebec's Historical Position on the Federal Spending Power, 1944–1998. Quebec City: Government of Quebec.

Smiley, D.V. 1962. "The Rowell-Sirois Report, Autonomy, and Post-War Canadian Federalism." (1962) 28 *Canadian Journal of Economics and Political Science* 54.

Smith, J. 2005. "The Case of Asymmetry in Canadian." In "2005 Special Series on Asymmetric Federalism." Working papers, ed. H. Lazar. Kingston: Institute of Intergovernmental Relations, Queen's University. Accessed online at http://www.iigr.ca/iigr.php/site/browse_publications?section=43

Syndicat national des employés de l'aluminium d'Arvida inc. c. Canada (Procureur général), Québec Court of appeal, [2006] R.J.Q. 2672.

Telford, H. 2003. "The Federal Spending Power in Canada: Nation-Building or Nation-Destroying?" In *Publius: The Journal of Federalism* 33(1): 23–44.

— 2005. "Survivance Versus Ambivalence: The Federal Dilemma in Canada." In "2005 Special Series on Asymmetric Federalism." Working papers, ed. H. Lazar. Kingston:

Institute of Intergovernmental Relations, Queen's University. Accessed online at http://www.iigr.ca/iigr.php/site/browse_publications?section=43

Tremblay, A. 1967. *Les Compétences legislatives au Canada et les Pouvoirs provinciaux en Matière de Propriété et de Droits civils.* 2nd ed. Ottawa: Éditions de l'Université d'Ottawa.

— 2000a. *Droit constitutionnel, Principes.* 2nd ed. Montréal: Thémis.

— 2000b. "Federal Spending Power." In *The Canadian Social Union Without Quebec: 8 Critical Essays*, eds. A.-G. Gagnon and H. Segal. Montreal: Institute for Research on Public Policy.

YMHA Jewish Community Centre of Winnipeg Inc. v. *Brown*, [1989] 1 S.C.R. 1532.

Yudin, D.S. 2002. "The Federal Spending Power in Canada, Australia and the United States." (2002) 13 *National Journal of Constitutional Law* 437.

16

Employment Insurance and Parental Benefits

Gordon DiGiacomo

L'approche du gouvernement du Canada en matière de relations intergouvernementales apparaît souvent contradictoire. Comme un scientifique politique le décrivait, l'approche « a alterné entre essayer de renforcer son autorité et de déléguer ses propres pouvoirs ». Ce document met à l'épreuve cette évaluation en abordant cette question : est-ce que le modèle décrit ci-dessus est visible dans le cas du traitement par le gouvernement fédéral des programmes de maternité et de bénéfices parentaux sous le programme d'assurance-emploi? Plus précisément, le gouvernement fédéral a finalement remporté une décision de la Cour suprême qui a rejeté sans équivoque une décision d'un tribunal de première instance en jugeant que les bénéfices maternels et paternels sont compatibles avec l'essence de la compétence fédéral sur l'IE. Toutefois, dans l'intervalle, Ottawa délégua les prestations parentales et de maternité en vertu de l'IE pour la province du Québec, indépendamment de ce que la Cour suprême pourrait décider. Ce document fait valoir en outre que le l'ambivalence fédérale au sujet de la vision constitutionnelle qu'elle souhaite défendre, semble être un facteur important pour expliquer la nature contradictoire de l'approche du gouvernement du Canada en matière de relations avec les gouvernements provinciaux.

INTRODUCTION

The Government of Canada's approach to federal-provincial relations is an odd one. In one scholar's words, it "has alternated between trying to reinforce its authority and devolving its own powers" (Clarkson 2002, 76)..This paper tests and offers an explanation for this assessment. It traces the federal government's views on the constitutionality of the unemployment insurance program in order to determine if Clarkson's characterization is applicable in the case of maternity and parental benefits, which are funded out of the unemployment insurance program. In other public policy areas, namely labour force training and environmental policy, Canadian scholars have shown fairly

convincingly that the federal government way of dealing with the provincial governments has been, first, to assert its authority over the area, then to surrender jurisdiction, and then, in its negotiations with the provinces, to give up far more than it needs to. Especially confounding about the approach of the federal government is that it cedes jurisdiction even when the courts uphold its authority. Is this pattern evident in the Government of Canada's treatment of maternity and parental benefits? This is the paper's central concern.

What might explain the federal government's reluctance to use the powers that the Constitution has given it? This paper suggests that Carolyn Tuohy's theory of institutionalized ambivalence, supplemented by Rocher and Smith's clashing constitutional visions, provides an explanation for the contradictory behaviour of the Government of Canada.

The paper opens by outlining Tuohy's theory and Rocher and Smith's constitutional visions. The next section discusses the federal maternity and parental benefits programs. It examines previous research on unemployment insurance, as well as a number of historical documents and court cases in an effort to determine if the pattern that Clarkson and others have identified holds in the case of maternity and parental benefits and how Tuohy's ambivalence theory applies.

THE THEORY: INSTITUTIONALIZED AMBIVALENCE

Tuohy has argued that the Canadian policy process is distinguished by ambivalence; that is, "ambivalence about the appropriate roles of the state and the market, about national and regional conceptions of political community, and about individualist and collectivist concepts of rights and responsibilities" (Tuohy 1992, 4). Though most other countries experience a degree of ambivalence, in Canada it "extends to the very legitimacy of the state itself and to the identity of the political community" (ibid., 5). The ambivalence "is 'built in' to the structures of the state" (ibid.). As a result, Canadians constantly find themselves pulled in competing directions.

Tuohy explains that the roots of Canada's institutionalized ambivalence lie in the country's relationship with the United States, in relations between Quebec and the rest of Canada, and in Canadian regionalism. It can also be said to lie in the ambivalent feelings of the country's founders regarding the establishment of Canada as an independent, autonomous country. Peter Russell has stated that "[t]he political elites who put Confederation together were happy colonials" (2004, 12). Indeed, their motivations may have had more to do with promoting more intercolonial trade than with creating a self-determining and democratic country on the northern half of the continent.

One of the political structures into which ambivalence is embedded is the Canadian Constitution itself. On its face, it provides for a relatively centralized federation. However:

In practice, the Canadian federation shows a mix of centralist and decentralist elements. It is one of the most fiscally decentralized in the world ... On the other hand, the principle of a federal "spending power" has developed over time, allowing the federal government to spend, and to attach conditions to its spending, in areas of exclusive provincial jurisdiction (Russell 2004, 6).

The Constitution's mix of centralism and provincialism is a consequence of judicial interpretations of the Constitution. The clear intention of the country's founders to create a strong central government was thwarted by the rulings of the Judicial Committee of the Privy Council, Canada's final court of appeal until 1949, leaving decision makers confused and conflicted about which vision of the country to take seriously. Tuohy does not say so, but the founders' decision not to establish a Canadian final court of appeal may be said to have resulted from their own ambivalent feelings about Canadian sovereignty and independence.

One product of the country's constitutional ambiguity is Canada's particular brand of federalism, which functions, Tuohy argues, without a definitive division of powers. Indeed, one can argue that federal and provincial governments have tended to regard federal constitutional powers as "tradable assets." According to Tuohy, the fact that the division of federal and provincial jurisdiction is never resolved means that the competing views about region and country "are always in play and are addressed anew with new policy issues" (ibid., 52). Another result is the excessive resort to elite accommodation, a process that, as Tuohy notes, has "limited constitutional grounding" and "only tenuous lines of accountability to the electorate" (ibid., 30). In addition, elite accommodation, or executive federalism, has tended to generate a preoccupation with the jurisdiction issue but insufficient attention to substantive policy concerns.

Institutionalized ambivalence has produced several constitutional visions, four of which have been set out by Rocher and Smith.

THE EQUALITY OF THE PROVINCES VISION

This vision can refer either to the equality of the provincial governments with the federal government, or to the equality of the provinces with each other.

The first interpretation – the equality of the two levels of government – stresses provincial autonomy. It sees each level as being sovereign in its areas of jurisdiction and able to act independently of the other. The implications of this interpretation are profound. As Rocher and Smith point out, "In this view, the provincial premiers have as much right to represent citizens as does the Prime Minister of Canada." The central government "is not in a position to speak for provincial interests" (Rocher and Smith 2003a, 24). Thus, the federal government is just another government in Canada.

The second interpretation – the equality of the provinces with each other – is expressed in two statements of the Calgary Declaration, a document cobbled together by the provincial governments after the constitutional wars of the late 1980s and early 1990s and accepted by all governments in Canada except that of Quebec. One states: "All provinces, while diverse in their characteristics, have equality of status." The second reads: "If any future constitutional amendment confers powers on one province, these powers must be available to all provinces."

While the first interpretation denies the subordination of the provincial level of government to the federal, the second denies the special status of any one province.

The first interpretation is similar to what has been called "collaborative federalism," which, say Cameron and Simeon, is "characterized more by the principle of co-determination of broad national policies than by either the Ottawa led co-operative federalism of the post-World War II period or the more competitive federalism of later periods" (Cameron and Simeon 2002, 49). Proponents of this approach see the governance of Canada "as a partnership between two equal, autonomous, and interdependent orders of government that jointly decide national policy" (ibid.). Examples of collaborative federalism at work in Canada include the Agreement on Internal Trade, the health care accords of 2000 and 2004, the federal-provincial accord on the environment, and recent international trade policy.

THE NATIONALIZING VISION

In this vision, the basis of political identity is Canada itself, not a province and not one of Canada's internal nations. It is a vision, say Rocher and Smith, that sees Canada as more than the sum of its parts. Since it privileges the federal level of government, it "tends also to be centralizing." Rocher and Smith identify three versions of the nationalizing vision: the view of the Fathers of Confederation; the view of the social democrats of the 1930s; and the Pierre Trudeau view, as expressed in the patriation and amendment of the Constitution in 1982.

With respect to the view of the Fathers of Confederation, it appears that there were varying degrees of support among the founders for the idea of a strong central government for Canada. Nevertheless, they all signed an agreement that equipped the federal government with substantial powers. Indeed, Bayard Reesor identifies ten powers set out in the *Constitution Act, 1867* that, in his opinion, "contradicted the federal principle." Among them are the power to strike down provincial legislation; the power of Parliament to declare "works" under provincial jurisdiction to be for the general advantage of Canada and, therefore, to bring them under federal jurisdiction; the power of Parliament to legislate for the "peace, order, and good government" of Canada; and the power of Parliament to spend its money as it sees fit (Reesor 1992, 80–82).

The second version developed during the Great Depression. F.R. Scott and others argued that the federal government needed the necessary powers to be able to intervene in the economy and society to "alleviate some of the worst effects of the Great Depression and to get Canada back on the road to economic recovery" (Rocher and Smith 2003a, 35). Interestingly, in a comment related to the thesis of this paper and published originally in 1931, Scott gave another reason for the disintegration of federal power, namely, "... the attitude of the leaders of the Dominion parties of recent years. They seem to have wished to hand over as much as possible to the local legislatures" (Scott 1977, 47).

The third version of the nationalizing vision came with the election of Pierre Trudeau in 1968. "In this view, Canadian political identity overrode regional and national political identities" (Rocher and Smith, 35). It is strongly opposed to asymmetrical federalism or special status for Quebec. Both the process of constitutional change and the substance of the *Constitution Act, 1982* reflected the Trudeau version of the nationalizing vision. With regard to the former, Rocher and Smith write:

> At various points in the process of negotiating the constitutional amendment of 1982, the Trudeau government threatened to proceed with constitutional change unilaterally, without the consent of the provinces. In doing so, Trudeau appealed explicitly "over the heads" of the provincial leaders to the people. This strategy stressed the symbolic dimension of the federal government's role as the sole government of all Canadians and the provinces as spoilers in the system (ibid., 36).

Thus, "... the Trudeau government attempted to undercut the provincial governments and to solidify citizens' loyalty to the national, i.e., federal level of government" (ibid.). With respect to the substance of the *Constitution Act, 1982,* the Charter of Rights and Freedoms was designed to "cement the attachment of Canadians to the federal level of government ... All Canadians enjoyed these rights equally, thus strengthening national sentiment" (ibid.).

It should not escape notice that, in describing the nationalizing vision, Rocher and Smith write: "Taken to its extreme, this centralizing dynamic permits the federal government to appropriate the authority to define a 'national interest'" (2003b, 9-10). That a federal government desire to define the national interest could be described as "extreme" is illustrative of how far the provincial autonomy advocates have taken their argument.

ASYMMETRICAL FEDERALISM

As used by Rocher and Smith, asymmetrical federalism emphasizes the multinational character of Canada. It proposes constitutional reforms that recognize Canada's internal nations. The vision has its origins in the compact theory of Confederation, a much-criticized theory that "views Confederation as a pact between the two founding nations" (ibid., 28). In practical terms, this dualism

requires an arrangement in which the Quebec government has constitutional powers that other provincial governments do not have; hence the phrase "asymmetrical federalism."

Asymmetry is espoused not only by many Quebecois writers. Aboriginal groups, too, have demanded a new type of relationship with Canada. Indeed, they seek to recast the relationship between the federal government and Aboriginal peoples "on a nation-to-nation basis." They propose a new order of government in which Aboriginal nations have the necessary powers to pursue their own path of political, economic and cultural development. The rise of a pan-Aboriginal nationalism "has rendered obsolete the dualist vision of Canada" (ibid., 33). It has given way to the three-nations understanding of Canada, necessitating a new division of powers, through further decentralization or "the granting of special status for Québec or the First Nations ..." (ibid.).

THE RIGHTS-BASED CONSTITUTIONAL VISION

In this vision, Rocher and Smith explain, "... the rights-bearers anchor their constitutional vision around individuals and groups as rights-bearers ..." (ibid., 38). Rocher and Smith see three versions of this vision. First, the Trudeau perspective has a significant rights dimension. It sees the Charter of Rights and Freedoms as adding a critically important aspect to the Canadian identity. A second version emphasizes collective rights, that is, the rights of certain communities in Canada, such as women, Aboriginal peoples, and ethno-cultural minorities. These groups represent "the entry of non-territorial equality concerns into constitutional discourse" (ibid.). Significantly, according to Rocher and Smith, "[t]hey see the role of the federal level of government as very important because only the federal level of government can create a level playing field for equality-seeking groups throughout the whole country" (ibid.). For these groups, the protection of the Charter and their Charter rights is paramount. The third version of the rights-based vision attaches collective rights to Canada's internal nations or national communities such as the Aboriginal nations and the Francophone Quebec nation.

The handling by the Government of Canada and the provincial governments of the policy area discussed next reflects a conflict of constitutional visions, primarily between the equality of the provinces vision – that is, the equality of the provinces with the federal government – and the nationalizing vision. As we shall see, such a conflict can occur not only between levels of government but also *within* the federal government.

MATERNITY AND PARENTAL BENEFITS

Does the Government of Canada's handling of its maternity and parental benefits initiatives exemplify its ambivalence regarding its own powers? Three

points should be made at the outset: first, these benefits, also referred to as special benefits, provide payments to workers whose employment is interrupted by pregnancy or the need to provide child care; Ottawa has been providing maternity benefits for over thirty years and parental benefits for about fifteen years; secondly, the programs are financed out of the unemployment insurance (UI) fund, not out of general revenues; and thirdly, unlike training and the environment, the Constitution does identify the federal government as the jurisdiction responsible for UI.

Until World War I, care of the unemployed in Canada was seen to be mainly the responsibility of the municipal governments. However, when the war ended and soldiers began returning home in large numbers, the federal government view of the problem started to evolve and new ideas made it to the political agenda. In 1918, Ottawa passed the *Employment Offices Coordination Act*, a cost-shared program with the federal government subsidizing provincial employment offices. In 1919, the federal Royal Commission to Investigate Industrial Conditions in Canada recommended a compulsory social insurance system covering old age, unemployment, sickness and invalidity. In 1919 also, the International Labour Conference recommended national UI and the federal Liberal Party adopted a resolution urging the federal government to establish a comprehensive social insurance program which would include, among other things, protection against unemployment and maternity benefits (Pal 1988, 35–36).

The momentum toward a national UI scheme stalled in the 1920s as its constitutionality emerged as a serious consideration. The weight of opinion held that it was a provincial responsibility. Undeterred and encouraged by the Roosevelt New Deal in the US, Conservative Prime Minister Bennett drafted an unemployment insurance plan and approached the provinces for support for a constitutional amendment. Ontario and Quebec refused. With an election in the offing, the Bennett government passed the *Employment and Social Insurance Act*, modelled on the British plan. The legislation provided for a flat-rate benefit, financed by contributions from employers, workers and the state and covering about two-thirds of the work force.

In 1935, Canada's longest-serving Prime Minister, William Lyon Mackenzie King, leader of the Liberal Party, returned to power. Opinion on his views on unemployment insurance is divided. Leslie Pal, for instance, suggests that King's concern about the constitutionality of a federal UI plan was a legitimate one (Pal 1988, 37). James Struthers, however, argues that the constitutional consideration was merely a convenient excuse for inaction (Struthers 1983, 10). In any event, King referred the *Employment and Social Insurance Act* to the Supreme Court of Canada for a determination of its constitutional validity. The Act was struck down by the Court in 1936, a decision that was upheld by the Judicial Committee of the Privy Council. According to Lord Atkin,

> There can be no doubt that, prima facie, provisions as to insurance of this kind, especially where they affect the contract of employment, fall within the class of

property and civil rights in the Province, and would be within the exclusive competence of the Provincial Legislature. (*A.-G. Canada v. A.-G. Ont.* [1937] A.C. 355 at 365)

In 1939, three factors combined to change King's mind about UI. The first was the outbreak of war. For King, it was "clear that unemployment insurance will be indispensable in coping with the problem of re-establishment" (Struthers, 198). In other words, UI would be necessary for the reconstruction of the war-time economy. Secondly, the resistance of the premiers to a constitutional amendment giving Ottawa jurisdiction over UI dissipated. The newly elected premier of Quebec, Adélard Godbout, was more receptive to an amendment than his predecessor, and Alberta Premier Aberhart indicated that he would not stand in the way if most of the other provinces were agreeable to a constitutional amendment (ibid., 198–199). Thirdly, the Cooperative Commonwealth Federation (CCF) was emerging as a major political force on the Left, providing workers and farmers with an alternative to the Liberal Party. As a result, in July 1940, the British Parliament amended the *British North America Act*, (now known as the *Constitution Act, 1867*), giving the federal government jurisdiction over UI and shortly thereafter the federal government enacted the necessary legislation.

Although its report was submitted after the decision to amend the Constitution had been made, the Royal Commission on Dominion-Provincial Relations provided additional support for federal control of UI. It recommended strongly that "... the Dominion alone should have jurisdiction over unemployment insurance ..." (Canada 1940, 39). For the Commissioners, the experience of the 1930s was "conclusive evidence that unemployment relief should be a Dominion function" (ibid., 24). It warned, however, that federal responsibility. for social welfare services "... should be deemed an exception to the general rule, and as such should be strictly defined." (ibid.)

Significantly, the Commissioners also recommended that UI benefits be available not only to those whose employment was interrupted for economic reasons. They wrote:

So long as cash payments only are provided there is no reason why insurance against unemployment resulting from illness should not be dealt with along with other unemployment, and we recommend that the Dominion should have the necessary powers to do this. (ibid., 40)

As we shall see, whether UI should be only for those whose unemployment is caused by economic developments was an issue for the Québec Court of Appeal.

Since 1940, the *Unemployment Insurance Act* has been amended several times. The most comprehensive reforms came in 1971; among other important measures, the *Unemployment Insurance Act, 1971* authorized the payment of special benefits to women who gave birth to a child, for a fifteen-week period including their confinement. This was the first time that UI contained

such a provision. The reforms were based on a 1970 white paper which, in turn, was based on an intensive 1969 study of the UI program.

The 1969 report has little to say about the constitutional context, for the obvious reason:

> The present power for the Canadian Parliament to legislate in this respect [that is, unemployment insurance] is not open to question as far as constitutional law is concerned. The antecedents that led to the enactment of the 1940 British North America Act Amendment are irrelevant from a legal point of view; the Westminster Parliament had the power to amend one of its own statutes, and this is what it did in this case. (Canada 1969b, 4)

The report's authors warn, however, that any benefits paid under the program, such as maternity, sickness and retirement benefits, must be indisputably related to unemployment; otherwise, its constitutionality could be contested.

The 1970 Government of Canada white paper also has little to say about the constitutional validity of UI. However, it does state that "[i]n looking at the problems of unemployment it becomes clear that it is the federal government which must continue to play a vital role in their solution" (Canada 1970a, 7). Yet another federal government paper, *Income Security and Social Services*, addresses the constitutional issue at greater length. Published in 1969 as one of several working papers on the Constitution under the name of Prime Minister Pierre Trudeau, it deals with the constitutional aspects of social policy and strongly endorses exclusive federal control of UI. It states:

> The case for exclusive federal powers over unemployment insurance ... lies in the nature and the source of the forces which give rise to unemployment, and hence the need for unemployment insurance, and the capacity of governments to deal with these forces. It is generally accepted that general unemployment is the product of a complexity of economic forces which are national and international in character. It rarely can be said to be the consequence of purely local forces. Moreover, the provincial and local governments cannot by themselves bring under control the forces that cause unemployment; to do so requires the full panoply of economic powers associated with a nation – fiscal, monetary, debt management, trade, and balance of payments policies, and indeed selective economic measures. Even these, to be fully effective, must be complemented by international economic arrangements. The viability of unemployment insurance, in other words, depends upon the successful use by the federal government of these instruments of economic policy: if they fall under federal jurisdiction, so should unemployment insurance. (Canada 1969a, 80)

The paper then sets out another reason for federal control of UI:

> The second reason ... lies in the uneven costs of unemployment insurance, as between the provinces. Certain provinces suffer from higher levels of

unemployment than do others, with the result that payments in these provinces tend to be relatively higher, and contributions to the unemployment fund from them tend to be relatively lower. It would be unreasonable, clearly, to ask these provinces to assume responsibility for unemployment insurance. (ibid., 82)

It ends the discussion on UI with this firm declaration: "It follows, as Canada learned during the 1930s, that responsibility for unemployment insurance must be placed with the government which has the power to combat unemployment, and has the capability of meeting the consequences of unemployment – the Parliament and Government of Canada" (ibid.).

Despite these unequivocal declarations of federal authority, the bill that was eventually adopted by Parliament contained an important concession to provincial autonomy. Section 64(5) of the *Unemployment Insurance Act, 1971* reads as follows:

> Where under a provincial law any allowances, monies or other benefits are payable to an insured person in respect of sickness or pregnancy that would have the effect of reducing or eliminating the benefits that are payable under this Act to such insured person in respect of unemployment caused by that illness or pregnancy, the premium payable under this Act in respect of that insured person shall be reduced or eliminated as prescribed but subject to paragraph (a) of section 65.

In other words, if a provincial government established its own program providing for maternity or sickness benefits, the federal program would cease to operate in that province. It is not clear why the federal government offered this concession given its strongly held view that UI is a federal responsibility. It had the assurance of the 1969 study of UI, and cabinet documents from 1971 reveal that the Cabinet Committee on Federal-Provincial Relations knew that "legal opinion was consistent with the proposal that loss of earnings due to sickness and maternity should be covered by insurance rather than welfare" (Canada 1971, 22). In addition, the Committee noted that "... it is only lately that Quebec has been challenging the legality of the sickness and maternity clauses on constitutional grounds. Before this, Quebec had simply argued that the clauses would create problems as they were incompatible with the philosophy of their social policy" (ibid.). The cabinet also had the report of the Royal Commission on the Status of Women in Canada, submitted in September 1970. The Commission had studied maternity leave and considered various ways for the federal government to provide this protection, finally agreeing that it could "best be done through the federal Unemployment Insurance Plan" (Canada 1970b, 87). It argued that "[b]oth unemployment insurance and paid maternity leave are intended to provide compensation for temporary loss of earnings, and the unemployment insurance plan already has a system for drawing contributions from the same sources that would be contributing to paid maternity leave" (ibid., 87–88). It therefore recommended

that the *Unemployment Insurance Act* be amended so that women contributors will be entitled to unemployment benefits for a period of 18 weeks or for the period to which their contributions entitle them, whichever is the lesser, (a) when they stop paid work temporarily for maternity reasons or (b) when during a period in which they are receiving unemployment benefits, they become unable to work for maternity reasons.

Notwithstanding these assurances and expressions of support, the government went ahead with subsection 64(5). It may be that, with the 1970 October crisis still fresh in its memory, the cabinet may have wished to avoid irritating Quebec. In any event, subsection 64(5) represents yet another example of the federal government asserting its jurisdiction over an area and then ceding it to the provinces, even though it was not necessary to do so (ibid., 88).

Since 1971, a considerable amount of attention has been paid to unemployment insurance, including the maternity benefits provision, by public policy makers, by interest groups and by the courts. The Supreme Court of Canada, for instance, in a 1979 case, *Bliss v. Attorney General of Canada*, came down with a highly significant decision on pregnancy benefits. It was asked to determine if a section of the *Unemployment Insurance Act*, which set out the limitations for the receipt of pregnancy benefits, was inoperative because it violated the equality-before-the-law clause of the *Canadian Bill of Rights* (Canada's first attempt at human rights legislation, now mostly dormant because of the constitutional entrenchment of the *Canadian Charter of Rights and Freedoms* and the passage of human rights acts by all of the provinces and by the federal government). In ruling that the section did not offend the *Canadian Bill of Rights*, the Supreme Court of Canada affirmed that the provision of pregnancy benefits is a valid federal program. Writing for a unanimous Court, Justice Ritchie stated:

> As I have indicated, s. 30 and s. 46 [the clauses in question] constitute a complete code dealing exclusively with the entitlement of women to unemployment insurance benefits during the specified part of the period of pregnancy and childbirth; these provisions form an integral part of a legislative scheme enacted for valid federal objectives ...

Two years earlier, the Supreme Court of Canada was asked to consider whether the regulations of the *Unemployment Insurance Act, 1971* allowing the Unemployment Insurance Commission to include, within the definition of insurable employment, self-employment and employment not under a contract of service, (a.k.a. an employment contract), were *ultra vires* of Parliament (*Martin Service Station Ltd. v. Minister of National Revenue*, [1977] 2 S.C.R. 996). Writing for a unanimous Court, Justice Beetz declared that they were not. He noted that it was in 1946 that Parliament first made UI benefits available to the self-employed or those not working under a contract of service, if the work is indistinguishable from that of those who work under a contract of

service. He noted further that in 1956 Parliament made benefits available to fishers, even though they are self-employed and do not work under an employment contract.

As a result of this ruling, the Court approved the expansion of the scope of UI beyond who was to be included by the original legislation. As a Canadian Labour Congress brief stated, the Court rejected the argument that "the scope of s. 91(2A) should be ascertained by reference to the framers' understandings of the limits of 'unemployment insurance' ..." (2004, 6). The Court refused "to confine Parliament's jurisdiction to insurance against the unemployment of employees under a contract of service ..." (ibid., 11).

A third important ruling came in 1989. In *Brooks v. Canada Safeway*, the Supreme Court of Canada determined that a Canada Safeway health plan, under which pregnant women were ineligible for benefits, was discriminatory. Chief Justice Dickson, writing for a unanimous Court, stated:

> It seems indisputable that in our society pregnancy is a valid health-related reason for being absent from work ... If the medical condition associated with procreation does not provide a legitimate reason for absence from the workplace, it is hard to imagine what would provide such a reason ... In terms of the economic consequences to the employee resulting from the inability to perform employment duties, pregnancy is no different from any other health-related reason for absence from the workplace. (*Brooks v. Canada Safeway Ltd.*, [1989] 1 S.C.R. 1219 at pp. 1237–1238)

What the Court affirmed here is that pregnancy is a valid reason for temporary absence from work and should be treated no differently than other causes of temporary unemployment. Again, the importance of this decision will become apparent at a later point.

In 1981, the Trudeau government established a Task Force on Unemployment Insurance, which did not look at the constitutional issues involved but did argue that " ... UI maternity benefits have come to be regarded as a necessary form of income support and an acceptable role for UI with its objective to protect the economic security of workers in Canada" (Canada 1981, 67).

Shortly after it assumed power, the Conservative Mulroney government set up its own Commission of Inquiry to study unemployment insurance. The Commission did not discuss the constitutional aspects of UI but, as part of its research effort, it asked former professor and former senator, Gérald-A. Beaudoin, to review these issues. He was asked specifically:

> From a constitutional viewpoint, does the definition of unemployment insurance cover such things as self-employment interruptions ... sickness, maternity and adoption benefits, employment services and job creation programs which may be components of an unemployment insurance scheme? (1986, 17)

With respect to maternity benefits, Mr. Beaudoin said simply: "We must conclude from the Bliss case that under s. 91.2A the Parliament of Canada may legislate in relation to payments to pregnant women" (ibid., 19).

In its brief to the Commission of Inquiry, the Canadian Advisory Council on the Status of Women addressed the suggestion that maternity benefits be removed from the UI program. In the Advisory Council's view, "... it is entirely appropriate that these benefits should be included in the program ..." (1986, 23). Its basic argument went as follows:

> Child-bearing and child-rearing are activities which parents undertake on behalf of society as a whole. We believe that society should ensure that those who undertake this vital work do not suffer a financial penalty for doing so. Given that the majority of women in their child-bearing years are already in the work force, we consider it essential that they be entitled to a replacement of lost earnings when those earnings are interrupted as a result of child-bearing or parenting responsibilities. Because UI is still a social insurance program, these benefits are given to women workers as a matter of right based on their earnings and contribution record. (ibid., 23–24)

The brief also referred to the constitutional aspect. According to the brief, there is "a constitutional basis for federal authority over special benefits like those for maternity and adoption, *as long as they are included in the program*" (ibid., 24). [Emphasis in original.] However,

> It is not clear that the federal government would retain jurisdiction if benefits were removed from the program. Canadian women's rights to earnings replacement while on maternity leave might then depend on provinces developing their own programs. Thus, a national program, with national standards, available to all women regardless of where they live, might be jeopardized. (ibid.)

In other words, a maternity-leave-benefits program, funded out of general revenues, could be found to be unconstitutional, leaving Canada with a patchwork of such programs.

In the mid-1980s, the Conservative Mulroney government also established a Task Force on Child Care which included maternity benefits in its review. It pointed out that benefits for maternity have been provided through UI since 1971 "in recognition that an employee's earnings can be interrupted not only by job loss, layoff, or illness, but also by maternity" (Canada 1986, 24). It recommended that "birth and adoption benefits continue to be provided through the vehicle of the Unemployment Insurance program" (ibid., 376).

Assertions of federal authority over UI, in the form of legislative amendments that expanded the availability of UI benefits, came frequently in the 1980s and 1990s. In 1984, as a result of an amendment to the *Unemployment Insurance Act, 1971*, pregnant women became eligible for regular benefits

during the eight weeks preceding and the six weeks following the birth of their child. Also, special parental benefits were made available for persons adopting a child. In 1988, changes to the Act allowed fathers to obtain special benefits when they took care of a newborn because the mother was ill or disabled. In 1990, the Canadian Parliament granted parental benefits to adoptive or biological fathers or mothers, and in 2000, parents whose child was born or adopted after December 30, 2000 became entitled to receive parental benefits for almost one year.

Despite these declarations of federal jurisdiction, the maternity benefits opting-out clause survived the 1996 overhaul of the *Unemployment Insurance Act*, renamed the *Employment Insurance Act* (EIA). Now section 69(2), the clause is virtually identical to section 64(5) of the previous Act but, significantly, the possible causes of unemployment that would trigger eligibility for receipt of UI benefits were increased to include injury, quarantine and child care. This, too, can be seen as an assertion of federal authority. The new section 69(2) reads:

> The [Unemployment Insurance] Commission shall, with the approval of the Governor in Council, make regulations to provide a system for reducing the employer's and employee's premiums when the payment of any allowances, money or other benefits because of illness, injury, quarantine, pregnancy or child care under a provincial law to insured persons would have the effect of reducing or eliminating the special benefits payable to those insured persons.

In a confidential interview, a senior official at Human Resources and Skills Development Canada explained that during the review of the legislation there was no thought given to the possibility of removing the opting-out provision. This is somewhat puzzling given that no province sought to make use of the provision since its insertion in legislation in 1971.

In 1996, the secessionist Parti Québécois government announced its intention to introduce a maternity and parental benefits plan for workers, to be implemented if and when the federal government vacated the field in Quebec. It subsequently initiated talks with the federal government to implement the plan, as provided for in section 69(2) of the Act. The talks began in February 1997 and ended in August 1997 without producing an agreement.

A confidential interview with a federal official, who was close to the negotiations, shed light on the motivations of the two governments. In this official's recollection, the Quebec government insisted on a large transition fund – in effect, a subsidy, amounting to between $100 million and $150 million. It did so, according to the official, because it wanted to establish an exceptionally generous parental insurance program without having to increase premium rates, at least in the short term. Extra cash from Ottawa would make this possible. Understandably, the federal government was not willing to do this for the secessionist government.

By 2000, when Quebec tried to re-open the negotiations, the federal position had hardened. Reluctant in the first place to transfer the programs, the Government of Canada had received a revised legal opinion that stiffened its resolve to resist devolution. The new legal opinion held that section 69(2) was not as clear as it appeared to be and that the federal government's discretion regarding devolution was wider than first thought. The official stresses, though, that the revised legal opinion was of secondary importance. What was primary was that the federal government really did not want to hand over the programs.

In March 2002, the Government of Quebec asked the Court of Appeal of Quebec to determine the constitutionality of sections 22 and 23 of the *Employment Insurance Act*, the sections authorizing payment of maternity and parental benefits. Under section 22, "... benefits are payable to a major attachment claimant who proves her pregnancy." Similarly, under section 23, "... benefits are payable to a major attachment claimant to care for one or more new-born children of the claimant or one or more children placed with the claimant for the purpose of adoption ..." In each case, the Act provides details on eligibility requirements and the duration of receipt of benefits.

The four questions that the Quebec Court of Appeal was asked to address are:

> Does section 22 of the *Employment Insurance Act* constitute an infringement of the jurisdiction of the provinces, particularly the jurisdiction with respect to property and civil rights or matters of a merely local or private nature pursuant to subsections 92(13) and 92(16) of the *Constitution Act, 1867*?

> Does section 23 of the *Employment Insurance Act* constitute an infringement of the jurisdiction of the provinces, particularly the jurisdiction with respect to property and civil rights or matters of a merely local or private nature pursuant to subsections 92(13) and 92(16) of the *Constitution Act, 1867*?

> Is section 22 of the *Employment Insurance Act ultra vires* the Parliament of Canada, particularly as regards the jurisdiction relating to unemployment insurance pursuant to subsection 91(2A) of the *Constitution Act, 1867*?

> Is section 23 of the *Employment Insurance Act ultra vires* the Parliament of Canada, particularly as regards the jurisdiction relating to unemployment insurance pursuant to subsection 91(2A) of the *Constitution Act, 1867*?

With respect to the first two questions, the Quebec Court of Appeal ruled in *A.-G. Québec v. A.-G. Canada* [2004] that the measures established by sections 22 and 23 of the Act do, in fact, fall within the jurisdiction of the provinces, specifically subsection 92(13) or subsection 92(16), that is, property and civil rights or matters of a merely local or private nature in a province.

For the last two questions, the Quebec Court of Appeal looked at three types of historical documents in order to ascertain the framers' intent in making

the 1940 constitutional amendment; they were the report of the Royal Commission on Dominion-Provincial Relations; the correspondence between the Prime Minister of Canada and the Premiers of Quebec during the period in question; and the House of Commons debates on the amendment. The Court concluded that the 1940 amendment "was aimed at enabling federal authorities to set up a plan to insure individuals against lost income following the loss of their job for economic reasons, not following the interruption of their employment for personal reasons."

> The pregnancy and parental benefits contemplated in sections 22 and 23 of the *Employment Insurance Act* are not at all part of the unemployment insurance canvas conceived in 1940. These special benefits are not paid further to the loss of a job for economic reasons; rather, they are paid further to the interruption of an individual's employment because of a personal inability to work ... These benefits must be seen instead as an assistance measure for families and children – that is, as a social assistance measure and a laudable one at that. (*A.-G. Québec v. A.-G. Canada* 2004, 28)

The Court agreed that the benefits "are not totally dissociated from the notion of employment ..." but, in its view, they are not at all what the framers had in mind when they added unemployment insurance to section 91 of the *Constitution Act, 1867.*

On February 23, 2004, the federal government filed an appeal with the Supreme Court of Canada, which heard the case in January 2005.

In its factum to the Supreme Court of Canada, the federal government argued that the only object of the disputed sections is to provide monetary benefits, on a temporary basis, to those who have lost their employment income. Significantly, it adds that, "ils n'ont ni pour objet, ni pour effet, de créer un régime de *congé* de maternité ou encore de *congé* parental" (Attorney General for Canada 2004, 14). [Emphasis in original.] (Neither their purpose nor their effect is the creation of a maternity or parental leave program.) It contends further that the Quebec Court of Appeal erred in describing the benefits as social security measures. Rather, "la caractéristique essentielle de ces prestations" (the essential characteristic of these benefits) is to provide

> un revenu temporaire aux femmes enceintes ou aux parents qui ont payé des cotisations et occupé un emploi assurable pendant le nombre d'heures requis et qui perdent leur revenu d'emploi en raison d'une grossesse ou pour prodiguer des soins à un jeune enfant. (ibid., 22)

> (... temporary income for pregnant women or for parents who made contributions and worked in insurable employment for the required number of hours and who lost their employment income because of a pregnancy or in order to take care of a young child).

The factum describes federal competence in social welfare matters in broad terms and denies that they are exclusively the responsibility of the provinces. It states:

> Les mesures de bien-être ou de sécurité sociale pour réduire la pauvreté ne sont pas une matière assignée par la *Loi Constitutionelle de 1867* à la compétence exclusive des provinces, contrairement à ce qu'a affirmé la Cour d'appel. Il s'agit plutôt d'un sujet diffus, comme la culture, la santé ou l'environnement. Les méfaits de la perte de revenu d'emploi, de la maladie ou de la pollution, sont des réalités omniprésentes qui confrontent tous les ordres de gouvernement, qu'ils soient fédéral ou provinciaux. Ils ne sont pas l'apanage de la compétence exclusive de l'un ou de l'autre. Le mieux-être de tous les habitants du Canada est un objectif commun à chaque ordre de gouvernement (ibid., 26).

> (Welfare or social security measures to reduce poverty are not a matter assigned by the *Constitution Act, 1867* to the exclusive jurisdiction of the provinces, contrary to what the Court of Appeal asserted. Rather it is a diffuse subject, like culture, health or the environment. The ravages from loss of employment income, from illness or from pollution, are omnipresent realities which confront all orders of government, whether they be federal or provincial. They are not the prerogative of either one jurisdiction or the other. The betterment of all of the citizens of Canada is a common objective of each order of government.)

The factum ends by observing that maternity benefits have been provided for over thirty years "et sont intégrées aux contrats de travail de plusieurs travailleurs. Depuis toutes ces années, les législatures provinciales n'y ont vu aucun obstacle constitutionnel" (ibid., 39). (... and have become integrated into the collective agreements of several workers. For all these years the provincial legislatures did not see any constitutional obstacle).

The Supreme Court of Canada's decision was delivered in October 2005. In a unanimous judgment, the Court rejected the Quebec government's contention that the federal government had exceeded its jurisdiction by providing a social program through the *Employment Insurance Act*. In upholding the federal case, the Supreme Court ruled that maternity benefits are in pith and substance a mechanism for providing replacement income during an interruption of work. It stated:

> This is consistent with the essence of the federal jurisdiction over unemployment insurance, namely the establishment of a public insurance program the purpose of which is to preserve workers' economic security and ensure their re-entry into the labour market by paying income replacement benefits in the event of an interruption of employment. (*Reference re: Employment Insurance Act* (Can.), ss.22 and 23, 2005 SCC 56, para. 68)

As far as parental benefits are concerned, they, too, are

> in pith and substance a mechanism for providing replacement income when an
> interruption of employment occurs as a result of the birth or arrival of a child,
> and that it can be concluded from their pith and substance that Parliament may
> rely on the jurisdiction assigned to it under s. 91(2A) of the *Constitution Act,
> 1867.* (ibid., para. 75)

The justices concluded:

> A generous interpretation of the provisions of the Constitution permits social
> change to be taken into account. The provincial legislatures have jurisdiction
> over social programs, but Parliament also has the power to provide income re-
> placement benefits to parents who must take time off work to give birth or care
> for children. The provision of income replacement benefits during maternity
> leave and parental leave does not trench on the provincial jurisdiction over prop-
> erty and civil rights and may validly be included in the EIA. (ibid., para. 77)

Surprisingly, on May 21, 2004, seventeen months before the Supreme Court
of Canada delivered its ruling, federal ministers, under a new prime minister,
Paul Martin, announced that the federal and Quebec governments had reached
an agreement-in-principle on the devolution of the maternity and parental
benefits plan. It stipulated that it would hold regardless of what the Supreme
Court decided. On March 1, 2005, almost eight months before the Supreme
Court handed down its decision, the Final Agreement between the Govern-
ment of Canada and the Government of Quebec was signed. The Agreement
reiterated that it would hold regardless of the Supreme Court's determination.

The Agreement provides that the federal government will reduce the EI
premium rate by an amount equivalent to the portion of the premium rate
covering maternity and parental benefits. This means that the federal govern-
ment will not collect roughly $750 million from Quebecers. This amount is
equal to the cost of a full year of EI maternity and parental benefits in Que-
bec. The premium reduction takes effect on January 1, 2006 when Quebec's
program commences.

The methodology used to calculate the EI premium rate reduction for
Quebecers will apply to other provinces and territories that want to establish
their own parental insurance plan.

The Agreement also provides that claimants receiving benefits will con-
tinue to receive benefits if they move to another province or territory.

The Government of Canada agreed to let Quebec use the federal Record of
Employment form and the Social Insurance Number. According to a federal
"Backgrounder" on the Agreement, "This will result in substantial savings to
Quebec, as it will not have to develop and maintain its own forms or systems,
and will ease the administrative burden on Quebec employers while at the
same time providing them with savings." Federal government generosity was

also displayed by its agreement to contribute a one-time payment of $200 million to Quebec. Again according to the "Backgrounder," this was done in "recognition of the significant investment required to implement Quebec's benefits program." *It is precisely the kind of payment that the Liberal Jean Chrétien government refused to make in the first round of negotiations in the late 1990s.*

Why did the Government of Canada not wait for the Supreme Court decision before negotiating a deal with Quebec? If it won the case, which it did, its bargaining position would have been strengthened considerably. Most probably, the Martin government's eagerness to get a deal with Quebec had to do with the federal election, held in June 2004, a month after the agreement-in-principle was signed. Reeling from the aftermath of a scandal involving members of the federal Liberal Party in Quebec, the Martin government may have thought that an agreement with Quebec would pay off for them electorally. It apparently had a minimal impact.

To summarize this discussion of maternity and parental benefits: in the late 1930s, a consensus emerged that responsibility for UI ought to reside with the federal government and the Constitution was amended accordingly. From 1940 to 1971, the *Unemployment Insurance Act* was amended several times, culminating in a major overhaul in 1971. Prior to passage of the new legislation, several federal documents assured the Cabinet of the constitutional validity of the legislation, including the provision on maternity benefits. These documents include the 1969 study of the UI program, the 1970 white paper, and a federal working paper on the constitutional aspects of income security and social welfare. In addition, Cabinet had a legal opinion confirming that delivering maternity benefits through the UI program was constitutional. And the Royal Commission on the Status of Women in Canada recommended to the Cabinet that the *Unemployment Insurance Act* be amended to include maternity benefits. Despite these assurances and its own vision of UI, the Government of Canada inserted into the 1971 amendments a clause requiring the federal government to cease delivering benefits to, and taking contributions from, the citizens of any province that established its own maternity leave program. From 1971 to 1996, at least two Supreme Court of Canada decisions and two federal task forces upheld the constitutionality of the federal maternity benefits program. The several legislative amendments passed during this period expanding the availability of benefits, including parental benefits, represented clear assertions of federal authority. Yet the maternity-benefits opting-out provision survived the legislative reforms of 1996, despite the absence of any provincial take-up of the option since its insertion in legislation in 1971. Most recently, the federal government, faced with a constitutional challenge from Quebec to the validity of the maternity and parental benefits clauses in the *Employment Insurance Act*, chose to agree to a deal with Quebec on devolution even before the Supreme Court of Canada

could decide on the constitutionality of the provisions. When the Court did decide, it upheld the federal case.

We can, therefore, deduce that the Government of Canada approach to the maternity and parental benefits programs is consistent with the assessment offered by Stephen Clarkson and others: that is to say, despite its declarations of jurisdiction over UI, and despite judicial and other support for the federal legislation, the federal government chose to give the provinces the option of taking over the maternity and parental benefits programs if they wanted to. In the clash of constitutional visions between the equality of the provinces vision (that is, the equality of the provinces with the federal government) and the nationalizing vision, it is the former which won out with the Canada-Quebec Agreement on maternity and parental benefits. Since all provinces were offered the same kind of arrangement made with Quebec, the Agreement could not be said to exemplify asymmetrical federalism.

As noted earlier, federal ambivalence about its own powers was demonstrated in other areas, particularly labour force training policy and environmental policy. Since the early 1900s, the Government of Canada has asserted its right to be involved in occupational training policy and has transferred funds to the provinces for that purpose. The provinces had considerable latitude in determining how those dollars would be spent. Despite federal declarations that it needs to be involved in labour force training, and has the constitutional authority to be involved, and even though the provinces always played a central role in deciding where federal dollars would go, the Government of Canada announced in 1995 that it would withdraw from the field of worker training. The main reason for this decision was the near victory of the secessionist forces in the 1995 referendum on Quebec secession. Aside from this reversal of tradition on the part of the federal government, the ambivalence of the Government of Canada was illustrated, in a very graphic way, when, on the one hand, it agreed to the insertion in the Labour Market Development Agreements that it signed with each province and territory of a clause acknowledging labour force training to be a provincial responsibility, but, on the other, it insisted on a role for itself in several areas of skills development, including job training for young people. To a significant extent, labour force training policy in Canada is set by a confederal body, the Forum of Labour Market Ministers.

In environmental policy, the approach of the federal government has been even more peculiar. As with labour force training, the Government of Canada frequently demonstrated its right and authority to be involved in environmental policy. However, unlike worker training, the environment is a field where the courts agreed with the federal claim – no fewer than five times! And yet, according to Kathryn Harrison, a Canadian political scientist who specializes in environmental policy, after the court decisions came down, "the federal government was more, rather than less, deferential to the provinces ..."

(Harrison 2003, 319). Thus, it signed with the provinces, except Quebec, a Canada-Wide Accord on Environmental Harmonization, managed by a confederal body, the Canadian Council of Ministers of the Environment. Even with several court victories under its belt, plus strong political support for federal involvement in environmental policy-making, and a record of episodic but significant environmental activism, the federal government still embraced the equality of the provinces vision, as expressed by the Environmental Harmonization Accord.

CONCLUSION

This paper has attempted to ascertain the degree to which the federal government's handling of its maternity and parental benefits programs is consistent with the view that, in federal-provincial relations, Ottawa's approach has "alternated between trying to enforce its authority and devolving its own powers." After discussing the four constitutional visions identified by Rocher and Smith, the paper turned to the maternity and parental benefits programs and showed that, despite repeated assertions of authority, the federal government still felt impelled to offer control of the maternity benefits program to the provinces, and to keep the offer open for several years. Thus, Clarkson's assessment was found to be valid.

What is particularly perplexing about the federal government approach is that it cedes jurisdiction even when its authority is upheld by the courts. On at least three occasions, decisions from the country's highest court supported federal UI policy. Given this support and that of assorted studies, why would the Government of Canada still agree to devolve a popular social program, one that enabled it to make a direct connection with the citizens of a province with a not insignificant secessionist movement? This study seems to demonstrate the validity of our central claim, which argues that clashing constitutional visions, an outcome of Canada's institutionalized ambivalence, can cause shifting approaches to federal-provincial relations. The Government of Canada, uncertain about its role in Quebec and the vision it wanted to promote in the province, eventually fell victim to pressure from Quebec politicians, whose position was strengthened by a pending federal election and the Liberal Party's scandal-related problems in the province.

REFERENCES

Attorney General for Canada v. Attorney General for Ontario, [1937] A.C. 355.

Attorney General for Canada. 2004. *Factum of the appellant. Attorney General for Québec v. Attorney General for Canada,* on appeal from the Québec Court of Appeal. File number 30187.

Attorney General for Québec v. Attorney General for Canada, [2004]. Accessed online at http://canlii.org/gc/cas/qcca/2004qcca10101.html

Beaudoin, G. 1986. *Unemployment Insurance and the Constitution: An Overview.* Study prepared for the Commission of Inquiry on Unemployment Insurance.

Bliss v. Attorney General of Canada, [1979] 1 S.C.R. 183.

Brooks v. Canada Safeway Ltd., [1989] 1 S.C.R. 1219.

Cameron, D., and R. Simeon. 2002. Intergovernmental relations in Canada: the emergence of collaborative federalism. *Publius: The Journal of Federalism* 32 (Spring): 49–71.

Canada. Cabinet. 1971. *Cabinet Conclusions.* Library and Archives Canada. Accessed online through ArchiviaNet at www.collectionscanada.ca/02/020150_e.html

Canada. Prime Minister. 1969a. *Income Security and Social Services.* Government of Canada Working Paper on the Constitution. Ottawa: Queen's Printer for Canada.

Canada. Royal Commission on Dominion-Provincial Relations. 1940. *Report.* Book II. Ottawa.

Canada. Royal Commission on the Status of Women. 1970b. *Report.* Ottawa: Minister of Supply and Services Canada.

Canada. Task Force on Child Care. 1986. *Report.* Ottawa: Minister of Supply and Services Canada.

Canada. Task Force on Unemployment Insurance. 1981. *Unemployment Insurance in the 1980s.* Ottawa: Minister of Supply and Services Canada.

Canada. Unemployment Insurance Commission. 1969b. *Report of the Study for Updating the Unemployment Insurance Programme.* Ottawa.

Canadian Advisory Council on the Status of Women. January 1986. *Brief presented to the Commission of Inquiry on Unemployment Insurance.*

Canadian Labour Congress. 2004. *Factum of the intervenor. Attorney General for Québec v. Attorney General for Canada*, on appeal from the Court of Appeal of Québec. File number 30187.

Clarkson, S. 2002. *Uncle Sam and Us.* Toronto, ON: University of Toronto Press and Washington, DC: Woodrow Wilson Center Press.

Harrison, K. 2003. Passing the Environmental Buck. In *New Trends in Canadian Federalism*, 2nd edition, eds. F. Rocher and M. Smith. Peterborough, ON: Broadview Press.

Martin Service Station Ltd. v. Minister of National Revenue, [1977] 2 S.C.R. 996.

Pal, L. 1988. *State, Class, and Bureaucracy: Canadian Unemployment Insurance and Public Policy.* Montreal and Kingston: McGill-Queen's University Press.

Reesor, B. 1992. *The Canadian Constitution in Historical Perspective.* Scarborough, ON: Prentice-Hall Canada.

Rocher, F. and M. Smith. 2003a. "The Four Dimensions of Canadian Federalism." In *New Trends in Canadian Federalism*, 2nd edition, eds. F. Rocher and M. Smith. Peterborough, ON: Broadview Press.

— 2003b. Introduction. In *New Trends in Canadian Federalism*, 2nd edition, eds. F. Rocher and M. Smith. Peterborough, ON: Broadview Press.

Russell, P. 2004. *Constitutional Odyssey: Can Canadians Become a Sovereign People?* 3rd edition. Toronto: University of Toronto Press.

Scott, F.R. 1977. *Essays on the Constitution: Aspects of Canadian Law and Politics.* Toronto: University of Toronto Press.

Struthers, J. 1983. *No Fault of Their Own: Unemployment and the Canadian Welfare State 1914–1941.* Toronto: University of Toronto Press.

Tuohy, C.J. 1992. *Policy and Politics in Canada: Institutionalized Ambivalence.* Philadelphia: Temple University. Press.

17

Networked Federalism

Janice Gross Stein

Le système fédéral canadien, tel qu'il est maintenant configuré et comment il fonctionne, n'équipe pas bien les Canadiens à prospérer dans un environnement mondial qui est aussi national et régional, et d'autant plus complexe et stratifié qu'il y a cinquante ans. Ce chapitre fait valoir que nous devons conceptualiser les relations entre les institutions fédérales en termes de 'fédéralisme en réseau', en les positionnant dans une grille qui est à la fois verticale et horizontale, et où la liberté de mouvement est le long de nombreux axes, non par un noyau central. Dans ce modèle, les institutions existent toujours, mais les schémas de circulation au sein et entre celles-ci peuvent changer. Une économie mondiale récompense ceux qui se déplacent de côté, ainsi que ceux qui montent et descendent le long de la grille, avec une grande tolérance à l'égard des structures fluides qui ont temps de réponse court. Le fédéralisme canadien a besoin d'être moins défini, pas plus ; moins concerné par les droits de juridiction, pas plus ; et beaucoup plus axé sur les résultats, sur ce qu'on doit accomplir, et comment y arriver.

INTRODUCTION

I argue that the Canadian federation is out of whack, seriously misaligned. This misalignment comes from three different sources. The responsibilities and the revenues of the two orders of government match less well than they ever have. The mismatch is compounded by a second factor. The federal government behaves globally very differently than it does locally. It shows one face abroad and another at home. As important, a third order of government, the municipal, has no face, no voice, no seat at the table with the other two orders of government. It is absent from the picture. This absence makes little sense in an era where 80 percent of our population lives in urban areas. Cities are already the magnets for immigration amongst an aging population and are the engines of innovation and growth in Canada.

None of these problems is new to Canadians. They were less serious, however, fifty years ago when states were the primary players in international politics and economies were largely national. This misaligned federation is a handicap as Canada moves into a world with a more globalized economy and increasingly dense connections across societies. Our federal system, as it is currently configured and as it now works, is not equipping Canadians well to thrive in an environment that is global as well as national and regional, and correspondingly more complex and layered than it was fifty years ago. The most serious mismatch is between Canadian federalism and the global economy and society.

I think of "networked federalism," located in a grid that is simultaneously horizontal and vertical, where movement is along many of the axes, not through a central hub. The institutions remain, but the pattern of movement among them and between them changes. The important questions become those of the genesis of policy ideas, the creation of shared policy space, the opportunities for feedback and correction, and the resilience of transmission lines. I ask whether a concept of "network federalism" might better reflect Canadian federalism in a global age.

I divide my argument into several parts. In the first part, I look at contemporary federalism in Canada. What does it look like and what does it do in an era of globalization? I then examine the three important fault lines of Canadian federalism, as it is now configured, and argue that neither our political structures nor our performance equip us to engage effectively in the global economy and global society. In the final part, I look at federalism as a network, working within a grid, and examine what such a model might deliver and how well Canadian federalism approximates this model.

To prefigure my conclusion, I argue that we are moving toward more overlap and shared policy space, not less. The attempt to match responsibilities and revenues neatly to the two orders of government, while logical and even elegant, is doomed to failure. A neat division of powers and alignment of responsibilities is, moreover, the wrong paradigm. A global economy rewards those who move sideways as well as up and down along the grid, with a large tolerance for fluid structures that give a quick response. Canadian federalism needs to be less well-defined, not more, less concerned with jurisdictional rights, not more, and much more focused on results, on what we need to get done and how we can get there.

FEDERALISM: WHAT DOES IT LOOK LIKE? WHAT DOES IT DO?

Federalism is a set of legal arrangements among orders of government that fulfills important economic, political, social, and cultural functions. Federal structures vary, of course, in their centralization, and Canada is one of the most decentralized federal structures among developed countries. A very decentralized federal system has distinct advantages as well as disadvantages in a global environment.

I argue that our federation is doing well in enabling Canadians to participate in global society but far less well in building what we need to compete in the global economy. Why?

- Federalism creates opportunities for difference and distinctiveness. It gives legal and political voice to different communities. In a unitary state, all communities find their voices within the same political structure and work within the same political space. In a federal structure, communities may have their own political structures, legally recognized, that give them voice within a larger context. Political spaces overlap.
- Federalism works to protect minority rights by layering levels of government. Here, it provides a significant advantage. If one order of government abuses the rights of its citizens, citizens have recourse to the other order. In well functioning federations, the temptation to abuse by one government should be less because another government is watching. Citizens in a unitary state have no such intermediary protections. As the global movement of people increases, and societies become more diverse, more multicultural, overlapping political spaces can be a distinct advantage and a magnet for attentive immigrants.
- Federalism also enables pluralism, a critical requisite of mature democracies. It acts as a check on authoritarian rule and promotes vertical checks and balances. In a global society, where pluralism and democracy are increasingly valued, federalism is a significant asset.
- A federal structure provides political opportunities and entry points at different levels of government. From one perspective, it maximizes the opportunities citizens have to participate in public life. From another perspective, federalism is "inefficient": it can provide these opportunities for political participation only because it creates overlapping and "redundant" layers of government. In the language of hierarchy, redundancy is a bad word; it is closely associated with inefficiency. In the language of networks, as I will argue, redundancy is an asset; it contributes to the suppleness and resiliency of our federal structures.

As globalization accelerates, local voice has become increasingly important. The local has become the counterpoint to the homogenizing forces of globalization, an important part of a diverse ecology, and a site of creativity in the global economy. I connect the importance of cities as a local site of global innovation later in the chapter, but here I want to make the generic point that federalism gives voice to the local – no mean achievement. Federalism as a political and legal structure may be better suited to globalization than less complex political structures. We need to ask whether Canadian federalism is creating enough room for the local, whether it is opening up enough space, for example, for Canadian cities. I return to this issue later.

Federalism does more than make space for the local. Well functioning federations open up room, but simultaneously blur differences so that national policies are possible. This too is no mean feat in an era of globalization. Federalism allows for overlapping layers of jurisdiction to blur lines of division, acting as a counterweight to the fragmenting consequences of globalization. These kinds of institutions that can cross divides, meld preferences – the bridge builders – in our societies have become much more important. They help to create shared cultural norms, values, and ideas across differences. In short, federalism can be very adaptive in the context of a global society.

Federal structures are less well suited to enable performance in a highly competitive global economy. The global economy privileges nimbleness, skill, efficiency, high-quality performance, and just-in-time delivery through firms that look more and more like networked supply chains that can maximize value, wherever value is to be found. Global firms always have national headquarters, and the national component continues to be important even in a global economy. But connected to these national headquarters, these firms subdivide and move globally to where the advantage is locally. They weave around and through structures of political and legal authority. Embedded in value chains, global corporations are less about place than their predecessors were fifty years ago.

Federal structures were not designed to be efficient or to deliver just in time. On the contrary, as I have argued, they self-consciously build in duplication, overlap, and redundancy. If efficiency were the highest value, Canada would have a single layer of government that could respond in real time to develop policies in a rapidly changing – and challenging – economic environment. Highly decentralized federal systems, of the kind we have, appear to be especially handicapped in managing economic performance in an era of accelerating globalization.

If we think about federalism less as an enabler and more as the designer of an appropriate regulatory framework for the economy, many of the same disadvantages apply. Good regulatory regimes provide free, high quality information to global investors. Strong regulatory regimes of capital markets, for example, are an important asset in a competitive global economy; they provide timely information as a public good, at little or no cost to firms and investors. In addition, they provide "insurance" to firms seeking global advantage, again at no cost to them. In a decentralized federal structure, regulatory agreements must be negotiated between orders of government when the issues cross jurisdictions, so the regulatory environment becomes more complex and slower to adapt in a decentralized federation than in unitary political systems. It is harder in Canada, for example, to create a national system to regulate securities markets, because of provincial jurisdictions. Canada is one of the few OECD countries without a national securities system.

A decentralized federal structure, even though it is less suited to a global economy than a unitary state, can nevertheless facilitate economic performance in two important ways. The first is obvious, in theory if not in practice. A federal system can make the strategic investments that are necessary to strengthen capacity to participate in the global economy. Investment in strategic infrastructure – goods, services and people have to move – in education, in training, in research, in commercialization of knowledge – are all vitally important. They are more important in a global economy than they were when national economic space was more prominent.

A second function is less obvious but no less important. A high-functioning federal system can help to equalize opportunities across differences. Unitary governments are able, if that is their political will, to redistribute wealth to those people and regions that are disadvantaged by globalization. Revenues and losses all go to the same government. In a federal system, the federal government has often taken upon itself to redistribute revenues, out of its tax revenues, to those governments and people that are faring less well. Almost all federal systems have some kind of equalization program, and Canada made its obligation to redistribute revenues constitutional in 1982, so that governments across the country could provide comparable public services at comparable levels of taxation. The "how much" and the "how" of equalization remains, however, politically contested. This contestation now takes place in the context of a global economy that advantages some parts of the country and disadvantages others.

Why would equalizing differences matter to performance in the global economy? It is clear why a federation would wish to do so in the name of social justice, but why link reduction of difference to economic performance? In fact, conventional wisdom suggests that it is inefficient to "prop up" unproductive regions by flowing resources to weak industries and retaining populations "in place" rather than encouraging mobility. Many "successful" economies – the United States, China, and India – have much larger socioeconomic differences among their populations than does Canada.

This conventional wisdom is no longer universally considered quite as conventional or quite as wise. It is undergoing revision in the context of a global competition for talent. There are two related arguments to consider, and both speak to the importance of equalization of large differences. For the "creative class" that sparks innovation and global economic leadership, the reduction of difference makes societies a more attractive and safer place to live, to invest, and to create. Cities that have well integrated and diverse populations and a high quality of life are more appealing as places to live and are more likely to become one of the "spikes" of innovation in the global economy. However, world-class cities, the spikes in the landscape of globalization, are not enough. Richard Florida, who studies global innovation, argues strongly

that governments will have to make their "second-tier" cities competitive and attractive places to live (Christensen 2006). Countries that have stable societies, well-educated populations, low rates of crime and violence, and well-developed legal regimes attract a disproportionate share of foreign direct investment. Other things being equal, sharp social inequalities act as a disincentive for highly mobile global entrepreneurs.

Second, equalizing differences does not necessarily translate into subsidizing inefficient industries or sustaining populations in place despite the absence of economic opportunity. Equalization can be considered a form of "social investment" that is an essential prerequisite of participation in the global economy. It can translate into investment in the public services – health, education, retraining, commercialization of knowledge – that are a mixture of federal and provincial responsibilities so that people are capable of adjusting, regenerating or moving. Whichever they do, the capacity to access equivalent services wherever they are or wherever they go is one of the most fundamental demands Canadians make of all their governments (see Council of the Federation 2006). For Canadians, equalization is as much about persons as it is about place.

In the current global context, a successful federation would simultaneously work to diminish economic and social differences even as it gives expression to political and cultural differences. It is this capacity simultaneously to blur and reflect which, I will argue, makes federalism so suitable to the challenges of a global environment.

THE FAULT LINES OF FEDERALISM

THE TWO FACES OF FEDERALISM: FEDERAL AND PROVINCIAL GOVERNMENTS

Federations vary in their degree of centralization. Canada is among the most decentralized in the world. Canadians are occasionally surprised to learn that only in Switzerland do the cantons have greater autonomy than the provinces have in Canada. Yet, Canada is riddled with conflict between provincial and federal governments. Provincial governments complain, often bitterly, that the federal government disposes of sources of revenue far greater than they need while provinces struggle to provide the basic services – health care and education – that Canadians want and need. The cost of these services, especially health care, has grown in the last two decades and will likely continue to grow faster than the economy. It is this structural problem that the provinces have come, with some sense of urgency, to call "fiscal imbalance."

The federal government responds that the provinces need to be more fiscally responsible, that they can always raise additional revenue by taxing more, that the provinces are perennially demanding and always ungrateful, no matter what they receive. More to the point, the federal government claims that it

embodies the "national project," the vision of all Canadians, and articulates the national standards for programs that all Canadians want. The federal government insists that it and it alone is the bridge across the geographical, regional, cultural, and linguistic divides of this country that spans a continent. Especially in a thickening global economy and society, the federal government claims that it is the focal point for Canadians.

Canadians listen to this increasingly raucous conversation, at times bemused but increasingly frustrated. There is disagreement not only between the provinces and the federal government, but also among the provinces themselves. Canadians are losing patience with the endless cacophony. They want high-quality services, delivered in ways that are transparent so that they can track results. They are pragmatists. Fix it, they demand. When it doesn't get fixed, they grow impatient with institutional gridlock. Many younger people especially, growing up in a just-in-time world, or in a virtual world, have no patience with the painfully slow pace of change. They are not only impatient, they are also mobile. They understand that jobs move and many younger Canadians move within the country, or in and out of it. They want access to services, wherever they are within Canada, and are impatient with the jurisdictional wrangling that repeatedly gets in their way.

THE ABSENT FACE OF FEDERALISM: CITIES

Cities are an unrepresented voice in our federal architecture. In Canada, an important "local" voice is missing. The sharpest fiscal imbalance in this country is between large cities – Montreal, Toronto, Winnipeg, Calgary, Edmonton and Vancouver – and their provincial governments. Historically, the municipal tax base of all the cities in Canada is far too low to provide the transit, the social services, and the infrastructure of modern, dynamic cities that are home to 80 percent of Canada's population. The mayors of large cities in Canada navigate between the two orders of government, moving up and down the hierarchy, pleading for funding to meet basic needs and provide basic services. Our cities are at risk, largely because they do not have adequate revenues to repair crumbling infrastructure and maintain social services, even in a period of prosperity. When recession comes, as it inevitably will, the burden will fall disproportionately on cities.

The dilemmas of cities are made more acute by processes of globalization. Canadian cities are growing in dynamism, in their attractiveness to entrepreneurs and new immigrants, as engines of wealth, as innovators, and as incubators of new forms of cultural expression. They are the "local" sites of creativity. They have become the "hubs" connecting diverse populations to hubs worldwide, the links in global chains. Our cities could become powerful global players, generating resources that dwarf those of provincial and federal governments. They are likely to be the primary producers of cultural products

that trade directly in global markets and "brand" Canada. Cities invest their tax revenues primarily in infrastructure, safety, and tourism to increase their attractiveness as hubs. But these cities do not have an adequate tax base to meet the needs of those marginalized by new forms of wealth creation. It is in the cities that social inequalities grow most sharply.

Federal and provincial governments bump up against each other all the time on policies that directly affect cities. Without significant immigration, Canada's productivity and growth will decline dramatically over the next fifty years. Indeed, in thirty years, some parts of Canada may well be depopulated unless immigration increases rapidly. Immigration is a concurrent responsibility that requires a collaborative policy regime among municipal as well as federal and provincial leaders; today, immigrants settle in cities. Settlement strategies are an essential element in the successful adjustment of immigrants to their new lives, historically within the jurisdiction of provinces. So is credentialing of the skills immigrants bring with them, historically the responsibility of provincially based associations and organizations. Public transportation and infrastructure, the lifelines of cities, are a mixture of federal and provincial responsibilities. Cultural institutions, which act as magnets within cities and draw outsiders to them, are the constitutional responsibility of neither order of government but draw support from both.

Within our cities, and more generally within big megalopolises worldwide – Mexico City, Buenos Aires, Bangalore, Beijing, Shanghai – live some of the most marginalized people who struggle at the edges of society. Income support is partly a federal and partly a provincial responsibility. Health care is a provincial responsibility but employment insurance is a federal program. It is in cities that the intermingling of federal and provincial jurisdictions stands out most clearly and it is here that they are tested most sharply. It is impossible to imagine that these overlapping jurisdictions could be disentangled from our city regions that are at the core of our future economic success.

Our federal institutions were designed in a different era. They were created to help build a national economy and reflect two founding cultures. They live now in a context of an increasingly multicultural, multilingual, and diverse urban society that is connected world wide and mobile, and where economic lines are no longer only east-west within national boundaries, but also north-south and increasingly transcontinental. Canada now lives in a largely post-industrial global economy with institutions designed before industrialization that, at best, have adapted reasonably well to the industrial age.

THE CHALLENGES TO FEDERALISM

What does this rapid survey of federalism in an era of globalization tell us? An effort to disentangle jurisdictions, to neatly sort responsibilities and match

them to revenues, as seductive a picture as that is, is an impossible task. It is also not desirable.

Roger Gibbons argues that it would be helpful to distinguish the provincial responsibility for place from the federal responsibility for persons. This idea is attractive conceptually: it provides a tidy organizational schema and promises to minimize the fractious bumping up of one order of government against another that has become so well known and so disliked by Canadians. However, it is very unlikely that we can easily separate persons from institutions nor can we separate institutions or persons from place. Federal funding for most social services, for example, is partly direct to persons and partly indirect through transfers to the provinces. Funding for post-secondary education, for example, only follows students to a very limited degree. A significant proportion of federal funding for post-secondary education goes to research done in universities. The students are mobile but the universities are not. In this sense, federal funding is partly place-based. Funding for health care follows people not at all. It is place-based and would be very difficult to change. There are practical constraints, then, to a neat separation between roles and responsibilities in a federal structure like ours.

I would like to make the more controversial argument that neat division and alignment is the wrong paradigm. If we think again about cities in the next fifty years, they are likely to be the site of "local" voices, engines of the economy, sources of innovation, sites of immigration and settlement, homes of the creative arts, places where the demand for social services and health care will be the strongest, neediest of renewal of their infrastructure, epicentres of epidemics, homes to head offices of global firms, and locations of Canada's research-intensive universities. Cities, not formally represented in our federal structure, will be the focal point, the site of globalization.

In cities, the responsibilities and the revenues of all three levels of government will be hopelessly intermingled, in theory, in policy, and in practice, in persons and in places. It is from this intermingling, from encounters rather than separation, from interconnected conversation rather than from silos, that creativity will flourish – in businesses, in universities, in the arts, and in government. It is from collaboration across diverse sectors, diverse ways of thinking, and diverse governments that innovative ideas and programs will grow.

I argue, therefore, that the federal project in Canada is not to disentangle overlapping jurisdictions. It is to acknowledge complexity and to draw on the best from the private, voluntary, and public sectors to create shared policy space across levels of government for new ideas, feedback, and correction. Our challenge of the next twenty-five years is not to simplify and order, as we intuitively think, but to build a grid that allows all three levels of government to manage complexity and avoid the gridlock that can be so crippling. The model of networks, embedded in a grid, is, as I will argue below, a more

useful metaphor than that of parallel lines of government neatly separated from one another.

I call this "networked federalism," located in a grid where movement is along many of the axes, not through a central hub. Others call it the "whole of government" or "multi-level governance." The idea is the same: for hard and complex problems, the resources, expertise, and jurisdictional authority of all levels of government need to be deployed in a coordinated way.

This is a hard argument to make today in a country that is prosperous, with an unemployment rate at historic lows. A resource-based economy, however, is at best a short-term fix, not a long-term strategy. Canada needs to invest in research and development, in new environmentally friendly technologies, in education, in science-based industries, in building the capacity to take discoveries to market, in state-of-the-art infrastructure, and in the support of its arts and culture which help to make this country and its cities such attractive places to live. None of this will happen in silos.

Federal, provincial, and municipal governments must work to forge new, more flexible structures that are more nimble, less rigid, less cumbersome, and more transparent to Canadians. Contrary to much of the current public rhetoric, the principal issue is not accountability. On this issue, we are using a sledgehammer to crack a nut and, in the process, crippling our public institutions. Corruption may be a terrific campaign issue, but it is not Canada's most important challenge. We need to let our officials loose, to free them up, so that they can take some reasoned risks as they work to position this country in a global market and society. Most Canadians are already there. We now need to let our governments catch up to us.

THE "NETWORKED" SOCIETY

What does "networked federalism" mean conceptually? What would it mean in practice? How would federalism change if it were networked? Would networked federalism help to solve the problems of institutional deadlock that are so frustrating to Canadians across this country? State power is alive and well, skeptics would argue correctly, and hierarchical institutions – command-and-control institutions where orders come down from the top and compliance flows up from the bottom – still shape significant parts of our society. Governments and federal arrangements are a fixed part of Canada's landscape and will remain so.

It is important to qualify the claims that I will make for networked federalism. Institutions rarely disappear, but as new institutions and forms of social organization appear, they co-habit within shared space and change their function. Our federal institutions need to co-habit and share policy space. To function within this larger grid, they are going to need better traffic rules and

more roads. I develop these arguments in part by telling a messy historical story of institutional evolution and co-habitation and then by looking over the frontier of social organization before pulling back again to look at our federal arrangements.

TRIBES, HIERARCHIES, MARKETS, AND NETWORKS

First, the evolutionary history of social organization. To make this narrative a little easier to follow, I borrow David Ronfeldt's story of history as an evolution through different forms of social organization (Ronfeldt 1996). Societies have evolved through four basic social units, he tells us, which exist in different combinations. We began as clans and tribes, organized as extended families around kinship. In some societies today, clans and tribes still remain the most important unit of social organization. It is hard to think about Saudi Arabia or Somalia, for example, without giving pride of place to tribes in politics and society. In their purest form, tribes are rooted in ties of extended family and kinship, in remembrance of a common ancestor and common traditions. Tribes have evolved and continue to exist in even the most advanced societies through their cultural and social ties.

Hierarchies soon emerged to co-exist with tribes and then to replace them as the dominant form of social organization. Empires and armies are hierarchical, as is the modern bureaucratic state and the corporation. Hierarchies have centres for decision and control, usually at the apex of the pyramid. Members report up and manage down. Think of the difficulties "whistle blowers" usually experience when they challenge the top of the pyramid. Hierarchies are more open than tribes because we can join a hierarchy, even if we are not connected through kinship. The weakness of hierarchies, however, is their limited capacity to handle complex flows of information and exchange. Information and exchange are all routed along the same roadway that gets more and more clogged, especially as volumes of traffic grow.

Open competitive markets rose to prominence in part because they were so much better at handling these complex flows of information and exchanges. In an open market, in theory but often not in practice, everyone is free to join, as long as they participate in an exchange. Markets generally work to open up spaces. The weakness of markets is their tendency to create uneven distributions of wealth, to grow inequality along with wealth. In the modern era, the state regulated markets and redistributed income to moderate these inequalities. Working in contrapuntal tones, hierarchies and markets dominated the last century as the principal forms of social organization. In the process, states took on new responsibilities and forged new social contracts with citizens. The state hierarchy evolved.

Networks, the latest organizational form to become prominent, are growing in importance because they are especially good at dealing with dense flows

of information. They connect all members to each other in a "flatter" structure, without a pyramid and sometimes even without a formal center. They enable communication and collaboration among members who may be dispersed in different organizations, in space, and in time. Networks multiply the channels through which information and exchange flow, and are, therefore, much less subject to blockage and gridlock.

Although networks have existed for centuries, the revolution in information and communications technology enabled them to proliferate and grow. They are only now becoming socially important because of their comparative advantage in handling the large volumes of information that flow around the world at unprecedented speed. Networks are joining tribes, hierarchies and markets as contenders to shape societies and states.

What is a network? We can think of a network as a collection of connected points or nodes. It can be one terminal, connected to the Internet, or one expert communicating with another in a common network devoted to a shared problem. I am a member of a global network that uses email every morning to share information and exchange views. In our network, we all communicate directly with one another, without going through a centre that controls the flow of information, in what is called a "distributed" form of communication (Baran 1964; Hafner 1996). In a distributed network, messages are broken into individual "packets" that then take many different paths to reach their destination. This kind of transmission allows communication to continue even if some nodes are destroyed or not working. When one node is not working, information is rerouted to others. In my email network, when one expert has turned off her computer, information still moves to the other computers; it is not blocked because one node is off-line. Networks are resilient because of their built-in redundancy; the more nodes are added to the network, the more resilient the network as a whole becomes. It is this distributed pattern of communication that makes gridlock much less likely as information moves simultaneously along several paths. Ask any commuter in a large city: reducing gridlock is a huge comparative advantage in a just-in-time world.

When a new form of social organization – such as a network – becomes prominent, older forms adapt. The most advanced societies have absorbed each new form of social organization without destroying its predecessors. New combinations emerge through adaptation and change the way older structures work. Hierarchies changed the way tribes operated, and markets changed the way tribes and hierarchies worked. As markets grew, states assumed the responsibility of moderating the inequalities that markets created. As the network grows in prominence, it too will change the way tribes, states, and markets work.

Corporations have already moved to more networked forms of organization to do business in global markets. They are consequently able to move information, ideas, and products much more quickly than they could if they

were organized exclusively as a hierarchy. Corporate headquarters set goals and strategies, and generally monitor overall performance, but decision making has been pushed down and out through global supply chains.

It is not only the corporate sector that has become more "network-like" in its behaviour. Using distributed forms of communication, open global networks of every kind have multiplied in the last decade: civil society activists, journalists, scientists, physicians, lawyers, scholars, and environmentalists. These networks have created new conditions for local and global political action. They have been able to go around one state to work with another to innovate on policy. One of the obvious consequences of networks, a consequence that we do not often talk about, is that states have lost their monopoly on public policy. They are already sharing space in the formulation of many public policies. Many of the new policy ideas are already generated outside government structures.

We may be only at the beginning of a revolutionary phase in information technology. The ongoing revolution will continue to diffuse power further from traditional command and control structures – away from hierarchies. The capacity of tiny silicon wafers is still multiplying, enabling computing power to grow as its costs per unit decline. As costs decline, networks will multiply and thicken, software will become "smarter" still and will develop the human capabilities of voice and vision. If not in the next ten years, certainly within the foreseeable future, we will see the "death of distance" as people anywhere will be able to connect in real time (Cairncross 1997; US Commission 1999). Advances in biotechnology and micro-electronics will also create new capabilities for connectivity and "micro-sensing." We are on the verge of allowing computers to knit together and work to solve shared problems. This "grid" technology would lash computers together to tackle problems. Technology would become almost like a utility, where users could then tap in to the problem-solving capacity of powerful unused computing capacity anywhere within the grid.

We need the equivalent in our political institutions. Policymaking is becoming less hierarchical as policy players from across sectors of society become more actively engaged in the policy arena. Multiple players participate in converting a problem into a policy issue, in putting these issues on the policy agenda, in disseminating policy-relevant knowledge, and in informing public debates. The making of public policy is becoming more network-like, with policy experts and highly knowledgeable policy-watchers connected to government. In this sense, our federal architecture is already living in a networked environment.

How has this sharing of policy space worked globally? Networks of human rights organizations have created new platforms to press governments to be accountable for the treatment of their citizens. They partnered with states to push for the creation of the International Criminal Court to hold leaders

accountable for genocide and crimes against humanity. Over the last two decades, these networks have changed norms and expectations worldwide about human rights. It was a network of non-governmental groups that partnered with Canada and other like-minded states to engineer the treaty banning land mines. The treaty was developed through this partnership, in a parallel process outside the United Nations. Only in its very last stages did the process become "official." Transparency International is a networked organization that monitors corruption in governments worldwide. Networks of environmentalists push to hold governments and corporations accountable for their performance on environmental commitments. Citizens' networks use boycotts to hold corporations accountable for their labour practices and push for "fair trade." Across the spectrum of public policy, locally and globally, networks are sharing – and shaping – policy space with states and in markets. They are changing the way states and markets work.

CANADA AND NETWORKED FEDERALISM

My analysis of networks and federalism suggests the following arguments:

1. *Networked federalism is most suited to areas where policy jurisdictions overlap.* Networked federalism is especially likely where global economic and social issues converge in Canadian political space. In areas where either order of government not only has a legal monopoly but exercises exclusive jurisdiction, shared policy space is unlikely to develop. I am not arguing that networked federalism replaces or substitutes for the existing legal and institutional arrangements that govern federalism in Canada. Nor am I arguing that these arrangements are inappropriate for those policy areas where policy does not cross, intersect, and overlap jurisdictions. Defence spending, for example, will obviously remain an exclusive area of federal activity, with no maladaptive consequences.

There are, however, remarkably few such policy issues that can be neatly segregated. International trade, for example, now directly impinges on provincial and municipal interests. Take, for example, the issue of the border between Canada and the United States, seemingly a straightforward issue of exclusive federal jurisdiction. Yet the practice is already very different. A summit meeting on "borders" in Gimli, Manitoba in May 2006 included most of the provincial premiers, many US governors, the ambassador from the United States to Canada as well as the Canadian ambassador to the United States and the prime minister of Canada. The summit followed the annual Western premiers' meeting, hardly the usual venue for this kind of international and federal-provincial discussion. Recent controversies over softwood lumber and passports convinced the premier of Manitoba, however, that premiers and

governors had to be part of Canada-US discussions. Around this meeting, parallel groups of experts from both countries have met to explore management of shared borders and are working together to feed their reports to federal agencies in Washington and in Ottawa as well as to premiers and governors. New ideas and information are moving, not along a single track, or up a chain of command, but along several tracks simultaneously connected in a grid-like structure. Even in an issue where one order of government has exclusive jurisdiction, the practice of federalism looks more and more like a network running along a grid.

How does this practice of networked federalism change the way federalism works? It provides information that is more comprehensive in a timely way and allows information to move around institutional blockages in central nodes. It is difficult to over-exaggerate the importance of just-in-time comprehensive information that can help to inform policy agendas. Networked federalism should also increase the costs of unilateral action by the federal government. As the participants increase in number and significance, it becomes harder for the federal government to abrogate understandings that are the result of a broadly based consensus.

Critics of networked, messy federalism could well respond with derision. Of the claims that can be made for networks, the claim that they are more functional and efficient at decision making is the most dubious. "Death by a thousand public consultations and working groups," one critic observed, "seems the more recognizable fate." This argument conflates form with substance. Public consultations are often cynical exercises to manipulate opinion. Governments know that opinion is divided and that the consultation will produce enough division so that they can do precisely as they wanted once the consultations are over.

The concept of networked federalism starts from a different place. In a network, governments connect with those who have important information, good policy ideas, and/or strategic assets in policy implementation. Since network membership is voluntary and fluid, those who participate expect real benefit over time. Federal, provincial, state, and foreign leaders who came to the Manitoba meeting expected to be better able to go around the one or two central players that generally control the flow of information on these kinds of issues. Practically, they wanted information flows to look much less like a hierarchy and more like a grid. Some of those who came also wanted unmediated and unfiltered access to information. They expected to acquire valuable information, push new ideas or proposals, and broaden the policy framework. All this on an issue that is classically considered one of exclusive federal jurisdiction.

Who has final power of decision when there is no consensus? This is a legitimate question to ask of networked federalism that works less through formally articulated channels and more through multiple connections of official

and unofficial participants, of decision makers, "policy wonks," and stakeholders who come in and out as the issues and problems change. In mixed networks of the kind I am talking about, decision-making power remains at all times with those who have legal authority. There is no ambiguity whatsoever about where the power to decide rests. Decisions are made by those empowered to do so, but in an iterative process, major decisions usually provoke a further round of problem-solving discussions as new questions arise. Feedback can be almost instantaneous.

What about accountability in networked arrangements? Who is ultimately held accountable by voters for getting things done? Networks generally place much less emphasis on accountability and representation, and pay much more attention to innovation and problem solving. The best networks generally wrestle with a problem, looking for new information and new ideas, and working to frame a problem so that it becomes more tractable. They judge each other by the value of the contribution they make. Over time, reputations are built for different kinds of skills and contributions – good quality information, good ideas, a willingness to experiment, ideas that work. Within the network, then, accountability does not loom large.

A focus on innovation and problem solving among people who have come to know and respect each other is not enough for voters. Voters need to know who is responsible for moving the agenda forward and who is blocking agreement. When all is said and done, whose file is this? Networks are not much help in answering this question, other than the reference to formal responsibility. On public security, for example, even though federal and provincial governments must work together and with partners in the private and voluntary sectors, it is federal officials who will be held formally accountable for achievements and for errors. The thrust of my argument has been that this kind of accountability, while politically necessary and legally mandated, is nevertheless misleading in our complex environments. Perhaps we are asking the wrong question.

I have argued that the global context in which federalism operates joins issues together in new ways and creates unanticipated linkages. I have already talked about shared public policy space in our cities, but many other policy issues – public health and health care, emergency preparedness, research and innovation, infrastructure, security – come to mind. Security, which falls exclusively within federal jurisdiction, may be a surprise on this list. Yet, it is now people, organized in networks, rather than states, that are more likely to be security threats. Many criminal networks and networks of terror thrive in urban areas, and have local as well as global connections. Federal security agencies will be unable to do their jobs without the active collaboration of agencies at the provincial and municipal levels. A silo approach, as the United States learned on September 11th, can generate devastating failure. The issue was not jurisdiction, nor roles and responsibilities, but the sharing and pooling of information in a timely way. Asking who was accountable for the intelli-

gence failure was not terribly helpful in figuring out how to do better in the future.

How would "networked federalism" help on these kinds of issues? The way it has begun to work already, only more so. The three levels of government would come together to create a shared policy space, governed by the minimum of rules. Networks of citizens and experts would be invited to contribute ideas. Officials would be encouraged to look outside Canada for innovative solutions. Officials from governments and other relevant institutions would work together to draft policies that could be shared until a consensus emerged or the responsible level of government is satisfied. Each level of government would contribute proportionately to the funding and would work out its contribution in collaboration with the other two. Small, temporary secretariats drawn from all three levels of government and other institutions would be created to evaluate the consequences of policy after it was rolled out and to provide feedback throughout the network. That is how high-functioning networks work.

This kind of a problem-solving network would be a parasite that would draw from existing institutions. It would borrow infrastructure, postage, telephones, a little space, and, most important, people. Networks of this kind appear to be inexpensive because, like their open source counterparts, they are making use of capacity that is available, at least for the moment. In this kind of network, federal, provincial, and municipal governments keep their identities; indeed, the need for recognition can be better met than in adversarial bargaining. A non-hierarchical, interdependent problem-solving network focuses on cross-policy linkages, consequences that cross jurisdictions, and designing modalities to get quick and constant feedback so that errors are corrected on an ongoing basis. It is possible to imagine immigration policy that is coordinated with settlement, infrastructure, and housing in major cities across Canada.

Some of what I am describing already happens, albeit in partial and limited ways. Officials from different jurisdictions do meet, share information, and talk about coordinated solutions to problems. Federal and provincial officials are working together with private partners on emergency preparedness and on managing pandemics. The new City of Toronto Act, given first reading in December, 2005, contains an important provision for "shared policy space" with the province. This is the first time in Canada that the policy development role – as opposed to a service delivery role – of a city will be recognized in legislation. There are a few, small experiments in tri-level approaches to problem solving in cities in the West. It is not happening often enough, however, and not broadly enough. When officials from the different orders of government do meet, moreover, they often complain privately about the lack of confidence in one another.

2. *Networked federalism requires "sticky networks" and social glue.* It is this social glue – shared norms, shared values, long-standing ties of friendship –

that often underpin high-functioning networks. From this perspective, federalism can be seen as a structure that is given life by the networks of informal political and social relationships among public officials, policy experts, and academics that connect one order of government to another. In Canada, there are a limited number of officials and experts who come to know one another over the years. These "sticky" networks of teachers and students, of officials and advisors, of policy experts and researchers, of staffers and pollsters, traditionally have helped to glue the social fabric of federalism together.

In the last decade, these "sticky networks" have not worked as well as they have in the past. Particularly since the sharp cuts in federal transfers in the mid-1990s, confidence and trust among officials from different orders of government seem to have broken down. The capacity to talk informally together, to complain about their elected bosses, to share stories, seems to be much less than it was a decade ago. In a series of interviews with provincial officials across the country that I did recently, I was struck by the distrust, the suspicion, the resort to "enemy" language. I was more familiar with that kind of imagery in international politics, but, to my surprise, it was alive and well in federal-provincial relations. It is troubling to hear this language in Canada.

When these "trust networks" break down, federal-provincial relations become rigid and brittle. Without these sticky networks, Canadian federalism becomes less able to share information across boundaries, less able to innovate, to test ideas, to broker compromise, and to move in something that remotely approaches "real time." The inability to talk freely, to go out for a beer with a federal or provincial counterpart, all make the day-to-day business of federalism much more difficult. Here "networked federalism" can compensate, at least to some degree. The shared experience of working on a common problem, repeated rounds of engagement, the sharing of data, the pooling of information, all help to break down barriers and build the sticky relationships, the "trust ties," as J. Stefan Dupré described them, which are essential to the functioning of any network.

3. Networked federalism does not require constitutional change, or the creation of a completely new set of institutions. The proposals I am making for "networked federalism" require neither constitutional amendments nor formal institutional change. On the contrary, all that is required is the linking together of existing institutions in new chains of connections, connections that can form and dissolve as necessary. The historic advantage of networks is their capacity to form, sustain, and contribute if there is agreement on principles and rules. Their geometry is variable. In this sense, networks are more flexible and less rigid than deeply embedded institutions.

What networked federalism absolutely does preclude is unilateralism. I argued earlier that there is a disturbing pattern of unilateralism in the last decade

by the federal government in its relationships with the provinces. Unilateralism undermines networked collaboration; indeed, it makes it impossible. Were the federal government to commit to a networked process, it would be committing to a collaborative solution. Why would it do so? Only because the process promised better information, more quickly and more cheaply, a better capacity to identify linkages and unintended consequences among policy issues, better ideas than it could generate alone, and better and cheaper feedback. These are considerable advantages, even to a government that has relatively greater resources. Finally, the federal government would have to get greater recognition and visibility, as would all other levels of government that participated in a networked process.

4. Networked federalism, to succeed in Canada, will require a deep change in culture among political elites. I have left the most serious obstacle, the one most likely to cripple experiments in shared policy space, to the last. The most serious obstacle to the renewal of federalism in Canada is the deeply embedded political culture of rights and entitlement of both orders of government and their emphasis on control. Over and over again, we hear about the rights a government has and the irresponsibility and bad faith of others. Our challenge is not another round of institutional design, but a shift in culture to accommodate networked politics.

Leaders at every level will have to move from this culture of rights and control to one of problem solving and innovation. This is probably the steepest and most important challenge Canada's leaders face if our institutions are to remain relevant to large numbers of our citizens, especially our young people. If this sounds like a tall order, it is helpful to remember that this kind of shift has already occurred in the corporate and voluntary sectors. In these two sectors, there were the equivalent of "centralized agencies" that play such an important role in government, but leaders in the other two sectors are more disciplined by their environments and, consequently, move faster. Leaders in government have to catch up.

A new set of leadership skills will be important. Matrix management, the capacity to steer throughout the grid, to look sideways, as well as forward, to have peripheral vision, is demanding of time and energy. It requires the capacity to elicit rather than to order, to listen as well as to speak, and to be alert to the unanticipated, the non-linear. Most challenging of all, network leadership requires a capacity to sustain messiness, iterated rounds of problem solving, and some loss of control. The advantages, however, can be significant. When a network is working well, the quality of information, its timeliness, and the opportunity to generate creative ideas and approaches more than compensates. In a knowledge-based economy and society, it is difficult to exaggerate the value of good information and good ideas.

CONCLUSION

Networked federalism will not solve the most important issues that dominate current federal-provincial discussions. At least, it will not do so directly. The arguments about the fiscal imbalance, or about equalization, or about representation, or about distinctiveness will not go away. These issues will remain part of our institutional landscape. They may, however, not continue to be the most prominent issues.

First, in a context of networked collaboration, of good governance of shared policy space, of a growing habit of collaboration, even of shared innovation and of greater policy responsiveness, in a Mondrian-like landscape, it may well be that these recurring issues that so embitter our politics will become less prominent in our federal landscape. They have not always been as prominent as they are now, especially when Canada has faced significant challenges. We face the challenge of investing in a sustainable future so that we are prepared to live in a global society and compete in the global economy. That is not an insignificant challenge. None of our current preoccupations speaks to this challenge. We cannot meet the challenge of the post-industrial world if we rely exclusively on ways of managing public business that were adaptive in the industrial age.

Second, governments everywhere are recognizing that "silo" policy-making is inadequate. The federal government, for example, has been struggling for the last five years to reduce the policy silos and to thicken the horizontal connections among departments. To give voice to what it wanted to do, it coined the quite awful word, "horizontality." Nevertheless, "horizontality" captures the urgency of working across departments and across policy issues so that linkages and consequences can be identified. Provincial governments focused on public emergencies have engaged in very similar processes. In all cases, it has been a struggle. Old habits die hard, sometimes only in the face of shock. SARS, for example, shook the Ontario government out of long-standing habits.

To replicate silo decision making in order to reduce federal-provincial friction would be to solve a smaller problem at the expense of a much larger challenge. Societies that do well in the next several decades will be those that innovate at the edges, where different policy issues meet and create friction. Innovation of environmentally friendly technologies and development of environmental policy cannot happen in silos. Immigration and strategic infrastructure must be considered in the context of health care, education, and social assistance in our large cities as a set of interconnected issues that will shape our capacity to mirror global society. If we get it right, that set of issues, bundled together as the consequences of one reshape another, will increase our productivity and our capacity to engage in the global economy.

Let me leave you with some bold assertions, deliberately phrased to provoke:

- A heavy emphasis on our traditional culture of control and order in our federal architecture will not serve us well as Canada engages more heavily in global markets and in global society. Messiness, overlap, and linkage are the incubators of creativity. Creativity and innovation will happen at the edges, where the tectonic plates bump up repeatedly against one another. In Canada, we overvalue order, especially in institutional design.
- Those societies that thrive in messiness and can see new patterns in what appears to be disorder will do best. They will attract the most creative people, at home and abroad, and will lead.
- Federal institutions, like all other government institutions, must better reflect the societies they govern. Jurisdictional arguments and silo arrangements reflect the past. They slow access by government to new information and new ideas, and lag in policy responsiveness. Problem solving "networked federalism" is just one approach to bring laggard governments up to speed with their societies. Time is pressing. Just-in-time delivery is here.

REFERENCES

Baran, P. 1964. *On Distributed Communications*. Santa Monica, CA: Rand.

Cairncross, F. 1997. *The Death of Distance: How the Communications Revolution will Change our Lives*. Boston: Harvard Business School Press.

Christensen, K. 2006. "Interview with a Creativity Guru: Richard Florida." *Rotman Magazine* Spring/Summer: 10–13.

Council of the Federation. 2006 (April). "The Citizen Dialogue Process," Appendix 3. In *Reconciling the Irreconcilable: Addressing Canada's Fiscal Imbalance*. Advisory Panel on Fiscal Imbalance, 109–112. Available at http://www.councilofthefederation.ca/pdfs/Report_Fiscalim_Mar3106.pdf

Hafner, K. 1996. *Where Wizards Stay Up Late*. New York: Simon and Schuster.

Ronfeldt, D.F. 1996. *Tribes, Institutions, Markets, Networks: A Framework about Societal Evolution*. Santa Monica, CA: Rand.

US Commission on National Security/21st Century. 1999(September). *New World Coming: American Security in the 21st Century*. Available at http://govinfo.library.unt.edu/nssg/Reports/NWC.pdf

Queen's Policy Studies
Recent Publications

The Queen's Policy Studies Series is dedicated to the exploration of major public policy issues that confront governments and society in Canada and other nations.

Our books are available from good bookstores everywhere, including the Queen's University bookstore (http://www.campusbookstore.com/). McGill-Queen's University Press is the exclusive world representative and distributor of books in the series. A full catalogue and ordering information may be found on their web site (http://mqup.mcgill.ca/).

School of Policy Studies

Dear Gladys: Letters from Over There, Gladys Osmond (Gilbert Penney ed.), 2008
ISBN 978-1-55339-223-1

Bridging the Divide: Religious Dialogue and Universal Ethics, Papers for The InterAction Council, Thomas S. Axworthy (ed.), 2008
Paper ISBN 978-1-55339-219-4 Cloth ISBN 978-1-55339-220-0

Immigration and Integration in Canada in the Twenty-first Century, John Biles, Meyer Burstein, and James Frideres (eds.), 2008
Paper ISBN 978-1-55339-216-3 Cloth ISBN 978-1-55339-217-0

Robert Stanfield's Canada, Richard Clippingdale, 2008 ISBN 978-1-55339-218-7

Exploring Social Insurance: Can a Dose of Europe Cure Canadian Health Care Finance? Colleen Flood, Mark Stabile, and Carolyn Tuohy (eds.), 2008
Paper ISBN 978-1-55339-136-4 Cloth ISBN 978-1-55339-213-2

Canada in NORAD, 1957–2007: A History, Joseph T. Jockel, 2007
Paper ISBN 978-1-55339-134-0 Cloth ISBN 978-1-55339-135-7

Canadian Public-Sector Financial Management, Andrew Graham, 2007
Paper ISBN 978-1-55339-120-3 Cloth ISBN 978-1-55339-121-0

Emerging Approaches to Chronic Disease Management in Primary Health Care, John Dorland and Mary Ann McColl (eds.), 2007
Paper ISBN 978-1-55339-130-2 Cloth ISBN 978-1-55339-131-9

Fulfilling Potential, Creating Success: Perspectives on Human Capital Development, Garnett Picot, Ron Saunders and Arthur Sweetman (eds.), 2007
Paper ISBN 978-1-55339-127-2 Cloth ISBN 978-1-55339-128-9

Reinventing Canadian Defence Procurement: A View from the Inside, Alan S. Williams, 2006
Paper ISBN 0-9781693-0-1 (Published in association with Breakout Educational Network)

SARS in Context: Memory, History, Policy, Jacalyn Duffin and Arthur Sweetman (eds.), 2006
Paper ISBN 978-0-7735-3194-9 Cloth ISBN 978-0-7735-3193-2
(Published in association with McGill-Queen's University Press)

Dreamland: How Canada's Pretend Foreign Policy has Undermined Sovereignty, Roy Rempel, 2006
Paper ISBN 1-55339-118-7 Cloth ISBN 1-55339-119-5
(Published in association with Breakout Educational Network)

Canadian and Mexican Security in the New North America: Challenges and Prospects, Jordi Díez (ed.), 2006 Paper ISBN 978-1-55339-123-4 Cloth ISBN 978-1-55339-122-7

Global Networks and Local Linkages: The Paradox of Cluster Development in an Open Economy, David A. Wolfe and Matthew Lucas (eds.), 2005
Paper ISBN 1-55339-047-4 Cloth ISBN 1-55339-048-2

Choice of Force: Special Operations for Canada, David Last and Bernd Horn (eds.), 2005
Paper ISBN 1-55339-044-X Cloth ISBN 1-55339-045-8

Force of Choice: Perspectives on Special Operations, Bernd Horn, J. Paul de B. Taillon, and David Last (eds.), 2004 Paper ISBN 1-55339-042-3 Cloth 1-55339-043-1

New Missions, Old Problems, Douglas L. Bland, David Last, Franklin Pinch, and Alan Okros (eds.), 2004 Paper ISBN 1-55339-034-2 Cloth 1-55339-035-0

The North American Democratic Peace: Absence of War and Security Institution-Building in Canada-US Relations, 1867-1958, Stéphane Roussel, 2004
Paper ISBN 0-88911-937-6 Cloth 0-88911-932-2

Implementing Primary Care Reform: Barriers and Facilitators, Ruth Wilson, S.E.D. Shortt and John Dorland (eds.), 2004 Paper ISBN 1-55339-040-7 Cloth 1-55339-041-5

Social and Cultural Change, David Last, Franklin Pinch, Douglas L. Bland, and Alan Okros (eds.), 2004 Paper ISBN 1-55339-032-6 Cloth 1-55339-033-4

Clusters in a Cold Climate: Innovation Dynamics in a Diverse Economy, David A. Wolfe and Matthew Lucas (eds.), 2004 Paper ISBN 1-55339-038-5 Cloth 1-55339-039-3

Canada Without Armed Forces? Douglas L. Bland (ed.), 2004
Paper ISBN 1-55339-036-9 Cloth 1-55339-037-7

Campaigns for International Security: Canada's Defence Policy at the Turn of the Century, Douglas L. Bland and Sean M. Maloney, 2004
Paper ISBN 0-88911-962-7 Cloth 0-88911-964-3

Understanding Innovation in Canadian Industry, Fred Gault (ed.), 2003
Paper ISBN 1-55339-030-X Cloth 1-55339-031-8

Delicate Dances: Public Policy and the Nonprofit Sector, Kathy L. Brock (ed.), 2003
Paper ISBN 0-88911-953-8 Cloth 0-88911-955-4

Beyond the National Divide: Regional Dimensions of Industrial Relations, Mark Thompson, Joseph B. Rose and Anthony E. Smith (eds.), 2003
Paper ISBN 0-88911-963-5 Cloth 0-88911-965-1

The Nonprofit Sector in Interesting Times: Case Studies in a Changing Sector, Kathy L. Brock and Keith G. Banting (eds.), 2003
Paper ISBN 0-88911-941-4 Cloth 0-88911-943-0

Clusters Old and New: The Transition to a Knowledge Economy in Canada's Regions, David A. Wolfe (ed.), 2003 Paper ISBN 0-88911-959-7 Cloth 0-88911-961-9

The e-Connected World: Risks and Opportunities, Stephen Coleman (ed.), 2003
Paper ISBN 0-88911-945-7 Cloth 0-88911-947-3

Knowledge Clusters and Regional Innovation: Economic Development in Canada, J. Adam Holbrook and David A. Wolfe (eds.), 2002
Paper ISBN 0-88911-919-8 Cloth 0-88911-917-1

Lessons of Everyday Law/Le droit du quotidien, Roderick Alexander Macdonald, 2002
Paper ISBN 0-88911-915-5 Cloth 0-88911-913-9

Improving Connections Between Governments and Nonprofit and Voluntary Organizations: Public Policy and the Third Sector, Kathy L. Brock (ed.), 2002
Paper ISBN 0-88911-899-X Cloth 0-88911-907-4

Governing Food: Science, Safety and Trade, Peter W.B. Phillips and Robert Wolfe (eds.), 2001
Paper ISBN 0-88911-897-3 Cloth 0-88911-903-1

The Nonprofit Sector and Government in a New Century, Kathy L. Brock and
Keith G. Banting (eds.), 2001 Paper ISBN 0-88911-901-5 Cloth 0-88911-905-8

The Dynamics of Decentralization: Canadian Federalism and British Devolution,
Trevor C. Salmon and Michael Keating (eds.), 2001 ISBN 0-88911-895-7

Institute of Intergovernmental Relations

Comparing Federal Systems, Third Edition, Ronald L. Watts, 2008 ISBN 978-1-55339-188-3

Canada: The State of the Federation 2005: Quebec and Canada in the New Century – New Dynamics, New Opportunities, vol. 19, Michael Murphy (ed.), 2007
Paper ISBN 978-1-55339-018-3 Cloth ISBN 978-1-55339-017-6

Spheres of Governance: Comparative Studies of Cities in Multilevel Governance Systems,
Harvey Lazar and Christian Leuprecht (eds.), 2007
Paper ISBN 978-1-55339-019-0 Cloth ISBN 978-1-55339-129-6

Canada: The State of the Federation 2004, vol. 18, *Municipal-Federal-Provincial Relations in Canada,* Robert Young and Christian Leuprecht (eds.), 2006
Paper ISBN 1-55339-015-6 Cloth ISBN 1-55339-016-4

Canadian Fiscal Arrangements: What Works, What Might Work Better, Harvey Lazar (ed.), 2005
Paper ISBN 1-55339-012-1 Cloth ISBN 1-55339-013-X

Canada: The State of the Federation 2003, vol. 17, *Reconfiguring Aboriginal-State Relations,*
Michael Murphy (ed.), 2005 Paper ISBN 1-55339-010-5 Cloth ISBN 1-55339-011-3

Canada: The State of the Federation 2002, vol. 16, *Reconsidering the Institutions of Canadian Federalism,* J. Peter Meekison, Hamish Telford and Harvey Lazar (eds.), 2004
Paper ISBN 1-55339-009-1 Cloth ISBN 1-55339-008-3

Federalism and Labour Market Policy: Comparing Different Governance and Employment Strategies, Alain Noël (ed.), 2004 Paper ISBN 1-55339-006-7 Cloth ISBN 1-55339-007-5

The Impact of Global and Regional Integration on Federal Systems: A Comparative Analysis,
Harvey Lazar, Hamish Telford and Ronald L. Watts (eds.), 2003
Paper ISBN 1-55339-002-4 Cloth ISBN 1-55339-003-2

Canada: The State of the Federation 2001, vol. 15, *Canadian Political Culture(s) in Transition,*
Hamish Telford and Harvey Lazar (eds.), 2002
Paper ISBN 0-88911-863-9 Cloth ISBN 0-88911-851-5

Federalism, Democracy and Disability Policy in Canada, Alan Puttee (ed.), 2002
Paper ISBN 0-88911-855-8 Cloth ISBN 1-55339-001-6, ISBN 0-88911-845-0 (set)

Comparaison des régimes fédéraux, 2ᵉ éd., Ronald L. Watts, 2002 ISBN 1-55339-005-9

Health Policy and Federalism: A Comparative Perspective on Multi-Level Governance,
Keith G. Banting and Stan Corbett (eds.), 2001
Paper ISBN 0-88911-859-0 Cloth ISBN 1-55339-000-8, ISBN 0-88911-845-0 (set)

Disability and Federalism: Comparing Different Approaches to Full Participation,
David Cameron and Fraser Valentine (eds.), 2001
Paper ISBN 0-88911-857-4 Cloth ISBN 0-88911-867-1, ISBN 0-88911-845-0 (set)

Federalism, Democracy and Health Policy in Canada, Duane Adams (ed.), 2001
Paper ISBN 0-88911-853-1 Cloth ISBN 0-88911-865-5, ISBN 0-88911-845-0 (set)

John Deutsch Institute for the Study of Economic Policy

The 2006 Federal Budget: Rethinking Fiscal Priorities, Charles M. Beach, Michael Smart and Thomas A. Wilson (eds.), 2007
Paper ISBN 978-1-55339-125-8 Cloth ISBN 978-1-55339-126-6

Health Services Restructuring in Canada: New Evidence and New Directions, Charles M. Beach, Richard P. Chaykowksi, Sam Shortt, France St-Hilaire and Arthur Sweetman (eds.), 2006 Paper ISBN 978-1-55339-076-3 Cloth ISBN 978-1-55339-075-6

A Challenge for Higher Education in Ontario, Charles M. Beach (ed.), 2005
Paper ISBN 1-55339-074-1 Cloth ISBN 1-55339-073-3

Current Directions in Financial Regulation, Frank Milne and Edwin H. Neave (eds.), Policy Forum Series no. 40, 2005 Paper ISBN 1-55339-072-5 Cloth ISBN 1-55339-071-7

Higher Education in Canada, Charles M. Beach, Robin W. Boadway and R. Marvin McInnis (eds.), 2005 Paper ISBN 1-55339-070-9 Cloth ISBN 1-55339-069-5

Financial Services and Public Policy, Christopher Waddell (ed.), 2004
Paper ISBN 1-55339-068-7 Cloth ISBN 1-55339-067-9

The 2003 Federal Budget: Conflicting Tensions, Charles M. Beach and Thomas A. Wilson (eds.), Policy Forum Series no. 39, 2004
Paper ISBN 0-88911-958-9 Cloth ISBN 0-88911-956-2

Canadian Immigration Policy for the 21st Century, Charles M. Beach, Alan G. Green and Jeffrey G. Reitz (eds.), 2003 Paper ISBN 0-88911-954-6 Cloth ISBN 0-88911-952-X

Framing Financial Structure in an Information Environment, Thomas J. Courchene and Edwin H. Neave (eds.), Policy Forum Series no. 38, 2003
Paper ISBN 0-88911-950-3 Cloth ISBN 0-88911-948-1

Towards Evidence-Based Policy for Canadian Education/Vers des politiques canadiennes d'éducation fondées sur la recherche, Patrice de Broucker and/et Arthur Sweetman (eds./dirs.), 2002 Paper ISBN 0-88911-946-5 Cloth ISBN 0-88911-944-9

Money, Markets and Mobility: Celebrating the Ideas of Robert A. Mundell, Nobel Laureate in Economic Sciences, Thomas J. Courchene (ed.), 2002
Paper ISBN 0-88911-820-5 Cloth ISBN 0-88911-818-3

The State of Economics in Canada: Festschrift in Honour of David Slater, Patrick Grady and Andrew Sharpe (eds.), 2001 Paper ISBN 0-88911-942-2 Cloth ISBN 0-88911-940-6

The 2000 Federal Budget: Retrospect and Prospect, Paul A.R. Hobson and Thomas A. Wilson (eds.), 2001 Policy Forum Series no. 37, 2001
Paper ISBN 0-88911-816-7 Cloth ISBN 0-88911-814-0

Our publications may be purchased at leading bookstores, including the Queen's University Bookstore
(http://www.campusbookstore.com/), or can be ordered online from: McGill-Queen's University Press, at
http://mqup.mcgill.ca/ordering.php

For more information about new and backlist titles from Queen's Policy Studies, visit the McGill-Queen's
University Press web site at:
http://mqup.mcgill.ca/

Institute of Intergovernmental Relations
Recent Publications

Available from McGill-Queen's University Press:

Canada: The State of the Federation 2005: Quebec and Canada in the New Century – New Dynamics, New Opportunities, vol. 19, Michael Murphy (ed.), 2007
Paper ISBN 978-1-55339-018-3 Cloth ISBN 978-1-55339-017-6

Spheres of Governance: Comparative Studies of Cities in Multilevel Governance Systems, Harvey Lazar and Christian Leuprecht (eds.), 2007
Paper ISBN 978-1-55339-019-0 Cloth ISBN 978-1-55339-129-6

Canada: The State of the Federation 2004, vol. 18, Municipal-Federal-Provincial Relations in Canada, Robert Young and Christian Leuprecht (eds.), 2006
Paper ISBN 1-55339-015-6 Cloth ISBN 1-55339-016-4

Canadian Fiscal Arrangements: What Works, What Might Work Better, Harvey Lazar (ed.), 2005
Paper ISBN 1-55339-012-1 Cloth ISBN 1-55339-013-X

Canada: The State of the Federation 2003, vol. 17, Reconfiguring Aboriginal-State Relations, Michael Murphy (ed.), 2005 Paper ISBN 1-55339-010-5 Cloth ISBN 1-55339-011-3

Money, Politics and Health Care: Reconstructing the Federal-Provincial Partnership, Harvey Lazar and France St-Hilaire (eds.), 2004
Paper ISBN 0-88645-200-7 Cloth ISBN 0-88645-208-2

Canada: The State of the Federation 2002, vol. 16, Reconsidering the Institutions of Canadian Federalism, J. Peter Meekison, Hamish Telford and Harvey Lazar (eds.), 2004
Paper ISBN 1-55339-009-1 Cloth ISBN 1-55339-008-3

Federalism and Labour Market Policy: Comparing Different Governance and Employment Strategies, Alain Noël (ed.), 2004 Paper ISBN 1-55339-006-7 Cloth ISBN 1-55339-007-5

The Impact of Global and Regional Integration on Federal Systems: A Comparative Analysis, Harvey Lazar, Hamish Telford and Ronald L. Watts (eds.), 2003
Paper ISBN 1-55339-002-4 Cloth ISBN 1-55339-003-2

Canada: The State of the Federation 2001, vol. 15, Canadian Political Culture(s) in Transition, Hamish Telford and Harvey Lazar (eds.), 2002
Paper ISBN 0-88911-863-9 Cloth ISBN 0-88911-851-5

Federalism, Democracy and Disability Policy in Canada, Alan Puttee (ed.), 2002
Paper ISBN 0-88911-855-8 Cloth ISBN 1-55339-001-6, ISBN 0-88911-845-0 (set)

Comparaison des régimes fédéraux, 2ᵉ éd., Ronald L. Watts, 2002 ISBN 1-55339-005-9

Health Policy and Federalism: A Comparative Perspective on Multi-Level Governance, Keith G. Banting and Stan Corbett (eds.), 2002
Paper ISBN 0-88911-859-0 Cloth ISBN 1-55339-000-8

Comparing Federal Systems, 2nd ed., Ronald L. Watts, 1999 ISBN 0-88911-835-3

The following publications are available from the Institute of Intergovernmental Relations, Queen's University, Kingston, Ontario K7L 3N6
Tel: (613) 533-2080 / Fax: (613) 533-6868; E-mail: iigr@qsilver.queensu.ca

Open Federalism, Interpretations Significance, collection of essays by Keith G. Banting, Roger Gibbins, Peter M. Leslie, Alain Noël, Richard Simeon and Robert Young, 2006
ISBN 978-1-55339-187-6

First Nations and the Canadian State: In Search of Coexistence, Alan C. Cairns, 2002 Kenneth R. MacGregor Lecturer, 2005 ISBN 1-55339-014-8

Political Science and Federalism: Seven Decades of Scholarly Engagement, Richard Simeon, 2000 Kenneth R. MacGregor Lecturer, 2002 ISBN 1-55339-004-0

The Institute's working paper series can be downloaded from our website www.iigr.ca